1998 Traveler's Guide to Art Museum Exhibitions

Tenth Anniversary Edition

The Guide "For art lovers who travel, and travelers who love art..." ™

Susan S. Rappaport, Editor & Publisher

Jennifer A. Smith and Susan Coll,
Associate Editors

Museum Guide Publications, Inc. ™

distributed by
Harry N. Abrams, Inc., New York

Front Cover:

Richard Diebenkorn, *Girl With Plant,* 1960. From *Richard Diebenkorn,* a traveling retrospective exhibition. Photo courtesy The Phillips Collection, Washington, D.C.

Whitney Museum of American Art, NY: Thru Jan. 11
Modern Art Museum of Fort Worth, TX: Feb. 8–Apr. 12
Phillips Collection, Washington, DC: May 9–Aug. 16
San Francisco Museum of Modern Art, CA: Oct. 9, 1998–Jan. 19, 1999

Acknowledgments

The editors wish to give special thanks to The Phillips Collection, Washington, D.C. for the loan of our Tenth Anniversary Edition cover image by Richard Diebenkorn, featured in the traveling retrospective exhibition; thanks to American Federation of Arts, Art Services International, Curatorial Assistance, Independent Curators Incorporated, Smithsonian Institution Traveling Exhibition Service, and the Trust for Museum Exhibitions for their generous help with the guide; our deepest thanks also to the public relations representatives and curatorial staffs from museums around the world who have shared exhibition and museum information; to Heather Ewing; and for the continued enthusiasm and guidance of Marti Malovany, Harry N. Abrams, Inc.

We would also like to give special acknowledgment to the late Jack Buchanek without whom the Guide would not have started ten years ago.

ISBN 0-8109-6345-0
Printed in the U.S.A.

Table of Contents

How to Use

The *Traveler's Guide to Art Museum Exhibitions*—the guide for art lovers who travel, and for travelers who love art—is a unique calendar-year index to fascinating national and international exhibitions. It is also a useful and easy reference to the outstanding permanent collections in museums throughout the United States and selected museums in Canada, Europe, Australia, and Japan.

The guide begins with 1998 Major Traveling Exhibitions, where the reader will find exhibitions listed alphabetically, with an itinerary for the entire year. All traveling exhibitions are marked with the symbol (T) in individual museum listings. The individual entries for each museum follow, organized by state (and by city within state) in the United States, and by country in Europe and elsewhere. Each entry includes exhibition schedules for 1998, highlights from permanent collections, a brief architectural history of each museum, as well as hours, admission, and tour schedules. This special Tenth Anniversary Edition also marks the inclusion of additional information about web site addresses, children's programs, and museum shops.

Every effort has been made to ensure accuracy; however, exhibition dates are subject to change. Be sure to double check by telephoning museums before your visit.

Tenth Anniversary Edition—Editor's Choice:

Welcome to the Tenth Anniversary Edition of the **Traveler's Guide to Art Museum Exhibitions**—the original museum planning guide for art lovers world-wide.

When the Guide was first published in 1988, there was no one central place to find exhibition schedules for the coming year. My goal was therefore to create a means for travelers who love art and art lovers who travel to plan ahead so that they and that must-see exhibition could be in the same city at the same time. Thanks to your enthusiastic response over the years, the Guide has more than doubled in size since its inception, and has evolved into an archive of information for nearly 300 major museums and not-to-be-missed small treasures around the world. Constantly expanding our information base, this year the guide includes museum website addresses (we will soon have our own website), and lists programs for children, as well as highlights of museum shops.

As reflected in the constantly evolving size of our guide, this past decade has seen enormous growth in the arts. The relaxing of tensions in Eastern Europe, for example, has made accessible works from the Hermitage, the Pushkin, and many other Russian and Central European Museums. Our broadened appreciation of what constitutes art has also sparked the birth of new venues such as the American Craft Museum, which opened in the late 1980s; the National Museum for the American Indian, which opened in 1994; and the new Georgia O'Keeffe Museum, which marks the first time a major museum has opened in celebration of an individual woman artist and, not insignificatly, rounds out a ten-year span that began with the opening of the National Museum of Women in the Arts. The Guggenheim has recently opened yet another venue—this one the architecturally lauded museum in Bilbao, Spain. Several museums have also launched major building and renovation projects in preparation for the new millenium, such as the Chicago Museum of Contemporary Art, the San Francisco Museum of Modern Art, the Philadelphia Museum of Art, and the grand, recently opened Getty Center in Los Angeles, to name just a few.

A glance at the major traveling exhibitions for the coming year serves as an instructive survey of modern art, and of the dominance of several American artists whose works have become major influences this century. The late California abstract colorist Richard Diebenkorn, for example, has been praised by critic Robert Hughes as "the American response to Matisse." A survey of Diebenkorn's work will travel across the country, and the itinerary is listed in our "Traveling Exhibition" section. Texas-born artist Robert Rauschenberg—hailed as the father of pop art—is also the subject of a highly publicized retrospective this year and is significant in that it has the rare distinction of celebrating a living artist. Also traveling this year are major retrospectives of Mark Rothko, Chuck Close, Stuart Davis, and Arthur Dove—all of which are detailed, along with many other exciting exhibitions—in the coming pages.

Bon voyage!

Susan Rappaport

Susan Rappaport, Editor

1998 Major Traveling Exhibitions

Ansel Adams: A Legacy

National Museum of American Art,
Washington, DC: Thru Mar. 29
J.B. Speed Museum, Louisville,
KY: Sept. 22–Nov. 15

Antonio Manuel, *Untitled,* 1966. From *Aligning Vision: Alternative Currents in South American Drawing.* Photo by George Holmes, courtesy Archer M. Huntington Art Gallery.

Africa! A Sense of Wonder

Phoenix Art Museum, AZ: Thru
Feb. 8
Smart Museum of Art, Chicago, IL:
May 14–July 12
Krannert Art Museum, University
of Illinois,Urbana-Champaign:
Sept. 18–Nov. 1

After the Photo Secession: American Pictorial Photography, 1910–1955

Montgomery Museum of Art, AL: Thru Feb. 8
Georgia Museum of Art, GA: June 27–Aug. 30
Portland Museum of Art, ME: Oct. 10–Dec. 6

Triumph of the Spirit: Carlos Alfonzo, A Survey 1976–1991

Miami Art Museum, FL: Thru Mar. 7
Hirshhorn Museum, Washington, DC: June 18–Sept. 13

Aligning Vision: Alternate Currents in South American Drawing

Archer M. Huntington Art Gallery, TX: Jan. 16–Mar. 8
Museo de Bellas Artes, Caracas, Venezuela: May 10–July 19

All-Stars: American Sporting Prints from the Collection of Reba and Dave Williams

Herbert F. Johnson Museum of Art, Ithica, NY: Thru Jan. 18
Meadows Museum of Art, Shreveport, LA: Feb. 13-Apr. 12
MSC Forsyth Center Galleries, College Station, TX: Jul. 31-Sept. 27
Hofstra Museum, Hempstead, NY: Nov. 8-Dec. 18

El Alma del Pueblo: Spanish Folk Art and its Transformation in the Americas

San Antonio Museum of Art, TX: Thru Jan. 4
Art Museum, Florida International University: Jan.–Mar.
Tucson Museum of Art, AZ: Apr. 24–Aug. 2
Spanish Institute & Americas Society, NY: Sept.–Dec.

American Indian Pottery: A Legacy of Generations
National Museum of Women in the Arts, DC: Thru Jan. 11
Heard Museum, Phoenix, AZ: Feb. 14–May 17

Ancient Gold: The Wealth of the Thracians, Treasures from the Republic of Bulgaria
St. Louis Museum of Art, MO: Feb. 7–Apr. 5
Kimbell Art Museum, Ft. Worth, TX: May 3–July 19
Fine Arts Museums of San Francisco, California Palace of the Legion of Honor, CA: Aug. 8–Oct. 11
New Orleans Museum of Art, LA: Oct. 31, 1998–Jan. 4, 1999

Ancient Gold Jewelry
Birmingham Museum of Art, AL: Jan. 25–Apr. 5
Musée des Beaux-Arts de Montréal, Canada: Apr. 30–July 19

Architecture of Reassurance: Designing the Disney Theme Parks:
Walker Art Center, Minneapolis, MN: Thru Jan. 18
UCLA Armand Hammer Museum, CA: May 9-Aug. 2
Cooper-Hewitt Museum, NY: Oct. 6, 1998-Jan. 10, 1999

Art of the Gold Rush
Oakland Museum of California: Jan. 24–May 31
Crocker Art Museum, Sacramento, CA: June 20–Sept. 13
National Museum of American Art, DC: Oct. 30, 1998–Mar. 7, 1999

Artist/Author: The Book as Art Since 1980
Weatherspoon Art Gallery, Greensboro, NC: Feb. 8–Apr. 5
Emerson Gallery, Hamilton College, Clinton, NY: Aug. 31–Oct. 18
Museum of Contemporary Art, Chicago, IL: Nov. 1998–Jan. 1999

Georg Baselitz: Portraits of Elke
Modern Art Museum of Ft. Worth, TX: Thru Jan. 18
North Carolina Museum of Art, Raleigh, NC: Feb. 21–May 17

Georg Baselitz, *Elke,* 1976. From *Georg Baselitz: Portraits of Elke.* Photo courtesy Modern Art Museum of Fort Worth.

Geoffrey Beene
Toledo Museum of Art, OH: Thru Jan. 4
Rhode Island School of Design, Providence, RI: Feb. 6–Apr. 19

Jacques Bellange: 17th-Century Printmaker of Lorraine
Georgia Museum of Art, Athens, GA: Thru Jan. 18
Spencer Museum of Art, Lawrence, KS: Mar. 14–May 17

George Bellows: Love of Winter
Norton Museum of Art, West Palm Beach, FL: Thru Feb. 8
Columbus Museum of Art, OH: July 10–Sept. 13

Joseph Beuys Multiples
Walker Art Center, Minneapolis, MN: Thru Jan. 4
Joslyn Art Museum, Omaha, NE: June 7–Aug. 9

Dawoud Bey: Portraits, 1975–1995
Cleveland Center for Contemporary Art, OH: Thru Feb. 8
Barbican Art Gallery, London, England: Apr. 1–June 4

Böcklin—De Chirico—Ernst: A Journey Toward the Unknown
Kunsthaus Zürich, Switzerland: Thru Jan. 18
Haus der Kunst, Munich, Germany: Feb. 6–May 3

Pierre Bonnard
Tate Gallery, London, England: Feb. 12-May 17
Museum of Modern Art, NY: June 21-Oct. 13

Mathew Brady's Portraits: Images as History, Photography as Art
National Portrait Gallery, Washington, DC: Thru Jan. 4
Fogg Art Museum, Harvard University, MA: Jan. 24–Apr. 12
International Center of Photography, NY: June 27–Sept. 26

British Delft from Colonial Williamsburg
Oklahoma City Art Museum, OK: Thru Jan. 10
Dixon Gallery, Memphis, TN: May 3-June 28

Lifecycles: The Charles E. Burchfield Collection
Montgomery Museum of Art, AL: Thru Jan. 25
Joslyn Art Museum, Omaha, NE: Mar. 14–May 17
Delaware Art Museum, Wilmington, DE: June 25–Sept. 7
Walter Anderson Museum of Art, Ocean Springs, MS: Nov. 6, 1998–Jan. 3, 1999

Alexander Calder, 1898–1976
National Gallery of Art, Washington, DC: Mar. 29–July 12
San Francisco Museum of Modern Art, CA: Sept. 5, 1998–Jan. 1, 1999

Sarah Charlesworth
Museum of Contemporary Art, San Diego, CA: Mar. 23–June 13
National Museum of Women in the Arts, DC: July 9–Sept. 27

Chihuly Over Venice
Portland Art Museum, OR: Thru Jan. 18
Columbus Museum of Art, OH: Oct. 9–Jan. 3, 1999

Chuck Close
Museum of Modern Art, NY: Feb. 26-May 26
Museum of Contemporary Art, Chicago, IL: June 20-Sept. 13
Hirshhorn Museum, Washington, DC: Oct. 15, 1998-Jan. 10, 1999

John Steuart Curry: Inventing the Middle West
Fine Arts Museums of San Francisco, M.H. DeYoung Memorial Museum, CA: June 13–Aug. 30
Nelson-Atkins Museum, Kansas City, MO: Oct. 11, 1998–Jan. 3, 1999

Stuart Davis
Palazzo delle Esposizioni, Rome, Italy: Thru Jan. 12
Stedelijk Museum, Amsterdam, Netherlands: Feb. 12–Apr. 19
National Museum of American Art, Wash., DC: May 22–Sept. 7

Roy DeCarava: A Retrospective
San Francisco Museum of Modern Art, CA: Jan. 23–Apr. 14
High Museum of Art, Atlanta, GA: June 27–Sept. 19

Degas and the Little Dancer
Joslyn Art Museum, Omaha, NE: Feb. 7–May 3
Sterling & Francine Clark Art Institute, Williamstown, MA: May 29–Sept. 7
Baltimore Museum of Art, MD: Oct. 4, 1998–Jan. 3, 1999

Arthur Dove, *Undated #3*. From *Reflections on Nature: Small Paintings by Arthur Dove, 1942-43*. Photo courtesy Wichita Art Museum and AFA.

Delacroix: The Late Work
Galeries Nationales du Grand Palais, Paris, France: Apr. 11–July 20
Philadelphia Museum of Art, PA: Sept. 20, 1998–Jan. 3, 1999

Designed for Delight: Alternative Aspects of 20th-Century Decorative Arts
Canadian Museum of Civilizations, Hull, Canada: Thru Feb. 15
Cincinnati Art Museum, OH: Mar. 15–May 24
Virginia Museum of Fine Arts, Richmond: Nov. 17, 1998–Jan. 31, 1999

Richard Diebenkorn
Whitney Museum of American Art, NY: Thru Jan. 11
Modern Art Museum of Ft. Worth, TX: Feb. 8–Apr. 12
Phillips Collection, Washington, DC: May 9–Aug. 16
San Francisco Museum of Modern Art, CA: Oct. 9, 1998–Jan. 19, 1999

Arthur Dove: A Retrospective
Phillips Collection, Washington, DC: Thru Jan. 4
Whitney Museum of American Art, NY: Jan. 15–Apr. 19
Addison Gallery of American Art, Andover, MA: Apr. 24–July 14
Los Angeles County Museum of Art, CA: Aug. 2–Oct. 5

Reflections on Nature: Small Paintings by Arthur Dove, 1942–43
McNay Art Museum, San Antonio, TX: Thru Feb. 15
Mitchell Gallery, St. John's College, Annapolis, MD: Mar. 6–May 3
California Center for the Arts, Escondido, CA: May 22–Aug. 16

The Work of Charles and Ray Eames: A Legacy of Invention
Vitra Design Museum, Weil am Rhein, Germany: Thru Jan. 4
Kunstmuseet Trapholt, Kolding, Denmark: May 26–Aug. 16
The Design Museum, London, England: Sept. 15, 1998–Jan. 3, 1999

Eternal China: Splendors from Ancient Xian
Dayton Art Institute, OH: Mar. 7–June 7
Santa Barbara Museum of Art, CA: July 18–Oct. 18

Evidence: Photography and Site
Cranbrook Art Museum, Bloomfield Hills, NJ: Thru Jan. 4
The Power Plant, Toronto, Canada: Jan. 16–Mar. 15

Expressions in Wood: Masterworks from the Wornick Collection
American Craft Museum, NY: Jan. 27-Mar. 22
Davenport Museum of Art, IA: June 19-Sept. 6

Recognizing Van Eyck
National Gallery, London, England: Jan. 14–Mar. 15
Philadelphia Museum of Art, PA: Apr. 4–May 31

Feeling the Spirit: Searching the World for the People of Africa by Chester Higgins, Jr.
Museum of Photographic Arts, San Diego, CA: Feb. 11-Apr. 12
National Civil Rights Museum, Memphis, TN: May 1-June 30

Peter Fischli and David Weiss: In a Restless World
The Institute of Contemporary Art, Boston, MA: Thru Jan. 11
Kunstmuseum, Wolfsburg: Jan. 30–May 3

The Flag in American Indian Art
High Museum of Art, Atlanta, GA: Feb. 21–June 13
National Museum of the American Indian, NY: Oct. 25, 1998–Jan. 3, 1999

For the Imperial Court: Qing Porcelain from the Percival David Foundation of Chinese Art, London
Kimbell Art Museum, Ft. Worth, TX: Thru Mar. 1
Society of Four Arts, Palm Beach, FL: Mar. 21–Apr. 15
Frick Art Museum, Pittsburgh, PA: May 3–July 24

French Master Drawings from the Pierpont Morgan Library, New York
The Pushkin State Museum of Fine Arts, Moscow: Mar.–May
The State Hermitage Museum, St. Petersburg: May–July
Pierpont Morgan Library, NY: Sept. 25, 1998–Jan. 8, 1999

Gifts of the Nile: Ancient Egyptian Faience
Cleveland Museum of Art, OH: May 10–July 5
Rhode Island School of Design, Providence: Aug. 24, 1998–Jan. 3, 1999

Jingdezhen Porcelain Flask. Qing dynasty, c. 1723-35. From *For the Imperial Court: Qing Porcelain from the Percival David Foundation of Chinese Art.* Photo courtesy American Federation of Arts.

Gold Fever! The Lure and Legacy of the California Gold Rush
Oakland Museum of California: Jan. 24–July 26
Autry Museum of Western Heritage, Los Angeles, CA: Sept. 19, 1998–Jan. 24, 1999

A Grand Design: The Art of the Victoria & Albert Museum
Baltimore Museum of Art, MD: Thru Jan. 18
Boston Museum of Fine Arts, MA: Feb. 25-May 17
Royal Ontario Museum, Toronto, Canada: June 20-Sept. 13
Museum of Fine Arts, Houston, TX: Oct. 18, 1998–Jan. 10, 1999

Nancy Graves: Excavations in Print
Middlebury College Museum of Art, VT: Jan 6-Feb. 8
Thorne-Sagendorph Art Gallery, Keene, NH: Mar. 20-May 29
Memphis Brooks Museum of Art, Memphis TN: June 28-Sept. 6

The Great American Pop Art Store: Multiples of the Sixties
Baltimore Museum of Art, MD: Mar. 25–May 24
Montgomery Museum of Fine Arts, AL: June 27–Aug. 23

Hallowed Ground: Preserving America's Heritage
Virginia Museum of Fine Arts, Richmond, VA: Mar.–Apr.
Savannah College of Art and Design, GA: Opens Oct.

the body and the object: Ann Hamilton 1984–1996
Miami Art Museum, FL: Mar. 27–May 3
Musée d'Art Contemporain, Montréal, Canada: Oct. 15–Jan. 3, 1999

Duane Hanson
Ft. Lauderdale Museum of Art, FL: Jan. 17–Aug. 2
Memphis Brooks Museum of Art, TN: Sept. 20–Nov. 29
Whitney Museum of American Art, NY: Dec. 17, 1998–Mar. 21, 1999

Hidden Treasures of the Tervuren Museum
Kimbell Art Museum, Ft. Worth, TX: Thru Jan. 25
Fine Arts Museums of San Francisco, California Palace of the Legion of Honor, CA: Feb. 21–Apr. 19
Museum for African Art, NY: May 22–Aug. 11

Hospice: A Photographic Inquiry
Norton Museum of Art, West Palm Beach, FL: Thru Jan. 11
Phoenix Art Museum, AZ: May 16–July 26

Hot Dry Men, Cold Wet Women
Arkansas Art Center, Little Rock, AK: Thru Feb. 8
John and Mable Ringling Museum of Art, Sarasota, FL: Mar. 2-Apr. 16

The Iberians
Galeries Nationales du Grand Palais, Paris, France: Thru Jan. 5
Kunst-und Ausstellungshalle, Bonn, Germany: May 15–Aug. 23

Ikat: Splendid Silks from Central Asia
Fine Arts Museums of San Francisco, M.H. DeYoung Memorial
Museum, CA: Thru Mar. 1
Arthur M. Sackler Gallery, Washington, DC: Apr. 26–Sept. 7

Imari: Japanese Porcelain for European Palaces
Mint Museum of Art, Charlotte, NC: Apr. 25–June 21
Honolulu Academy of Arts, HI: July 29–Sept. 13

In the Spirit of Resistance: African-American Modernists and the Mexican Muralist School
Dayton Art Institute, OH: Thru Feb. 1
Mexican Museum, San Francisco, CA: Feb. 27–Apr. 26

India: A Celebration of Independence, 1947–1997
Royal Festival Hall, London, England: Thru Jan. 18
Virginia Museum of Fine Arts, Richmond, VA: May–July
Indianapolis Museum of Art, IN: Sept. 6–Nov. 15
Knoxville Museum of Art, TN: Dec. 18, 1998–Feb. 28, 1999

Intimate Encounters: Love and Domesticity in 18th-Century France
Hood Museum of Art, Dartmouth College, NH: Thru Jan. 4
Toledo Museum of Art, OH: Feb. 15–May 10
Museum of Fine Arts, Houston, TX: May 31–Aug. 23

Inventing the Southwest: The Fred Harvey Company and Native American Art
The Nelson-Atkins Museum of Art, MO: Thru Jan. 4
The Autry Museum of Western Heritage, L.A., CA: Feb. 7–Apr. 19
Carnegie Museum of Natural History, Pittsburgh, PA: June 13–Sept. 6
Denver Art Museum, CO: Oct. 10, 1998–Jan. 3, 1999

The Invisible Made Visible: Angels from the Vatican Collection
Armand Hammer Museum, UCLA, L.A., CA: Feb. 4–Apr. 12
St. Louis Art Museum, MO: May 9–Aug. 2
Detroit Institute of Arts, MI: Aug. 23–Oct. 18
Walters Art Gallery, Baltimore, MD: Nov. 8, 1998–Jan. 3, 1999

It's Only Rock 'n' Roll: Rock 'n' Roll Currents in Contemporary Art

Lowe Art Museum, Coral Gables, FL: Thru Feb. 8
Milwaukee Art Museum, WI: Mar. 20–May 24
Arkansas Art Center: June 24–Sept. 1

Jerry Kearns, *Mojo*. From *It's Only Rock 'n' Roll: Rock 'n' Roll Currents in Contemporary Art*. Photo courtesy North Carolina Museum of Art.

Jasper Johns: Process and Printmaking

Dallas Museum of Art, TX: Jan. 25–Mar. 29
Hood Museum of Art, Dartmouth College, NH: Apr. 25–July 5
Cleveland Museum of Art, OH: Aug. 16–Nov. 15

Consuelo Kanaga: An American Photographer

The Phillips Collection, Washington, DC: Jan. 24–Apr. 5
Greenville County Museum of Art, SC: Apr. 22–June 21

King of the World: A Mughal Manuscript from the Royal Library, Windsor Castle

Metropolitan Museum of Art, NY: Thru Feb. 8
Los Angeles County Museum of Art, CA: Feb. 26–May 17
Kimbell Art Museum, Ft. Worth, TX: May 31–Aug. 23
Indianapolis Museum of Art, IN: Sept. 6–Nov. 29

Yayoi Kusama, 1958–1968

Los Angeles County Museum of Art, CA: Mar. 1–June 1
Museum of Modern Art, NY: July 9–Sept. 22
Walker Art Center, Minneapolis, MN: Dec. 19, 1998–Mar. 7, 1999

A Legacy for Maine: Masterworks from the Collection of Elizabeth B. Noyce

Portland Museum of Art, ME: Thru Jan. 4
Farnsworth Art Museum, Rockland, ME: Apr. 12–June 14

Fernand Léger

Museo Nacional Centro de Arte Reina Sofía, Spain: Thru Jan. 12
Museum of Modern Art, NY: Feb. 15–May 12

Annie Leibovitz Photographs

Center for Contemporary Art, Ujazdowski, Warsaw, Poland: Jan. 18-Mar. 14
National Gallery of Hungary, Budapest: Apr. 15-May 30

Lorenzo Lotto: Rediscovered Master of the Renaissance
National Gallery of Art, Washington, DC: Thru Mar. 1
Accademia Carrara, Bergamo, Italy: Apr. 2–June 28

Michael Lucero: Sculpture 1976–1994
Renwick Gallery, Washington, DC: Thru Jan. 4
Carnegie Museum of Art, Pittsburgh, PA: Feb. 28–May 24

Making It Real
Portland Museum of Art, ME: Jan. 15-Mar. 22
Bayly Art Museum, University of VA, Charlottesville, VA: Sept. 18-Nov. 15

Manet and the Impressionists at the Gare Saint-Lazare
Musée d'Orsay, Paris, France: Feb. 2-May 17
National Gallery of Art, Washington, DC: June 14-Sept. 20

Masters of Light: Dutch Painters in Utrecht during the Golden Age
Walters Art Gallery, Baltimore, MD: Jan. 11-Apr. 5
National Gallery, London, England: May 6-Aug. 2

Margaret Mee: Return to the Amazon
Dixon Gallery and Gardens, Memphis, TN: Feb. 8–May 3
Huntington Library, San Marino, CA: May 23–Aug. 23

Crimes and Splendors: The Desert Cantos of Richard Misrach
Contemporary Museum, Honolulu, HI: Thru Feb. 1
San Jose Museum of Art, CA: Oct. 3, 1998–Jan. 3, 1999

Modotti and Weston: Mexicanidad
Austin Museum of Art, TX: Aug. 29-Oct. 25
Gilcrease Museum, Tulsa, OK: Nov. 13, 1998-Jan. 3 1999

Turning Point: Monet's Débacles at Vétheuil
University of Michigan Museum of Art, Ann Arbor, MI: Jan. 24-Mar. 15
Dallas Museum of Art, TX: Mar. 28-May 17
Minneapolis Institute of Arts, MN: May 31-July 26

Monet: Paintings of Giverny from the Musée Marmottan
Walters Art Gallery, Baltimore, MD: Mar. 29-May 31
San Diego Museum of Art, San Diego, CA: June 27-Aug. 30
Portland Art Museum, OR: Sept. 20 1998-Jan. 1 1999

Thomas Moran
National Gallery of Art, Washington, DC: Thru Jan. 11
Gilcrease Museum, Tulsa OK: Feb. 8-May 10
Seattle Art Museum, WA: June 11-Aug. 30

William Sidney Mount: American Genre Painter
New York Historical Society, NY: Aug. 14-Oct. 25
Frick Art Museum, Pittsburgh, PA: Nov. 20, 1998-Jan. 10, 1999

Alphonse Mucha: The Flowering of Art Nouveau
San Diego Museum of Art, CA: Feb. 28-Apr. 26
Charles and Emma Frye Art Museum, Seattle, WA: May 22-July 19
Norton Museum of Art, West Palm Beach, FL: Nov. 7, 1998-Jan. 10, 1999

The Symbolist Prints of Edvard Munch: The Vivian and David Campbell Collection
Vancouver Art Gallery, Canada: Jan. 31-Apr. 13
Baltimore Museum of Art, MD: May 13-July 19
University of Michigan Museum of Art, Ann Arbor: Aug. 15-Oct. 25

Gabriel Münter: The Years of Expressionism, 1903-1920
Milwaukee Art Museum, WI: Thru Mar. 1
Columbus Museum of Art, OH: Apr. 17-June 21
Virginia Museum of Fine Arts, Richmond, VA: July 14-Sept. 20
McNay Art Museum, San Antonio, TX: Nov. 3, 1998-Jan. 3, 1999

Native Visions: Northwest Coast Art, 18th Century to the Present
Seattle Art Museum, WA: Feb. 19-May 10
Anchorage Museum of History and Art, AK: Oct. 18, 1998-Jan. 10, 1999

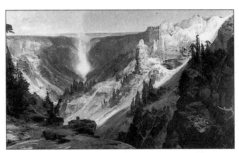

Thomas Moran, *Grand Canyon of the Yellowstone,* 1872. Photo courtesy Department of the Interior Museum and the National Gallery of Art, Washington, D.C.

Kinships: Alice Neel Looks at the Family
Smith College Museum of Art, Northampton, MA: Thru Jan. 11
Norton Museum of Art, West Palm Beach, FL: Feb. 14-Mar. 29

New Russian Art: Paintings from the Christian Keesee Collection
Memorial Art Gallery, University of Rochester, NY: Thru Jan. 25
Lowe Art Museum, Coral Gables, FL: Feb. 19–Apr. 5

New Worlds From Old: Australian and American Landscape Painting of the 19th Century
National Gallery of Australia, Canberra: Mar. 7-May 17
National Gallery of Victoria, Melbourne: June 2-Aug. 11
Wadsworth Atheneum, Hartford, CT: Sept. 12-Dec. 8

Old Masters Brought to Light: European Paintings from the National Museum of Art of Romania
Denver Art Museum, CO: Thru Jan. 25
Joslyn Art Museum, Omaha NE: Feb. 14-Apr. 12
Philbrook Museum of Art, Tulsa OK: May 17-July 12
San Diego Museum of Art, CA: Aug. 31-Oct. 31

Claes Oldenburg: Printed Stuff
Columbus Museum of Art, OH: Jan. 23-April
Detroit Institute of the Arts, MI: April-June 14

Our Nation's Colors: A Celebration of American Masters
Wichita Art Museum, KS: Thru Jan. 25
Mississippi Museum of Art, Jackson, MS: Mar. 7-July 26
Orlando Museum of Art, FL: Aug. 21-Oct. 18
Davenport Museum of Art, IA: Nov. 3, 1998-Jan. 10, 1999

Augustin Pajou, Royal Sculptor
Musée du Louvre, Paris, France: Thru Jan. 19
Metropolitan Museum of Art, NY: Feb. 26-May 24

Half-Past Autumn: The Art of Gordon Parks
Corcoran Gallery of Art, Washington, DC: Thru Jan. 11
Minnesota Museum of American Art, St. Paul, MN: Feb. 21-May 17

A Passion for the Past: The Collection of Bertram K. and Nina Fletcher Little
The Minneapolis Institute of Arts, Minneapolis MN: Thru. Jan. 25
Fred Jones Jr. Museum, Norman OK: Feb. 13-Apr. 3

Picasso: Masterworks from the Museum of Modern Art
High Museum of Art, Atlanta: Thru Feb. 15
National Gallery of Canada, Ottawa: Apr. 3-July 12

Pierre-Paul Prud'hon
Galeries Nationales du Grand Palais, Paris, France: Thru Jan. 12
Metropolitan Museum of Art, NY: Mar. 10–June 7

Robert Rauschenberg: A Retrospective
Solomon R. Guggenheim, NY: Thru Jan. 7
Guggenheim Museum SoHo, NY: Thru Jan. 4
Menil Collection, Houston, TX: Feb. 12-May 17
Museum of Fine Arts, Houston, TX: Feb. 12-May 17
Contemporary Arts Museum, Houston, TX: Feb. 12-May 17
Museum Ludwig, Cologne, Germany: June 26–Oct. 11
Museo Guggenheim Bilbao, Spain: Nov. 20, 1998–Feb. 26, 1999

Charles Ray
Whitney Museum of American Art, NY: June 4-Oct. 19
Museum of Contemporary Art, L.A., CA: Nov. 15, 1998–Feb. 21, 1999

Renoir's Portraits: Impressions of an Age
Art Institute of Chicago, IL: Thru Jan. 4
Kimbell Art Museum, Ft. Worth, TX: Feb. 8-Apr. 26

Rhapsodies in Black: Art of the Harlem Renaissance
California Palace of the Legion of Honor, San Francisco, CA: Jan. 17-Mar. 15
Corcoran Gallery of Art, Washington, DC: Apr. 11–June 22
Los Angeles County Museum of Art, CA: July 15–Sept. 13

Faith Ringgold: The French Collection/the American Collection
Akron Art Museum, OH: Jan. 24-Mar. 2
New Museum of Contemporary Art, NY:
Sept. 29–Dec. 20

Heavenly Hallucinations: A.G. Rizzoli
Museum of American Folk Art, NY: Jan. 10-Mar. 8
San Francisco Museum of Modern Art, CA: Mar. 27–June 23

Unknown artist, *Gourd for Bawon Samedi,* c.
1950s. From *Sacred Arts of Haitian Vodou.*
Photo courtesy New Orleans Museum of Art.

The Hands of Rodin: A Tribute to B. Gerald Cantor
Arkansas Art Center, Little Rock, AR: Feb. 13–May 17
Portland Art Museum, OR: June 2–Sept. 6

Mark Rothko
National Gallery of Art, Washington DC: May 3-Aug. 16
Whitney Museum of American Art, NY: Sept. 17, 1998-Jan. 10, 1999

Cindy Sherman, *Untitled Film Still #8*. Photo by Susan Einstein, courtesy Museum of Contemporary Art, Chicago.

Sacred Arts of Haitian Vodou
New Orleans Museum of Art, LA: Feb. 1-Apr. 12
Baltimore Museum of Art, MD: June 14-Aug. 30

Scandinavia and Germany, 1800-1914
Deutsches Historisches Museum, Berlin, Germany: Thru Jan.6
Nationalmuseum, Stockholm, Sweden: Feb. 27-May 24

Sean Scully
Milwaukee Art Museum, WI: Mar. 13–May 10
Denver Art Museum, CO: June 6–Oct. 24

The Search for Ancient Egypt
Dallas Museum of Art, TX: Thru Feb. 1
Denver Art Museum, CO: Apr. 4–Aug. 2
Seattle Art Museum, WA: Oct. 15 1998-Jan. 17 1999

George Segal
Hirshhorn Museum, Washington, DC: Feb. 19-May 17
Jewish Museum, NY: June 14-Oct. 4

Cindy Sherman: Retrospective
Museum of Contemporary Art, Los Angeles, CA: Thru Feb. 1
Museum of Contemporary Art, Chicago, IL: Feb. 28-June 7
Galerie Rudolfinum, Prague: June 25-Aug. 23
Barbican Art Gallery, London, England: Sept. 10–Dec. 13

Silver and Gold: Cased Images of the California Gold Rush
Oakland Museum of Art, CA: Jan. 24-July 26
National Museum of American Art, DC: Oct. 30, 1998-Mar. 7, 1999

Sandy Skoglund: Reality Under Seige
Smith College Museum of Art, Northampton, MA: Mar. 12-May 24
Cincinnati Art Museum, OH: June 28-Aug. 23

Soul of Africa: African Art from the Han Coray Collection
Munson-Williams-Proctor Institute, Utica, NY: Mar. 15-Sept. 13
Toledo Museum of Art, OH: Oct. 25 1998-Jan. 3 1999

Chaim Soutine: 1913-1943
Jewish Museum, NY: Apr. 26-Aug. 16
Cincinnati Art Museum, OH: Sept. 1998-Jan. 1999

Stanley Spencer: An English Vision
Hirshhorn Museum, Washington, DC: Thru Jan. 11
Centro Cultural/Arte Contemporaneo, Mexico City: Feb. 19-May 10
California Palace of the Legion of Honor, CA: June 6–Sept. 6

Splendors of Ancient Egypt
Detroit Institute of the Arts, MI: Thru Jan.4
Portland Art Museum, OR: Mar. 8-Aug. 16

Still Life: The Object in American Art, 1915-1995
Society of the Four Arts, Palm Beach, FL: Jan. 3-Jan. 30
Salina Art Center, Salina, KS: Mar. 3-May 3

Paul Strand, circa 1916
Metropolitan Museum of Art, NY: Feb. 10-May 3
San Francisco Museum of Modern Art, CA: May 22-Sept. 8

A Taste for Splendor: Treasures from the Hillwood Museum
Society of the Four Arts, Palm Beach, FL: Feb. 14-Mar. 11
Fresno Metropolitan Museum, Fresno, CA: Apr. 7-Aug. 9
The Philbrook Museum of Art, Tulsa, OK: Sept. 6-Nov. 1

Ties That Bind: Fiber Art by Ed Rossbach and Katherine Westphal from the Daphne Farago Collection
Museum of Art, Rhode Island School of Design, Providence RI: Thru Jan. 11
American Craft Museum, NY: June 25-Sept. 6

Treasures of Deceit: Archeology and the Forger's Craft
Davenport Museum of Art, IA: Apr. 18–June 7
Memphis Brooks Museum of Art, TN: Nov. 26, 1998–Jan. 17, 1999

Victorian Faerie Painting
Royal Academy of Art, London, England: Thru Feb. 8
Art Gallery of Ontario, Canada: June 10-Sept. 13

Bill Viola
Los Angeles County Museum of Art, CA: Thru Jan 11
Whitney Museum of American Art, NY: Feb. 12-May 10
Stedelijk Museum, Amsterdam: October-December

Visionary States: Surrealist Prints from the Gilbert Kaplan Collection
Boston College Museum of Art, Chestnut Hill, MA: Jan.9–May 24
Chicago Cultural Center, IL: Sept. 19-Nov. 15

When Silk Was Gold: Central Asian and Chinese Textiles
Cleveland Museum of Art, OH: Thru Jan. 4
Metropolitan Museum of Art, NY: Mar. 3-May 17

Whistler: Impressions of an American Abroad
Tampa Museum of Art, FL: Thru Jan. 11
Samuel P. Harn Museum of Art, Gainsville, FL: Feb. 6-Apr. 3
National Academy of Design, NY: May 1-June 26
Le Musée du Québec, Canada: July 24-Sept. 18
Cummer Museum of Art, Jacksonville, FL: Oct. 16-Dec. 11

Woven by the Grandmothers
National Museum of Women in the Arts, Washington, DC: Thru Jan. 11
The Heard Museum, Phoenix, AZ: Jan. 31-Apr. 26

Written in Memory: Portraits of the Holocaust, Photographs by Jeffrey A. Wolin
The Chrysler Museum, Norolk, VA: Apr. 8-June 14
Fine Arts Gallery, Indiana University, Bloomington: Sept.–Oct.

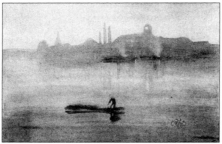

J.M. Whistler, *Nocturne, the River at Battersea,* 1878. From *Whistler: Impression of an American Abroad.* Photo courtesy Carnegie Museum of Art and AFA.

SELECTED MUSEUMS
WITHIN THE UNITED STATES

Robert Rauschenberg, *Cloister
(Arcadian Retreat),* 1996. From *Robert
Rauschenberg: A Retrospective.* Photo
by George Holzer, courtesy Solomon
R. Guggenheim Museum.

21

Birmingham Museum of Art

2000 Eighth Ave. North, Birmingham, AL 35203
(205) 254-2566; 254-2565 (recording)
http://www.artsBMA.org

1998 Exhibitions

Continuing
The Artist in the Studio
An interactive, hands-on
exhibition for both
students and adults,
designed to allow visitors
to experience the studio
environment.

Pair of Earrings with Female Figure, Greek, late 4th–early
3rd century B.C., from *Ancient Gold Jewelry*. Photo
courtesy Birmingham Museum of Art.

Thru Feb. 1
*An American
Impressionist: Edward
Henry Potthast*
Approximately 40 works by this American painter known for his beach
scenes of the Northeast.

Thru Apr. 5
Finder's Keepers: Illuminations by Harry Anderson
Over 20 striking lamps made from found materials by this contemporary
artist.

Jan. 25-Apr. 5
Ancient Gold Jewelry
Over 100 superb examples of Greek, Etruscan, Roman, and Near Eastern
gold jewelry dating from the seventh to first centuries B.C. (T)

Apr. 26-June 14
*Otsu-e: Japanese Folk Paintings from the Harriet and Edson Spencer
Collection*
Over 20 popular tourist souvenirs featuring religious or folk themes that
were sold at roadside stands during the Edo period (1615-1868) to pilgrims
and travelers to the town of Otsu.

*Images of the Floating World: Japanese Prints from the Birmingham
Museum of Art*
The first exhibition to focus on the museum's collection of Japanese prints
acquired over the past decade. Featured works include prints from the Edo
and Meiji periods, as well as works by contemporary masters.

July 12-Sept. 6
William Christenberry: The Early Years, 1954-1968
Although known for his depictions of rural life in the South and works
inspired by the Civil Rights movement, the artist's early career features
startling large-scale abstractions.

Oct. 4, 1998-Jan. 3, 1999
Chokwe! Art and Initiation of Chokwe and Related Peoples
The first U.S. exhibition featuring the art of the Chokwe and related peoples of Angola, Zaire, and Zambia. Explores the role of art objects in the transmission of knowledge.

Permanent Collection

Collection of over 17,000 works of art dating from ancient to modern times, including European, American, and Asian works; growing collections of African, Native American, and pre-Columbian art; the Charles W. Ireland Sculpture Garden. **Highlights:** Kress collection of Renaissance art; Beeson Collection of Wedgwood, the finest outside England; Hitt collection of 18th-century French furniture and decorative objects; *Birmingham Persian Wall*, a recently-acquired glass installation by Dale Chihuly; library has 1,200 Wedgwood books, letters, and catalogues; multi-level sculpture garden designed by Elyn Zimmerman. **Architecture:** 1959 original International Style building; 1965, 1967, 1974, and 1980 additions by Warren, Knight, and Davis; 1993 expansion and renovation by Edward Larrabee Barnes.

Admission: Free; donations accepted. Handicapped accessible. Braille signage, auditorium aids for the hearing-impaired, elevators, and wheelchairs available.
Hours: Tues.–Sat., 10–5; Sun., 12–5. Closed Mon., Thanksgiving, Dec. 25, and Jan. 1.
Programs for Children: Education Gallery with hands-on interactive exhibitions for children. Museum school offers art classes for all ages.
Tours: Free tours, Tues.–Fri., 11:30, 12:30; Sat.–Sun., 2; Group tours available by appointment. Call (205) 254-2318.
Food & Drink: Terrace café, open Tues–Sat, 11–2:30; Jazz Brunch, first Sun. of month, 11–2. Picnics allowed in the garden areas.
Museum Shop: Offers handmade jewelry and other unique gifts.

Montgomery Museum of Fine Arts

One Museum Dr., Montgomery, AL 36117
(334) 244-5700

1998 Exhibitions

Thru Jan. 11
ARTNOW: Michael Olszweski
Fabric constructions, combining traditional batik and Japanese dyeing techniques with embroidery, express personal responses to sorrowful human experiences.

Thru Jan. 25
Life Cycles: The Charles E. Burchfield Collection
Surveys the work of this American painter, naturalist, and social critic through themes of American life, landscape, time, and memory. (T)

Angels and Scribes
Features 27 manuscripts dating from the 12th to the 18th century, reflecting the transition from hand-illustrated literature to mass-produced printed texts.

Thru Feb. 8
After the Photo Secession: American Pictorial Photography, 1910-1955
Depicts the revival of pictorial photography and its use as a tool for personal expression in the dawning Machine Age. (T)

Feb. 7-Apr. 5
African-American Works on Paper from the Cochran Collection
Works on paper by 65 influential artists of the later 20th century, including Romare Bearden, Jacob Lawrence, Lois Mailou Jones, and Betty Saar.

Apr. 18-June 14
Qamanittuaq: Where the River Widens, Inuit Drawings by Baker Lake Artists
Features a selection of compelling works by contemporary artists, illustrating a rich heritage of shamanistic and traditional spirit imagery.

Walter Anderson's Animals
Colorful works on paper and ceramics convey this Mississippi Gulf Coast artist's lifelong fascination with animals as a source of inspiration.

June 27-Aug. 23
The Great American Pop Art Store: Multiples of the Sixties
Celebrates the delightful and witty world of Pop Art multiples and its influence on later object design, featuring 100 pieces by Jim Dine, Jasper Johns, Andy Warhol, and others. Catalogue. (T)

Permanent Collection

18th-, 19th-, and 20th-century American painting, sculpture, and graphic arts; Old Master prints; works by Southern historical and contemporary artists. **Highlights:** The Blount Collection of American Art; First Period Worcester Porcelain from the Loeb Collection. **Architecture:** 1988 building by Barganier, McKee Sims Architects Associated.

Admission: Free. Handicapped accessible, including ramp and elevator; touching tours available for the vision-impaired.
Hours: Tues.–Sat., 10–5; Thurs., 10–9; Sun., 12–5. Closed Mon.
Programs for Children: ARTWORKS, children's interactive gallery, studio programs, puppet show.
Tours: Call tour coordinator at (334) 244-5700.
Food & Drink: The Terrace Café open Tues.–Sat., 11–2. Reservations for groups are encouraged. For private parties, call (334) 244-5747.
Museum Shop: Open Tues.–Sat., 10–4:30; Sun., 1–4.

Anchorage Museum of History and Art

**121 W. Seventh Ave.,
Anchorage, AK 99501
(907) 343-4326**

1998 Exhibitions

Jan. 1-Dec. 31
The Alaska Native Art Collection
30 years of work in a variety of
media, by influential Native artists
including Ron Senungetuk, Larry
Ahvakana, and Susie Bevins.

Jan. 11-Apr. 19
Temporary Contemporary
Contemporary paintings,
sculptures, prints, and drawings
from the museum's collection.

Nathan Jackson, *Mask*, c.1973. Photo courtesy
Anchorage Museum of History and Art.

Mar. 29-Apr. 26
Leslie Morgan
A series of superrealist paintings
depicting the personal
iconography–including plants,
animals, saints and sinners–of this artist who lives and works in Ketchikan,
Alaska.

Apr. 26-Oct. 4
Artists for Nature in the Copper River Delta
About 60 works illustrating the geography and wildlife of the delta,
produced during one summer by a group of international artists.

May 7-Sept. 13
Spirit of the North: The Art of Eustace Paul Ziegler
Over 100 works by this artist renowned for his ability to capture the spirit of
the early 20th-century Alaskan frontier. Catalogue.

Sept. 27-Nov. 21
Hamish Fulton: Alaska Walks
An environmental artist who has worked and walked since the 1960s,
Fulton's installations are inspired by the geography, weather, his thoughts,
and his reactions to the environment as he walks.

Oct. 18, 1998-Jan. 10, 1999
Native Visions: Northwest Coast Art, 18th Century to the Present
Examples of Northwest Coast art demonstrate how this tradition is
constantly evolving by the inclusion of individual inspirations. (T)

Nov. 27, 1998-Jan. 3, 1999
Dolls and Toys
Annual holiday exhibition of antique dolls, toys, and carousel horses, a
favorite tradition for Anchorage families.

Nov. 29, 1998-Jan. 10, 1999
The Sixth International Shoebox Sculpture Exhibition
A popular triennial exhibition from the University of Hawaii, featuring small sculptures by international artists.

Permanent Collection
Traditional and contemporary Alaska art; objects from the Athapaskan, Aleut, Tlingit, Haida, Eskimo peoples, the Russian period, American whaling, the Gold Rush, World War II, contemporary life. **Architecture:** 1968 building and 1975 addition by local firm of Schultz & Maynard; cast concrete frieze encircling the exterior by Alex Duff Combs; 1986 addition by Mitchell/Giurgola of New York.

Admission: Adults, $5; seniors, $4.50; members, children, free. Handicapped accessible.
Hours: Mid-May–mid-Sept: daily, 9–6. Mid-Sept.–mid-May: Tues.–Sat., 10–6; Sun., 1–5. Closed Mon.
Programs for Children: Children's Gallery features themed shows and interactive activities; special art classes and workshops.
Tours: Summer: Alaska Gallery, daily, 10, 11, 1, 2. Call (907) 343-4326.
Food & Drink: Gallery Café open during museum hours, with full lunch service available 11–2.
Museum Shop: Features Alaska books and Native art.

The Heard Museum

22 E. Monte Vista Rd., Phoenix, AZ 85004
(602) 252-8840; 252-8848 (recording)
http://www.heard.org

1998 Exhibitions
Continuing
Native Peoples of the Southwest: The Permanent Collection of The Heard Museum

Old Ways, New Ways
Interactive history of Native American life.

Thru Jan. 11
The Cutting Edge: Contemporary Southwestern Jewelry and Metalwork
Focuses on Southwestern jewelry of innovative materials and design, featuring inspiring works by master artists such as Charles Loloma and Kenneth Begay.

Thru Feb. 1
Following the Sun and Moon: Hopi Katsina Dolls
More than 300 Katsina dolls give visitors a glimpse into Hopi life and the importance of the Katsina spirits.

Thru July
Ramona Sakiestewa: Weaver, Designer, and Recent Acquisitions from the Heard Museum
Showcases blankets created by Hopi designer Sakiestewa, and also features pieces recently acquired by the museum.

Thru Aug. 2
The 7th Native American Fine Art Invitational
Features innovative and provocative Native art by contemporary artists from the United States and Canada.

Thru Mar. 1999
HORSE
Examines the impact of the horse on indigenous cultures in North America, from its introduction by 16th-century Spaniards to the present day.

Jan. 31-Apr. 26
Woven by the Grandmothers
Features 44 exquisite wearing blankets woven between 1825 and 1880, from the collection of the National Museum of the American Indian. (T)

Feb. 14-May 17
American Indian Pottery: A Legacy of Generations
Examines the traditions of Native pottery, from matriarchs such as Lucy Lewis (Acoma) and Maria Martinez (San Ildefonso) to their descendants. Features 100 pieces by 28 Pueblo potters. (T)

Pima Basket, early 1900s, from *HORSE*. Photo courtesy Heard Museum.

May 16, 1998-Apr. 1999
Zuni and Navajo Silverwork
Showcases Zuni and Navajo metalwork from the early 20th century, from the museum's C.G. Wallace Collection.

June 1998-Dec. 1999
Risky Business
Explores how Native American artists are taking risks and pushing the boundaries in their artistry.

Permanent Collection
Extensive collection of Native American fine art, jewelry, textiles, pottery, quillwork, beadwork, baskets; Hispanic traditional arts; African and Oceanic tribal art. **Highlights:** 1,200 katsina dolls from the past 100 years; 4,000-item Fred Harvey Fine Art Collection; 3,600 20th-century paintings, prints

and sculptures. **Architecture:** Charming 1929 Spanish Colonial Revival building by Herbert Green; 1984 wing following original design; recent renovation and expansion with unusual museum shop.

Admission: General, $6; seniors 65+, $5; children 4–12, $3. Handicapped accessible.
Hours: Mon.–Sat., 9:30–5; Sun., 12–5. Closed holidays.
Programs for Children: Regular series of special programs, including hands-on gallery activities, a Zuni pueblo, and a Kiowa longhouse.
Tours: Public tours daily, Sept.–May: Mon.–Sat., 12, 1:30, 3; Sun., 1:30, 3; June–Aug.: Mon.–Fri., 1:30; Sat., 11, 1:30, 3; Sun., 1:30, 3. Group tours, reserve three weeks in advance; call (602) 251-0275.
Museum Shop: Unique jewelry, crafts, and art by Native American artists.

Phoenix Art Museum

1625 N. Central Ave., Phoenix, AZ 85004
(602) 257-1880; 257-1222 (recording)

1998 Exhibitions

Thru Mar. 15
Baubles, Bangles and Beads
Exploration of ornamentation, featuring clothing, jewelry, and a variety of accessories, illustrates and examines our need to ornament ourselves.

Thru Feb. 8
Africa! A Sense of Wonder
Sub-Saharan African art dating from the 16th to early 20th century. Includes wood carvings, masks, figural pieces, beaded objects, textiles, and works of ivory, parchment, and bronze. Catalogue. (T)

Feb. 28-Apr. 19
Meditations on China: An Exploration of Nature and Chinese Art—Three Exhibitions of Chinese Art

Dan Face Mask, mid-20th century, Faletti Family Collection, from *Africa! Sense of Wonder.* Photo courtesy Phoenix Art Museum.

Bridge: Illusion in Clay
World premiere of a 60-foot-long ceramic sculpture by Taiwan artist Ah-Leon.

Worlds Within Worlds: The Richard Rosenblum Collection of Chinese Scholars' Rocks
Includes 80 rocks of diverse types dating from the Song (960-1279), Yuan (1279-1368), Ming (1368-1644), and Qing (1644-1911) dynasties, with a few from the 20th century.

Art and the Chinese Scholar: Paintings and Furniture of the Ming and Qing Dynasties
Explores the unique aesthetic created by scholar-officials during centuries of imperial rule in China through furniture, painting and other art objects.

Mar. 28-Aug. 2
Black...and White

May 16-July 26
Hospice: A Photographic Inquiry
Five contemporary photographers deal with issues of death, dying, and grief in their examination of the Hospice movement. (T)

Aug. 15-Oct. 4
1998 Phoenix Triennial
Recognizes the latest developments in contemporary art of the Southwest.

Sept.-Nov.
Napoleonic Clocks

Dec. 12, 1998-Feb. 28, 1999
Old Master Paintings on Copper, 1525-1775
Highlights the practice of painting on copper, featuring 75-100 of the most spectacular and best-preserved examples of works by masters.

Permanent Collection

Exceptional collection of over 13,000 objects including American art, European art of the 18th–19th centuries, Western American art, 20th-century art, Latin American art, Asian art and 18th–20th century fashion design. **Highlights:** Monet, *Flowering Arches, Giverny;* Frida Kahlo, *Suicide of Dorothy Hale*; and works by Picasso, Georgia O'Keeffe and Diego Rivera. **Architecture:** 1959 building; recently renovated and expanded; integrates art and architecture with the Southwestern landscape.

Admission: Free. Special exhibitions: adults, $5; senior citizens, $4; full-time students, children over 6, $2; members and children under 6, free. Handicapped accessible; ramps, electronic doors, elevators.
Hours: Tues.–Sun., 10–5; Thurs.–Fri., 10–9; closed Mon. and major holidays.
Programs for Children: "Artworks" interactive gallery for children and families; museum also provides school and children's tours and art classes.
Tours: Groups call (602) 257-4356.
Museum Shop: Items reflective of both the collection and artists' works such as pottery, carvings, and jewelry. Open during museum hours.

Tucson Museum of Art

140 N. Main Ave, Tucson, AZ 85701
(520) 624-2333
http://www.azstarnet.com/~tmaedu/index.html

NOTE: Main Museum galleries will be closed for expansion/construction, Jan. 26-Mar. 23. The Goodman Pavilion of Western Art, La Casa Cordova, and the Corbett House will be open as usual.

1998 Exhibitions

Thru Jan. 18
Contemporary Southwest Images XII: The Stonewall Foundation Series: Emmi Whitehorse
Evocative, abstract canvases reflecting the artist's Navajo heritage and her own language of semi-pictographic symbols.

Thru Mar. 31
El Nacimiento
Celebrating 20 years at the museum, this elaborate Mexican nativity scene is a seasonal favorite. Features over 200 hand-made miniatures arranged by Maria Luisa Tena.

Mar. 20-May 24
La Vida Norteña: Photographs of Sonora, Mexico by David Burckhalter
Features over 60 vivid and sensitive portrayals of Seri and Mayo Indians and Mexicans. In conjunction with the release of the book of the same title.

Mar. 27-May 4
Directions: Point of Fracture–Amy Zuckerman
In this moving tribute, Zuckerman combines photographs and tape recordings of the families of murder victims.

Apr. 24-Aug. 2
El Alma del Pueblo: Spanish Folk Art and its Transformation in the Americas
Explores the nature of Spanish folk art—its role in past and present Spanish society and its modification in Mexico and the Latin communities of the United States. (T)

Sept. 11-Nov. 1
Miriam Schapiro: Works on Paper
Focuses on the artist's works on paper, multiples, and prints using a variety of techniques, including watercolor, etching, lithography and collage.

Nov. 13, 1998-Jan. 3, 1999
Tucson Collects: Tribal Rugs from Arizona Collections
Explores weaving techniques, featuring 100 rugs and a reconstructed traditional Turkish room. Also includes jewelry and related materials.

Nov. 21, 1998-Mar. 31, 1999
El Nacimiento

Permanent Collection

Pre-Columbian art, Spanish Colonial and Mexican folk art; Western American art of the 19th and 20th centuries. **Architecture:** The museum operates five historic properties from the late 1860's to 1907, on long term lease from the City of Tucson.

Admission: Adults, $2; students and seniors, $1; children under 12 and Tues., free.
Hours: Mon.–Sat., 10–4; Sun., 12–4; closed holidays.
Tours: Tours of Historic Block, Wed.-Thurs.

Arkansas Arts Center

Ninth & Commerce Sts., Little Rock, AR 72202
(501) 372-4000

1998 Exhibitions

Thru Feb. 8
Hot Dry Men, Cold Wet Women
Examines theories of humors in the medical practices of the 17th century, featuring paintings, sculptures, prints, porcelains, and textiles. (T)

Recent Acquisitions: Selections from the Permanent Collection

Jan. 11-Feb. 15
Earl Pardon: Joy in the Making
Features 50 works by this contemporary, constructivist jewelry-maker.

Feb. 13-May 17
The Hands of Rodin: A Tribute to B. Gerald Cantor's Fifty Years of Collecting (T)

Feb. 13-Mar. 15
Twentieth-Century American Drawings from the Permanent Collection

Mar. 20-May 3
Mark Rothko: The Spirit of Myth, Early Paintings from the 1930s and 1940s
Explores the high emotional tone of Rothko's early abstractions, and traces the development of his atmospheric, color field style.

Apr. 26-June 14
Pure Vision: American Bead Artists

June 24-Sept. 1
It's Only Rock 'n' Roll: Rock 'n' Roll Currents in Contemporary Art
Explores the influences of four decades of rock and roll music and culture on contemporary art, featuring works by artists such as Warhol, Basquiat, Mapplethorpe, and Rauschenberg. Catalogue. (T)

Permanent Collection

Major works by Rembrandt, Guercino, van Gogh, Degas, Cézanne, Tiepolo, Delacroix, and others typify distinguished collection of Old Master and modern European drawings; over 750 American drawings.

Admission: Free. Handicapped accessible.
Hours: Mon.–Thurs., Sat., 10–5; Fri., 10–8:30; Sun., 12–5. Closed Dec. 25.
Tours: Call (501) 372-4000.
Food & Drink: Vineyard in the Park restaurant, Mon.–Fri., 11:15–1:30.

Berkeley Art Museum/ Pacific Film Archive

University of California, 2626 Bancroft Way, Berkeley, CA 94720
(510) 642-0808
http://www.bampfa.berkeley.edu

1998 Exhibitions

Thru Jan.
Jochen Gerz: The Berkeley Oracle
Internet-based artwork by this
renowned German conceptual artist
invites website users to pose
questions.

Jackson Pollock, *Number 6,* 1950.
Anonymous gift. Photo courtesy Berkeley
Art Museum/Pacific Film Archive.

Thru Jan. 4
Knowledge of Higher Worlds:
Rudolf Steiner's Blackboard
Drawings
Drawings made between 1920 and
1924 by this founder of
Anthroposophy, whose occult
theories influenced later artists such as Joseph Beuys.

Thru Jan. 11
Luc Tuymans: Drawings
First retrospective of this contemporary Belgian artist's work, focusing on
his drawings and other works on paper dating from 1975 through 1996.

Thru Jan. 18
Bernard Maybeck Drawings
Architectural designs by this Bay Area architect, trained in the Beaux Arts
tradition and influenced by the region's arts and crafts movement.

Jan. 28-Apr. 19
William Hogarth and His Times
Works on paper from the British Museum depict 18th-century English life.

Feb. 25-July 12
MATRIX Berkeley: 20th Anniversary Exhibition

Sept. 26, 1998-Jan. 17, 1999
Transformation: The Art of Joan Brown
The first major retrospective of the late, contemporary Bay Area artist,
ranging from early figurative and abstract expressionist paintings to her
interest in mythology and religious symbolism. (Also at Oakland Museum.)

Permanent Collection

Paintings, photographs, prints, drawings, conceptual art, including 16th- to 19th-century works by Cézanne, Renoir, Rubens, Bierstadt; Asian art; 20th-century works by Bacon, Calder, Duchamp, Frankenthaler, Rothko; Sculpture Garden; Pacific Film Archive of over 7,000 international films. **Highlights:** Recent acquisition of *Number 6*, a 1950 drip painting by Jackson Pollock; largest collection of Hans Hoffmann paintings in the world; Asian art galleries; newly installed European and American collections. The Pacific Film Archive, also housed in the museum, presents nightly public showings of film and video. **Architecture:** 1970 building, with exposed-concrete walls and floor-to-ceiling windows, designed by a team of young architects, Richard Jorasch and Ronald Wagner, working with well-known San Francisco architect, Mario Ciampi.

Admission: Adults, $6; seniors, students, $4. Handicapped accessible.
Hours: Wed.–Sun., 11–5; Thurs., 11–9. Closed Mon.–Tues., holidays.
Tours: Thurs., 12; Sun., 2. Groups call (510) 642-5188.
Food & Drink: Café Grace open daily, 11–4.

Orange County Museum of Art

Orange County Museum of Art, Newport Beach

850 San Clemente Dr., Newport Beach, CA 92660
(714) 759-1122
http://www.ocartsnet.org/ocma

1998 Exhibitions

Ongoing
Celebrating 100 Years of California Art
A selection of 150 works from the permanent collection.

Thru Feb. 24
Belle Yang: The Odyssey of a Manchurian
Features 30 watercolors by this San Francisco artist that merge narrative and painting in the story of a man's three-year journey.

Jan. 10-Apr. 19
Manuel Neri: The Early Works, 1953–1978
Traces the early development of the work of this important Bay Area sculptor.

Jan. 17-June 7
Curvature by David Bunn
Explores the multivalent aspects of mapping in a concave, birch-panelled chamber by this Los Angeles-based artist.

Apr. 4-June 28
Muybridge Photographs

June 27-Oct. 4
Fleurs du Mal
Showcases a selection of works celebrating the flower, featuring art by Georgia O'Keeffe (1887-1986) and Robert Mapplethorpe (1947-1989).

Oct. 17, 1998-Jan. 10, 1999
Gold Rush to Pop: 200 Years of California Art
Over 100 paintings examine California's wilderness landscape, immigrant responses to culture, urban life, and modern responses to high-technology.

Permanent Collection
American art with a focus on the development of art in California, including early-20th-century Impressionist paintings and contemporary art.
Highlights: Works by Arnoldi, Baldessari, Bengston, Brandt, Burden, Burkhardt, Celmins, Diebenkorn, Dixon, Goode, Kauffmann, McLaughlin, Moses, Park, Payne, Rose, Ruscha and Viola. **Architecture:** 1929 building; 1986 renovation.

Admission: Adults, $5; seniors, students, $4; children under 16, members, free. Handicapped accessible.
Hours: Tues.–Sun., 11–5. Closed Mon.
Programs for Children: Offers hands-on activities and workshops.
Tours: Tues.–Fri., 12:15, 1:15; Sat.–Sun., 2. Groups call (714) 759-1122.
Food & Drink: Sculpture Garden Café open Mon.–Fri., 11:30–2:30.

Orange County Museum of Art at South Coast Plaza Gallery
3333 Bristol St., Costa Mesa, CA 92626
(714) 662-3366

Admission: Free. Handicapped accessible.
Hours: Mon.–Fri., 10–9; Sat., 10–7; Sun., 11:30–6:30.

Los Angeles County Museum of Art
5905 Wilshire Blvd., Los Angeles, CA 90036
(213) 857-6111
http://www.lacma.org

1998 Exhibitions
Thru Jan. 11
Bill Viola
Surveys the work of this influential contemporary artist, including 15 major video installations and drawings from the 1970s to the present. (T)

Thru Feb. 23
Developing a Collection: The Ralph M. Parsons Foundation and the Art of Photography
Includes works by modern American and European photographers such as Berenice Abbott, Ansel Adams, Sebastião Selgado, and Carrie Mae Weems.

Feb. 26-May 17
King of the World: A Mughal Manuscript from the Royal Library, Windsor Castle
A rare exhibition of the treasured illustrated manuscript, *The Padshanama*, which was commissioned by the Mughal emperor Shah-Jahan in 1639. (T)

Mar. 1-June 1
Love Forever: Yayoi Kusama, 1958–1968
Includes 80 installations, paintings, and other works by this post-minimalist Japanese artist, dating from her most influential years. (T)

Mar. 26-June 15
Retail Fictions: The Commercial Photography of Ralph Bartholomew, Jr.
Examines the fusion of the experimental and artistic potentials of photography with the consumer drive of postwar American culture.

July 15-Sept. 13
Rhapsodies in Black: Art of the Harlem Renaissance
This international exhibition explores the Harlem Renaissance and its influence on the culture of early-20th-century America and Europe. Includes paintings, sculptures, film, vintage posters, books, and decorative arts. (T)

Aug. 2-Oct. 5
Arthur Dove: A Retrospective
Surveys the career of this 20th-century American Modernist, including over 80 paintings, assemblages, pastels, and charcoal drawings spanning the years 1909–1946. (T)

Permanent Collection
Ancient, Egyptian, Far Eastern, Indian, Southeast Asian art; Islamic art; pre-Columbian Mexican pottery, textiles; Noted European and American paintings, sculptures, prints, drawings, decorative arts; glass from antiquity to the present; costumes, textiles; photographs. **Highlights:** B. Gerald Cantor Sculpture Garden; Heeramaneck collection of art from India, Nepal, Tibet; de La Tour, *Magdalene with the Smoking Flame*; Rodin bronzes. **Architecture:** 1965 Ahmanson, Bing, and Hammer buildings by William Pereira; 1986 Anderson building and central court by Hardy Holzman Pfeiffer Associates; 1988 Pavilion for Japanese Art by Goff and Prince.

Admission: Adults, $6; seniors, students with ID, $4; children 6–17, $1; members, children under 5, free. Second Tues. of month, free. Handicapped accessible; wheelchairs available.
Hours: Mon., Tues., Thurs., 12–8; Fri., 12–9; Sat.–Sun., 11–8. Closed Wed.
Tours: Daily. Call (213) 857-6108 for information.
Food & Drink: Plaza Café open Tues., 10–3; Wed.–Thurs., 10–4:30; Fri., 10–8:30; Sat.–Sun., 11–5:30.

The Museum of Contemporary Art
MOCA at California Plaza
250 S. Grand Ave., Los Angeles, CA 90012
(213) 626-6222
http://www.MOCA-LA.org

1998 Exhibitions
Continuing
Timepieces: Selected Highlights from the Permanent Collection
Includes works in all media by artists such as Diane Arbus, Jasper Johns, Robert Rauschenberg, Mark Rothko, and Andy Warhol.

Thru Feb. 1
Cindy Sherman: Retrospective
Mid-career survey of the work of this significant 20th-century American photographer. Includes selections from each of her key series, such as Untitled Film Stills, Centerfolds, Fashion, and Fairy Tales. (T)

Thru Feb. 8
Focus Series: Catherine Opie
Works that explore the urban architecture and infrastructure of the city of Los Angeles by this local photographer. Includes the *Freeways* series.

Focus Series: Todo Cambia
Large-scale installation by a young Cuban artist examines human ingenuity and the dislocation of Latin American culture.

Feb. 1-Apr. 12
Ana Mendieta
A series of photographs made between 1972 and 1977 document this Cuban artist's use of her body in performative outdoor sculptural installations that reflect themes of nature, the mythic female, and Cuban spiritual traditions.

May 3-July 26
Focus Series: Lewis Baltz
Recent color works that reflect the late-20th-century crisis of technology, globalism, and the human body, by this California-born photographer.

July 12-Oct. 18
Christopher Wool
First major survey of Wool's work, which examines the complexities of abstraction and representation through the vernacular references of techniques, images, and language.

Aug. 9-Oct. 25
Focus Series: Dove Bradshaw/Jan Henle
Bradshaw treats the surface of her works with oxidizing agents that allow changes over time. Henle's work features documentation of a site-sculpture made by clearing the land of an abandoned Puerto Rican coffee plantation.

Nov. 8, 1998-Jan. 3, 1999
Focus Series: Amy Adler
Features hybrid drawings and photographs manipulated through computer-enhancement by this Los Angeles-based artist.

Nov. 15, 1998-Feb. 21, 1999
Charles Ray
Mid-career survey of this internationally-recognized artist, encompassing conceptual photographs, furniture, mannequins, and other work from the 1970s to the present. (T)

Dec. 6, 1998-Apr. 4, 1999
Kay Rosen
Presents a 20-year survey of text-based paintings, drawings, wall works, and books by this Texas-born artist.

The Geffen Contemporary at MOCA
152 N. Central Ave., Los Angeles, CA 90013
(213) 626-6222

1998 Exhibitions
Thru Jan. 4
Robert Gober
Sculptural installations by this New York-based artist evoke collective and personal memories relating to the home, the urban environment, ecology, and Catholicism. Catalogue.

Thru Nov. 14, 1999
Elusive Paradise: Los Angeles Art from the Permanent Collection
Surveys the development of post-war art in Los Angeles, including works by Richard Diebenkorn, Sam Francis, Robert Frank, and Alexis Smith.

Feb. 8-May 10
Out of Actions: Between Performance and the Object, 1949-1979
Examines the genesis and evolution of actions/performances embodied in works of art, as seen in such international movements as the New York School, Neo-Dada, nouveau realism, happenings, and arte povera.

Sept. 6, 1998-Jan. 3, 1999
Richard Serra
Installation by this important contemporary artist whose sculptures, made for specific urban or architectural sites, heighten perceptual awareness and encourage interaction.

Permanent Collection
Art from 1940 to the present, featuring paintings, sculpture, works on paper, photographs, and environmental work of regional and international importance; also explores new art forms combining dance, theater, film, and music. **Highlights:** Heizer, *Double Negative*; Kline, *Black Iris*; Rauschenberg, *Interview*; Rothko, *Red & Brown*; Rothenberg, *The Hulk*; Ruscha, *Annie*; Syrop, *Treated and Released*; works by Nevelson, Twombly, Warhol. **Architecture:** 1983 The Geffen Contemporary warehouse renovation by Frank Gehry; 1986 California Plaza building by Arata Isozaki.

Admission: Adults, $6; seniors, students with ID, $4; members, children under 12, free. Thurs., 5–8, free. Handicapped accessible.
Hours: Tues.–Sun., 11–5; Thurs., 11–8. Closed Mon., Jan. 1, Dec. 25.
Programs for Children: MOCA offers a variety of education programs throughout the year for children, families, and adults.
Tours: Free. Tues.—Sun., 12, 1, 2; Thurs., 6.
Food & Drink: Patinette at MOCA Café open during museum hours.
Museum Shop: The shop at Geffen Comtemporary is open during museum hours. The shop at California Plaza is open Tues.–Sun., 11–6; Thurs., 11–9.

The J. Paul Getty Museum

1200 Getty Center Drive, Ste. 400, Los Angeles, CA 90049
(310) 440-7360
http://www.getty.edu

NOTE: New location of The J. Paul Getty Center in Los Angeles. The former location, now called the Getty Villa in Malibu, is closed for renovation and will reopen in 2001 as a center devoted to ancient art, including the museum's collection of Greek and Roman antiquities.

1998 Exhibitions

Thru Feb. 22
Collection of Drawings of the J. Paul Getty Museum: The First 15 Years
Celebrates the growth of the museum's collection of drawings over the past 15 years.

Irresistible Decay: Ruins Reclaimed
Explores the allure of ruins, from historical examples such as the Temple of Olympian Zeus in Greece and Angkor Wat in Cambodia to the more modern results of natural disasters.

Cult Statue of Aphrodite?, Greek (Sicilian), c.400–425 B.C. Photo courtesy J. Paul Getty Museum.

Thru Feb. 28
Incendiary Art: The Representation of Fireworks in Early Modern Europe
Examines the dazzling pyrotechnical displays of 16th- to 19th-century European history that have been immortalized in paintings, prints, drawings, and published narratives.

Thru Mar. 22
Time Not in Motion: A Celebration of Photographs
Explores the various ways in which the element of time becomes a material
subject in photography.

Masterpieces of Medieval and Renaissance Manuscript Illumination
Features 43 of the museum's finest examples of the art of illumination,
dating from the 10th to the 16th century.

Thru Oct. 18
Beyond Beauty: Antiquities as Evidence
Explores the qualities of aesthetic beauty in ancient Greek and Roman art,
and how the variety of cultural, historical, and scientific evidence embedded
within works of art impacts our interpretations.

Thru Dec. 6
Making Architecture: The Getty Center from Concept through Construction
Examines the 15-year collaborative effort that has culminated in the recent
opening of the newly-constructed Getty Center.

Permanent Collection

Extensive and important collection of Greek and Roman antiquities;
European paintings from the 13th through 19th century; Medieval and
Renaissance European manuscripts; French decorative arts; European
sculpture and drawings; comprehensive collection of American and
European photographs. **Highlights:** Mantegna, *Adoration of the Magi;* van
Gogh, *Irises*; paintings by Rembrandt, Monet, Renoir, and Cézanne;
sculpture by Cellini, Canova, and Bernini; drawings by Michelangelo,
Leonardo, and Raphael; recent acquisition of *Pearblossom Hwy., 11-18th
April 1986, #2* by David Hockney. **Architecture:** Beautiful new $1 billion,
6-building, 110-acre arts and cultural campus designed by Richard Meier,
completed in 1997. Set in the foothills of the Santa Monica Mountains in the
historic Sepulveda Pass. Gardens include 3-acre *Central Garden* designed
by Robert Irwin.

Admission: Free; parking (reservation required), $5. Handicapped
accessible.
Hours: Tues.–Wed., 11–7; Thurs.–Fri., 11–9; Sat.–Sun., 10–6. Closed
Mon., major holidays.
Programs for Children: Family Room offers activities and games;
interactive learning centers; after Sept. 1998, special hours for school tours,
Tues.–Fri., 9–11.
Tours: Available in English and Spanish; call (310) 440-7332 for
information.
Food & Drink: Full-service restaurant and two cafés; call for hours.
Museum Shop: Offers wide selection of books related to museum
collections and exhibitions.

Oakland Museum of California

The Oakland Museum of California Art, Ecology and History
1000 Oak St., Oakland, CA 94607
(510) 238-2200
http://www.museumca.org

NOTE: The Museum also operates the Oakland Museum of California Sculpture Court at the City Center, 1111 Broadway, which features three exhibits annually of work by contemporary California sculptors.

1998 Exhibitions

Jan. 24-July 26
Gold Fever! The Lure and Legacy of the California Gold Rush
Examines the impact of the California Gold Rush on the people, environment, and economics of the region, in celebration of its 150th anniversary. Includes 600 artifacts, specimens, and related materials. (T)

Unknown artist, *James Warner Woolsey, Nevada City, with Nugget Weighing Over Eight Pounds,* from *Silver and Gold: Cased Images from the California Gold Rush.* Collection of Mrs. Vivienne Bekeart. Photo courtesy Oakland Museum of California.

Silver and Gold: Cased Images of the California Gold Rush
Photographic documentation of the Gold Rush following the 1848 discovery of gold in California, featuring daguerrotypes and other "cased" images. (T)

Jan. 24-May 31
Art of the Gold Rush
Explores the origins of California regional art. Includes 64 paintings, drawings, and watercolors created between 1849 and the mid-1870s. (T)

Sept. 26, 1998-Jan. 17, 1999
Transformation: The Art of Joan Brown
The first major retrospective of the late, contemporary Bay Area artist, ranging from early figurative and abstract expressionist paintings to her interest in mythology and religious symbolism. (Also at Berkeley Museum.)

Sept.-Dec.
Farewell, Promised Land
A sobering look at the transformations of California's natural environment by photographer Robert Dawson and historian Gray Brechin.

Maidu Paintings by Dal Castro: From the Aeschliman-McGreal Collection of the Oakland Museum of California
Retrospective survey of the folk paintings made between 1975 and 1993 by this Native American artist from Northern California, featuring depictions of Nisenan Maidu creation myths, animal legends, and historical events.

Oct. 18-Nov. 30
Days of the Dead
Annual celebration of the Days of the Dead, with altars made by local artists and community groups.

Nov. 14, 1998-May 1999
California Underground: Our Caves and Other Subterranean Habitats
Dramatic images of California's underground world, made by using a highly-specialized photographic process.

Permanent Collection

Several galleries combining several disciplines in one museum: **Gallery of California Art** contains works in all media by California artists or artists dealing with California themes; **Cowell Hall of California History** exhibits artifacts and memorabilia illustrating major events and trends that have shaped the state's history from before recorded history to the 1980s; and **Hall of California Ecology** depicts the interrelated life activities of plants and animals. The new **Aquatic California Gallery** presents a broad view of the region's aquatic environments. **Highlights:** Decorative objects from California Arts & Crafts movement; 19th-century landscape paintings; outdoor sculpture; the Dorothea Lange archive; Gold Rush artifacts. **Architecture:** Unique and unprecedented tiered garden environment, housing a three-level museum (science, history, and art). Opened in 1969 and occupying four downtown city blocks, it was Kevin Roche's first major museum design. Garden landscape design by Daniel Kiley.

Admission: Adults, $5; seniors, students, $3; children under 5, free. (During Gold Fever, Jan. 24–July 26: special additional fee of $3.) Handicapped accessible; ramps, elevator, and wheelchairs available.
Hours: Wed.–Sat., 10–5; Sun., 12–7. Closed Mon., Tues., Jan. 1, July 4, Thanksgiving, Dec. 25. (During Gold Fever, Jan. 24–July 26: Tues.–Thurs., Sat.–Sun., 10–5; Fri., 10–9.)
Programs for Children: Family Explorations! Programs throughout the year. Call (510) 238-3818 for information.
Tours: Weekday afternoons; weekends upon request. Groups call (510) 238-3514.
Food & Drink: Museum Café open Wed.–Sat., 10–4; Sun., noon–5. Picnic areas available in the museum gardens.
Museum Shop: Newly remodeled shop offers gifts and books relating to California culture, art, and history.

Palm Springs Desert Museum

101 Museum Drive, Palm Springs, CA 92262
(760) 325–7186
http://palmsprings.com/points/museum.html

1998 Exhibitions

Thru Mar. 1
Llyn Foulkes: Between a Rock and a Hard Place

Jan. 21-June 14
The California Deserts: Today and Yesterday

Mar. 18-July 5
Collaborations: William Allan, Robert Hudson, William Wiley

Mar. 27-Aug. 30
Cactus Flowers

May 1-May 31
Mitos, Imagenes e Idioma

July 7-Nov. 8
Desert Volcanoes

July 11-Oct. 4
Luis Jimenez: Working Class Heroes

Oct. 21, 1998-Jan. 3, 1999
Paul Kleinschmidt

Nov. 23, 1998-May 15, 1999
The Greatest Roadrunner

Permanent Collection

American paintings, sculpture, and works on paper from the 19th century to the present; natural science collections.

Admission: Adults, $7.50; seniors, $6.50; children 6–17, students and military with ID, $3.50; members and children under 6, free. First Fri. of every month, 10–5, free. Handicapped accessible.
Hours: Sun.–Fri., 10–5. Closed Mon., major holidays.
Tours: Tues.–Sun., 2. Groups call (760) 325-7186.
Food & Drink: Gallery Café open Tues.–Fri., Sat.–Sun., 11–3.

Norton Simon Museum

411 W. Colorado Blvd., Pasadena, CA 91105
(818) 449-6840; 449-3730
http://www.citycent.com/CCC/Pasadena/nsmuseum.html

1998 Exhibitions

Due to the current renovation project, no exhibitions are scheduled this year.

Permanent Collection

One of the most outstanding collections of European art in the USA, from the Renaissance through the 20th century, including works by Raphael, Rembrandt, Rubens, Zurbarán, Goya, Monet, Degas, van Gogh, Picasso, Klee, Kandinsky; sculpture from the Indian subcontinent, the Himalayas and Southeast Asia; spectacular sculpture garden. **Highlights:** Raphael, *Madonna*; Zurbarán, *Still Life with Lemons, Oranges, and a Rose*; Dieric Bouts, *Resurrection of Christ*; Manet, *Ragpicker;* Degas bronzes. **Architecture:** Contemporary 1969 building by Ladd and Kelsey; renovation in 1975; 1996 interior renovation design by Frank O. Gehry, scheduled to be completed in autumn of 1998. New sculpture garden design by landscape architect Nancy Power, currently under construction.

Admission: Adults, $4; seniors, students, $2; members and children under 12, free. Handicapped accessible, including ramps and elevators.
Hours: Thurs.–Sun., 12–6. Closed Mon.–Wed., Jan. 1, Christmas Day, Thanksgiving.
Tours: Call (818) 449-6840, ext. 245 for information.
Food & Drink: A tea house serving light refreshments is scheduled to open in the sculpture garden in the autumn of 1998.
Museum Shop: Offers art books, prints, slides, posters, and cards.

Crocker Art Museum

216 O St., Sacramento, CA 95814
(916) 264-5423
http://www.sacto.org/crocker

1998 Exhibitions

Continuing
Clouds and Cranes: Masterworks from Korea
A selection of Korean ceramics, paintings, and decorative arts.

Thru Jan. 25
Studio Rodin: Bronzes from the Stanford University Museum of Art
Includes Rodin's most famous early portrait, *The Mask of the Man with a Broken Nose,* 1864; his first masterpiece, *The Age of Bronze,* 1875-76; and *The Kiss,* 1881-82.

Thru July 15
Paper, Plastic, Cowries and Coins! The Art and History of Money
Curious and unusual objects used as currency throughout history.

Thru Oct. 12
California Impressionists
Approximately 50 paintings by over 30 California artists, dating from about 1895 through the 1920s.

Thru Feb. 15
Indian Miniature Paintings from the Crocker Collection

Jan. 9-Mar. 9
Dreams and Traditions: British and Irish Paintings from the Ulster Museum
Traces British and Irish painting from the late 17th century to the present.

Feb. 20-Apr. 19
Photography from the Crocker Collection

Apr. 3-May 28
1998 Crocker—Kingsley Exhibition
Exhibition open to artists residing in Northern California

Opens May 6
Figurative Art from Ancient Israel
Features objects spanning more than twelve millennia, from the Natufian period through the Christian Crusader period.

June 20-Sept. 13
The Art of the Gold Rush
Explores the origins of California regional art. Includes 64 paintings, drawings, and watercolors created between 1849 and the mid-1870s. (T)

E. Hall Martin, *Mountain Jack and a Wandering Miner*, c. 1850, from *Art of the Gold Rush*. Collection Oakland Museum of California. Photo by M. Lee Fatheree.

Permanent Collection

Old Master paintings; 19th-century California art; 19th-century German painting; Northern California art since 1945; American Victorian furniture and decorative arts, photography, Asian art; arts of the Americas.
Highlights: Hill, *Great Canyon of the Sierras, Yosemite*; Nahl, *Sunday Morning in the Mines* and *The Fandango*. **Architecture:** 1873 Crocker Art Gallery by Seth Babson; 1969 Herold wing; 1989 Crocker mansion wing by Edward Larrabee Barnes.

Admission: Adults, $4.50; children 7–17, $2; children 6 and under, free. Handicapped accessible.
Programs for Children: Hands-on Art activities every Saturday from noon-3 p.m.; ArtVenture Days one Saturday per month; ArtMasters summer classes for children 8-15.
Hours: Tues.–Sun., 10–5; Thur., 10–9. Closed Mon., major holidays.
Tours: By reservation; call (916) 264-5537, Mon.–Fri., 10–12.
Museum Shop: Handcrafted decorative arts and jewelry by regional artists, fine art books, stationery, educational crafts and toys.

Museum of Contemporary Art, San Diego
700 Prospect St., La Jolla, CA 92037
(619) 454-3541

1998 Exhibitions
Thru Mar. 11
John Altoon
Survey of approximately 50 paintings and works on paper created in the 1960s by this west coast abstract expressionist artist.

Mar. 23-June 13
Sarah Charlesworth: A Retrospective
The first mid-career survey of this American artist's work, including over 60 large-scale photo-objects that address issues of media, gender politics, art history, mythology, and magic. Catalogue. (T)

MCA Downtown
1001 Kettner Blvd., San Diego, CA 92101
(619) 234-1001

1998 Exhibitions
Thru Jan. 4
Geoffrey James: Running Fence
Canadian photographer turns his lens on the fence that runs along the western-most border of the United States and Mexico.

Jan. 17-Apr.12
William Kentridge
South African artist and filmmaker combines the projected and drawn image, allegorically rendering the gulf between the powerful and the oppressed.

Apr. 19-July 19
Silvia Gruner
Mexican-born artist whose work focuses on issues related to culture, identity, and gender.

Permanent Collection
Twentieth-century holdings spanning a variety of media, with particularly strong Minimalist, Pop, postmodern work. **Highlights:** André, *Magnesium-Zinc Plain*; Kelly, *Red Blue Green*; Ruscha, *Ace*; Oldenburg, *Alphabet* and *Good Humor*; Warhol, *Flowers*; Stella, *Sinjerli I* and *Sabra III*; Long, *Baja California Circle.* **Architecture:** La Jolla: 1916 private residence by Irving Gill; 1959, 1979 expansions by Mosher; 1996 renovation and expansion by Venturi, Scott Brown & Associates. Downtown: part of 1993 America Plaza complex designed by Helmut Jahn.

Admission: Adults, $4; seniors, students, military, $2; children under 12, free. First Tuesday and Sunday of the month, free. Handicapped accessible.

Programs for Children: "Free for All First Sundays" Family programs held on the first Sunday of each month, free admission.

Hours: La Jolla: Tues.–Sat., 10–5; Wed., 10–8; Sun., 12–5; closed Mon. Downtown: Tues.–Sat., 10–5; Fri., 10–8; Sun., 12–5; closed Mon.

Tours: La Jolla, Sat. and Sun., 2 p.m.; Wed., 6 p.m. Downtown: Fri., 6 p.m.; Sat. and Sun., 2 p.m.

Food & Drink: Museum Cafe open Tues.– Sun., 11–3; Wed. 11–8; closed Mon.

Museum Shop: Broad selection of contemporary gift items for home or office; personal accessories; contemporary art and architecture books. Many items for children and infants.

San Diego Museum of Art

1450 El Prado, Balboa Park, San Diego, CA 92101
(619) 232-7931
http://www.sddt.com/sdma.html

1998 Exhibitions

Thru Feb. 1
Matisse: Florilège des Amours de Ronsard — A Celebration of French Renaissance Poetry
An extensive series of lithographs created by Matisse in the 1940s, based on the writings of Pierre Ronsard (1524-1585). Includes themes of love, plant life, classical mythology, and descriptive abstract designs.

Feb. 28-Apr. 26
Alphonse Mucha: The Flowering of Art Nouveau
Major exhibition includes 180 posters, decorative panels, illustrations, and paintings by Art Nouveau artist Alphonse Mucha (1860-1939). (T)

June 27-Aug. 30
Monet: Late Paintings of Giverny from the Musée Marmottan
Blockbuster exhibition features 22 paintings by Claude Monet (1846-1926). Includes lesser-known later works featuring the flower and water gardens of Monet's property in the rural village of Giverny. (T)

Aug. 31-Oct. 31
Old Masters Brought to Light: European Paintings from the National Museum of Art of Romania
A rich collection of Old Master paintings from the 15th through the 17th centuries. Includes works by Rembrandt, El Greco, and Zurbarán never seen before in the U.S. (T)

Permanent Collection

European painting and sculpture from the Renaissance to the 20th century, including notable Italian Renaissance and Spanish Baroque works;

recently-acquired works by Picasso, Chagall, and Dufy; American paintings by Chase, Eakins, Homer, O'Keeffe, and Peale; world-renowned Indian paintings; Asian art, including Buddhist sculptures and ritual bronzes, Japanese prints; largest collection of contemporary California art.
Highlights: Beckmann, *Moon Landscape*; ter Borch, *The Love Letter*; Bougereau, *The Young Shepherdess*; Braque, *Still Life*; Giorgione, *Portrait of a Young Man*; Rubens, *Allegory of Eternity*; Sanchez Cotán, *Quince, Cabbage, Melon, and Cucumber*; sculpture garden with works by Hepworth, Moore, Rickey, Rodin. **Architecture:** 1926 Spanish Colonial-style building by William Templeton Johnson, a leading San Diego architect from the pre-WWII era, with Robert W. Snyder. The richly embellished entrance, modeled after one at the University of Salamanca, centers around the seashell (a reference to San Diego–St. James) and features Spanish and Italian masters.

Admission: Adults, $7; seniors, $5; military, $4; children 6–17, $2; children under 6, members, free. Handicapped accessible.
Hours: Tues.–Sun., 10–4:30. Closed Mon., Jan. 1, Thanksgiving, Dec. 25.
Tours: Tues.–Thurs., Sat., 10, 11, 1, 2; Fri., Sun., 1, 2.
Food & Drink: Sculpture Garden Café, Tues.–Fri., 10–3, Sat., Sun., 10–5.

Ansel Adams Center for Photography

250 Fourth St., San Francisco, CA 94103
(415) 495-7000

1998 Exhibitions

Thru Feb. 8
Phenomena: Science as Subject in Contemporary Photography
Survey of recent work demonstrating the interaction between art and science in the creation of images inspired by the forces of nature.

Permanent Collection
Over 130 vintage Ansel Adams prints; historic and contemporary photographic work. **Highlights:** *Moonrise, Hernandez, New Mexico; Clearing Winter Storm*; *Yosemite National Park, California*.
Architecture: 1989 building by Robinson, Mills & Williams of San Francisco.

Admission: Adults, $5; students, $3; seniors, children 12–17, $2; members, children under 12, free. Handicapped accessible.
Hours: Tues.–Sun., 11–5; first Thurs. of every month, 11–8. Closed Mon.
Tours: Sat., 1:15; call (415) 495-7000 for information.
Museum Shop: Open during museum hours.

Asian Art Museum of San Francisco
The Avery Brundage Collection
Golden Gate Park, San Francisco, CA 94118
(415) 668-8921 [voice]; (415) 752-2635 [TDD]
http://www.asianart.org

1998 Exhibitions
Thru Jan.
Hokusai and Hiroshige: Great Landscape Prints from the James A. Michener Collection, Honolulu Academy of Arts
Offers a rare opportunity to view original prints from Hokusai's *36 Views of Mt. Fuji* and Hiroshige's *53 Stations on Tokaido Highway*, drawn from this noted collection of Japanese *ukiyo-e* prints.

Thru Jan. 25
Paintings by Masami Teraoka
Features 40 recent paintings by this Japanese-born Pop artist who uses the traditional style and imagery of woodblock prints to examine current social issues. Catalogue.

Jan. 17-Sept. 6
Chinese Furniture From the Hung Family Collection
Explores the aesthetic and social issues reflected in over 40 pieces of furniture dating from the late-16th to the mid-18th century.

Feb. 14-May 10
Hopes and Aspirations: Decorative Painting of Korea
Examines the culture and folklore of pre-modern Korea through abstract forms and bold compositions in 16 paintings, screens, and scrolls.

May 10-Ongoing
Chinese Bronze and Sculpture from the Permanent Collection
Highlights a selection of Chinese bronzes and sculptures dating from the early Neolithic period to the 20th century.

June 13-Sept. 13
Fusion: Art of the Philippines and the Filipino Diaspora Today
Explores the themes of politics, identity, assimilation, isolation, and interpretation, featuring works by 25 contemporary Filipino artists.

Nov. 19-Ongoing
Chinese Jade from the Permanent Collection
Examines the technical aspects and cultural significance of jade, which has been in continuous use in China for nearly 7,000 years. Includes 500 pieces from the museum's collection.

Permanent Collection
More than 12,000 objects representing the art of China, Japan, Korea, Southeast Asia, India, the Himalayas; sculptures, paintings, bronzes, jades, ceramics, textiles, decorative objects, architectural elements representing all stylistic movements of Asian art. **Highlights:** Oldest-known dated Chinese Buddha (338 A.D.); largest collection of Gandharan sculpture in North America; collection of Japanese *netsuke* and *inro*. **Architecture:**

Construction is currently underway on the future location of the Asian Art Museum in the 1917 former library building at Civic Center; design by Gae Aulenti, architect Robert Wong, and Hellmuth, Obata & Kassabaum; the new building is scheduled to open in 2001.

Admission: Adults, $5; seniors, $3; children 12–17, $2; children under 12, free. First Wed. of each month, free. Handicapped accessible; wheelchairs and assistive listening devices available.
Hours: Wed.–Sun., 10–5. First Wed. of each month, 10–8:45. Closed Mon., Tues., some holidays. Special hours during major exhibitions.
Tours: Six tours daily; call (415) 750-3638 for group reservations.
Food & Drink: Café located in adjacent de Young Museum.

The Fine Arts Museums of San Francisco
California Palace of the Legion of Honor
Lincoln Park, near 34th Ave.
& Clement St., San Francisco,
CA 94121
(415) 863-3330 (recording)
http://www.famsf.org

1998 Exhibitions
Thru Jan. 18
Thirty-five Years at Crown Point Press
Works produced at this printmaking center from 1962 to the present. Includes prints by Diebenkorn, LeWitt, Frankenthaler, and Cage.

Jan. 17-Mar. 15
Rhapsodies in Black: Art of the Harlem Renaissance
This international exhibition explores the Harlem Renaissance and its influence on the culture of early-20th-century America and Europe. Includes paintings, sculptures, film, vintage posters, books, and decorative arts. (T)

Jan. 24-Apr. 26
Printed Portraits: Selections from the Anderson Collection

El Greco, *Saint Francis Venerating the Crucifix,* c. 1600.
Photo courtesy California Palace of the Legion of Honor.

Feb. 21-Apr. 19
Hidden Treasures of African Art from the Tervuren Museum
A selection of 125 Central African masks, sculptures, and other objects originally collected to increase European understanding of the area called the Kongo, now known as Zaire. Catalogue. (T)

Feb. 28-May 17
Toulouse-Lautrec

March
Bouquets To Art

May 9-Aug. 9
Contemporary Screenprints: Selections from the Anderson Collection

Jean Baptiste-Camille Corot, *View of Rome: The Bridge and Castel Sant'Angelo with the Cupola of St. Peter's,* 1826-27. Photo courtesy California Palace of the Legion of Honor.

June 6-Sept. 6
Stanley Spencer: An English Vision
Features paintings by this 20th-century British artist. (T)

Aug. 8-Oct. 11
The Wealth of the Thracians: Treasures from the Republic of Bulgaria
Over 200 masterpieces of gold and silver metalwork from ancient Thrace, located in central Europe between 4,000 B.C. and the 4th century A.D. (T)

Aug. 22-Nov. 29
Robert Motherwell's A la Pintura: Selections from the Anderson Collection

Sept. 26, 1998-Jan. 3, 1999
Achenbach Collection of Graphic Arts

Oct. 10, 1998-Jan. 3, 1999
Picasso and the War

Permanent Collection
The city's European art museum, its collections span 4,000 years and include major holdings of Rodin sculpture, 70,000 prints and drawings, a 15th-century Spanish ceiling, and paintings by Rembrandt, Rubens, Watteau, de la Tour, Vigée LeBrun, Cézanne, Monet and Picasso, among other Dutch, Italian, German, English and French masters. **Architecture:** Beaux-Arts building by George Applegarth; Newly re-opened after 1991-5 expansion and renovation by Edward Larrabee Barnes/ John M.Y. Lee & Partners.

Admission: Adults, $7; seniors, $5; youths 12–17, $4; college student annual pass, $10; members, children under 12, free. Handicapped accessible; wheelchairs and assistive listening devices available.
Hours: Tues.–Sun., 10–5.
Food and Drink: Café with views of gardens and ocean.

The M. H. de Young Memorial Museum

Golden Gate Park, Eighth Ave. & JFK Dr., San Francisco, CA 94118
(415) 863-3330 (recording)

1998 Exhibitions

Ongoing
Gallery One: An Exhibition for Children

Thru Jan. 4
Morgan Flagg Collection
A selection of works from the private collection of this Bay Area resident includes works by Diebenkorn, Brown, Thiebaud, and others.

Thru Mar. 1
Ikat: Splendid Silks from Central Asia
Collection of 70 textiles produced using the ancient method of resist dyeing. 19th-century ikats from Central Asia are unrivaled for their bold designs and vibrant colors. Catalogue. (T)

Thru Apr. 12
Art of the Americas: Art and Ethnography
Explores the complex issues of interdisciplinary scholarship and the perception of cultural differences.

Feb. 7-May 3
Crosscurrents in Later Paintings from India, 1780-1910: The Ehrenfeld Collection
Features 95 works encompassing the time of the Mughal kingdoms through the British "Raj," demonstrating artistic interaction between these cultures.

June 13-Aug. 30
John Steuart Curry: Inventing the Middle West
Paintings, drawings, and watercolors by this American artist known, with Grant Wood and Thomas Hart Benton, as one of the trinity of Regionalism. (T)

Permanent Collection

Outstanding holdings in American paintings, sculpture and decorative arts. Arts of Oceania, Africa, the Americas; jewelry from the ancient world; Egyptian mummies. **Highlights:** American paintings by Bingham, Cassatt, Church, Copley, Harnett, Sargent; Revere silver. **Architecture:** 1921 building by Mullgardt. Set in park, with beautiful Japanese garden.

Joshua Johnson, *Letitia Grace McCurdy*, c. 1800. Photo courtesy M.H. de Young Memorial Museum.

Admission: Adults, $7; seniors, $5; 12–17 years of age, $4; children under 12, members, free. First Wed. of the month, free; college student annual pass, $10.
Hours: Wed.–Sun., 10–5 p.m.; first Wed., 10–8:45. Closed Mon., Tues.
Tours: Call (415) 750-3638.
Food & Drink: Café de Young open Wed.–Sun., 10–4, first Wed., 6–8.

51

San Francisco Museum of Modern Art

151 Third Street, San Francisco, CA 94103
(415) 357-4000; 357-4514 [TDD]
http://www.sfmoma.org

1998 Exhibitions

Thru Jan. 4
Encounters with Modern Art: Works from the Rothschild Family Collections
Includes 100 paintings, drawings, prints, and sculptures from major
European schools—Futurism, Cubism, Constructivism, and De Stijl—with
works by Arp, Delaunay, Schwitters, and others. Catalogue.

Thru Jan. 6
Present Tense: Nine Artists in the Nineties
Explores current themes of artmaking, including beauty and craft, mourning
and loss, personal obsession and meaning.

Thru Jan. 20
Police Pictures: The Photograph as Evidence
The first museum exhibition to examine the social significance of
photographs taken as police evidence or forensic documentation.

Thru Feb. 3
Tatsuo Miyajima: New Work
Features the premiere of *Counter Line*, a new permanent installation,
representing the themes of time, space, and environment.

Thru Feb. 24
Making Art Histories: On the Trail of David Park
Demonstrates how art histories are constructed through acquisition and
selectivity, focusing on Bay Area figurative artist David Park.

Thru Mar. 3
Likeness and Guise: Portraits by Paul Klee
Explores the Swiss artist's approach to the human figure, ranging
stylistically from exaggerated realism to refined abstraction.

Thru Mar. 10
Zaha Hadid
Features the large scroll-like paintings of this London-based architect.

Opening Spreads from Wired *magazine, from the Permanent Collection of
Architecture and Design*
A selection of spreads from this magazine that has redefined the appearance
of the large concepts of digitally produced media.

Jan. 23-Apr. 14
Roy DeCarava: A Retrospective
Surveys 200 works spanning half a century by one of the major figures in
post-war American photography. Includes themes of social awareness,
humanity, and jazz. (T)

Feb. 6-Apr. 28
Fabrications
Presents various architectural installations as assembled pieces that instruct and delight by engaging the viewer in direct physical experiences.

Feb. 13-May 5
New Work: Steven Pippin
This British photographer transforms ordinary household objects–in this case washing machines–into cameras, challenging what the artist sees.

Feb. 27-Apr. 21
Steve McQueen Film Installation
Features the work of this young British artist who, through a synthesis of film and art, explores form and contemporary issues of sex and race.

Mar. 13-July 7
Sargent Johnson and Modernism
A survey of this artist who was influenced by European Modernism, traditional African art, and the Bohemian culture of San Francisco.

Mar. 27-June 23
Heavenly Hallucinations: A.G. Rizzoli
Features 85 renderings of architectural monuments created by this reclusive San Francisco draftsman from the 1930s through the 1970s. (T)

Mar. 27-July 3
April Greiman Graphics

May 15-Sept. 22
Nauman/Oursler/Anderson

May 22-Sept. 8
Paul Strand, Circa 1916
Over 50 extremely rare prints reflect Strand's period of transition from soft-focus pictorial style to a bold and distinctively American modernism. (T)

Roy DeCarava, *Ketchup bottles, table and coat*, 1952, from *Roy DeCarava: A Retrospective*. Photo courtesy San Francisco Museum of Modern Art.

Snapshots
Examines the relationship between fine art photography and the popular snapshot used to capture everyday life. Includes work by Walker Evans and Larry Sultan. Catalogue.

July 17-Oct. 20
Refined Normality: Recent Dutch Design
The work of designers from the Netherlands who have contributed to the design consciousness of their country.

Sept. 5, 1998-Jan. 1, 1999
Alexander Calder: 1898-1976
Retrospective celebrating the centenary of the artist's birth, presenting over 200 works by one of the great formal innovators of the 20th century. (T)

Oct. 9, 1998-Jan. 19, 1999
Richard Diebenkorn
The most comprehensive survey to date of this contemporary, late American artist's career, featuring over 150 paintings and works on paper, including his celebrated *Ocean Park* series, figurative works, and early abstractions. Catalogue. (T)

Permanent Collection

Twentieth-century works of international scope in all media. **Highlights:** Gorky, *Enigmatic Combat*; Matisse, *The Girl with Green Eyes*; Pollock, *Guardians of the Secret*; Rauschenberg, *Collection*; Rivera, *The Flower Carrier*; Tanguy, *Second Thoughts*; paintings by Bay Area artists Diebenkorn, Neri, Oliveira, Thiebaud; exceptional selection of photographs by Adams, Stieglitz, Weston. **Architecture:** Second largest structure in the U.S. devoted to modern art, the stunning new 1995 SFMOMA is Swiss architect Mario Botta's first museum project.

Admission: Adults, $8; seniors, $5; students, $4; members, children 12 and under, free. Handicapped accessible.
Hours: Fri.–Tues., 11–6; Thurs., 11–9. Closed Wed.
Programs for Children: Bi-annual Family Day; Children's Art Studio for ages 2-6; and a studio for families, the third Sun. of each month, 12–3.
Tours: Weekdays, 11:30, 1:15, 2:30, 3:45, (Thurs. 6:15, 7:15); Sat.–Sun., 11:30, 1, 2:30. Call (415) 357-4095 for information.
Food & Drink: Stunning and delicious Caffè Museo open Fri.–Tues., 10–6; Thurs., 10–9.
Museum Shop: Features outstanding collection of art books, jewelry, clocks, and decorative arts; open Fri.–Tues., 10:30–6; Thurs., 10–9.

San Jose Museum of Art

110 S. Market, San Jose, CA 95113
(408) 294-2787
http://www.sjmusart.org

1998 Exhibitions

Thru Jan. 4
San Jose: A Museum of Reflections, Photographs by Joseph Schuett
Images of architectural landmarks in the San Jose area by this photographer from Chicago.

Thru Feb. 1
Flying Colors: The Innovation and Artistry of Alexander Calder
Sculpture, watercolors, prints, and other art objects by this important and innovative American artist.

Thru Feb. 8
Holding Patterns: Selections from the Collection of W. Donald Head, Old Grandview Ranch
California *plein air* landscapes and early-20th-century works selected from the collection of this South Bay Area resident.

Thru Oct. 18
American Art in the Age of Technology: Selections from the Permanent Collection of the Whitney Museum of American Art
Investigates works of the last 30 years that alternately embrace, incorporate, critique, and sometimes satirize the mechanics and technologies of the post-industrial world.

Thru Winter
Patrick Dougherty: A Site-Specific Installation
A special installation by this North Carolina-based artist known for his use of twigs and branches.

Feb. 21-May 31
Mary Marsh: Daily Drawings
Drawings that address mass media and popular culture. Includes works from her 1995 series of daily sketches on the front page of the *New York Times.*

We Shall Overcome: Photographs from the American Civil Rights Era
Examines the public and private conflicts, through words and images, of this pivotal movement in American history.

June 13-Sept. 20
In Over Our Heads: The Image of Water in Contemporary Art
Examines the imagery and metaphors of water, featuring contemporary works in all media by artists such as David Hockney and Jennifer Bartlett.

Oct. 3, 1998-Jan. 3, 1999
Crimes and Splendors: The Desert Cantos of Richard Misrach
Retrospective of this San Francisco photographer's ongoing epic series, which examines civilization's relationship to its environment. (T)

From *We Shall Overcome: Photographs from the American Civil Rights Era.* Photo by Bob Fitch, courtesy San Jose Museum of Art.

Holding Patterns: Selections from the Photography Collection of Arthur Goodwin
Works by artists such as Mark, Avedon, and Kertesz, from the collection of this Bay Area resident.

Nov. 14, 1998-Feb. 14, 1999
Gronk x 3: A Site-Specific Installation, Works on Paper, and Collaborations
Featuring murals, theatrical designs, and prints by this Los Angeles artist who approaches his work with passion, energy, and wit. Catalogue.

Permanent Collection
Focuses on 20th-century art (post-1940) and features works by local and national artists. **Architecture:** 1892 Historic wing by Willoughby Edbrooke; contemporary 1991 wing by Skidmore, Owings & Merrill.

Admission: Adults, $6; seniors, students, $3; children 5 and under, free; first Thurs. of the month, free. First Tues. of month, free to seniors. Thurs., 5–8, half-price. Handicapped accessible, including ramp, elevator, and parking. Signed tours and wheelchairs available.
Hours: Tues.–Sun., 10–5; Thurs., 10–8. Closed Mon.
Programs for Children: Kids ArtSunday, last Sun. of month, 11–3, includes hands-on activities. Storytelling, second Sun. of month, 11:15–12.
Tours: Daily, 12:30, 2:30. Call (408) 291-5393 for information.
Food & Drink: Caffè La Pastaia al Museo open during museum hours. Picnic areas available in public park across the street.
Museum Shop: Open during museum hours.

The Huntington Library, Art Collections, and Botanical Gardens

1151 Oxford Rd., San Marino, CA 91108
(626) 405-2141
http://www.huntington.org

1998 Exhibitions

Jan. 27-April 19
Sacred and Profane: Themes in Renaissance Prints

May 23-Aug. 23
Margaret Mee: Return to the Amazon
Botanical drawings made by the explorer (1909-1988) during her travels to the rain forest. (T)

Sept. 1998-Jan. 1999
Jack London

Oct. 6, 1998-May 31, 1999
The Great Experiment: George Washington and the American Republic
The most ambitious exhibition in over a decade on the life of George Washington, timed to coincide with the bicentennial of his death in 1799.

Studio of Charles Willson Peale, *George Washington*. Photo courtesy Huntington Library.

Permanent Collection

Fabulous library with rare books, manuscripts from the 11th century to the present; 18th- and 19th-century British paintings; Renaissance paintings and bronzes; important 17th-century works by Claude, van Dyck; 18th-century French paintings by Boucher, Nattier, Watteau; European decorative arts; 18th- to 20th-century American art by Cassatt, Copley, Hopper; decorative

art objects by architects Greene & Greene. **Highlights:** Cassatt, *Breakfast in Bed*; Church, *Chimborazo*; Constable, *View on the Stour*; Gainsborough, *The Blue Boy*; Hopper, *The Long Leg*; Lawrence, *Pinkie*; van der Weyden, *Madonna and Child*; Gutenberg Bible; Chaucer's *Canterbury Tales*; early editions of Shakespeare; letters and papers of the Founding Fathers; botanical gardens including the Japanese, Desert, Rose, Jungle gardens. **Architecture:** 1909–11 mansion designed for philanthropist Huntington by Hunt and Grey; 1984 Scott Gallery of American Art by Warner and Grey.

Admission: Adults, $7.50; seniors, $6; students, $4, free for children under 12. Handicapped accessible, with wheelchair map of gardens available.
Hours: Tues.–Fri., 12–4:30; Sat.–Sun., 10:30–4:30. Closed Mon., holidays; summer hours: 10:30–4:30 daily (except Monday).
Programs for Children: Scheduled throughout the year.
Tours: Garden tours, Tues.–Sun. Groups call (626) 405-2127.
Food & Drink: Rose Garden Café open Tues.–Fri., noon–4:30; Sat.–Sun., 10:30–4:30. English tearoom: Tues.–Fri., 12–3:45; Sat.–Sun., 10:30–3:45.
Museum Shop: Offers good selection of books, cards; open Tues.–Fri., 12:30–5; Sat.–Sun., 11–5.

Santa Barbara Museum of Art

1130 State St., Santa Barbara, CA 93101
(805) 963-4364

1998 Exhibitions

Thru Jan. 4
Beatrice Wood: A Centennial Tribute
Last venue for the comprehensive retrospective of this renowned figure of the New York Dada movement. Features over 130 works, covering almost a century of creativity.

Feb. 1-Apr. 19
Santa Barbara Collects: Impressions of France
Paintings by Barbizon, Impressionist, and Post-Impressionist French artists, including Rousseau, Corot, and Monet.

Jan. 29-Mar. 29
Revealing the Holy Land: The Photographic Discovery of Palestine
Explores the modern rediscovery of Palestine by Western travelers, focusing on 90 vintage photographs made in the 1860s. Catalogue.

Apr. 11-June 7
Out of Sight: Imaging/Imagining Science
The dynamic world of scientific discovery as interpreted by artists in photography and video.

July 18-Oct. 18
Eternal China: Splendors from Ancient Xian
Major exhibition of 90 works from Xian, China, featuring life-size terracotta horsemen from the Qin dynasty (221-206 B.C.) and other objects unearthed in archeological excavations. Catalogue. (T)

Permanent Collection

Houses more than 15,000 works; important holdings of American and Asian art, classical antiquities, European paintings, 19th-century French art, 20th-century art, photography, works on paper. Artists represented include Homer, Sargent, Picasso, Matisse, Chagall, Hopper, Kandinsky, and Dali. **Architecture:** 1914 Neoclassical building designed as a post office by John Taylor Knox; 1941 redesign by David Adler; 1991 addition by Paul Gray. The museum is undergoing a major expansion, scheduled for completion in Jan. 1998.

Admission: Adults, $4; seniors, $3; students, children 6–17, $1.50; Thurs., and first Sun. of the month, free. (Fees and hours may change after the opening of the new wing.) Handicapped accessible.
Hours: Tues.–Wed., Fri.–Sat., 11–5; Thurs., 11–9; Sun., noon–5. Closed Mon. and major holidays. The Fearing Art and Reference Library is open Tues.–Fri., 12–4.
Programs for Children: Children's participatory center, located in the newly-expanded area of the museum. Classes for children and adults are offered throughout the year at the Ridley-Tree Education Center at McCormick House, 1600 Santa Barbara St., (805) 962-1661.
Tours: Tues.–Sun., 1; special focus tours, Wed., Thurs., Sat., Sun., 12; monthly bilingual Spanish-English tour. Call (805) 963-4364.
Museum Shop: Offers books, jewelry, and unique gift items.

Stanford University Museum of Art

Lomita Dr. & Museum Way, Stanford, CA 94305
(415) 723-4177
http://www-leland.stanford.edu/dept/SUMA

NOTE: The museum is temporarily closed due to damage suffered in the 1989 earthquake. It will reopen in Jan. 1999 with a new wing by Polshek and Partners.

1998 Exhibitions

Spring 1998
B. Gerald Cantor Rodin Sculpture Garden
The garden, temporarily closed, is scheduled to reopen in spring 1998. Contains more than 20 works by Auguste Rodin (1840-1917), including *The Gates of Hell.*

Permanent Collection
Works from antiquity to the present including early and late 20th-century art; African and Oceanic art; 19th-century European art; Native American art; 19th-century American art; pre-1800 European art; and Asian art. Also, the recently completed New Guinea Sculpture Garden displays the techniques and cultural traditions of the Kwoma and Latmul people of Papua New Guinea. **Architecture:** 1891–93 Beaux-Arts building by Percy & Hamilton, modeled on the National Museum of Athens. Reopening of the museum, with renovations, scheduled for Jan. 1999.

Admission: Free. Partially handicapped accessible.
Hours: Tues.–Fri., 10–5; Sat.–Sun., 1–5. Closed Mon., holidays.
Tours: Call (415) 723-3469. Docent-guided Campus Sculpture Walks are available the first Sun. of each month.

Yerba Buena Center for the Arts

701 Mission St., San Francisco, CA 94103
(415) 978-2700; (415) 978-ARTS (Tickets)
http://www.yerbabuenaarts.org

1998 Exhibitions

Thru Mar. 1

Hunter Reynolds
Features large, amalgamated photographic collages, and Patina De Prey's Memorial Dress.

Scott Williams
Large-scale paper stencils, in the tradition of street propaganda design, depict everyday life in San Francisco's Mission District.

Rodney O'Neal Austin: Beavercreek, OH
A local legend for his memorable drag performances, Austin's satirical drawings and "memory dolls" celebrate sex, difference, and life in general.

To Be Real
Artists who explore issues of representation, memory, and fantasy through the use of realism. Features Mark Bennett's television-inspired architectural blueprints and John Brotzman's psychological sculptures.

From *Beavercreek, OH: A One-Person Show by Rodney O'Neal Austin.* Photo courtesy Yerba Buena Center for the Arts.

Mar. 14-May 31

Alan Rath
Local artist uses high technology to make multimedia installations of computer-programmed sculpture.

Last Judgment
Assesses the 20th century through the eyes of surviving Socialist Realist painters from the former Soviet Union, featuring large specially commissioned canvases.

Heidi Kumao
Homemade projection equipment casts simple kinetic shadow images directly onto the walls.

Needles and Pins
A survey of new drawing by young artists from the Bay Area who literally pin their work to the wall or use pins within the work.

June 13-Aug. 16
Photo Backdrops: The George Berticevich Collection
Large, painted photo backdrop canvases collected by a local resident from carnivals and itinerant photographers around the world.

June 13-Aug. 23
Commotion: Martin Kersels
The first survey of work by this Los Angeles-based artist, who explores the expressive potential of machines and the human body.

Artists' Work Books
A selection of artists' sketchbooks and other artifacts explores the "behind the scenes" images, marks, and notes made by artists during the creative process.

Sept. 3-Nov. 1
Desert Cliché
Features work by Israeli and American artists who analyze Israel's current situation and attempt to dispel media stereotypes.

Migrant Artists and Migratory Ideas
Artists from Mexico City use various media to explore the mutual influences of Mexican and Californian culture.

Nov. 14, 1998-Jan. 3, 1999
Mark Dion
Features works by this American conceptual artist who relates the animal world to natural and human phenomena.

Fletcher + Rubin
Collaborative team of local artists examines the aesthetics of everyday life.

Criminal Justice Photographs
Local photographer Robert Gumpert documents the police and court systems of San Francisco.

Permanent Collection
No permanent collection; constantly rotating exhibitions. Multidisciplinary visual, media, and performing arts complex presents a diverse cross-section of arts and education. **Architecture:** Two-building complex and garden located across from the San Francisco MOMA; Galleries and Forum designed by architect Fumihiko Maki in association with Robinson, Mills & Williams. Theater designed by James Stewart Polshek and Partners.

Admission: Adults, $5; seniors, students, $3; members, free. Handicapped accessible, including braille signage and sign interpreters.
Hours: Tues.–Sun., 11–6.
Programs for Children: In-Conversion discussion series; family programs.
Tours: Second Sat. of each month, 1.
Food & Drink: Two restaurants located in the garden complex.
Museum Shop: Unique variety of jewelry and other hand-crafted objects, art publications, and children's books; open museum hours.

Denver Art Museum

100 W. 14th Ave. Pkwy., Denver, CO 80204
(303) 640-4433; (303) 640-2789 [TTY]
http://www.denverartmuseum.org

1998 Exhibitions

Thru June 7
The Norwest Collection-paper REVOLUTION: Graphics, 1890-1940
Features nearly 50 posters representing various artistic styles, including the Arts and Crafts Movement, Art Nouveau, Art Deco, and Bauhaus.

Thru Jan. 11
Austrian Visions
First time American audiences can view a selection of nearly 70 works by Austrian artists such as Christian Ludwig Attersee, Hermann Nitsch, Arnulf Rainer, and Franz West.

Thru Jan. 18
Herbert Bayer: Early Works on Paper
A selection of intimate renderings by Austrian-born Herbert Bayer, including works from his years in the Bauhaus, Berlin, and New York.

Thru Jan. 25
Old Masters Brought to Light: European Paintings from the National Museum of Art of Romania
A rich collection of Old Master paintings from the 15th through the 17th centuries. Includes works by Rembrandt, El Greco, and Zurbarán never seen before in the U.S. (T)

Jan. 10, 1998-Jan. 2000
Classical Chinese Furniture from the Dr. S.Y. Yip Collection
Rotating exhibition features selections of Classical Chinese furniture, including valued pieces from the Ming period (1368-1644).

Jan 31-Nov. 29
Indian Fashion Show
Highlights designs by American Indian artists that were first featured in a traveling 1940s runway fashion show drawn from the museum's collections.

Apr. 4-Aug. 2
The Search for Ancient Egypt
Bronze, bone, wood, textile and other objects excavated from Egypt and Nubia dating from the early dynastic through the Ptolemaic periods. (T)

June 6-Oct. 24
Sean Scully: Works on Paper, 1975-1996
Large-scale abstract canvases and accompanying watercolors by the Irish-born American. Catalogue. (T)

June 20, 1998-June 20, 1999
White on White: Chinese Jades and Ceramics
Highlights the subtle variations of white as represented in exquisite pieces ranging in date from the Tang to Qing dynasties (8th–19th centuries).

Oct. 10, 1998-Jan. 3, 1999
Inventing the Southwest: The Fred Harvey Company & Native American Art
Retrospective of early American railroad travel and its effect on Native peoples and Native American art. (T)

Permanent Collection

Extensive North American Indian collection; notable Pre-Columbian and Spanish Colonial collections; 19th- and early 20th-century painting; art of the American West; Renaissance and Baroque painting; Asian art; Modern & Contemporary; Architecture, Design & Graphics. **Highlights:** Remington, *The Cheyenne*; O'Keeffe, *Petunia and Glass Bottle*; Monet, *Waterloo Bridge,* di Suvero, *Lao-Tzu.* **Architecture:** 1971 building by Italian designer and architect Gio Ponti with Sudler Associates, housing galleries in twin towers with uniquely-shaped windows framing views of the city. An additional floor of gallery space, dedicated to European, American and Western art, plus newly renovated galleries on two other floors opens Nov. 15. Renovated Asian, Pre-Columbian and Spanish Colonial Galleries opened in 1993; new Architecture, Design & Graphics galleries debuted in 1995.

Navajo Pictoral Textile, c. 1885. From *Inventing the Southwest: The Fred Harvey Company and Native American Art.* Photo courtesy Heard Museum

Admission: Adults, $4.50; seniors, students, $2.50; children under 5, free. Sat., free. Handicapped accessible.
Programs for Children: Adventures in Art education center offers classes for children and adults; call for more information.
Hours: Tues.–Sat., 10–5; Sun., 12–5. Closed Mon., major holidays.
Tours: Tues.–Sun., 1:30; Fri., 12; Sat., 11. Summer schedule: Tues.–Sat., 11, 1:30; Fri., 12; Sun., 1:30. Groups call (303) 640-7596.
Food & Drink: New restaurant opened in November 1997.
Museum Shop: New museum shop opened in November 1997.

Wadsworth Atheneum

600 Main St., Hartford, CT 06103
(860) 278-2670

1998 Exhibitions

Thru Feb.
Making Magic: Sandra Woodall Designs for the Hartford Ballet
Highlights Woodall's original costumes for the 1996 productions of *Le Spectre de la Rose* and *Firebird.*

Jan.-Apr.
Mierle Laderman Ukeles/MATRIX 135
Examines the art of this feminist, mother, and social activist who since the 1970s has been at the forefront of the "new genre public art."

Feb. 8-Apr. 5
Canaletto to Constable: English Landscapes from the Yale Center for British Art
Surveys the development of the British landscape tradition from the early-18th through early-19th centuries, with paintings by Constable, Turner, and Gainsborough.

Sept. 12-Dec. 8
New Worlds from Old: Australian and American Landscape Painting of the 19th Century
Compares the traditions of these former British colonies during a period when landscape became a focus. Includes works by Frederic Church, Thomas Cole, Winslow Homer, Augustus Earle, and John Glover. (T)

Permanent Collection

Sixteenth- and 17th-century Old Master, Hudson River school, and Impressionist paintings; Nutting Collection of Pilgrim-period furniture and two restored period rooms; African-American, 20th-century art. **Highlights:** Caravaggio, *Ecstasy of Saint Francis;* landscapes by Church, Cole; Goya, *Gossiping Women*; Pollock, *Number 9*; Picasso, *The Painter*; Renoir, *Monet Painting in His Garden at Argenteuil*; Zurbarán, *Saint Serapion.* **Architecture:** Five connected buildings reflecting the history and growth of the

Tom Roberts, *Allegro con brio: Bourke Street West,* c. 1886. From *New Worlds from Old: Australian and American Landscape Painting of the 19th Century.* Photo courtesy National Gallery of Australia.

Atheneum, one of America's oldest continuously operated public art museums. Original 1844 Gothic Revival style building by Ithiel Town and A.J. Davis; two buildings designed by Benjamin Morriss in 1907, modest Tudor-style Colt Memorial and the imposing Renaissance Revival style Morgan Memorial; 1934 Avery Memorial with International Style interior; 1969 Goodwin building.

Admission: Adults, $7; seniors, students, $5; youths 6–17, $4; members, children under 6, free. Handicapped accessible; TDD listening devices available.
Hours: Tues.–Sun., 11–5. First Thurs. each month, 11–8. Closed Mon., holidays.
Programs for Children: Offers classes, treasure hunts, workshops, birthday parties, and other activities throughout the year. Call for details.
Tours: Tues.–Fri., 1; Sat.–Sun., 2. Groups call (860) 278-2670, ext. 3046.
Food & Drink: Museum Café open for lunch Tues.–Sat. and for brunch, Sun.; open for dinner on select Thurs.

Yale Center for British Art

1080 Chapel St., New Haven, CT 06520
(203) 432-2800
http://www.yale.edu/ycba

1998 Exhibitions
Thru Jan. 4
Irish Paintings from the Collection of Brian P. Burns
Features 19th- and 20th-century paintings from the collection of this Irish-American resident of California.

NOTE: On Jan. 5, the Center will close for roof repair, gallery renovation, and permanent collection reinstallation. Access by appointment only to the Reference Library, the Department of Prints and Drawings, and the Department of Rare Books and Archives. The museum will reopen in 1999.

Permanent Collection
The most comprehensive collection of English paintings, drawings, prints, and rare books outside Great Britain. Focuses on British art, life, and thought from the Elizabethan period onwards; emphasis on work created between the birth of Hogarth in 1697 and the death of Turner in 1851, considered the golden age of English art. **Highlights:** Constable, *Hadleigh Castle*; Gainsborough, *The Gravenor Family*; Reynolds, *Mrs. Abington as Miss Prue in Congreve's "Love for Love"*; Rubens, *Peace Embracing Plenty*; Stubbs, *A Lion Attacking a Horse*; Turner, *Dort or Dor-drecht: The Dort Packet-Boat from Rotterdam Becalmed.* **Architecture:** 1977 building, the final work of Louis I. Kahn's distinguished career, presents an austere facade of poured concrete filled with matte "pewter-finish" stainless steel panels and reflective plate glass windows. Inside, rooms finished in white oak panelling encircle two open courts filled with natural light.

Admission: Free. Handicapped accessible.
Hours: Tues.–Sat., 10–5; Sun., noon–5. Closed Mon.
Programs for Children: Call the Curator of Education at (203) 432-2855.
Tours: Call (203) 432-2858 for information.
Food & Drink: The Center is located near many of the city's restaurants.
Museum Shop: Open during museum hours. (203) 432-2828.

Yale University Art Gallery

1111 Chapel St. at York, New Haven, CT 06520
(203) 432-0600
http://www.cis.yale.edu/yups/yuag

Permanent Collection

Works from ancient Egyptian dynasties to the present. Asian art, including Japanese screens, ceramics, prints; artifacts from ancient Dura-Europos; Italian Renaissance art; 19th- and 20th-century European paintings; early modern works by Kandinsky, Léger, Picasso; American art through the 20th century, featuring paintings, sculptures, furniture, silver, pewter. **Highlights:** Reconstructed Mithraic shrine; van Gogh, *The Night Café*; Malevich, *The Knife Grinder*; Smibert, *The Bermuda Group*; Trumbull, *The Declaration of Independence*; contemporary sculpture by Moore, Nevelson, Smith. **Architecture:** Two connecting buildings house the oldest university art museum in the West. 1928 building by Edgerton Swartout based on a gothic palace in Viterbo, Italy; 1953 landmark building by internationally acclaimed architect Louis I. Kahn.

Admission: Free. Handicapped accessible.
Hours: Tues.–Sat., 10–5; Sun., 2–5. Closed Mon., Aug., holidays.
Tours: Wed., Sat., 1:30. Call (203) 432-0620 for special tours.

Delaware Art Museum

2301 Kentmere Pkwy., Wilmington, DE 19806
(302) 571-9590
http://www.udel.edu/delart

1998 Exhibitions
Thru Feb. 22
The White House Collection of American Crafts
Outstanding collection of 70 contemporary American crafts.

Monica Castillo, *Self-portraits with Women's & Men's Shirts*, 1995. From *Mexico Now: Point of Departure*. Photo courtesy Delaware Art Museum.

June 25-Sept. 7
Life Cycles: The Charles E. Burchfield Collection
Surveys the work of this American painter, naturalist, and social critic through themes of American life, landscape, time, and memory. (T)

Oct. 8-Nov. 29
Mexico Now: Point of Departure
Contemporary work by artists such as Monica Castillo.

Permanent Collection

Largest display of Pre-Raphaelite art in the United States; the primary repository of American illustration, including unrivalled collection of works by Howard Pyle. American painting from 1840 to the present, including Church, Eakins, Hassam, Henri, Homer, Hopper, Sloan, Calder, Nevelson and Held. **Architecture:** 1938 Georgian-style building; 1956 addition; 1987 wing by Victorine and Samuel Homsey, Inc.

Admission: Adults, $5; seniors, $3; students with ID, $2.50; members, children under 6, free. Sat., 10–1, free. Handicapped accessible.
Hours: Tues.–Sat., 9–4; Sun., 10–4; Wed., 9–9. Closed Mon., Jan. 1, Thanksgiving, Dec. 25.
Programs for Children: Participatory gallery, Pegafoamasaurus.
Tours: Group reservations, call (302) 571-9590 six weeks in advance.
Food & Drink: Café open during museum hours.
Museum Shop: Open during museum hours.

The Corcoran Gallery of Art

500 17th St. NW, Washington, DC 20006
(202) 639-1700
http://www.corcoran.org

1998 Exhibitions

Continuing

Treasures of the Corcoran: The Permanent Collection on View
Selection of paintings, sculpture, photographs and drawings.

The Salon Doré
Superb example of late 18th-century French interior design and artistry.

Aaron Douglas, *Into Bondage,* 1936. From *Rhapsodies in Black: Art of the Harlem Renaissance.* Photo courtesy Corcoran Gallery of Art.

Thru Jan. 11

Half Past Autumn: The Art of Gordon Parks
First retrospective of the works of this noted American artist who has overcome adversity to create works that express his message of hope. (T)

Thru Feb. 15

Ken Aptekar: Talking to Pictures
First museum exhibition of this artist who reworks old masters, bolting glass with sandblasted words to his interpretations of artistic icons, to reevaluate the nature of authorship.

Jan.-Mar.

Nancy Chunn
More than 300 drawings, using front pages of the *New York Times,* document and critique the year 1996.

Feb. 1-16
Burgess/Dreyfuss/Tipton Collaboration
Performance/sculptural installation by Washington sculptor John Dreyfuss, choreographer Dana Tai Soon Burgess, and light designer Jennifer Tipton.

Mar. 14-June 1
Nothing Personal: Ida Applebroog, 1987-1997
A comprehensive survey of 50 paintings and installations created over the past decade by this accomplished and influential artist. The exhibition coincides with the celebration of her 70th birthday. Catalogue.

Apr. 11-June 22
Rhapsodies in Black: Art of the Harlem Renaissance
This international exhibition explores the Harlem Renaissance and its influence on the culture of early-20th-century America and Europe. Includes paintings, sculptures, film, vintage posters, books, and decorative arts. (T)

Apr. 18-July 6
Lyle Ashton Harris and Thomas Allen Harris: Alchemy
A multimedia collaboration by these artist/brothers explores the social and spiritual relationship between West African Yoruba culture and contemporary African-American families.

June 3-July 27
ArtSites 98
Multi-site biennial exhibition showcasing new work by leading and emerging contemporary artists in the local Washington, D.C. area.

July-Oct.
45th Biennial: The Corcoran Collects
A critical exploration of the history of the more than 200 painting acquisitions made by the museum since the inception of the Biennial in 1907. Includes paintings by Homer, Cassatt, Hopper, and Eakins.

Permanent Collection
American art and photography, from colonial portraits to contemporary works; 17th-century Dutch art; 19th-century Barbizon and Impressionist painting; American sculpture by French, Powers, Remington, Saint-Gaudens. **Highlights:** The Salon Doré; Bellows, *Forty-two Kids*; Bierstadt, *Mount Corcoran*; Church, *Niagara;* Cole, *The Departure* and *The Return*; Eakins, *The Pathetic Song*; Glackens, *Luxembourg Gardens*; Homer, *A Light on the Sea.* **Architecture:** 1897 Beaux Arts building by Ernest Flagg; 1927 Clark Wing by Charles Platt.

Admission: Suggested donation: adults, $3; seniors, students, $1; family groups, $5; members, children under 12, free. Handicapped accessible.
Hours: Wed.–Mon., 10–5; Thurs., 10–9. Closed Tues.
Programs for Children: Throughout the year, including Family Days, art activities, films, music programs, and storytelling.
Tours: Daily, 12; Sat.–Sun., 10:30, 12, 2:30; Thurs., 7:30.
Food & Drink: Café des Artistes, open Mon., Wed., Fri., Sat., 11–3; Sun., 11–2; Thurs. 11–8:30.
Museum Shop: Offers interesting items focusing on current exhibitions; open during museum hours.

Folger Shakespeare Library

201 E. Capitol St. SE, Washington, DC 20003
(202) 544-7077
http://www.folger.edu

1998 Exhibitions

Thru Jan. 31
The Housewife's Rich Cabinet: Remedies, Recipes, and Helpful Hints
Useful remedies devised by English women in the 16th and 17th centuries,
including recipes for snail water and
pomander bracelets.

Feb. 14-June 26
Mapping Early Modern Worlds

July 13-Oct.
Porcelains and Papers: Two Gift Collections

Nov. 1998-Mar. 1999
The Drawings of George Romney

Permanent Collection

A preeminent international center for
Shakespeare research; rich collection of
15th–18th-century printed books; prints
and engravings, manuscript materials,
maps, paintings, memorabilia.
Highlights: Copy of the 1623 First
Folio. **Architecture:** Modernized
neoclassical style building by Paul
Philippe Cret in 1932, with Art Deco

Martin Droeshout, William
Shakespeare's First Folio, 1623. Photo
by Juilie Ainsworth, courtesy Folger
Shakespeare Library.

aluminum grilles on windows and doors, and nine bas-reliefs depicting
Shakespeare scenes on the facade. Tudor interior reminiscent of an
Elizabethan college Great Hall; authentic Elizabethan theatre; elegant
Reading Room designed in 1982 by Hartman & Cox.

Admission: Free. Handicapped accessible; entrance ramp at rear driveway.
Hours: Mon.–Sat., 10–4; closed Sun., federal holidays.
Programs for Children: Children's Shakespeare School Festival,
Shakespeare's Birthday Open House (around Apr. 23), and workshops.
Tours: Mon.–Sat., 11, Tues., 10, 11. Groups call (202) 675-0365.
Museum Shop: Shakespeare, Etc. is open during museum hours.

Freer Gallery of Art

**Smithsonian Institution, Jefferson Dr. at 12th St. SW,
Washington, DC 20560
(202) 357-2700**

1998 Exhibitions

Continuing

Shades of Green and Blue: Chinese Celadon Ceramics
Illustrates the development of the family of glazes first developed in the
Shang dynasty (ca. 1600-1050 B.C.) and known in the West as celadon.

Art for Art's Sake
Examines the rise of Aestheticism, an English artistic movement commonly
defined as "art for art's sake." Works by Whistler, Tryon, and other late-
19th-century artists.

Thru Apr. 26

Japanese Arts of the Meiji Era (1868-1912)
Focuses on the Freer's holdings of paintings, drawings, ceramics, lacquer,
metalwork, and cloisonné from the Meiji period in Japan.

Jan. 31-Aug. 2

In the Mountains
This exhibition of paintings and objects from the second century B.C. to the
18th century explores the depiction of mountains—real and imaginary—in
the Chinese landscape tradition.

Opens May 1

Arts of the Islamic World
Sixty works celebrating the artistic legacy of the Islamic world, dating from
the 9th to the 19th century. Includes Koran pages, metalwork, ceramics,
glass vessels, manuscript paintings, and calligraphy.

June 6, 1998-Jan. 3, 1999

Japanese Art in the Age of Koetsu
Works produced in the flourishing cultural renaissance of early 17th-century
Kyoto, focusing on the art and objects of Hon'ami Koetsu (1558-1637).

June 20-Continuing indefinitely

Charles Lang Freer and Egypt
Explores Charles Lang Freer's eclectic collection of ancient Egyptian
artifacts, including faience, glass, stone and bronze, dating from the New
Kingdom to the Roman
period. Includes material
archiving Freer's travels.

Elephant-
shaped ritual
wine server,
Shang Dynasty,
China, c. 1200
B.C. Photo by
Jeff Crespi,
courtesy Freer
Gallery of Art.

Opens June 27

Masterpieces of Indian Art

Opens Aug. 29

Chinese Paintings

Opens Sept. 27

Anniversary Gifts
The centerpiece of the Freer Gallery of Art's 75th anniversary celebration,
featuring gifts and purchases made in honor of the anniversary. Catalogue.

Permanent Collection
World-renowned collection of Asian art, comprising Japanese, Chinese, Korean, South and Southeast Asian, and Near Eastern; 19th- and early 20th-century American art collection, including the world's most important collection of works by James McNeill Whistler. **Highlights:** Whistler interior: *Harmony in Blue and Gold: The Peacock Room;* Japanese screens; Korean ceramics; Chinese paintings; Indian bronze sculptures.
Architecture: 1923 building by renowned architect Charles Platt; 1993 renovation and expansion joining Sackler Gallery.

Admission: Free. Handicapped accessible.
Hours: Daily, 10–5:30. Closed Dec. 25.
Tours: Call (202) 357-4880, ext. 245, Mon.–Fri.

Hillwood Museum and Gardens
4155 Linnean Ave. NW, Washington, DC 20008
(202) 686-5807

NOTE: The museum will be closed for renovation until late 1999.

Permanent Collection
Former residence of heiress Marjorie Merriweather Post. Mansion, auxiliary buildings, and gardens on 25 acres in northwest Washington. Impressive collection of French and Russian objects from the 18th and 19th centuries; Native American objects. **Highlights:** Dinner plates commissioned by Catherine the Great; Fabergé eggs; Sèvres porcelain; a replica of a Russian dacha.

Hirshhorn Museum and Sculpture Garden
Smithsonian Institution, Independence Ave. at Seventh St. SW, Washington, DC 20560
(202) 357-2700

1998 Exhibitions
Thru Jan. 11
Stanley Spencer: An English Vision
Features paintings by this 20th-century British artist. (T)

Thru Feb. 22
Directions—Toba Khedoori
Features works by this Los Angeles-based American artist.

Feb. 19-May 17
George Segal
A selection of 20 monumental sculptures by this American artist known for his life-size figures placed in the banal environment of everyday life. (T)

June 4-Nov. 29
The Collection in Context: Henry Moore

June 18-Sept. 13
Triumph of the Spirit: Carlos Alfonzo, A Survey, 1976-1991
Includes large-scale paintings,
works on paper, and related
sculptures by the late Cuban-born
painter. (T)

July 16-Oct. 25
Directions—Tony Oursler

Oct. 15, 1998-Jan. 10, 1999
Chuck Close
Surveys the full spectrum of this
American artist's remarkable
career, including over 90
paintings, drawings, prints, and
photographs featuring his early
gray-scale works and later
colorful patchwork paintings. (T)

Nov. 19, 1998-Feb. 14, 1999
Directions—Julião Sarmento

Permanent Collection
Comprehensive holdings of
modern and contemporary

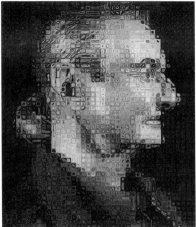

Chuck Close, *Roy II*, 1994. Photo by Lee Stalsworth,
courtesy Hirshhorn Museum and Sculpture Garden.

sculpture, painting, drawing; largest U.S. public collection of sculpture by
Moore; works by Hepworth, Calder, Maillol, Tucker in the sculpture garden;
19th- and 20th-century American and European paintings, works on paper;
contemporary art. **Highlights:** de Kooning, *Queen of Hearts*; Eakins, *Mrs.
Thomas Eakins*; Golub, *Four Black Men*; Kiefer, *The Book*; Matisse, *Four
Backs*; Moore, *King and Queen*; Rodin, *Monument to Balzac* and *Burghers
of Calais*; Smith, *Cubi IX*; Cragg, *Subcommittee*; Munoz, *Conversation
Piece;* Oldenburg, *7-UP;* Close, *Roy II;* Cornell, *Medici Princess*
Architecture: 1974 building by Gordon Bunshaft of Skidmore, Owings,
and Merrill; 1981 sculpture garden renovation by Lester Collins; 1992
sculpture plaza renovation by James Urban.

Admission: Free. Handicapped accessible; touch tours for the vision-
impaired available, call (202) 357-3235 for reservations.
Hours: Daily, 10–5:30; Sculpture Garden, 7:30–dusk. Closed Dec. 25.
Programs for Children: "Young at Art" Programs with hands-on art
workshops for children ages 6–9, offered monthly, Sat.; call for information
and reservations.
Tours: Mon.–Fri., 12; Sat–Sun., 12, 2. Tours of Sculpture Garden: Mon.–
Sat., 12:15 (May, October only). Foreign language tours available with one-
month advance reservation. Call (202) 357-3235 for information.
Food & Drink: Full Circle Café open on outdoor plaza overlooking
sculpture garden from Memorial Day thru Labor Day, daily, 11:30–3.
Museum Shop: Offers unusual contemporary jewelry, crafts, and an
extensive collection of art books; open during museum hours.

Library of Congress
Thomas Jefferson Building, 10 First St., SE, Washington, DC 20540
(202) 707-8000; (202) 707-6200 [TTY]
http://www.loc.gov

1998 Exhibitions
Ongoing
American Treasures of the Library of Congress
A rotating exhibition of the rarest and most significant items from the Library's collections relating to America's past.

Feb. 4-May 2
The African-American Odyssey: The Quest for Full Citizenship
Explores the African-American quest for full citizenship from slavery to the civil rights era, featuring books, pamphlets, prints, paintings, recordings, and films.

June 4-Aug. 22
Religion and the Founding of the Republic, 1607-1835
Over 200 works examine the role of religion in the formulation of the founding principles of the United States. Includes documents, correspondence, and artifacts.

Oct. 15, 1998-Jan. 17, 1999
Sigmund Freud: Conflict and Culture
Vintage photographs, prints, films, manuscript letters, and artifacts explore Freud's life, work, and the impact of psychoanalysis on 20th-century culture.

Permanent Collection
Repository of the nation's collection of books, including prints, manuscripts, and artifacts of American historical importance. Includes the Ralph Ellison Collection, the Woodrow Wilson Collection, and the Oliver Wendell Holmes Library. **Architecture:** 1873 Italian Renaissance-style building designed by Smithmeyer and Pelz, opened to the public in 1897. Renovation completed in 1997, managed by the Office of the Architect of the Capitol, with consultation by Arthur Cotton Moore & Associates.

Admission: Free. Handicapped accessible; call (202) 707-6362 to request sign interpretation.
Hours: Mon.–Sat., 10–5. Closed Sun., federal holidays.
Tours: Mon.–Sat., 11:30, 1, 2:30, 4. Groups call (202) 707-2630 for reservations.
Food & Drink: Cafeteria open Mon.–Fri., 12:30–2; Montpelier Buffet Dining Room (fixed price buffet) open Mon.–Fri., 11:30–2; coffee shop and snack bar located in the Madison Building. Picnic areas available in the outdoor plaza facing the U.S. Capitol.
Museum Shop: Unusual collection of cards and stationery; open Mon.–Sat., 9:30–5.

National Building Museum

401 F St. at Judiciary Square, NW, Washington, DC 20001
(202) 272-2448
http://www.nbm.org

1998 Exhibitions

Thru Jan. 4
*Main Street Five-and-Dimes: The Architectural Heritage of S.H. Kress &
Company*
Examines the role played by this chain of variety stores in defining the face
of Main Street America from New York to Hawaii.

Thru Jan. 11
*Lying Lightly on the Land: Building America's National Park Roads and
Parkways*
Traces the development of roads and parkways in America's national parks,
through artworks, historic photographs, vintage construction films, design
models, vehicles, and tourist memorabilia.

Thru Apr. 19
Tools as Art III: All Saws, The Hechinger Collection
Explores the myriad possibilities of art with the common household saw.

Thru May 11
Civic Lessons: Recent New York Public Architecture
Highlights 75 diverse projects initiated by 24 public agencies over the past
ten years, including the U.S. Court House at Foley Square.

Thru June 30
Planning Washington's Monumental Core: L'Enfant to Legacy
Explores the history of city planning in Washington from Charles
L'Enfant's visionary design in 1791 to the recently unveiled Legacy plan of
the National Capital Planning Commission.

Feb. 27, 1998-Jan. 9, 1999
Breaking Through: The Creative Engineer
A series of case studies examining the role and process of engineering as a
creative activity, in conjunction with National Engineers Week.

May 1, 1998-Feb. 5, 1999
Do It Yourself: Home Improvement in 20th-Century America
Explores the historical developments that have shaped Americans' home
improvement choices since 1900. Examines themes such as the role of
media, marketing, and gender stereotypes.

Permanent Collection

Photographs, documents, architectural plans and models, and artifacts
relating to the original design of Washington, D.C. **Architecture:** The old
Pension Building, an enormous red brick basilica-shaped structure, with the
largest Corinthian columns in the world inside, built in 1887 by
Montgomery C. Meigs; 1985 restoration by Keyes, Condon, Florance.
Unusual gift store featuring architecture and design items.

Admission: Free. Handicapped accessible.
Hours: Mon.–Sat., 10–4; Sun., 12–4; summer (June–Aug.): open until 5.
Tours: For group reservations, call (202) 272-2448, ext. 3300.
Food & Drink: Courtyard Café open during museum hours.
Museum Shop: One of the best, offering fascinating and beautiful designs focusing on architectural items, books, stationery, and desk supplies; open during museum hours.

National Gallery of Art

**Fourth St. at Constitution Ave., NW,
Washington, DC 20565
(202) 737-4215; (202) 842-6176 [TDD]
http://www.nga.gov**

1998 Exhibitions

Thru Jan. 11
Thomas Moran
First-ever retrospective of this 19th-century painter best known for his western landscapes. Includes the paintings *Grand Canyon of the Yellowstone*, *Chasm of the Colorado*, and *Mountain of the Holy Cross*. (T)

Thru Apr. 26
M.C. Escher: A Tribute
Examines the artist's contemporary *trompe l'oeil* masterpieces which have been highly popular since the 1960s.

Thru Mar. 1
Lorenzo Lotto: Rediscovered Master of the Renaissance
Features some 50 paintings by Lotto (c.1480-1556), whose formal and iconographic experiments set him apart from the mainstream culture of Renaissance art. Catalogue. (T)

Thru Apr. 19
Building the Collection
Recent acquisitions of works on paper, including drawings, prints, and photographs by such artists as Bellini, Guercino, Degas, and O'Keeffe.

Mar. 29-July 12
Alexander Calder, 1898-1976
Retrospective celebrating the centenary of the artist's birth, presenting over 200 works by one of the great formal innovators of the 20th century. (T)

Apr. 12-July 12
Degas at the Races
120 paintings, works on paper, and sculptures explore the Impressionist painter's life-long fascination with the theme of horses and racing, featuring his early masterpiece, *The Steeplechase: The Fallen Jockey*. Catalogue.

May 3-Aug. 16
Mark Rothko
This retrospective reveals the depth of Rothko's career, with an emphasis on his surrealist and classic periods. Includes 100 works on canvas and paper dating from the 1920s to 1970. Catalogue. (T)

June 7-Sept. 7

Artists and the Avant-Garde Theater in Paris

Explores the unique relationship between the visual and performing arts, including painters, writers, and patrons, that developed in Paris in the late-19th century.

June 14-Sept. 20

Manet and the Impressionists at the Gare Saint-Lazare

Examines the heroic symbol of the Saint-Lazare station and its influence on Impressionist artists in Baron Haussmann's late-19th-century Paris. (T)

Lorenzo Lotto, *Virgin and Child Enthroned with Saints Catherine, Augustine, John the Baptist, Sebastian, and Anthony Abbot,* 1521. Collection Santo Spirito, Bergamo. From *Lorenzo Lotto: Rediscovered Master of the Renaissance.* Photo courtesy National Gallery of Art.

Permanent Collection

A preeminent museum in the United States, focusing on European and American art from the 13th to 20th centuries in diverse media: paintings, sculpture, drawings, prints, decorative art, Kress collection of Renaissance and Baroque paintings, Netherlandish painting from the Golden Age, French Impressionist and Post-Impressionist paintings, outstanding 20th-century collection. **Highlights:** Calder, *Untitled* (mobile); Moore, *Knife Edge Mirror Two Piece;* Motherwell, *Reconciliation Elegy;* Rembrandt Peale, *Rubens Peale with a Geranium;* Picasso, *Family of Saltimbanques*; Pollock, *Number 1, 1950;* Raphael, *Alba Madonna* and *Saint George and the Dragon*; Rembrandt, *Self-Portrait*; Titian, *Venus with a Mirror*; the only painting by Leonardo in this country: *Ginevra de' Benci*; Whistler, *White Girl.* **Architecture:** Neo-Classical 1941 West Building, with a Rotunda fashioned after the Pantheon, by John Russell Pope; dynamic geometric granite and glass 1978 East Building by I.M. Pei.

Admission: Free. Handicapped accessible; wheelchairs available. Call (202) 842-6690, weekdays 9–5, for assistance with disabilities.

Hours: Mon.–Sat., 10–5; Sun., 11–6. Closed Jan. 1, Dec. 25.

Programs for Children: Family Programs; call (202) 789-3030.

Tours: Call (202) 737-4215 for information.

Food & Drink: Terrace Café open Mon.–Sat., 11:30–3; Sun., noon–4. Call (202) 789-3201 for reservations. Concourse Buffet open Mon.–Fri., 10–3; Sat., 10–3:30; Sun., 11–4. Garden Café open Mon.–Sat., 11:30–3, Sun., noon–6:30. Call (202) 789-3202 for reservations. Cascade Espresso Bar open Mon.–Sat., noon-4:30; Sun., noon–5:30.

Museum Shop: Two locations offer a large selection of books, stationery, posters, games, and books; open during museum hours.

National Museum of African Art

**Smithsonian Institution, 950 Independence Ave. SW,
Washington, DC 20560
(202) 357-4600
http://www.si.edu/**

1998 Exhibitions

Ongoing

Images of Power and Identity

*The Ancient West African City of
Benin, A.D. 1300-1897*

*The Ancient Nubian City of
Kerma, 2500-1500 B.C.*

The Art of Personal Object

Thru Jan. 4

*Gifts to the National Collection
of African Art*
Features museum acquisitions
from the past two years,
representing the finest examples
of Africa's visual traditions.

Olowe of Ise-Ekiti (d. 1938), *Bowl with
Figures.* Bequest of William A.
McCarty-Cooper. Photo courtesy
National Museum of African Art.

Thru Apr. 26

The Poetics of Line: Seven Artists of the Nsukka Group
Features the work of seven artists associated with the University of Nigeria,
Nsukka, who bridge the past and present by revealing a contemporary
artistic sensibility through a sensitive and selective use of tradition.

Feb. 1-Apr. 26

A Spiral of History: A Carved Tusk from the Loango Coast, Congo
Highlights a carved 19th-century tusk that reveals historical, ceremonial,
anecdotal, and daily events through a spiraled band of narrative scenes.

Mar. 15-Sept. 7

Olowe of Ise: A Yoruba Sculptor for Kings
More than 30 works explore the unique carving style of Olowe of Ise (c.
1873-1938), who received commissions from the Ekiti-Yoruba kings.

Aug. 16-Nov. 29

African Design and the Furniture of Pierre Legrain
Explores the influence of African chair forms on the work of French artist
Legrain (1889-1929) and the Art Deco style.

Opens Oct. 18

Modern African Art: Selections from the Collection
Rotating exhibition features modern works by contemporary artists from all
regions of Africa.

Dec. 20, 1998-Mar. 7, 1999

Toward a History of African Photography
Examines the breadth and depth of African photography, featuring works
dating from the 1920s to the present by as many as 50 artists.

Permanent Collection

Four permanent galleries serve as a comprehensive introduction to the numerous visual traditions of Africa: carved wood, ivory, modeled clay, forged- or cast-metal works, masks, jewelry, textiles, figures, and everyday household objects, mostly from the late 19th and 20th centuries.

Highlights: Extensive photography collection. **Architecture:** Part of a creative three-story underground museum complex by Jean-Paul Carlhian of Shepley, Bulfinch, Richardson, and Abbott, opened in 1987.

Admission: Free. Handicapped accessible.
Hours: Daily, 10–5:30. Closed Dec. 25.
Tours: Call (202) 357-4600, ext. 221 for tour information.

National Museum of American Art

Smithsonian Institution, 8th and G Sts. NW, Washington, DC 20560
(202) 357-2700
http://www.nmaa.si.edu

1998 Exhibitions

Thru Jan. 25
The Paintings of Charles Burchfield
Reexamines this famous watercolorist and his achievements in the context of the culture and artistic environment in which he worked.

Thru Mar. 8
Colonial Art from Puerto Rico: Selections from the Gift of Teodoro Vidal
A selection of 28 paintings, miniatures, and sculpture from this recent gift to the museum, including works by José Campeche and Felipe de Espada.

Charles Burchfield, *Orion in December.* Gift of S.C. Johnson and Son, Inc. Photo courtesy National Museum of American Art.

Thru Mar. 29
Ansel Adams: A Legacy
115 images from the end of Adams's career reflect the evolution of his art and his ideas, both as a photographer and an advocate of environmental issues. (T)

Thru Apr. 5
Sports in Art
A celebration of sports as seen by a variety of painters, sculptors, and photographers, including Claes Oldenburg, Paul Cadmus, and Man Ray.

Mar. 27-Aug. 9
Posters American Style
Surveys poster design in America from circus posters of the 1890s to psychedelic and propaganda images of the 1960s and 1970s. Includes works by Robert Rauschenberg and Ben Shahn. Catalogue.

May 22-Sept. 7

Stuart Davis
50 paintings by this American artist who combined a sophisticated understanding of French modernism with an intense interest in American popular culture. Catalogue. (T)

Sept. 25, 1998-Jan. 31, 1999

Eyeing America: Robert Cottingham Prints
Celebrates the career of this great American printmaker, featuring works from 1972 to the present.

Oct. 30, 1998-Mar. 7, 1999

Art of the Gold Rush
Explores the origins of California regional art. Includes 64 paintings, drawings, and watercolors created between 1849 and the mid-1870s. (T)

Silver and Gold: Cased Images of the California Gold Rush
Photographic documentation of the Gold Rush following the 1848 discovery of gold in California, featuring daguerrotypes and other "cased" images. (T)

Permanent Collection

More than 37,500 works comprise the nation's museum of American painting, sculpture, folk art, photography, and graphic art from the 18th century to the present. **Highlights:** Works by Cassatt, Ryder, Sargent, Brooks, Hopper, and Twachtman; contemporary works in the Lincoln Gallery, by artists such as Hockney, Motherwell, Frankenthaler, and Nevelson; stained glass windows by La Farge in the Gilded Age rooms; Catlin's Indian paintings; African-American art. **Architecture:** 1836 Old Patent Office by Robert Mills, completed in 1867 by Thomas Ustick Walter. Building also houses the Archives of American Art and the National Portrait Gallery.

Admission: Free. Handicapped accessible, entrance at 9th and G Sts.
Hours: Daily, 10–5:30. Closed Dec. 25.
Programs for Children: Frequent activities including Family Days and monthly "Saturday Art Stop" programs.
Tours: Call (202) 357-3111 for information.
Food & Drink: Patent Pending Café open daily, 10–3:30, overlooking lovely courtyard where summer visitors may enjoy lunch from the grill.
Museum Shop: Open during museum hours. (202) 357-1545.

Jose Campeche, *Isabel O'Daly*, 1808. Gift of Teodoro Vidal. From *Colonial Art from Puerto Rico*. Photo courtesy National Museum of American Art.

National Museum of Women in the Arts

1250 New York Ave. NW,
Washington, DC 20005
(202) 783-5000
http://www.nmwa.org

1998 Exhibitions

Thru Jan 11
American Indian Pottery: A Legacy of Generations
Examines the traditions of Native pottery, from matriarchs such as Lucy Lewis (Acoma) and Maria Martinez (San Ildefonso) to their descendants. Features 100 pieces by 28 Pueblo potters. (T)

Woven By the Grandmothers
Features 44 exquisite wearing blankets woven between 1825 and 1880, from the collection of the National Museum of the American Indian. (T)

Emma Lewis Mitchell, *Jar with lizard design,* 1996. Collection of the artist. From *American Indian Pottery: A Legacy of Generations.* Photo courtesy National Museum of Women in the Arts.

Thru Apr. 26
Preserving the Past, Securing the Future: Donations of Art, 1987-1997
Celebrates the museum's 10th anniversary through a reinstallation of the collection, highlighting acquisitions of works by artists such as Kauffman, Sirani, Vigée-LeBrun, Kahlo, and Nevelson.

Thru May 23
Artists on the Road: Travel as Source of Inspiration
Paintings, drawings, prints, sketchbooks, and rare illustrated volumes from the 17th century to the present capture the delights of holiday travel, scientific explorations, spiritual quests, and imaginary journeys.

Feb. 5-June 7
Lavinia Fontana
The first U.S. exhibition of work by this late-Italian Renaissance painter, including portraits and large-scale religious works. Catalogue.

Feb. 26-May 17
Captured Light: The Sculpture of Nancy du Pont Reynolds
Since the 1950s, this American artist has worked in acrylic Lucite to create delicately-carved landscapes and depictions of underwater life.

July 9-Sept. 27
Sarah Charlesworth
The first mid-career survey of this American artist's work, including over 60 large-scale photo-objects that address issues of media, gender politics, art history, mythology, and magic. (T)

Permanent Collection

Offers the single most important collection of art by women in the world. The permanent collection provides a survey of art from the 16th century to the present. **Highlights:** Eulabee Dix Miniature Gallery; Cassatt, *The Bath;* Kahlo, *Self Portrait;* works by Camille Claudel, Elisabeth Vigée-LeBrun, Rosa Bonheur, Georgia O'Keeffe and Helen Frankenthaler. **Architecture:** 1907 Renaissance Revival style building, once served as the Masonic Grand Lodge of the National Capital, by Waddy Wood; award-winning renovation/ restoration began in 1984 and was completed in 1987, by David Scott and Keyes, Condon, and Florance; 1997 Elisabeth A. Kasser Wing by RTKL.

Admission: Donation suggested: adults, $3; seniors, students, $2. Handicapped accessible; wheelchairs and large-print version of exhibition texts available.
Hours: Mon.–Sat., 10–5; Sun., noon–5. Closed major holidays.
Programs for Children: Family Days, workshops, and other programs offered throughout the year. Call (202) 783-7370 for information.
Tours: Docent-led tours offered. Call (202) 783-7370 for reservations.
Food & Drink: Mezzanine Café open Mon.–Sat., 11:30–2:30.
Museum Shop: Offers books and unique items created by women.

National Portrait Gallery

Smithsonian Institution, Eighth and F Sts. NW, Washington DC 20560
(202) 357-2700
http://www.npg.si.edu

1998 Exhibitions

Thru Jan. 4
Breaking Racial Barriers: African Americans in the Harmon Foundation Collection
Portraits of distinguished African Americans that were first presented in 1944 to combat racial inequity. Includes memorabilia from the historic 1944 exhibition.

Mathew Brady's Portraits: Images as History, Photography as Art
More than 100 images from the career of this key figure in American photography span the history of the medium in 19th-century America. (T)

Thru Jan. 25
Edith Wharton's World: Portraits of People and Places
Paintings, photographs, and literary memorabilia from the Gilded Age.

Thru Feb. 22
Recent Aquisitions
Works acquired for the permanent collection, including portraits in various media by artists such as Alice Neel and George Catlin.

Thru July 12
George C. Marshall: Soldier of Peace
Paintings, photographs and memorabilia document the life and career of this American general and statesman, in commemoration of the 50th anniversary of the Marshall Plan.

Mar. 20-Aug. 2
Faces of TIME
75 works commissioned from distinguished artists for the cover of *TIME*, in celebration of the magazine's 75th anniversary.

Apr. 10-Aug. 23
Celebrity Caricature in America
The witty portraiture that reflected a new urbanity and a concept of modern celebrity, which gained popularity in the mid-20th century.

Sept. 18-Nov. 29
Photographs by Philippe Halsman
Surveys the prolific career of this *LIFE* magazine photographer, from the 1920s through the 1960s. Catalogue.

Oct. 30, 1998-Feb. 7, 1999
Theodore Roosevelt: An American Presence
About 75 paintings, sculptures, photographs, and caricatures follow the life and career of this outdoorsman, writer, and 26th president of the U.S.

Hans Namuth: Photographs
A selection of photographs by this German-born artist, who established his reputation in the 1950s by his compelling images of Jackson Pollock.

Nov. 20, 1998-Dec. 19, 1999
The Presidential Portraits of George Washington, 1789-1797
Images of Washington made during his two terms of office, marking the 200th anniversary of the death of this first U.S. president.

Permanent Collection
Paintings, sculptures, prints, drawings, and photographs of Americans who contributed to the history and development of the United States. **Highlights:** Portrait sculptures by Davidson; Civil War gallery; one of the last photographs of Lincoln; the Hall of Presidents, including portraits of George Washington and Thomas Jefferson by Gilbert Stuart. **Architecture:** 1836 Old Patent Office by Mills, completed in 1867 by Thos. Ustick Walter.

Admission: Free. Handicapped accessible, wheelchairs available.
Hours: Daily, 10–5:30. Closed Dec. 25.
Tours: Mon.–Fri., 10–3; Sat.–Sun., holidays, 11–2.
Food & Drink: Café open Mon.–Fri., 10-3:30; Sat.–Sun., 11–3:30.

The Phillips Collection

1600 21st St. NW, Washington, DC 20009
(202) 387-2151

1998 Exhibitions

Thru Jan. 4
Arthur Dove: A Retrospective
Surveys the career of this 20th-century American Modernist, including over 80 paintings, assemblages, pastels, and charcoal drawings spanning the years 1909–1946. Catalogue. (T)

Jan. 24-Apr. 5
Consuelo Kanaga: An American Photographer
Retrospective of the career of this photojournalist (1894-1978), including over 100 gelatin silver prints featuring portraits of African Americans, urban and rural views, and still lifes. Catalogue. (T)

Alfred Sisley, *Snow at Louveciennes*, 1874. From *Impressionists in Winter: Effets de Neige.* Photo courtesy Phillips Collection.

May 9-Aug. 16
Richard Diebenkorn
Most comprehensive survey to date of this contemporary, late American artist's career, featuring over 150 paintings and works on paper, including his celebrated *Ocean Park* series, figurative works, and early abstractions. Catalogue. (T)

Sept. 19, 1998-Jan. 3, 1999
Impressionists in Winter: Effets de Neige
Examines the type of Impressionist winter landscape characterized by "the effects of snow." Includes 65 paintings by such artists as Monet, Pisarro, Sisley, Caillebotte, and Morisot.

Permanent Collection

Founded by Duncan Phillips, who sought to create "a museum of modern art and its sources"; late 19th- and early 20th-century European and American painting and sculpture, including Impressionist and Post-Impressionist masterpieces; works by Bonnard, Vuillard, Cézanne, Picasso, Matisse, van Gogh; American artists range from Inness and Homer to American Impressionists Prendergast and Twachtman and artists of the Stieglitz circle. **Highlights:** Renoir, *Luncheon of the Boating Party;* Bonnard, *The Palm*; Cézanne, *Self-Portrait*; Chardin, *Bowl of Plums, a Peach, and a Water Pitcher*; Delacroix, *Paganini*; El Greco, *The Repentant Peter*; Ingres, *The Small Bather;* Picasso, *The Blue Room;* collections of Klee and Rothko. **Architecture:** 1897 Renaissance Revival building and 1907 Music Room by

Hornblower and Marshall; 1920 and 1923 additions by McKim, Mead, and White; 1960 bridge and annex by Wyeth and King; 1980s expansion by Arthur Cotton Moore Associates.

Admission: Tues.–Fri.: donation suggested; Sat.–Sun: adults, $6.50; seniors, students, $3.25; children 18 and under, members, free. Artful Evenings on Thurs., 5–8:30, $5; members, free. Handicapped accessible.
Hours: Tues.–Sat., 10–5; Thurs., 10–8:30; Sun., 12–7. Closed Mon., Jan. 1, July 4, Thanksgiving, Dec. 25. Sunday summer hours may differ. Please call to confirm.
Programs for Children: Please call for information.
Tours: Tours can be specially designed. Reservations are requested at least one month in advance. Call (202) 387-2151, ext. 247.
Food & Drink: Café open Tues.–Sat., 10:45–4:30; Sun., 12–6. Sunday summer hours may differ. Please call to confirm. Closed Mon.
Museum Shop: Open during museum hours. (202) 387-2151, ext. 238.

Renwick Gallery
**National Museum of American Art, Smithsonian Institution,
Pennsylvania Ave. at 17th St. NW, Washington, DC 20560
(202) 357-2700
http://www.nmaa.si.edu/renwick/renwickhomepage.html**

1998 Exhibitions
Thru Jan. 4
Michael Lucero: Sculpture 1976-1994
Features 47 works by this ceramic sculptor who expands traditional Western ideas of art by integrating diverse non-Anglo cultures. Catalogue. (T)

Mar. 6-July 5
Inspiring Reform: Boston's Arts and Crafts Movement
Examines Boston's contribution to the Arts and Crafts movement and the city's shift from a literary to a visual culture.

Sept. 11, 1998-Jan. 10, 1999
Daniel Brush: Objects of Virtue
More than 60 objects showcase the creations of one of the foremost artists in metals working today. Catalogue.

The Stoneware of Charles Fergus Binns
60 stoneware vessels (dating from 1888 to 1943) and related memorabilia from the career of Binns, known for his initiation of the "Alfred pot."

Permanent Collection
Focus on 20th-century American crafts and decorative arts, including works by Albert Paley, Dale Chihuly, and Beatrice Wood.

Wendell Castle, *Ghost Clock*, 1985.
Photo courtesy Renwick Gallery.

83

Architecture: 1859 Second Empire-style building by James Renwick, Jr., designed originally to house William Wilson Corcoran's art collection; Octagon Room and Grand Salon restored and furnished in 1860s and 1870s style.

Admission: Free. Handicapped accessible.
Hours: Daily, 10–5:30. Closed Dec. 25.
Tours: Call (202) 357-2531.

Arthur M. Sackler Gallery

Smithsonian Institution, 1050 Independence Ave. SW, Washington, DC 20560
(202) 357-2700

1998 Exhibitions
Thru Mar. 8
Twelve Centuries of Japanese Art from the Imperial Collections
The first major overseas exhibition of rarely seen Japanese art from the Imperial Household Agency and the Emperor of Japan, featuring paintings and calligraphy from the 9th to early 20th century.

Mar. 8-July 7
Sakhi: Friend and Messenger in Rajput Love Paintings
Works created in northern India between the 17th and 19th centuries, portraying the theme of love and the role of the "sakhi" as confidant and messenger in Rajput society.

Sundara and Paravai, Tamil Nadu, 16th century. Gift of Arthur M. Sackler. Photo courtesy Arthur M. Sackler Gallery.

Apr. 26-Sept. 7
Ikat: Splendid Silks from Central Asia
Collection of 70 textiles produced using the ancient method of resist dyeing. 19th century ikats from Central Asia are unrivaled for their bold designs and vibrant colors. Catalogue. (T)

Nov. 22, 1998-Mar. 1999
The Mughals and the Jesuits
Paintings, books, and objects examining the blending of Eastern and
Western artistic styles that resulted from early Catholic missions in Asia
following Vasco de Gama's 1498 discovery of the sea route to the Indian
Ocean.

Permanent Collection
Asian art spanning cultures and centuries: ancient Chinese bronzes and
jades, contemporary Japanese ceramics, South Asian sculpture, ancient Near
Eastern metalware, Persian and Indian painting. **Highlights:** Sasanian
rhyton; Shang dynasty bells; Ming dynasty paintings; Chinese furniture;
Persian painting and calligraphy; ancient Near Eastern silver and gold.
Architecture: 1987 building, part of a three-story underground complex by
Jean-Paul Carlhian of Shepley, Bulfinch, Richardson and Abbott.

Admission: Free. Handicapped accessible.
Hours: Daily, 10–5:30. Closed Dec. 25.
Tours: Free. 11:30 and 12:30 daily. Groups call (202) 357-4880, ext. 245.
Food & Drink: Beverage cart available at public programs.
Museum Shop: Wonderful shop offers clothing and gift items related to
Asian art.

Linga covers, Maharashtra or Karnataka, 18th–19th century. On loan from the Collection of Paul F. Walter.
Photo courtesy Arthur M. Sackler Gallery.

Lowe Art Museum
1301 Stanford Dr., Coral Gables, FL 33124
(305) 284-3535
http://www.lowemuseum.org

1998 Exhibitions

Thru Jan. 18
Philippe Halsman: Portrait Photography from the Permanent Collection
Celebrities of the stage and screen from the 1940s to 1950s are captured by
this photographer to the stars.

Thru Jan. 25
Sagemono: Japanese Objects of Personal Adornment
A selection of netsuke, inro, pipe cases, and pouches from the museum's
permanent collection.

Thru Feb. 8
It's Only Rock 'n' Roll: Rock 'n' Roll Currents in Contemporary Art
Explores the influences of four decades of rock and roll music and culture
on contemporary art, featuring works by artists such as Warhol, Basquiat,
Mapplethorpe, and Rauschenberg. Catalogue. (T)

Thru Mar. 31
*History and Narrative, the Story Teller's Art: 18th–20th-Century
Paintings and Drawings from the Permanent Collection*
Features paintings and works on paper that reveal a variety of myths,
religious stories, and historical incidents.

Thru Dec. 28
The Art of the Miniature: Doll Houses from the Heller Collection
Features hand-made, miniature doll houses in celebration of the holiday
season.

Feb. 19-Apr. 5
New Russian Art: Paintings from the Christian Keesee Collection
Features 45 works produced in the late 1980s and early 1990s during the
disintegration of the Soviet Empire. (T)

Apr. 16-July 26
Containers of Beauty: Eighteenth-Century Flower Vessels
A selection of 55 floral containers created during the 18th century for both
utility and ornament. Also includes modern floral-inspired textile designs.

Apr. 4-Oct. 4
Art in Bloom: The Permanent Collection
A selection of paintings, works on paper, and decorative arts featuring
floral imagery. Rotating flower arrangements will also be on view.

June 11-July 26
Gods and Goddesses, Myths and Legends in Asian Art
Examines the development of myth, legend, and religion in South and East
Asia, featuring 145 works from India, Nepal, Tibet, China, and Japan.

Aug. 6-Sept. 6
Third Annual Florida Artists Series: Christine Federighi
Works by this artist and sculpture professor from the University of Miami.

Permanent Collection
Antiquities; Renaissance and Baroque works; modern and contemporary works by renowned American and European artists; Pre-Columbian, Asian, and African art. **Highlights**: Major non-Western collection, including some of the finest North American Indian textiles; Kress Collection of Italian Renaissance and Baroque art. **Architecture**: 1996 expansion/renovation by Charles Harrison Pawley.

Admission: Adults, $5; seniors, students, $3; under 12, free. Handicapped accessible.
Hours: Tues.–Sat., 10–5; Sun., 12–5.
Tours: Call (305) 284-3535 for information.

Museum of Art, Fort Lauderdale

One E. Las Olas Blvd., Fort Lauderdale, FL 33301
(954) 525-5500; 763-6464 (recording)

1998 Exhibitions
Thru Jan. 4
Breaking Barriers: Selections from the Museum of Art's Contemporary Cuban Collection
Examines the Cuban exodus, the influence of religion, the African connection, natural forces, and gender relations in work created by contemporary Cuban artists living in exile.

Jan. 16-Apr. 12
By Popular Demand: Karel Appel CoBrA's Wild Man
About 30 paintings dating from the late-1940s to the mid-1980s by this controversial post-World War II, Northern European Expressionist artist.

Jan. 17-Aug. 2
Duane Hanson: A Survey of His Works from the 1930s to the 1990s
Examines the work of this 20th-century American artist known for his life-size and life-like plastic figures of ordinary people. (T)

Jan. 31-Apr. 15
Chagall and the Bible: Paintings and Lithographs
Dreamlike works by Russian Jewish artist Marc Chagall (1887-1985).

Feb. 2-Apr. 30
Works by Lydia Rubio (In Honor of the Whitbread International Around-the-World Yachting Race)
Spotlights the work of this Cuban-born, magical realist painter, who captures the challenge and perils of the yachting race.

Apr. 18-Aug. 2
Works by María Brito
Paintings, sculptures, and installations by this artist who is part of the "Miami Generation" of Cuban-born American painters.

Apr. 25-Aug. 2
Tropical Terrain: South Florida Landscapes
Paintings by six contemporary artists, including John David Hawver and Mary Louise O'Sullivan.

Two Narratives: Paintings by Peter Olsen and Rebecca "Betty" Pinkney
Highlights works by these two local artists in the popular 1990s genre of narrative painting.

May 12-Oct. 15
Glackens: The Story Teller
Focuses on the exquisite draftsmanship in 20 illustrative drawings by this early 20th-century artist known as "America's Renoir."

July 17-Oct. 4
Selections from the Museum of Art's CoBrA Collection
Features a selection of CoBrA works, a term that signifies the origination of the group members: the cities Copenhagen, Brussels, and Amsterdam.

Permanent Collection
European and American art with emphasis on the 20th century including Picasso, Matisse, Calder, Moore, Dali, Warhol; impressive holdings of CoBrA art; largest U.S. repository of works by William Glackens; Oceanic, West African, Pre-Columbian, American Indian art; regional art. **Highlights:** Appel, *Personality*; Frankenthaler, *Nature Abhors a Vacuum;* Glackens, *Lenna in a Chinese Costume*, Warhol, *Mick Jagger*. **Architecture:** 1985 building by Edward Larrabee Barnes.

Admission: Adults, $6; seniors, $5; students with ID, $3; youth ages 5-18, $1; children under 5, members, free. Groups of 10 or more, $4 per person. Handicapped accessible; wheelchairs available.
Hours: Tues., Thurs., Sat., 10–5; Fri., 10–8; Sun., 12–5. Closed Mon., holidays.
Programs for Children: Offers art classes, family days, and other programs throughout the year; call for details.
Tours: Tues., 1–7; Thurs.–Fri., 1. Group reservations required.

The Jacksonville Museum of Contemporary Art

4160 Boulevard Center Dr., Jacksonville, FL 32207
(904) 398-8336

1998 Exhibitions

Thru Jan. 25
Neil Rashaba: Architectural Photography

Mark Massersmith: New Mythologies

Jan. 24-Mar. 8
Louise Freshman Brown

Feb. 3-Mar. 29
Kate Ritson

June 18-Aug. 16
A Collector's View: Photographs from the Sondra Gillman Collection

Aug. 11-Oct. 4
Ivy Bigbee

Sept. 12-Nov. 8
Sophie Tedeschi

Permanent Collection

Concentrates on the contemporary and visual arts. **Highlights:** Miro, *Metras*; Calder, *Dawn* and *Dusk*; Paschke, *Malibu*; Pomodoro, *Modello Per Disco*; Oldenburg, *Arch in the Form of a Screw for Times Square, NYC* and *Lipstick Ascending on Caterpillar.* Other featured artists include Longo, Gillam, Frankenthaler and Picasso. **Architecture:** 1966 building by Robert Broward and Taylor Hardwick.

Admission: Adults, $3; students and seniors, $2; children under 6 and members, free. Fees for special exhibitions. Handicapped accessible.
Hours: Tues., Wed., Fri., 10–4; Thurs., 10–10; Sat., Sun., 1–5; closed Mon. and holidays.
Tours: No walk-in tours. Call (904) 398-8336, ext. 18 for reservations and information.

Miami Art Museum of Dade County

101 West Flagler St., Miami, FL 33130
(305) 375-3000; 375-1700 (recording)

1998 Exhibitions

Thru Jan. 11
New Work: Carlos Capelán
Uruguay-born artist draws on his experience as an exile and addresses it in anthropological terms. Includes paintings, prints, and installations.

Thru mid-April
Dream Collection: Gifts and just a few Hidden Desires...part two
Latest gifts and acquisitions to the permanent collection are unveiled.

Thru Mar. 7
Triumph of the Spirit: Carlos Alfonzo, A Survey 1976-1991
Includes large-scale paintings, works on paper, and related sculptures by the late Cuban-born painter. (T)

Mar. 27-May 3
the body and the object: Ann Hamilton 1984-1996
Features site-specific installations and earlier video works by this internationally acclaimed artist who creates haunting environments using unexpected materials. (T)

Permanent Collection

International art with a focus on the art of the Western Hemisphere from the World War II era to the present.

Admission: Adults, $5; seniors, students, $2.50; children 6–12, free; Thurs. 5-9 p.m. free. Handicapped accessible; wheelchairs available.
Hours: Tues.–Fri., 10–5; Thurs., 10–9; Sat.–Sun., 12–5. Closed Mon.
Programs for Children: Second Saturdays are free for families; free interactive programs from 1–4 on second Sat. of each month.
Tours: Call (305) 375-4073 for information.

Bass Museum of Art

2121 Park Ave., Miami Beach, FL 33139
(305) 673-7530

1998 Exhibitions

Jan. 14-Mar. 8
The Zahm Collection of 20th Century Fashion Illustrations
Over 200 images offer an all-inclusive view of the fashion industry during the 20th century, reflecting both artistic and cultural trends.

Mar.-Apr.
Contemporary Fashion Photography: The Collector's Eye
Works from the museum's collection.

Mestre Didi
Powerful and emblematic sculptures by this artist who, as an Afro-Brazilian priest, draws inspiration from the sacred entities of his Yoruban ancestry.

May 27-Oct. 4
Steven Brooke: Views of Jerusalem and the Holy Land
100 platinum prints, made in recognition of the State of Israel's 50th anniversary, by this respected American architectural photographer.

Thru Dec. 28
Shaken, Not Stirred: Cocktail Shakers and Design
Over 70 objects evoke the glamour of the Art Deco age and trace the evolution of the cocktail shaker from the turn of the century through Prohibition and the Depression of the 1930s.

Permanent Collection
Features Old Master paintings, sculpture, textiles, ecclesiastical artifacts.
Highlights: Works by Rubens, Dürer, Bol, Hopper, Delacroix, Toulouse-Lautrec, van Haarlem. **Architecture:** 1930 Art Deco building by Russell Pancoast; 1964 addition by Robert Swartburg.

Admission: Adults, $5; seniors, students, $3; children under 6, members, free. Handicapped accessible, including ramps and elevators; sign language interpretors available.
Hours: Tues.–Sat., 10–5; Sun., 1–5. Second and fourth Wed. of the month, 1–9. Closed Mon. and holidays.
Programs for Children: Art classes; summer art camps; interactive concerts, lectures, and dance performances; family days. Call for details.
Tours: Call (305) 673-7530 for information and reservations.
Museum Shop: Open during museum hours.

Flagler Museum
One Whitehall Way, P.O. Box 969, Palm Beach, FL
(561) 655-2833
http://www.flagler.org

1998 Exhibitions
Jan. 16-May 1
A Society of Painters: Flagler's St. Augustine Art Colony
Explores turn-of-the-century works of art by such artists as Martin Johnson Heade, Frank Shapleigh, and Felix de Crano, who worked in Henry Flagler's art studio at the Ponce de Leon Hotel.

Henry M. Flagler Museum

Permanent Collection

Whitehall, the Gilded Age estate home of industrialist Henry Morrison Flagler, is now open to the public as the Flagler Museum. Henry Flagler, a founding partner of Standard Oil, linked the coast of Florida through his railroad holdings and many luxury hotels, and established tourism as a major industry in the state. Flagler's estate was completed in 1902, at which time it was hailed as "the Taj Mahal of America."

Admission: Adults, $7; children 6–12, $3. The first floor of the museum is wheelchair accessible.
Hours: Tues.–Sat., 10–5; Sun., 12–5.
Programs for Children: Organized school tours available.
Tours: Guided tours available. Group rates available with advanced reservation.
Museum Shop: Open during museum hours. Offers items related to America's Gilded Age and to Florida history.

The Society of the Four Arts
Four Arts Plaza, Palm Beach, FL 33480
(407) 655-7226

1998 Exhibitions
Jan.3-Jan. 30
Still Life: The Object in American Art 1915-1995, Selections from The Metropolitan Museum of Art
Highlights the vitality of the American still-life tradition during the 20th century, featuring 66 paintings by more than 50 artists. (T)

Jane Freilicher, *Bread and Bricks,* 1984. Collection Metropolitan Museum of Art. From *Still Life: The Object in American Art, 1915-1995.* Photo courtesy American Federation of Arts.

Feb. 14-March 11
A Taste for Splendor: Treasures from the Hillwood Museum
Features a selection of paintings and decorative arts from the legendary collection of Marjorie Merriweather Post. (T)

Mar. 21-Apr. 15
For the Imperial Court: Qing Porcelain from the Percival David Foundation of Chinese Art, London
A remarkable collection of porcelain from the Qing period (1644-1911), including 65 works that provide insight into the customs and preoccupations of the imperial court and the Qing elite. Catalogue. (T)

Permanent Collection

Features a new exhibition monthly during the winter–spring season; small permanent collection includes the monumental sculpture, *Intetra,* by Isamu Noguchi, *Maternidad,* by Carlos Castenada and *Reaching,* by Edward Fenno Hoffman, III. **Architecture:** 1929 building by Addison Mizner; 1974 renovation by John Volk.

Admission: Suggested donation: $3; gardens and libraries, free.
Hours: Until Apr. 24: Mon.–Sat., 10–5; Sun., 2–5.
Programs for Children: Children's library offers regularly scheduled story hours and special events. Call (561) 655-2776 for information.
Tours: Call for information and reservations.
Museum Shop: Reception desk offers exhibition catalogues, postcards, and note cards, Mon.–Sat., 10–5.

Museum of Fine Arts

255 Beach Dr. NE, St. Petersburg, FL 33701
(813) 896-2667

1998 Exhibitions

Thru Jan. 5
Miniature and Travelling Hanukiyyot
From the Julius and Ann Kaplan Collection.

Thru Jan. 25
Paintings by Robert Vickery

Selections from the Permanent Collection

Feb. 8-Mar. 22
Selections from the Norton and Nancy Dodge Collection of Nonconformist Art from the Soviet Union

Mar. 1-June 28
Treasures from the Petit Palais Museum of Modern Art, Geneva, Switzerland
First American exhibition of works from this museum, featuring stellar European Impressionist, Post-Impressionist, and modern works by over 60 artists including Degas, Toulouse-Lautrec, and De Chirico.

Maurice Utrillo, *Notre Dame,* 1917. From *Treasures of the Petit Palais Museum of Modern Art, Geneva, Switzerland.* Photo courtesy Museum of Fine Arts, St. Petersburg.

Giants of European Modernism
Includes work by artists such as Cézanne, Monet, Gauguin, and Picasso.

Permanent Collection

17th- to 20th-century European and American paintings, drawings, and sculpture; a distinguished collection of French Impressionist paintings; outdoor sculpture garden; 19th- and 20th-century photographs and prints;

decorative arts, including a gallery of Steuben glass and Jacobean and Georgian period rooms; African, Asian, Pre-Columbian, and Native American art; ancient Greek and Roman art. **Highlights:** Barye, *War* and *Peace*; Cézanne, *Oxen Hill at the Hermitage;* Monet, *Road to the Village of Vétheuil, Snow*; *Springtime in Giverny, Afternoon; Parliament, Effect of Fog*; Rodin, *Invocation*; Morisot, *Reading*; Gauguin, *Goose Girl, Brittany*; Renoir, *Woman Reading*; Thomas Moran, *Florida Landscape (Saint John's River)*; Henri, *Village Girl–Lily Cow*; O'Keeffe, *Poppy* and *White Abstraction (Madison Avenue)*. **Architecture:** Palladian-style building by John Volk, opened to public in 1965; 1989 expansion by Harvard, Jolly, Marcet, and Associates.

Admission: Adults, $6; seniors and groups of 10 or more, $4 each; students, $2; members, children under 6, Sun., free. Fully accessible to those with physical challenges. Wheelchairs, large-type self-guided and signed tours, and elevators available.
Programs for Children: Classes, workshops, tours, films, and summer camp; Eye to Eye program; docent classroom visits.
Hours: Tues.–Sat., 10–5; Sun., 1–5. Closed Mon., Thanksgiving, Dec. 25, Jan. 1.
Tours: Tues.–Fri., 10, 11, 1, 2; Sat., 11, 1; Sun., 1, 2. Call (813) 896-2667 for foreign language and signed tours.
Food & Drink: No café, but visitors may picnic in the Membership Garden. Parks are adjacent to the museum, as is the downtown Waterfront.
Museum Shop: Includes original jewelry, porcelain, and housewares.

The John and Mable Ringling Museum of Art

5401 Bay Shore Rd., Sarasota, FL 34243
(813) 359-5700
http://www.ringling.org

1998 Exhibitions
Ongoing
Alexander Series Tapestries
Three monumental tapestries on the theme of Alexander the Great.

Dutch Baroque Portraiture
Including works by Paulus Lesire, Isaak Luttichuys, Nicolaes Maes, Jan Mostaert and Pieter Nason.

Thru Jan. 18
Collection Highlights III: John Ringling Collects
Includes a selection of works acquired in 1928, including Cypriot antiquities and decorative arts from the Gavet, Vanderbilt, and Belmont Collection.

Mar. 2-Apr. 16
Hot Dry Men, Cold Wet Women
Examines theories of humors in
medical practices of the 17th century,
featuring paintings, sculptures, prints,
porcelains, and textiles. (T)

Museum of the Circus

Ongoing
John Ringling: Circus King
Circus Posters/French Gypsy Circus

Feb. 6-Sept.
Sarasota Winter Quarters:
Photographs by Loomis Dean

Nov. 27, 1998-Sept. 1999
The History of the Ringling Family
Circus

Permanent Collection
Outstanding collection of European
Renaissance, Baroque and Rococo

Rembrandt van Rijn, *Adam and Eve,* 1638. From
Hot Dry Men, Cold Wet Women. Photo courtesy
Museum of Fine Arts, Boston and American
Federation of Arts.

paintings; antiquities, decorative arts, tapestries, photographs, drawings,
prints; modern and contemporary art. Museum of the Circus features circus
costumes, wagons, props, complete scale model of a miniature circus;
circus-related fine art and memorabilia. Evolution of sculpture is traced
through full-size reproductions in the Italian Renaissance–style courtyard.
Highlights: Italian 16th- and 17th-century paintings; French, Dutch,
Flemish, Spanish Baroque works. **Architecture:** 1924–26 Venetian Gothic
Ringling residence, the Ca' d'Zan. 1927–29 Renaissance-style villa
museum; 1966 addition.

Admission: Adults, $8.50; seniors, $7.50; Florida teachers, students,
children 12 and under, free; group rates available. Handicapped accessible.
Hours: Daily, 10–5:30. Closed Jan. 1, Thanksgiving, Dec. 25.
Tours: Call (813) 359-5700 for information.

Norton Museum of Art

1451 S. Olive Ave., West Palm Beach, FL 33401
(561) 832-5196
http://www.norton.org

1998 Exhibitions
Thru Jan. 11
Hospice: A Photographic Inquiry
Five contemporary photographers deal with issues of death, dying, and grief
in their examination of the Hospice movement. (T)

Thru Jan. 25
Dick and Jane
Original drawings
from the beloved
children's books,
dating from the 1920s
to the 1960s.

Thru Feb. 8
*George Bellows: Love
of Winter*
Interpretations of
winter created between
1908 and 1915 by this
important 20th-century
artist from Columbus,
OH. Catalogue. (T)

George Bellows, *Winter Afternoon,* 1909. Collection
Norton Museum of Art.

*Blanketed in Snow:
American Winter Scenes*
Selection of paintings, works on paper, and photographs by noted late-19th-
century American artists that offer varied impressions of the winter season.

Jan. 31-Mar. 15
Vows!
Features the wedding photography of artist Edward Keating, whose work is
frequently found in the Sunday edition of the *New York Times.*

Feb. 7-Apr. 26
Dale Chihuly: Installations, 1964-1996
Features examples from various series by this noted glass sculptor,
including the Indian Blanket series and his round glass "floats."

Feb. 14-Mar. 29
Kinships: Alice Neel Looks at the Family
Highlights the work of this acclaimed American portrait painter, whose
realist works have been admired by Warhol and Pearlstein. (T)

Mar. 21-June 21
M.C. Escher
Examines the artist's contemporary *trompe l'oeil* masterpieces which have
been highly popular since the 1960s.

Apr. 4-May 17
Favorites
A selection of works chosen by local members of the community as their
favorites, with accompanying explanations.

May 23-Oct. 25
Dynasties: Selections from the Norton Museum Chinese Collection
Expanded installation of the museum's holdings, featuring jades, bronzes,
ceramics, and Buddhist sculpture from 2,000 B.C. to the 19th century.

June 27-Dec. 13
Platemarks
A representative selection of prints from the 16th century to the present,
illustrating various techniques, tools, and materials.

Sept. 5-Oct. 25
Seeing the Unseen: Dr. Harold E. Edgerton and the Wonders of Strobe Alley
Works by this pioneer of stroboscopic stop-action photography, including images of a bullet cutting a card and a drop of milk hitting a cup's surface.

Nov. 7, 1998-Jan. 10, 1999
Alphonse Mucha: The Flowering of Art Nouveau
Major exhibition includes 180 posters, decorative panels, illustrations, and paintings by Art Nouveau artist Alphonse Mucha (1860-1939). (T)

Permanent Collection
Over 4,000 works of art, including French Impressionist and Post-Impressionist paintings by Cézanne, Matisse, Monet, and Renoir; American art from 1900 to the present, featuring works by Davis, Hopper, Marin, Motherwell; Chinese archaic bronzes, jades, ceramics, and Buddhist sculpture. **Highlights:** Gauguin, *Agony in the Garden;* Braque, *Still Life with a Red Tablecloth;* Bellows, *Winter Afternoon;* Pollock, *Night Mist.* **Architecture:** 77,500 sq. ft. expansion, completed in Jan. 1997, includes galleries, an Education wing, three gardens, and a café.

Admission: Requested donation: adults $5, students ages 14–21, $3; children under 13, free. Additional charges for special exhibitions. Handicapped accessible.
Hours: Tues.–Sat., 10–5; Sun., 1–5. Closed Mon., major holidays.
Programs for Children: Offered every Sun.; call (561) 832-5196.
Tours: Call (561) 832-5196 for information and reservations.
Food & Drink: Taste By the Breakers Café open seasonally, Mon.–Sun.; call (561) 832-5196 for dates and hours.
Museum Shop: Open during museum hours.

Michael C. Carlos Museum

Emory University
571 South Kilgo Street, Atlanta, GA 30322
(404) 727-4282
http://www.cc.emory.edu/CARLOS/

1998 Exhibitions
Thru Oct.
Tears of the Moon: Ancient American Precious Metals from the Permanent Collection
Focuses on metallurgical techniques and art in ancient and colonial Peru. Includes ceremonial knives, cups, earspools, and other items of daily life.

Jan. 24-Apr. 1
Sepphoris in Galilee: Crosscurrents of Culture

May-Oct.
Buddha's Art of Healing

Permanent Collection
Houses 16,000 objects, including art from Egypt, Greece, Rome, the Near East, the Americas, Asia, Africa, and Oceania; European and American prints and drawings from the Middle Ages to the 20th-century.
Architecture: 1919 Georgian marble facade building, with traditional clay tile roof, located on the historic quadrangle of the university campus; renovation and major expansion by Michael Graves completed in 1993.

Admission: Suggested donation: $3. Handicapped accessible, including parking, elevators, and braille signage.
Hours: Mon.–Sat., 10–5; Sun., noon–5. Closed major holidays.
Programs for Children: Programs and workshops throughout the year. Call (404) 727-4282 for information.
Food & Drink: Caffè Antico open Mon.–Fri., 8:30–4:30; Sat., 10:30–4:30; Sun., noon–5.
Museum Shop: Offers books, cards, and gifts. (404) 727-0516.

Georgia Museum of Art
University of Georgia, Athens, GA 30602
(706) 542-GMOA or 4662; (706) 542-1007 [TDD]

1998 Exhibitions
Thru Jan. 18
British Watercolors from the West Collection
Watercolors from the 19th century, with subjects ranging from seascapes and rural landscapes to scenes of industrial society.

Jacques Bellange: 17th-Century Printmaker of Lorraine
Consists of 44 prints by this great 17th-century printmaker who worked in the Duchy of Lorraine during the late Mannerist period. Catalogue. (T)

Thru Feb. 1
Intimate Expressions: Two Centuries of American Drawings
Works on paper by American artists including Benjamin West and John Singleton Copley. Catalogue.

Thru Feb. 7
Steuben Glass from the McConnell Collection
Art-nouveau glass produced by the Steuben Glass Works, which was founded in 1903. Includes examples of Aurenne and double-etched wares.

Jan. 24-Mar. 21
The Prints of Stuart Davis
Includes 24 prints by this champion of American abstract art.

Feb. 21-Apr. 25
From Desert to Oasis: Arts of the People of Central Asia
Over 130 objects from Central Asia, including furniture, jewelry, textiles, rugs, and vessels. Catalogue.

May-June 1998
The Sculptures of Larry Mohr
A variety of geometric and figural sculptures by Mohr, designed for pure
visual response and pleasure, requiring no associations or symbols.

June 27-Aug. 30
After the Photo-Secession: American Pictorial Photography, 1910-1955
Depicts the revival of pictorial photography and its use as a tool for personal
expression in the dawning Machine Age. (T)

July-Sept. 6
The Loves of Isadora
Objects and documents relating to the life and career of dancer Isadora
Duncan. Includes letters,
drawings, photographs, and
personal objects.

Sept. 12, 1998-Jan. 3, 1999
*Art Glass and Pottery from the
McConnell Collection*

Nov. 7, 1998-Jan. 10, 1999
*Rembrandt: Treasures from the
Rembrandt House, Amsterdam*

Permanent Collection
Over 7,000 works, featuring
19th- and 20th-century
American paintings and
American and European prints
and drawings dating from the
16th century to the present.
Also includes Japanese prints,
the Samuel H. Kress Study
Collection of Italian
Renaissance Paintings, and
British watercolors and
Neoclassical sculptures on

Randolph Rogers, *Nydia, the Blind Flower Girl of
Pompeii,* c. 1867-1891. On loan from the West Foundation
Collection. Photo courtesy Georgia Museum of Art.

long-term loan from the West Foundation. **Architecture:** The new museum
building, which opened in 1996 as part of the Performing and Visual Arts
Complex of the East Campus of the University of Georgia, was designed by
Thompson Ventulett Stainback & Associates.

Admission: Suggested donation: $1. Handicapped accessible, including
ramps, elevators, braille signage, and wheelchairs.
Hours: Mon.–Thurs., Sat., 9–5; Fri., 9–9; Sun., 1–5.
Programs for Children: Guided tours, monthly Family Day programs, and
occasional films and special events.
Tours: Reservations can be made for group tours. Call (706) 542-4662.
Food & Drink: The On Display Café, open Mon.–Fri., 10–2; closed most
state and federal holidays.
Museum Shop: Open Tues.–Sat., 11–4; Sun., 1–4.

High Museum of Art

1280 Peachtree St. N.E., Atlanta, GA 30309
(404) 733-HIGH or 4444
http://www.high.org

1998 Exhibitions

Thru Feb 15
Pablo Picasso: Masterworks from the Museum of Modern Art
Approximately 125 works of painting, sculpture, drawings, and prints give
an overview of the 20th-century master's career. (T)

Mar. 24-June 13
*Walker Evans Simple Secrets: Photographs from the Collection of Marian
and Benjamin A. Hill*
Approximately 90 vintage prints reveal the complexity of this major
American photographer. Includes early abstractions and urban scenes.

Mar. 24-June 14
Henri de Toulouse-Lautrec: Poster and Prints from the Stein Collection
Fin-de-siècle images of dancers and cabaret performers by one of the
greatest early modern printmakers. Catalogue.

Art at the Edge: Gaylen Gerber
Issues of perception and aesthetic value by this Chicago-based artist best
known for monochromatic canvases that challenge the viewer to take a
closer look.

July 14-Sept. 20
Out of Bounds: American Self-Taught Artists of the Twentieth Century
Over 200 works by 32 artists who, despite a lack of formal training for a
variety of reasons, have developed a distinct artistic vocabulary.

Oct. 20, 1998-Jan. 17, 1999
Monet and Bazille: Early Impressionism and Collaboration
Examines the brief but momentous relationship of these two 19th-century
artists, who shared a Paris studio and struggled to develop the new style of
painting that later became known as Impressionism. Catalogue.

Permanent Collection

European painting and sculpture from the Renaissance to the 20th century;
sub-Saharan African art; American and European prints, photographs,
decorative arts; American 18th- to 20th-century paintings and sculptures.
Highlights: Lichtenstein, *Sandwich and Soda;* Peale, *Senator William H.
Crawford of Georgia;* Prendergast, *Procession, Venice;* Rauschenberg,
Overcast III; Stella, *Manteneia I;* Whittredge, *Landscape in the Harz
Mountains.* **Architecture:** Award-winning 1983 building by Richard Meier.

Admission: Adults, $6; seniors, students with ID, $4; children 6–17, $2;
children under 6, members, free. Thurs., 1–5, free. Handicapped accessible.
Hours: Tues.–Sat., 10–5; Sun., 12–5; fourth Fri. of every month, 10–9.
Closed Mon., holidays.

Tours: Call (404) 733-4444 for information.
Food & Drink: High Café with Alon's open Mon., 8:30–3; Tues.–Fri., 8:30–5; Sat.–Sun., 10–5.

High Museum of Art Folk Art and Photography Galleries
30 John Wesley Dobbs Ave., N.E., Atlanta, GA 30303
(404) 577-6950

1998 Exhibitions

Thru Feb. 14
Carl Chiarenza
Recent one-of-a-kind prints by one of America's most challenging abstract photographers.

Thru Mar. 7
Henry Darger: The Unreality of Being
58 drawings from the fantastic 12-volume illustrated manuscript that was Darger's life's work, unknown and unsuspected until after his death in 1972.

Feb. 21-June 13
The Flag in American Indian Art
Works from the late 19th to early 20th century illustrate how the Lakota, Navajo, Kiowa, and other Native artists recast the traditional patriotic symbol to express their own heritage. (T)

Mar. 21-June 13
American Photographs: The First Century
Examines the variety and influence of photographic media since the mid-19th century, ranging from daguerrotypes to silver and platinum prints.

June 27-Sept. 19
Roy DeCarava: A Retrospective
Surveys 200 works spanning half a century by one of the major figures in post-war American photography. Includes themes of social awareness, humanity, and jazz. (T)

Architecture: 1986 building by Parker and Scogin Architects, Inc.
Admission: Free.
Hours: Mon.–Sat., 10–5.

Roy DeCarava, *Boy Selling Balloons,* 1953. From *Roy DeCarava: A Retrospective.* Photo courtesy San Francisco Museum of Modern Art.

The Contemporary Museum

2411 Makiki Heights Drive
Honolulu, HI 96822
(808) 526-1322
http://www.fhb.com/fhc/gallery.html

1998 Exhibitions

Thru Feb. 1
Crimes and Splendors: The Desert Cantos of Richard Misrach
Retrospective of this San Francisco photographer's ongoing epic series, which examines civilization's relationship to its environment. (T)

Feb. 11-Apr. 19
Dominic DiMare: A Retrospective

101 Visions: Photographs from the Charles Cowles Collection

Apr. 29-July 12
Ray Yoshida

July 22-Sept. 28
Satoru Abe: A Retrospective

Permanent Collection
Includes over 1200 works in all media by local, national, and international artists

Judy Fox, *Courtesan.* Photo courtesy Contemporary Museum, Honolulu.

from approximately 1940-present. In addition to recently acquired works by Edward Kienholz and Nancy Reddin Kienholz, Andy Warhol, Robert Motherwell, and Dennis Oppenheim, the collection includes artists such as Robert Graham, Mark Tobey, Louise Nevelson, Jim Dine, Jasper Johns and Deborah Butterfield. **Highlights:** Permanent installation by David Hockney based on the set from 1925 Ravel opera *L'Enfant et les Sortileges;* Viola Frey's *Two Women and a World.* **Architecture:** Located on the Spalding Estate, a 3.5 acre sight formerly home to Alice Cooke Spalding. Built in the 1920s, building has been expanded and renovated many times, most recently by the CJS Group in 1988. A new space, the Milton Cades Pavillion, was created to house the Hockney installation.

Admission: Adults, $5; students, seniors, $3; children 12 and under, free; designated handicapped parking; upper gallery access with view of lower galleries; handicapped restrooms and accessibility to cafe and shop.
Hours: Tues.–Sat., 10–4; Sun., 12–4.
Programs for Children: Guided tours; "Expression Session" art workshops; "Art off the Wall" performance-art based on museum's exhibitions.
Tours: Tues.–Sun., 1:30.
Food & Drink: Contemporary Café open Tues.–Sat., 11–3; Sun., 12–4.
Museum Shop: Unusual and exclusive items; open during museum hours.

Honolulu Academy of Arts

900 S. Beretania St., Honolulu, HI 96813
(808) 532-8700; 532-8701 (recording)

1998 Exhibitions

Thru Jan 4
Electronic Super Highway: Nam June Paik in the 90s
Traces the development of this internationally acclaimed, Korean-born
video artist's career from the 1960s to the 1990s.

Thru Jan. 11
Keoni of Hawaii: Aloha Shirt Designs, 1938-1951
Examines the work of the popular Honolulu-based shirt designer, John
Meigs, featuring vintage shirts, original paintings, and fabric swatches.

Thru Jan. 21
Hiroshige's Tokaido: Steps on a Modern Pilgrimage
Rotating exhibition showcases 19th-century Japanese artist Ando
Hiroshige's *53 Stations of the Tokaido* print series.

Thru Jan.
Pentagon: Group Exhibition with Alan Leitner, Timothy Ojile

Jan. 9-Feb. 7
Byoung Yong Lee: Recent Paintings
Large scale, abstract paintings by this Hilo-based Korean artist represent
both Asian and Western approaches to simple themes in a minimalist style.

Jan. 15-Mar. 15
Robert Squeri & Hawaii Printmaking of the 1960s and 1970s
Showcases renowned Hawaii printmakers of this 20-year period, including
ten years of prints by Squeri.

Feb. 4-May 3
Views of the Pearl River Delta: Macao, Canton, and Hong Kong
Examines representational art inspired by cultural interactions during
Western trade with China in the 18th and early 19th centuries.

Adornment for Eternity: Status and Rank in Chinese Ornament
Examines Chinese metal arts, with over 100 objects of gold, silver, bronze,
and jade dating from the Shang period to the Meng dynasty.

Feb. 18-May 4
Art and Life in Colonial America

Mar. 26-May 24
*English Silver: Masterpieces by Omar Ramsden from the Campbell
Collection*
Showcases one of world's finest collections of English silver.

Mar.-Apr.
Group Exhibition with George Wollard, Jinja Kim, and Others

May 7-10
Hawaiian Hospitality: Garden Club of Honolulu Exhibition

June 3-Aug. 2
All That Glitters: Award-Winning Designs from Hawaii Jewelers Association

July 29-Sept. 13
Imari: Japanese Porcelain for European Palaces
Over 100 examples of 18th- and early-19th-century porcelain, copied in Europe from designs used in Japanese royal palaces. (T)

July 30-Sept. 13
Lithographs from the Academy's Collection

Aug. 6, 1998-Jan. 17, 1999
Hawaii and its People
Pictorial heritage of Hawaii includes examples of "documentary" art created during the late-18th and 19th centuries by voyaging artists.

Sept. 24, 1998-Jan. 17, 1999
Art of the Goldsmith: Masterworks from Buccellati
Over 50 works, including 14 masterworks, that illustrate the art of jewelry making and small-scale sculpture.

Sept. 23-Nov. 1
Southwest Weaving
One of three national exhibitions in the series "The Vision Persists: Native Folk Art of the West." Includes over 90 examples of Pueblo, Navajo, and New Mexico hand-woven textiles. Catalogue.

October
International Lithography Exhibition

November
Chen Ke Zhan: Contemporary Chinese Paintings

Permanent Collection

Hawaii's only general art museum; objects from cultures around the world and throughout history. Asian art, including James A. Michener collection of Japanese woodblock prints; Kress collection of Renaissance and Baroque paintings; American paintings and decorative arts from the Colonial period to the present day; works from Africa, Oceania, the Americas; contemporary graphic arts. **Highlights:** Delaunay, *The Rainbow*; van Gogh, *Wheatfields*; Ma Fen, *The Hundred Geese*; Monet, *Water Lilies*; Chinese and Persian bronzes; six garden courts. **Architecture:** 1927 building by Bertram Goodhue.

Admission: Adults, $5; seniors, students, military, $3; children under 12, free. Handicapped accessible.
Hours: Tues.–Sat., 10–4:30; Sun., 1–5. Closed Mon., holidays.
Tours: Tues.–Sat., 11; Sun., 1. For special tours, call 532-8726.
Food & Drink: Garden Café open Tues.–Sat.

The Art Institute of Chicago

111 South Michigan Ave. at Adams St., Chicago, IL 60603
(312) 443-3600; 443-3500 (recording)
http://www.artic.edu/aic/

1998 Exhibitions

Thru Jan. 4
Renoir's Portraits: Impressions of an Age
Selection of portraits by the French Impressionist, including some of the artist's best-known and most-loved figure paintings. Catalogue. (T)

Thru Feb. 1
Irving Penn, A Career in Photography
Over 150 prints highlight every stage of this artist's career, including his trend-setting fashion photography and portraits of women. Catalogue.

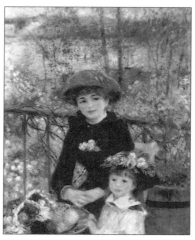

Pierre Auguste Renoir, *Two Sisters*, 1881. From *Renior's Portraits, Impressions of an Age.* Photo courtesy Art Institute of Chicago.

Feb. 14-May 10
Baule: African Art/Western Eyes
Presents 125 works by Baule artists of the Ivory Coast in West Africa, featuring naturalistic wooden sculptures, masks, figures, and other objects in ivory, bronze, and gold.

Mar. 7-May 25
Italian Baroque Sculpture: Terracotta from the Collection of The State Hermitage Museum
Features rarely seen works by Bernini, Algardi, and other 17th-century Italian sculptors purchased by the Czar of Russia in 1800.

May 16-Aug. 1
Songs on Stone: The Lithographs of James McNeill Whistler
Explores the interrelationship of Whistler's lithographic images and his work in other media. Features 200 prints, including nocturnes, figurative works, and portraits. Catalogue.

Sept. 12-Dec. 6
Art and Archaeology of Ancient West Mexico
Examines the complex Mesoamerican societies that developed in West Mexico between 200 B.C. and 800 A.D., including new excavational findings and terracotta tomb sculptures. Catalogue.

Sept. 19, 1998-Jan. 3, 1999
Julia Margaret Cameron's Women
Explores the emotional content of this innovative 19th-century British
photographer's portraits of women. Includes portraits of Julia Jackson and
Alice Liddell. Catalogue.

Oct. 13, 1998-Jan. 10, 1999
Mary Cassatt: Modern Woman
Features 125 paintings, pastels, drawings, and prints by this innovative and
important American Impressionist artist, patron, and collector.

Permanent Collection

One of the major museums in the U.S., spanning 40 centuries of art. Chinese
bronzes, ceramics, jades; Japanese prints; works from Africa and Oceania;
ancient Meso-American and Peruvian ceramics and figurative art; Harding
collection of arms and armor; acclaimed Impressionist collection; American
and European fine and decorative arts; major collection of 20th-century art.
Highlights: Impressionist and Post-Impressionist collection, including
Caillebotte, *Paris Street; Rainy Day*; Cassatt, *The Bath*; Goya, *The Capture of
Maragato by Fray Pedro*; El Greco, *Assumption of the Virgin;* Monet, *On the
Bank of the Seine, Bennecourt*; large group of Picassos; Seurat, *A Sunday on
La Grand Jatte–1884;* Wood, *American Gothic;* six extraordinary panels from
a large early Renaissance altarpiece by Giovanni di Paolo depicting the life of
Saint John the Baptist; reconstructed Chicago Stock Exchange Trading Room
designed by Adler and Sullivan. **Architecture:** 1894 Beaux Arts building by
Shepley, Rutan, and Coolidge; 1986 renovation by Skidmore, Owings, and
Merrill; 1988 South Building by Hammond, Beeby, and Babka; 1991 Modern
Art renovation by Barnett and Smith, Architects, and the Office of John Vinci;
1992 Chinese, Japanese, and Korean Gallery renovation by Cleo Nichols
Design, with Japanese Screens Gallery by Tadao Ando; 1994 opening of
Galleries of Ancient Art: Egyptian, Greek, Etruscan, Roman, designed by
architect John Vinci.

Admission: Suggested donation: adults, $7; seniors, students with ID, children,
$3.50. Tues., free. Handicapped accessible, including ramps and elevators; use
Columbus Drive entrance.
Hours: Mon., Wed.–Fri., 10:30–4:30; Tues., 10:30–8; Sat., 10–5; Sun.,
holidays, 12–5. Closed Thanksgiving, Dec. 25.
Programs for Children: Family programs and exhibitions in the Kraft
Education Center, throughout the year; call for details.
Tours: Call (312) 443-3933.
Food & Drink: Court Cafeteria open Mon.–Sat., 10:30–4; Tues., 10:30–7;
Sun., 12–4. Restaurant on the Park open Mon.–Sat., 11–2:30.

Museum of Contemporary Art

220 E. Chicago Ave., Chicago, IL 60611
(312) 280-2660; 280-5161 (recording)
http://www.mcchicago.org

1998 Exhibitions

Thru Jan. 4
Toshio Shibata
First solo U.S. museum exhibition
by this Tokyo-based photographer
known for his large-format prints
of landscapes, featuring 25 black &
white images.

Thru Jan. 25
*Hall of Mirrors: Art and Film
Since 1945*
Explores the dynamic and profound
relationship between cinema and
the visual arts in the postwar
period, featuring 170 objects, films,
and film excerpts.

Francis Bacon, *Study for a Portrait,* 1949. Photo courtesy Museum of Contemporary Art, Chicago.

Thru Feb. 1
Jasper Johns, In Memory of My
Feelings—Frank O'Hara
Examines how Johns was inspired by O'Hara's poetry and friendship in the
creation of this 1961 painting, recently acquired by the museum.

Thru Apr. 5
Envisioning the Contemporary: Selections from the Permanent Collection
Approximately 125 works tracing historical developments in art-making
from 1945 to the present including works by Leon Golub, Mike Kelley, and
Cindy Sherman, as well as 15 sculptures by Alexander Calder.

Jan. 17-Mar. 29
Joe Scanlan
New York-based sculptor's hand-crafted objects are functional domestic
items with a twist, including nesting bookshelves, biodegradable flower
pots, and extended-wear underwear.

Feb. 14-May 24
California Scheming
Features artworks by California artists of the last two generations who are
inspired by West Coast popular culture and the artificiality of Hollywood.

Feb. 28-June 7
Cindy Sherman: Retrospective
Mid-career survey of the work of this significant 20th-century American
photographer. Includes selections from each of her key series, such as
Untitled Film Stills, Centerfolds, Fashion, and Fairy Tales. (T)

Apr. 11-July 5
Abigail Lane
Works by this young British artist explore themes of bodily traces and surveillance, including installations and sculpture using wax casts, recorded sound works, and wallpaper projects.

June 20-Sept. 13
Chuck Close
Surveys the full spectrum of this American artist's remarkable career, including over 90 paintings, drawings, prints, and photographs featuring his early gray-scale works and later colorful patchwork paintings.
Catalogue. (T)

Oct. 1998-Jan. 1999
Robert Heinecken
Examines the manipulated photographic images, dating from the 1960s to the present, by this artist who has been called an "image scavenger."

Jana Sterbak
Mid-career survey of this Canada-based Czech artist best known for a dress made of flank steak that evokes themes of 17th-century *vanitas* paintings. Includes sculptures, installations, photographs, and videos.

Nov. 1998-Jan. 1999
Artist/Author: The Book as Art Since 1980
Surveys contemporary artists' book production, including fanzines, assemblies, visual poetry, sketchbooks, illustrated books, and collaborations with the commercial world. (T)

Permanent Collection
Twentieth-century works in all media, including photographs, films, videotapes, audio pieces by Abahakowicz, Christo, Dubuffet, Duchamp, Holzer, Oldenburg, Rauschenberg, Segal. **Highlights:** Bacon, *Man in Blue Box*; Magritte, *The Wonders of Nature;* Calder sculptures and mobiles, conceptual and minimal works. **Architecture:** Newly opened building and sculpture garden, designed by Josef Paul Kleihues.

Admission: Adults, $6.50; seniors, students, $4; children 12 and under, members, free; First Tues. of each month, free. Handicapped accessible, including elevators; wheelchairs available.
Hours: Tues., Thurs., Fri., 11–6; Wed., 11–9; Sat., Sun., 10–6. Closed Mon., major holidays. Galleries may be closed for new installations.
Tours: Weekdays, 12:15; additional tour Wed., 7:15; Sat., Sun., 11:15, 12:15, 2:15.
Food & Drink: Museum restaurant open during regular museum hours; seasonal outdoor dining overlooking Lake Michigan and the sculpture garden.

Terra Museum of American Art

666 N. Michigan Ave., Chicago, IL 60611
(312) 664-3939

1998 Exhibitions

Thru Mar. 8
American Artists and the Paris Experience, 1880–1910
Documents the experiences of American artists in late-19th-century Paris.
Includes works by Cassatt, Sargent, Hassam, and others.

American Artists in Giverny: The Summer Art Colony, 1887–1914
Examines the artists' colony of Giverny and the influence of resident
Impressionist painter Claude Monet on American artists.

Gallery of the Louvre
Highlights the work of Samuel F.B. Morse, painter and inventor of the
telegraph, who made 38 copies of Old Master paintings in 1831-1833.

Permanent Collection

Based on the personal collection of the late Daniel Terra, spanning two
centuries of American art. **Highlights:** Bingham, *The Jolly Flatboatmen;*
Morse, *Gallery of the Louvre;* works by Cassatt, Homer, Sargent, Whistler.
Architecture: Award-winning 1987 design by Booth-Hansen and
Associates, blending two formerly distinct buildings.

Admission: Suggested donation; adults, $5; seniors, $2.50; students, $1;
members, educators, children under 14, free; Tues., first Sun. of every
month, free. Handicapped accessible.
Hours: Tues., 12–8; Wed.–Sat., 10–5; Sun., noon–5. Closed Mon.
Programs for Children: Family Day, first Sun. of month; Family Fair for
ages 5-12 offered daily, 1–3, includes hands-on studio workshop and tours.
Tours: Mon.–Fri., 12; Sat.–Sun., 12, 2. Groups call (312) 664-3939.
Museum Shop: Open daily, 10–5; Tues., 10–8.

Indianapolis Museum of Art

1200 W. 38th St., Indianapolis, IN 46208
(317) 923-1331
http://web.ima-art.org/ima

1998 Exhibitions

Jan. 25-Apr. 5
Design 1885-1945: The Arts of Reform and Persuasion

Sept. 6-Nov. 15
India: A Celebration of Independence
Features 240 photographs that show the changing cultural awareness in
India over the past 50 years. (T)

Sept. 6-Nov. 29
King of the World: A Mughal Manuscript from the Royal Library, Windsor Castle
A rare exhibition of the treasured illustrated manuscript, *The Padshanama*, which was commissioned by the Mughal emperor Shah-Jahan in 1639. (T)

Permanent Collection
J. M. W. Turner Collection of watercolors and drawings; Holliday Collection of Neo-Impressionist Art; Clowes Fund Collection; Eli Lilly Collection of Chinese Art; Eiteljorg Collection of African Art.
Architecture: Lilly Pavilion of Decorative Arts: original J. K. Lilly mansion modeled after 18th-century French chateau; 1970 Krannert Pavilion by Ambrose Richardson; 1972 Clowes Pavilion; 1973 Showalter Pavilion; 1990 Mary F. Hulman Pavilion by Edward Larrabee Barnes.

Admission: Free. Fee for special exhibitions, free on Thurs. Handicapped accessible.
Hours: Tues.–Sat., 10–5; Thurs., 10–8:30; Sun., 12–5. Closed Mon., major holidays.
Tours: Call (317) 923-1331 for information.
Food & Drink: Museum Café, Garden on the Green.

Davenport Museum of Art
1737 West 12th St., Davenport IA 52804
(319) 326-7804
http://www.gconline.com/arts/DMA

1998 Exhibitions
Thru Mar. 22
Tracing the Spirit: Haitian Art from the Permanent Collection
Over 150 works ranging from "first generation" of Haitian artists working mid-century to contemporary developments. Catalogue.

Apr. 18-June 7
Treasures of Deceit: Archaeology and the Forger's Craft
Explores how art historians and scientists determine whether a work of art is genuine. Viewers are encouraged to examine objects. (T)

William Meritt Chase, *Reverie: Portrait of the Artist's Wife,* c. 1890. Collection Wichita Art Museum. From *Our Nation's Colors: A Celebration of American Painting.* Photo courtesy Davenport Museum of Art.

June 19-Sept. 6
Expressions in Wood: Masterworks from the Wornick Collection
Works by more than 40 artists from the U.S., Australia, and England chronicle important woodworking craft artists of the last forty years. (T)

Nov. 13, 1998-Jan. 10, 1999
Our Nation's Colors: A Celebration of American Painting
Highlights modernist American painting, with important works by Bellows,
Cassatt, Henri, Eakins, Homer, Hopper, and O'Keeffe. Catalogue. (T)

Permanent Collection
Includes many nationally and internationally known objects and bears
witness to more than seven decades of philanthropy and civic pride. The
collections, organized in seven areas—America, Regionalist, Mexican
Colonial, Haitian, Asian, European, and Contemporary—offer a distinctive
look at art from the 15th century to the present.

Admission: Varies with exhibition. Call for details. Handicapped
accessible: enter through Wiese Fine Arts addition.
Hours: Tues.–Sat., 10–4:30; Thurs., 10–8; Sun., 1–4:30.
Programs for Children: Children's Learning Center located in Wiese Fine
Arts addition.
Museum Shop: Books and gifts as well as arts and crafts by local artists.
Open museum hours.

Des Moines Art Center

4700 Grand Ave., Des Moines, IA 50312
(515) 277-4405

1998 Exhibitions

Thru Jan. 4
Agnes Weinrich: 1873-1946
First museum exhibition of modernist paintings, drawings, and prints by this
Iowa native.

Jan. 2-Mar. 1
Styles of the Times: Works on Paper from the 1940s
Features works created in the 1940s, from the permanent collection.

Jan. 24-May 10
*Building an International Art Collection: The Des Moines Arts Center's
Story*
Major show celebrates the works of art acquired by the museum over the
past 50 years. Subjects covered include funding sources, major gifts,
controversial acquisitions, and collection care.

Mar. 6-Apr. 26
Styles of the Times: Works on Paper from the 1950s
Works created in the 1950s, from the permanent collection.

May 1-June 28
Styles of the Times: Works on Paper from the 1960s
Features works from the permanent collection created in the 1960s.

May 23-Sept. 6
Iowa Artists 1998
Features artists living and working in Iowa.

July 3-Aug. 30
Styles of the Times: Works on Paper from the 1970s
Works created in the 1970s, from the permanent collection.

Sept. 4-Nov. 1
Styles of the Times: Works on Paper from the 1980s
Features works from the permanent collection created in the 1980s.

Sept. 26, 1998-Jan. 8, 1999
Abstraction/Realism: Philip Guston, Georgia O'Keeffe, Gerhard Richter
Major works by each of these distinguished 20th-century artists
demonstrate their range of style from abstraction to realism.

Sept. 26, 1998-Jan. 9, 1999
Golden Anniversary Dreams: Art the Collection Needs and Why
A selection of works on loan, with explanations of why the museum needs
these kinds of works for its own collection.

Nov. 6, 1998-Jan. 3, 1999
Styles of the Times: Works on Paper from the 1990s
Features works from the permanent collection created in the 1990s.

Permanent Collection
Nineteenth- and 20th-century
European and American
paintings and sculptures;
African and primitive arts.
Highlights: Bacon, *Study after
Velázquez's Portrait of Pope
Innocent X* ; Johns, *Tennyson*;
Judd, *Untitled*; Kiefer,
Untitled; Monet, *Rocks at
Belle-Île*; MacDonald-Wright,
Abstractions on Spectrum;
Marden, *Range.* **Architecture:**
1948 building by Eliel
Saarinen; 1968 addition by I.
M. Pei & Partners; 1985 addition by Richard Meier & Partners.

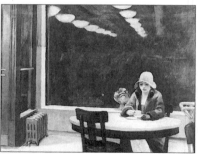

Edward Hopper, *Automat,* 1927. Photo courtesy Des
Moines Art Center.

Admission: Daily, 1–4: Adults, $4; seniors, students with ID, $2; daily,
11–1, Thurs. (all day), members, children under 12, scheduled docent
tours, free. Handicapped accessible.
Hours: Tues.–Sat., 11–4; Thurs., first Fri. of every month, 11–9; Sun.,
12–4. Closed Mon., holidays.
Programs for Children: Offers classes and workshops throughout the
year. Children's scholarships available. Call for information.
Tours: Please make reservations with the Education Dept. 3–4 weeks in
advance.
Food & Drink: Restaurant open Tues.–Sat., 11–2; Thurs. dinner, 5:30–9,
reservations recommended; first Fri. of every month, 5–8.
Museum Shop: Open during museum hours.

Spencer Museum of Art

University of Kansas, Lawrence, KS 66045
(913) 864-4710
http://www.ukans.edu/~sma

1998 Exhibitions

Jan.-Feb.
Lithography: A Bicentennial Appreciation
Celebrates the 200th anniversary of Alois Senefelder's invention of the lithographic process with works from its early days to the present.

Jan.-Mar.
Photographs from the Collection

Jan. 17-Mar. 8
Abstraction and Expression in Chinese Calligraphy
A selection of works from the collection of H. Christopher Luce shows the resonances of calligraphic art from the Ming dynasty to contemporary works by Pollock, Kline, and Miró.

Mar. 14-May 17
Jacques Bellange: 17th Century Printmaker of Lorraine
Consists of 44 prints by this great 17th-century printmaker who worked in the Duchy of Lorraine during the late Mannerist period. Catalogue. (T)

Apr.-May
A Century of Kansas Printmaking
An overview of printmaking in the state, from the etchings of F.O. Marvin at the turn of the century to the Prairie Print Makers and more recent works.

Ubu's Almanac: Alfred Jarry and the Graphic Arts

Apr. 4-May 31
Robert Motherwell on Paper: Gesture, Variation, Continuity
Survey of Motherwell's drawings, prints, and collages dating from the 1940s to 1989. Themes include abstraction/figuration and the creative process.

Aug. 22-Oct. 18
Crossing the Threshold

Permanent Collection:

American and European painting, sculpture; Edo period paintings; Korean ceramics; Japanese prints; contemporary Chinese painting. **Highlights:** Homer, *Cloud Shadows*; Kandinsky, *Kleine Welten VI*; Studio of Sassetta, *Head of an Angel*; Rossetti, *La Pia de' Tolommei;* Fragonard, *Portrait of a Young Boy*; Benton, *The Ballad of the Jealous Lover of Lone Green Valley*.

Admission: Free. Handicapped accessible.
Hours: Tues.–Sat., 10–5; Thurs., 10–9; Sun., noon–5. Closed Mon., Jan. 1, July 4, Thanksgiving, Dec. 24–25.
Tours: Call (785) 864-4710 for information.

Wichita Art Museum

619 Stackman Dr., Wichita, KS 67203
(316) 268-4921
http://www.feist.com/~wam

1998 Exhibitions

Thru Jan. 25
Toward an American Identity: Selections from the Wichita Art Museum
Highlights modernist American painting, with important works by Bellows, Cassatt, Henri, Eakings, Homer, Hopper, and O'Keeffe. Catalogue. (T)

Edward Hopper, *Sunlight on Brownstones,* 1956. The Roland P. Murdoch Collection, Wichita Art Museum.

Mar. 1-June 7
Paintings of the Southwest: The Arvin Gottlieb Collection in the National Museum of American Art and Wichita Connections with the Southwest
Exhibition features 31 paintings and watercolors by members of the Taos Society of Artists and their associates who embraced America's western landscape and Native American cultures.

Sept. 27, 1998-Jan. 10, 1999
Lester Raymer Retrospective Exhibition
Paintings, religious sculptures, furniture, and other decorative objects by this influential artist who taught and worked in Kansas for more than 40 years.

Permanent Collection

American painting, graphics, sculpture, decorative arts, with an emphasis on painting from 1900 to 1950: American Impressionism, The Eight, early modernism, Regionalism and American Scene. **Highlights:** Major works by Copley, Eakins, Ryder, Cassatt, Henri, Prendergast, Glackens, Hopper, Marin, Dove; works by Charles M. Russell.

Admission: Free. Handicapped accessible.
Hours: Tues.–Sat., 10–5; Sun., 12–5. Closed Mon.
Programs for Children: WAM for Kids, with hands-on activities.
Tours: Call (316) 268-4907 three weeks in advance.
Food & Drink: Truffles Café open Tues.–Sat., 11:30–1:30; Sun. brunch, 12–2.
Museum Shop: Open during museum hours.

J.B. Speed Art Museum
2035 S. Third St., Louisville, KY 40201
(502) 636-2893
http://www.speedmuseum.org

1998 Exhibitions
Thru Feb. 15
Dale Chihuly: Selections from Louisville Collections
Features works of glass by this acclaimed contemporary American artist.

June 2-Aug. 16
Wyeth: Three Generations
Features the work of important American artists N.C., Andrew, and Jamie Wyeth.

Sept. 22-Nov. 15
Ansel Adams: A Legacy
115 images from the end of Adams's career reflect the evolution of his art and his ideas, both as a photographer and an advocate of environmental issues. (T)

Permanent Collection
Over 3,000 works, including European and American paintings, sculptures, and prints from antiquity to the present; Native American and Asian art; 17th-century Dutch art; 18th-century French art; 20th-century sculpture and painting. **Highlights:** Elaborately carved oak-paneled English Renaissance room; sculpture garden; Brancusi, *Mlle Pogany*; Rubens, *The Triumph of the Eucharist*; Audrey Flack, *Colossal Head of Medusa*. **Architecture:** 1927 building; 1954 and 1973 wings; 1983 addition by Geddes; renovation, 1997.

Admission: Free. Charge for selected special exhibitions.
Hours: Tues., Wed., Fri., 10:30–4; Thurs., 10:30–8; Sat., 10:30–5; Sun., 12–5 (Sculpture Court open at 10:30). Closed Mon., Dec. 25, Jan. 1.
Tours: Call for information and reservations.
Food & Drink: Café open museum hours, Thurs. until 9, Sun. brunch at 10:30.

University of Kentucky Art Museum
Rose Street and Euclid Avenue, Lexington, KY 40506
(606) 257-5716

1998 Exhibitions
Thru Jan. 18
A Fine Line: 20th Century Master Etchings from the Collection
Featuring graphic works by David Hockney, Wayne Thiebaud, Robert Bechtle, Lucian Freud, and others.

Jan. 18-Mar. 8
Panoramas of Passage: Changing Landscapes of South Africa
Uses broad interpretation of landscape as a theme and features some 80 South African artists working in a variety of media.

Jan.-Aug.
Minimal/Pop/Op: Art from the 1960s and 1970s from the Collection
Selection of paintings, sculptures, and works on paper by a diverse group of artists including Friedel Dzubas, Sol LeWitt, Martha Boto, Lucio Pozzi, George Rickey, and Joe Goode.

Sept.-Dec.
Edward Franklin Fisk: An American Modernist
Paintings and prints by former Lexington resident and professor.

Permanent Collection
Collection of over 3,000 works includes 17th-20th century

Sol LeWitt, *Incomplete Open Cube, #7,* 1974. From *Minimal/Pop/Op Art from the 1960s and 1970s.* Photo by M.S. Renzy, courtesy University of Kentucky Art

European and American paintings by Carracci, Crespi, Wilard Metcalf, Miro, Dubuffet; photographs by Bernice Abbott, Ansel Adams, Meatyard, Frank; decorative arts of Tiffany, Galle; old master and contemporary prints by Durer, Rembrandt, Motherwell, Katz, Kruger; and contemporary regional art.

Admission: Free. Handicapped accessible.
Hours: Tues.–Sun., 12–5.
Tours: Group tours available with advance reservation by calling (606) 257-5716; tours given Mon.–Fri., 8:30–3:30.
Programs for Children: Group tours available for pre-school through high school; writing and special-interest tours available with advance reservation.
Museum Shop: Posters, postcards, and exhibition catalogues are available in the gallery or by calling (606) 257-5716.

New Orleans Museum of Art

1 Collins Diboll Circle, City Park, New Orleans, LA 70124
(504) 488-2631
http://www.noma.org

1998 Exhibitions
Thru Jan. 7
Meissen Porcelain Figures from the H. Lloyd Hawkins Collection
Approximately 350 antique porcelain figures, including detailed scenes of people, animals, and birds created by the Meissen factory in Germany.

Grotesqueries: Form and Fantasy in 19th Century European Ceramics, the Collection of Brooke Hayward Duchin
Ceramics, decorated with animal forms, collected by the writer.

Paintings by George Dunbar
Works by the contemporary New Orleans artist.

Feb. 1-April 12
Sacred Arts of Haitian Vodou
Examines this religion brought to Hispaniola by enslaved Africans from the perspectives of mythology, folklore, anthropology, and the arts. Features paintings, handcrafted vessels, handsewn fabric arts, and vodou altars. (T)

Pierrot Barra, *Miniature Coffins for Gede Altar*, 1994. From *Sacred Arts of Haitian Vodou*. Photo courtesy New Orleans Museum of Art.

Oct. 31, 1998-Jan. 4, 1999
Ancient Gold: The Wealth of the Thracians, Treasures from the Republic of Bulgaria
Over 200 masterpieces of gold and silver metalwork from ancient Thrace, located in central Europe between 4,000 B.C. and the 4th century A.D. (T)

Permanent Collection
Extraordinary strengths in French and American art; the nation's sixth-largest collection of glass; photography from its beginnings to the present; the arts of Africa; Japanese works, particularly from the Edo period; and theWeisman Galleries, dedicated to contemporary Louisiana artists. The collection also includes pre-Columbian, Native American, and Oceanic art.
Highlights: Degas, especially *Portrait of Estelle Muson Degas*; other Impressionists including Monet, Renoir, and Cassatt; Fabergé Imperial Easter eggs and the bejeweled *Imperial Lilies-of-the-Valley Basket,* on extended loan from the Matilda Geddings Gray Foundation; Vigée-Lebrun, *Marie Antoinette, Queen of France.* **Architecture:** 1911 Beaux Arts structure by Samuel Marx in a 1,500-acre city park; 1993 addition doubled museum size.

Admission: Adults, $6; seniors, $5; children 3–17, $3. Thurs., 10–12, free to Louisiana residents.
Hours: Tues.–Sun., 10–5. Closed Mon., holidays.
Programs for Children: stARTing point is an interactive educational gallery that explores where artists get their ideas.
Tours: Discounts for groups of 20 or more with reservations. Call (504) 488-2631 for information.
Food & Drink: Courtyard Café, Tues.–Sun., 10:30–4:30; view of City Park.
Museum Shop: Offers jewelry, books, and a special children's section.

Bowdoin College Museum of Art

Walker Art Building, Brunswick, ME 04011
(207) 725-3275
http://www.bowdoin.edu/cwis/acad/museums

NOTE: The Winslow Homer Gallery of wood engravings and memorabilia is open only during the summer.

1998 Exhibitions
Thru Jan. 11
American Landscapes from the Permanent Collection

Jan. 22-Mar. 16
Embedded Metaphor

Apr. 2-May 31
Still Time: Sally Mann

Permanent Collection
Over 12,000 objects, including Assyrian, Greek, Roman antiquities; European and American paintings, prints, drawings, sculpture, decorative arts; Kress study collection; Molinari Collection of Medals and Plaquettes; Winslow Homer memorabilia; Far Eastern, African, New World, and Pacific art. **Architecture:** 1894 building by Charles Follen McKim of McKim, Mead and White; 1975 addition by Edward Larrabee Barnes.

Admission: Free. Handicapped accessible; call (207) 725-3275 in advance for assistance.
Hours: Tues.–Sat., 10–5; Sun., 2–5. Closed Mon., holidays.
Tours: Call (207) 725-3276 two weeks in advance for reservations.

Farnsworth Art Museum

P.O. Box 466, 352 Main St., Rockland, ME 04841
(207) 596-6457
http://www.midcoast.com/farnsworth

1998 Exhibitions
Thru Jan. 4
A Life of Their Own: Contemporary Photography by Jonathan Bailey and Historic Photography from the Rydell Collection
First in a series of exhibitions highlighting new Maine photographers.

Ed Gamble: Sculpture, Watercolors, Drawings
Images of sea and shore by contemporary Maine artist.

Thru Spring
Maine in America
Rotating exhibition traces the development of art in Maine, with selected works from the museum's collection of 19th- and 20th-century American art, including works by Cole, Twachtman, Hartley, Porter, and Nevelson.

Opens Spring
Maine in America
Reinstallation of the permanent collection in celebration of the museum's
50th anniversary.

Thru Apr. 5
The Wyeth Collection
Features works from the permanent collection by N.C., Andrew, and James
Wyeth.

Jan. 18-Apr. 5
Beverly Hallam
Traces the evolution of this painter's imagery of flowers and gardens
throughout her distinguished career.

Apr. 12-June 14
*A Legacy for Maine: Masterworks from the Collection of Elizabeth B.
Noyce*
Features masterworks by artists such as Frederic Church, Winslow Homer,
Charles Demuth, Edward Hopper, and Andrew Wyeth. Catalogue. (T)

June 21-Sept.
*Wondrous Strange: The Pursuit of the Marvelous in the Art of the Wyeth
Family*
Explores the dimensions of narrative, fantasy, and reality in the art of this
important family of American artists, with new perspectives from literature,
history, and local lore. Catalogue.

June 28-Nov. 8
Bellows and Benson in Maine: Reality and the Dream
Examines works from the collection in a larger context, featuring Bellows's
portrayal of the Maine shipyards and Benson's social portraits from 1915.

Nov. 15, 1998-Feb. 14, 1999
Charles Lewis Fox

Permanent Collection
Acclaimed collection of American art of the 19th and 20th centuries,
including works by the Wyeth family, Fitz Hugh Lane, John Marin, and
Edward Hopper; special emphasis on artists from Maine. **Highlight:**
Collection of 60 works by Louise Nevelson. **Architecture:** 1850
Farnsworth Homestead and Olson House on the museum grounds. New
Farnsworth Center for the Wyeth Family scheduled to open in June 1998.

Admission: Adults, $5; seniors, $4; ages 8–18, $3. Handicapped accessible,
including ramps and elevators.
Hours: Winter (Oct. 13–May 30): Tues.–Sat., 10–5; Sun., 12–5. Closed
Mon. Olson House and Farnsworth Homestead closed. Summer (May 31–
Oct. 12): Mon.–Sat., 9–5; Sun., 12–5. Farnsworth Homestead: Mon.–Sat.,
10–5; Sun., 12–4. Olson House: Mon.–Sat., 11–4; Sun., 12–4.
Programs for Children: School tours, outreach, story hours, and in-school
programs.
Tours: Call (207) 596-6457 for information.
Museum Shop: Offers books, gifts, and limited-edition prints.

Portland Museum of Art

7 Congress Sq., Portland, ME 04101
(207) 775-6148
http://www.portlandmuseum.org

1998 Exhibitions

Thru Jan. 4
A Legacy for Maine: Masterworks from the Collection of Elizabeth B. Noyce
Features masterworks by artists such as Frederic Church, Winslow Homer, Charles Demuth, Edward Hopper, and Andrew Wyeth. Catalogue. (T)

Thru Jan. 18
Poetic Vision: Photographs by Ernst Haas
Examines the career of this influential photojournalist (1921-1986), including over 40 of his finest photographs.

Jan. 15-Mar. 22
Making It Real
Contemporary large-scale photographs that, without computer enhancement, call into question the idea that photographic images capture "reality." (T)

Jan. 31-Apr. 23
Marsden Hartley, American Modern
Surveys the life and art of this 20th-century American artist, through 53 paintings and works on paper.

Apr. 9-June 7
Stephen Etnier

June 25-Oct. 18
Monet to Matisse: Responses to the Riviera
Highlights the Impressionist and Modernist European and American masters who were active on the Riviera from 1880 to 1940. Includes works by Monet, Renoir, Murphy, Man Ray, and others.

Oct. 10-Dec. 6
After the Photo-Secession: American Pictorial Photography, 1910-1955
Depicts the revival of pictorial photography and its use as a tool for personal expression in the dawning Machine Age. (T)

Permanent Collection:

Maine's oldest arts institution, founded in 1882, featuring a collection of 18th- through 20th-century fine and decorative arts. **Highlights:** Major European movements, from Impressionism through Surrealism, represented by the Joan Whitney Payson, Albert Otten, and Scott M. Black collections featuring Renoir, Degas, Monet, Picasso, Munch, Magritte. Other highlights include works by Winslow Homer, John Singer Sargent, Rockwell Kent, Marsden Hartley and Andrew Wyeth. **Architecture:** 1983 award-winning building designed by I.M. Pei, & Partners.

Admission: Adults, $6; students, seniors, $5; children 6-12, $1; children under 6, free. Handicapped accessible.
Hours: Tues., Wed., Sat., 10–5; Thurs.-Fri., 10–9; Sun., 12–5. Closed Mon. July through Columbus Day, the museum is open on Mondays, 10–5.
Programs for Children: Family Festivals, first Fri. of month.
Tours: Daily, 2pm; Thurs., Fri., 6. Groups $4 per person; call 3 weeks ahead for reservations.
Food & Drink: Year-round Museum Café; call for hours.
Museum Shop: Open during museum hours.

American Visionary Art Museum

800 Key Highway, Baltimore, MD 21230
(410) 244-1900
http://www.doubleclickd.com/avamhome.html

1998 Exhibitions
Thru Apr. 19
The End is Near! Visions of Apocalypse, Millenium, and Utopia
Over 250 works by self-taught artists express concerns and prophecies of the coming new millenium. Includes illustrations of the *Book of Revelation*, a *Doomsday Computer* environment, and a prophesying machine.

Opens May
Error and Eros: Love Profane and Define

Permanent Collection
Features visionary art by self-taught ("outsider") artists, including Gerlad Hawkes, Ted Gordon, and Dr. Otto Billig. **Highlights:** Outdoor wind-powered *Whirligig* sculpture by Vollis Simpson. **Architecture:** Complex includes a Sculpture Barn (formerly the Four Roses whisky warehouse, with 45-ft. ceilings); wild flower sculpture garden; and wooden meditation chapel by Ben Wilson. Main building's central stair balustrade and garden gates cast by artist David Hess.

Admission: Adults, $6; children, students, seniors, $4; groups of 10 or more, $3 per person. Handicapped accessible, including ramps and elevators.
Hours: Tues.–Sun., 10–6. Closed Mon.
Programs for Children: Call (410) 244-1900 for information.
Tours: Offered daily; call for more information.
Food & Drink: Joy America Café features acclaimed chef Peter Zimmer.
Museum Shop: Open during museum hours.

The Baltimore Museum of Art

Art Museum Dr. at N. Charles & 31st Streets, Baltimore, MD 21218
(410) 396-7100 (recording)
http://www.artbma.org

1998 Exhibitions

Thru Jan. 11
A Century of American Photography/A Decade of Photo Acquisitions
Features photographs by Man Ray, Steiglitz, and Levitt.

Thru Jan. 18
A Grand Design: The Art of the Victoria and Albert Museum
Presents the history of a museum through a comprehensive exhibition of 250 masterworks from the V&A's immense collections, spanning 2,000 years of artistic achievement. Catalogue. (T)

Benvenuto Cellini, *Head of Medusa,* c. 1545. From *A Grand Design: The Art of the Victoria and Albert Museum.* Photo courtesy Baltimore Museum of Art.

Majesty in Miniature: The Kings and Queens of England from William the Conqueror to Elizabeth II
Showcases over 100 dolls created in 1953 to represent the monarchs of Britain and their attendants, tracing 900 years of British royalty.

Thru Feb. 15
In Prayse of the Needle: English Needlework from the 17th –19th Centuries
Textiles made in Britain and Europe, featuring "stumpwork," samplers, pictorial silk embroideries, and crewelwork-decorated objects.

Jan. 28-Mar. 8
Pictures from America by Jeffrey Henson Scales
Photographs and digital prints depicting urban, social, political, and aesthetic issues of the African-American experience.

Feb. 4-Apr. 5
Prints from Utrecht
Focuses on the Dutch city's role as center of 17th-century print production.

Feb. 18-Apr. 12
The Image Business: Shop and Cigar Store Figures from America
The first in-depth examination of this 19th-century sculptural tradition.

Mar. 10-July 12
Deidre Scherer
Unique quilts inspired by the hospice movement.

Mar. 25-May 24
The Great American Pop Art Store: Multiples of the Sixties
Celebrates the delightful and witty world of Pop Art multiples and its influence on later object design, featuring 100 pieces by Jim Dine, Jasper Johns, Andy Warhol, and others. Catalogue. (T)

May 13-July 19
The Symbolist Prints of Edvard Munch: The Vivian and David Campbell Collection
The technical experimentation of Munch's graphic work is underscored in 59 prints by this important Norwegian artist, depicting themes of love and death in works such as *Madonna, The Sick Child,* and *Vampire.* (T)

June 14-Aug. 30
Sacred Arts of Haitian Vodou
Examines this religion brought to Hispaniola by enslaved Africans from the perspectives of mythology, folklore, anthropology, and the arts. Features paintings, handcrafted vessels, handsewn fabrics, and vodou altars. (T)

Maryland by Invitation: Photographs by Carl Clark, Robert Houston, Kenneth Royster
Spotlights these local Maryland artists who have documented images of Baltimore's African-American church life.

Oct. 4, 1998-Jan. 3, 1999
Degas and the Little Dancer
Focuses on the evolution of the famous bronze sculpture *Little Dancer, Fourteen Years Old* by the French Impressionist. (T)

Permanent Collection

Paintings, sculptures, prints, photographs, drawings; period rooms from 19th-century Maryland houses; Asian, African, Pre-Columbian, Native American, Oceanic art. White Collection of Maryland silver; Cheney Miniature Rooms; Syrian mosaics from Antioch; sculpture gardens. Recent acquisitions of African art and works by African-American artists, including Gilliam, Ringgold, Beardon, and Lawrence. **Highlights:** Cone Collection of Post-Impressionist works; Cézanne, *Mont Sainte-Victoire Seen from the Bibemus Quarry*; van Gogh, *A Pair of Boots*; Matisse, *Large Reclining Nude and Purple Robe* and *Anemones*; Picasso, *Dr. Claribel Cone* and *La Coiffure*; Pollock, *Water Birds*; Raphael, *Emilia Pia da Montefeltre*; Rembrandt, *Titus*; van Dyck, *Rinaldo and Armida*; West, *Self-Portrait,* Warhol, *Last Supper.* **Architecture:** 1929 building and 1937 addition by Pope; 1980 Wurtzburger Sculpture Garden by Bower Fradley Lewis Thrower and George Patton; 1982 wing and 1986 addition by Bower Lewis Thrower; 1988 Levi Sculpture Garden by Sasaki Associates; 1994 West Wing for Contemporary Art by Bower Lewis Thrower, Architects.

Admission: Adults, $6; full-time students, seniors, $4; age 18 and under, members, Thurs., free. Handicapped accessible; wheelchairs available.
Hours: Wed.–Fri., 11–5; Sat.–Sun., 11–6. First Thurs. of month, 11–9. Closed Mon., Tues., major holidays.
Programs for Children: Education programs and activities year-round.
Tours: Available by appointment. Call (410) 396-6320 for information.
Food & Drink: Donna's at the BMA, open Tues.–Wed., 11:30–9; Thurs., 11:30–10; Fri.–Sat., 11:30–11; Sun., 11–9.
Museum Shop: Open Tues.–Wed., 11–5; Thurs.–Sat., 11–9; Sun., 11–6.

The Walters Art Gallery

600 N. Charles St., Baltimore, MD 21201
(410) 547-9000; 547-ARTS (recording)

1998 Exhibitions

Jan. 11-Apr. 5
Masters of Light: Dutch Painters in Utrecht during the Golden Age
Reveals the splendid accomplishments of painters working in Utrecht during its height as an artistic center in the early 17th century. (T)

Mar. 29-May 31
Monet: Paintings of Giverny from the Musée Marmottan
Blockbuster exhibition features 22 paintings by Claude Monet (1846-1926). Includes lesser-known later works featuring the flower and water gardens of Monet's property in the rural village of Giverny. (T)

Nov. 8, 1998-Jan. 3, 1999
The Invisible Made Visible: Angels from the Vatican Collection
Traces the iconography of angels in various cultures from the 9th century B.C. to the 20th century A.D., including more than 100 works of art and artifacts never before seen outside the Vatican. (T)

Permanent Collection

Antiquities of Egypt and the ancient Near East; Asian, Greek, Etruscan, Roman art; early Christian and Byzantine art; medieval art of Western Europe; Islamic art; illuminated manuscripts; 16th- to 19th-century paintings, sculptures, prints; Ethiopian religious art; Hackerman House, the Walters Art Gallery Museum of Asian Art. **Highlights:** Bellini, *Madonna and Child Enthroned with Saints and Donors;* Fabergé Easter eggs from the Russian Imperial collection; Géricault, *Riderless Racers at Rome*; Manet, *At the Café*; Raphael, *Virgin of the Candelabra*; van der Goes, *Donor with Saint John the Baptist.* **Architecture**: 1904 Renaissance Revival building by Adams and Delano; courtyard modeled after Palazzo Balbi in Genoa, Italy; 1974 wing by Shepley, Bulfinch, Richardson, and Abbott. Hackerman House: 1850 mansion; 1991 renovation by Grieves, Worrall, Wright & O'Hatrich.

Admission: Adults, $6; seniors, $4; students, $3; children ages 6-17, $2; children under 6, free. Handicapped accessible.
Hours: Wed.–Fri., 10–4; Sat.–Sun., 11–5. Closed Mon., holidays.
Tours: Wed., 12:30; Sun., 1. Groups call (410) 547-9000, ext. 232 or 298.
Food & Drink: Troia at the Walters. Lunch: Tues.–Sat., 11:30–3:30; Dinner: Wed.–Sat., 5:30–11. Call (410) 727-CAFE.
Museum Shop: Offers gifts, books, fine estate and reproduction jewelry.

The Addison Gallery of American Art

Phillips Academy, Andover, MA 01810
(508) 749-4015
http://www.andover.edu/addison/home.html

1998 Exhibitions

Thru Jan. 4
Joel Shapiro: Sculpture in Clay, Plaster, Wood, Iron, and Bronze, 1971-1997

The Serial Attitude

Jan. 17-Mar. 29
Robert Hudson and Richard Shaw: Ceramic Sculpture
Features new works by these artists created while in residence at Phillips Academy.

Jan. 17-Apr. 5
Justin Kirchoff: New Work
Recent work by the artist includes panoramic photographs produced in Lawrence, Massachusetts.

Expanded Visions: The Panoramic Photograph
Features 19th- and 20th-century panoramas in a variety of photographic media, with special emphasis on images by contemporary artists.

Apr. 25-May 24
David Ireland: Creation of the Visiting Artist Apartment

Apr. 25-July 14
Arthur Dove: A Retrospective
Surveys the career of this 20th-century American Modernist, including over 80 paintings, assemblages, pastels, and charcoal drawings spanning the years 1909–1946. Catalogue. (T)

Apr. 25-July 31
Urban Visions: Paintings, Photographs, and Works on Paper

Permanent Collection
Over 11,000 American paintings, sculpture, works on paper, and photography. Includes works by Davis, Homer, Hopper, LeWitt, and Frank Stella. **Architecture:** Neoclassical building by Charles Platt, 1930.

Admission: Free. Handicapped accessible.
Hours: Tues.–Sat., 10–5; Sun., 1–5. Closed Mon., holidays, Dec. 24, August 1 through Labor Day.
Programs for Children: School tours and art activities, call the Education Coordinator at (508) 749-4017 for information and reservations.
Tours: For information, call (508) 749-4015.

Isabella Stewart Gardner Museum

280 The Fenway, Boston, MA 02115
(617) 566-1401
http://www.boston.com/gardner

1998 Exhibitions

Thru Jan. 4
Olivia Parker and Jerry Uelsmann: Dwellings of the Imagination
Focuses on the last 20 years of work by these photographers who use found objects and digital manipulation to create artificial environments.

Isabella Stewart Gardner's Holiday Table
Recreates the opulence of a turn-of-the-century holiday table, set with the art patron's china, glassware, and ornamental tableware.

Jan. 23-Apr. 26
Titian and Rubens: Power, Politics, and Style
Examines the influence of the Venetian Renaissance master Titian on the Flemish Baroque artist Rubens. Includes versions of *Europa,* copied by Rubens from Titian's original.

Sept. 1998-Jan. 1999
New Photography by Abelardo Morell
New work by this photographer known for his black & white images that examine familiar objects and environments.

Permanent Collection

Italian Renaissance paintings; Dutch, French, German, Spanish masterpieces; American paintings; rare books, manuscripts; decorative arts. Works permanently arranged as Mrs. Gardner specified. **Highlights:** Indoor sculpture and flower garden; Botticelli, *Madonna of the Eucharist*; Crivelli, *Saint George and the Dragon*; Giotto, *Presentation of the Child Jesus at the Temple*; Rembrandt, *Self-Portrait*; Sargent, *Isabella Stewart Gardner*; Titian, *The Rape of Europa.* **Architecture:** 1899–1902 Venetian-style building, created from 15th- and 16th-century fragments, by Sears.

Admission: Adults, $9; seniors, $7, students with current ID, $5; youths 12–17, $3; children under 12, members, free. Wed., students, $3. Handicapped accessible.
Hours: Tues.–Sun., 11–5. Closed Mon., holidays.
Tours: Call (617) 278-5147 for information and reservations.
Food & Drink: Gardner Café open Tues.–Fri., 11:30–4; Sat.–Sun., 11–4.

The Institute of Contemporary Art

955 Boylston St., Boston, MA 02115
(617) 266-5152
http://www.primalpub.com/ica

1998 Exhibitions

Thru Jan. 11
Peter Fischli and David Weiss: In a Restless World
Features inventive and humorous transformations of ordinary objects drawn
upon the work of Marcel Duchamp and the Dada artists. (T)

Permanent Collection

No permanent collection. **Architecture:** 1886 Richardsonian building by
Vinal; 1970s facade restoration and interior renovation by Gund.

Admission: Adults, $5.25; students, $3.25; seniors, children under 16, $2.25;
members, Thurs., 5-9, free.
Hours: Wed., Fri.–Sun., 12–5; Thurs., 12–9. Closed Mon.–Tues., holidays.
Tours: Sat., Sun., 1, 3. Call (617) 266-5152.

Museum of Fine Arts, Boston

465 Huntington Ave., Boston, MA 02115
(617) 267-9300
http://www.mfa.org

1998 Exhibitions

Thru Jan. 4
Picasso: The Early Years, 1892-1906
First comprehensive survey of the early genius of the 20th-century's most
prolific artist, including examples of his "Blue and Rose" periods.
Catalogue. (last venue)

Thru Jan. 11
Glass Today by American Studio Artists
Examines dramatic trends in contemporary glass art by over 20 artists.

Thru Apr. 12
America Draws
Features American works on paper from the past 200 years.

Thru May 1999
Beyond the Screen: Chinese Furniture of the 16th and 17th Centuries
Showcases Ming period Chinese furniture in decorative period rooms.

Jan. 28-May 31
Images of Fashion
Explores the evolution of the fashionable image in 16th- to 20th-century
Europe and America.

Feb. 25-May 17
A Grand Design: The Art of the Victoria and Albert Museum
Presents the history of a museum through a comprehensive exhibition of 250 masterworks from the V&A's immense collections, spanning 2,000 years of artistic achievement. Catalogue. (T)

Mar. 18-June 6
Photographs by Julia Margaret Cameron
Features images by the innovative 19th-century British photographer.

July 7-Sept. 27
PhotoImage: 60s—90s
Explores the ongoing dialogue between photographic imagery and contemporary printmaking.

Sept. 20-Dec. 27
Monet in the 20th Century
Selection of 75 remarkable paintings produced by the French Impressionist between 1900 and his death in 1926. (only U.S. venue)

Oct. 21, 1998-Jan. 10, 1999
French Prints from the Musketeers
Examines printmaking and society in 17th-century France, featuring 125 prints by major and lesser-known artists.

Permanent Collection
Extensive holdings include Egyptian and Classical works; Asian and Islamic art including Chinese export porcelain; Peruvian and Coptic textiles, costumes; French and Flemish tapestries; European and American paintings, decorative arts; ship models; ancient musical instruments. **Highlights:** *Bust of Prince Ankh-haf*; *Minoan Snake Goddess*; *Greek Head of Aphrodite*; Cassatt, *Five o'clock Tea*; Chen Rong, *Nine Dragon Scroll*; Copley, *Mrs. Samuel Quincy*; Duccio, *Crucifixion*; Monet, *Haystack* series; O'Keeffe, *White Rose with Larkspur No. 2*; Picasso, *Rape of the Sabine Women*; Renoir, *Le Bal à Bougival*; Revere, *Liberty Bowl*; Sargent, *The Daughters of Edward D. Boit*; Turner, *The Slave Ship*; Velázquez, *Don Balthasar Carlos and His Dwarf*; Warhol, *Red Disaster*. **Architecture:** 1909 building by Guy Lowell; 1915 Evans Wing; 1928 White Wing by Stubbins; 1981 West Wing by I. M. Pei.

Admission: Adults, $10; seniors, college students, $8; children 17 and under, free. Thurs. and Fri. after 5, $2; Wed. 4–closing, free. Handicapped accessible.
Hours: Mon., Tues., 10–4:45; Wed.–Fri., 10–9:45; Sat.–Sun., 10–5:45.
Programs for Children: Offers workshops, classes, and other programs.
Tours: For adults and college students, available by appointment call (617) 369-3368. Admission discount available. School and youth groups appointments also available by appointment, call (617)369-3310.
Food & Drink: Cafeteria open Tues., Sat.–Sun., 10–4; Wed.–Fri., 10–8. Fine Arts Restaurant open Tues.–Sun., 11:30–2:30; Wed.–Fri., 11:30–2:30 and 5:30–8:30. Galleria Café open Tues., Sat.–Sun., 10–4; Wed.–Fri., 10–9:30; Sun., 10-5.

Harvard University Art Museums

Busch-Reisinger Museum

32 Quincy St., Cambridge, MA 02138
(617) 495-9400
http://www.artmuseums.harvard.edu

1998 Exhibitions

Thru Oct. 11

Positioning Nature and Industry: A Selection of Contemporary Art from the Busch-Reisinger Museum
Explores the breakdown of the ideological boundary between nature and technology, with works by Joseph Beuys, K.H. Hödicke, and others.

Permanent Collection

Specializes in art of German-speaking Europe: 16th-century painting; late medieval, Renaissance, Baroque sculpture; 18th-century porcelain from Germany, Austria, the Low Countries; 20th-century art. **Architecture:** 1921 building by Bestelmeyer; 1991 building by Gwathmey, Siegel, and Associates.

Fogg Art Museum

32 Quincy St., Cambridge, MA 02138
(617) 495-9400

1998 Exhibitions

Ongoing

The Art of Identity: African Sculpture from the Teel Collection
Examines the complexity of sub-Saharan African art traditions through diverse representations of identity.

Investigating the Renaissance
This reinstallation of three permanent collection galleries forms one of the foremost collections of early Italian Renaissance painting in North America.

Sublimations: Art and Sensuality in the Nineteenth Century
Examines the perceptions of the 19th century as an era of propriety, in contrast with its engagement of the senses, through paintings and objects selected for their sensual, often erotic charge.

The Persistence of Memory: Continuity and Change in American Cultures
Explores the culture of memory, through 60 paintings, sculptures, and decorative art objects representing native and immigrant traditions.

Circa 1874: The Emergence of Impressionism
A selection of paintings reflecting the "new painting" style that became known as Impressionism. Includes works by Monet, Degas, and Renoir.

France and the Portrait, 1799-1870
Explores the changing conventions of portraiture in France between the Napoleonic era and the fall of the Second Empire.

Thru Jan. 4
Rome and New York: A Continuity of Cities
Examines how images of these cities combine to form a profound lineage
from the classical era to the present. Features prints, maps, and posters.

Jan. 24-Apr. 12
Mathew Brady's Portraits: Images as History, Photography as Art
More than 100 images from the career of this key figure in American
photography span the history of the medium in 19th-century America. (T)

Opens Feb. 28
Sketches in Clay by Gianlorenzo Bernini
Features 27 terracotta sculptures by this significant 16th-century Italian
Baroque artist, in celebration of the quartercentenary of his birth.

Permanent Collection
Masterpieces of Western painting, sculpture, graphic art. **Highlights:**
Rembrandt; Fra Angelico, *Crucifixion*; van Gogh, *Self-Portrait*; Ingres,
Odalisque; Monet, *Gare Saint-Lazare*; Picasso, *Mother and Child*; Poussin,
Infant Bacchus Entrusted to the Nymphs; Renoir, *Seated Bather*.
Architecture: 1927 Neo-Georgian exterior by Coolidge Bulfinch & Abbott;
Italianate courtyard.

The Arthur M. Sackler Museum
485 Broadway, Cambridge, MA 02138
(617) 495-9400

1998 Exhibitions
Ongoing
Coins of Alexander the Great
Explores the political and artistic legacy of the dazzling military conquests
of Alexander the Great (336-323 B.C.).

Thru Feb. 22
*"Drawing is another kind of language": Recent American Drawings from
a New York Private Collection*
Presents nearly 100 drawings by contemporary American artists including
Jasper Johns, Ellsworth Kelly, Sol LeWitt, and Brice Marden.

Thru Aug. 30
Paragons of Wisdom and Virtue: Later East Asian Figure Painting
Examines the figurative and landscape traditions of later Chinese, Korean,
and Japanese paintings, featuring portraits of civil officials, monks, and
poets.

Apr. 4-June 7
Drawings and Watercolors in the Age of Goethe: Fuseli to Menzel
A selection of 19th-century German drawings and watercolors, from the
Age of Enlightenment through the Romantic era.

Permanent Collection
Renowned collections of ancient Chinese art, Japanese prints, Indian and
Islamic paintings, Greek and classical sculpture, Roman coins; Oriental
carpets. **Highlights:** Chinese jades, cave reliefs, bronzes; Japanese

woodblock prints; Persian paintings, calligraphy. **Architecture:** 1985 building by James Stirling.

All Three Museums:
Admission: Adults, $5; seniors, $4; students, $3; age 18 and under, Sat., 10–noon, free. Handicapped accessible, including wheelchair-accessible entrances; hearing assists; sign interpreters upon request (with reservation).
Hours: Mon.–Sat., 10–5. Sun., 1–5. Closed holidays.
Tours: Daily, Mon.–Fri. Call (617) 496-8576 for information.
Museum Shop: Open during museum hours.

Smith College Museum of Art

Elm Street at Bedford Terrace, Northampton, MA 01063
(413) 585-2760

1998 Exhibitions
Thru Jan. 11
Kinships: Alice Neel Looks at the Family
Highlights the work of this acclaimed American portrait painter, whose realist works have been admired by Warhol and Pearlstein. (T)

Sandy Skoglund, *Radioactive Cats,* 1980. Collection Smith College Museum of Art. From *Sandy Skoglund: Reality Under Seige.* Photo courtesy Cincinnati Art Museum.

Mar. 12-May 24
Sandy Skoglund: Reality Under Siege
The first major retrospective of this sculptor, photographer, and installation artist. Features *Radioactive Cats*, *Peaches in a Toaster*, and other works. (T)

Permanent Collection
Emphasis on 18th- to 20th-century French and American works in all media.
Highlights: Late Roman head of Emperor Gallienus; Bouts, *Portrait of a Young Man*; Courbet, *La Toilette de la Mariée*; Degas, *Jephthah's Daughter*; Eakins, *Mrs. Edith Mahon*; Elmer, *Mourning Picture*; Kirchner, *Dodo and her Brother*; Lehmbruck, *Torso of the Pensive Woman*; Picasso, *Table, Guitar, and Bottle*; Rembrandt, *The Three Crosses*; Rodin, *Walking Man*; Sheeler, *Rolling Power*; Terbrugghen, *Old Man Writing by Candlelight.* **Architecture:** 1973 building by John Andrews/Anderson/Baldwin.

Admission: Free. Handicapped accessible, including parking; wheelchairs, assisted-listening devices, and signed tours available (2 weeks notice).
Hours: Sept.–June: Tues., Fri., Sat., 9:30–4; Wed., Sun., 12–4; Thurs., 12–8. July–Aug.: Tues.–Sun., 12–4. Closed Mon., Jan. 1, July 4, Thanksgiving, Dec. 24 and 25.
Tours: Groups call (413) 585-2760 for information and reservations.
Museum Shop: Open during museum hours.

Springfield Museum of Fine Arts

220 State St., Springfield, MA 01103
(413) 263-6800
http://www.spfldlibmus.org/home.htm

1998 Exhibitions

Jan. 7-Mar. 1
*Gilded Age Watercolors
and Pastels from the
National Museum of
American Art*
Exhibition of 50 rarely
seen works that capture
the Gilded Age, inspired
by British watercolors
and French Impressionist
pastels.

Edgar Degas, *Rehearsal Before the Ballet*, c. 1877. Photo courtesy Springfield Library & Museums.

Mar. 15-Apr. 19
*Art Scene: Mark Brown
and Susan Boss*
Contemporary interpretations of traditional folk crafts, featuring quilts and decorated saw blades.

May 6-June 28
Vietnam: A Book of Changes: Photographs by Mitch Epstein

Oct. 3-Dec. 27
Listening to Rugs: Navajo Weaving in a Storytelling Context
Viewed from the perspective of an ongoing oral tradition, a selection of 45 rugs is presented with attention to their cultural significance and design.

Permanent Collection

American paintings from the 18th to 20th centuries; European paintings from the 14th to the 20th centuries; works by Canaletto, Degas, Bonnard, Brueghel the Elder, Géricault, Pissarro, and others. **Highlights:** Erastus Salisbury Field, *Historical Monument of the American Republic*; Homer, *The New Novel*; Monet, *Haystack*. **George Walter Vincent Smith Art Museum:** 19th-century American paintings, Japanese decorative arts, and Islamic textiles. **Highlights:** Shinto shrine; ancient and Renaissance sculpture. **Architecture:** 1896 Neoclassical palazzo.

Admission: Adults, $4; children 6–18, $1; children under 6, free. Handicapped accessible, including elevator to all floors.
Hours: Wed.–Sun., noon–4. Closed Mon.–Tues., Jan. 1, July 4, Thanksgiving, Dec. 25.
Programs for Children: Sat. and afternoon classes, summer art camp, school programs, and afternoon family programs. Call museum for details.
Tours: Call (413) 263-6800, ext. 472, for information.
Museum Shop: Offers unique ceramics, glassware, and jewelry.

Davis Museum and Cultural Center

(formerly the Wellesley College Museum)
Wellesley College, Wellesley, MA 02181
(617) 283-2051

1998 Exhibitions
Not available at press time.

Permanent Collection
Includes Greek and Roman, Mesoamerican, Asiatic, African, and medieval objects, Renaissance and Baroque paintings and sculpture, 19th century French sculpture, early modernist works, vintage and contemporary photographs, and contemporary paintings and sculpture. **Architecture:** 1993 building featuring a central stair that scissors back and forth allowing views to galleries, by acclaimed Spanish architect, Jose Rafael Moneo.

Admission: Free. Handicapped accessible.
Hours: Tues., Fri., Sat., 11–5; Wed., Thurs., 11–8; Sun., 1–5. Closed Mon.
Tours: Call (617) 283-2081.
Food & Drink: Call (617) 283-3379 for café hours.

Sterling and Francine Clark Art Institute

225 South St., Williamstown, MA 01267
(413) 458-9545
http://www.clark.williams.edu/

1998 Exhibitions
Feb. 14-May 3
The Museum and the Photograph: The Collection of the Victoria and Albert Museum, 1856-1998
Only U.S. venue for this exhibition of late-19th-century photography from the V&A Museum, London.

May 29-Sept. 7
Degas and the Little Dancer
Focuses on the evolution of the famous bronze sculpture *Little Dancer, Fourteen Years Old* by the French Impressionist. (T)

Permanent Collection
Outstanding collection of Old Master paintings, prints, drawings by Piero, Gossaert, Memling, Rembrandt, Tiepolo; distinguished holdings of French 19th-century Impressionist and academic painting and sculpture; work by Barbizon artists Corot, Millet, Troyon; English silver; American works by Cassatt, Homer, Remington, Sargent. **Highlights:** Degas, *Dancing Lesson*;

Homer, *Saco Bay, Prout's Neck*; Renoir, *Sleeping Girl with Cat;* Turner, *Rockets and Blue Lights*; Fragonard, *Portrait of a Man (The Warrior);* over 30 works by Renoir. **Architecture:** 1955 building by Daniel Perry; 1973 building by Pietro Belluschi and The Architects Collaborative, with 1996 addition by Ann Beha, Associates; 1963 service building with 1986 addition.

Admission: Free. Handicapped accessible, including braille signage and tour transcripts for the hearing impaired. Wheelchairs available.
Hours: Tues.–Sun., 10–5. Open daily, July and August. Closed Mon., Jan. 1, Thanksgiving, Dec. 25.
Programs for Children: Children's activity hand-outs available at Information Desk. Call for special programs.
Tours: July–Aug.: Mon.–Sun., 3. Call for group reservations.
Food & Drink: Snack cart, July–Oct., 10–5; picnic facilities.
Museum Shop: Open during museum hours.

Williams College Museum of Art

Main St., Williamstown, MA 01267
(413) 597-2429
http://williams.edu/WCMA

1998 Exhibitions

Ongoing

An American Identity: Nineteenth-Century American Art from the Permanent Collection
Examines the role the visual arts played in establishing an American national identity in the early years of the new republic. Includes works by Eakins, Harnett, La Farge, Remington, Saint-Gaudens, and Whistler.

Art of Ancient Worlds
A selection of ancient sculptures, vases, and artifacts from Greece, Rome, Egypt, the Near East, and the Americas, from the permanent collection.

Vital Traditions: Old Master Works from the Permanent Collection
A selection of 17 paintings by artists such as Gaudi, Ribera, and van Ostade highlight the artistic transition from the Renaissance to the Baroque periods.

Thru Feb. 1

Maurice Prendergast: The State of the Estate
A selection of 30 objects from the museum's vast holdings of works by Prendergast explores the "unofficial" view of his career, through sketches and abandoned works left in the artist's studio at his death.

Thru Apr. 19

Sculpture from the Permanent Collection
Features selected pieces by 20th-century artists, including Kiki Smith and Louise Nevelson.

Thru Apr. 26
Bill Pierson: When I Was a Painter
Features the memoirs of artist and former Williams College professor
William Pierson, Jr., including 25 paintings, watercolors, and drawings.

Thru June 1999
*"Inventing" the Twentieth Century: Selections from the Permanent
Collection (1900-1950)*
Examines the change in outlook and artistic representation caused by
science and technology in the self-consciously "new" world of the early
20th century.

Jan. 17, 1998-Dec. 2000
Tradition and Transition
Explores African royal art and colonial through postcolonial art collecting,
featuring functional objects used in religious or political ceremonial life.

Opens Feb. 28
The Edges of Impressionism
Explores the definition of "impressionism" through approximately 30
paintings and watercolors dating from the 1850s to the 1920s.

Opens Apr. 25
*Graphic Persuasion in the Mechanical Age: Selections from the Collection
of Merrill C. Berman*
Graphic materials, including posters, magazines, books, and drawings, by
designers such as Rodchenko, Schwitters, and van Doesburg. Catalogue.

Permanent Collection
Late 18th- to 19th-century American art by Copley, Eakins, Harding,
Harnett, Hunt, Inness, Peto, Stuart; early modern works by Demuth,
Feininger, Hopper, Marin, O'Keeffe, Prendergast, Wood; contemporary
works by de Kooning, Avery, Hofmann, Holzer, Motherwell, Rauschenberg,
Warhol; South Asian art including Indian 10th- to 18th-century sculpture,
17th- to 19th-century Mughal paintings. **Highlights:** American modernist
painting and sculpture; Cambodian and Indian sculptures; Charles and
Maurice Prendergast; Warhol, *Self-Portrait.* **Architecture:** 1846 Classical
Revival building by Tefft; 1983 and 1986 additions by Charles Moore.

Admission: Free. Handicapped accessible.
Hours: Tues.–Sat., 10–5; Sun., 1–5. Closed Mon., Jan. 1, Thanksgiving,
Dec. 25.
Tours: Call (413) 597-2429 for information and group reservations.

Worcester Art Museum

55 Salisbury St., Worcester, MA 01609
(508) 799-4406
http://www.worcesterart.org

1998 Exhibitions

Thru Jan. 4
American Impressionism: Paintings of Promise
Major exhibition of 50 paintings, watercolors, and pastels by artists such as Cassatt, Hassam, and Sargent. Catalogue.

American Impressionist Works on Paper
Includes works on paper by Cassatt and Prendergast from the museum's collection.

Jan. 25-Mar. 22
Worcester's Homers

Feb. 7-Mar. 15
Prints from the 1890s

Apr. 11-June 14
Highlights from European Color Prints

Apr. 18-June 21
Master Drawings from the Worcester Art Museum

Frank Benson, *Portrait of My Daughters*, 1907. From *American Impressionism: Paintings of Promise*. Photo courtesy Worcester Art Museum.

Permanent Collection

Fifty centuries of art from East to West, antiquity to the present: Indian, Persian, Japanese, Chinese art; 17th-century Dutch paintings; American 17th- to 19th-century paintings; contemporary art. **Highlights:** Benson, *Portrait of Three Daughters*; Copley, *John Bours*; Hokusai, *The Great Wave at Kanagawa*; del Sarto, *Saint John the Baptist*. **Architecture:** 1898 Neoclassical building by Stephen C. Earle; 1933 addition by William T. Aldrich; 1970 Higgins Wing by the Architects Collaborative; 1983 Hiatt Wing by Irwin A. Regent.

Admission: Adults, $6; seniors, students, youth 13–18, $4; children 12 and under, Sat. 10–12, free. Handicapped accessible, including parking. Wheelchairs and assisted-listening devices available.
Hours: Wed.–Fri., 11–4; Sat., 10–5; Sun., 11–5. Closed Mon., Tues.
Programs for Children: Contact the Education Dept. at (508) 799-4406, ext. 3007 for information.
Tours: For adult tours and packages, call (508) 799-4406, ext. 3076; for school tours call (508) 799-4406, ext. 3061.
Food & Drink: Museum Café open Wed.–Sun., 11:30–2. Closed Sun., June–Sept.
Museum Shop: Open during museum hours.

University of Michigan Museum of Art

525 S. State St., Ann Arbor, MI 48109
(313) 764-0395
http://www.umich.edu/~umma

1998 Exhibitions

Thru Jan. 4
Fifteen Visions: Books by Contemporary Regional Artists
Presents new and classic directions in book design, featuring 15 works by midwestern artists.

Glances and Gazes of the Social Fantastic: Early 20th-Century French Photography
A selection of photographs that capture the modern and extraordinary in everyday life, created by international artists working in France.

Lost Russia: Photographs by William Craft Brumfeld
Features images of crumbling churches and ruined castles in Russia.

Thru Feb.
Selections from the Lannan Foundation Gift, Part II
Features selections from a recent, major gift of contemporary art.

Jan. 10-Mar. 22
Dust-Shaped Hearts: Portraits of African-American Men by Donald Camp
Presents contemporary images created using pre-1900 photographic techniques.

Jan. 24-Mar. 15
Monet at Vétheuil: The Turning Point
Examines a transitional series of paintings that Monet executed in the winter of 1880, in which he depicts the elemental forces of nature in deserted landscapes. (T)

Aug. 15-Oct. 25
The Symbolist Prints of Edvard Munch: The Vivian and David Cambell Collection
The technical experimentation of Munch's graphic work is underscored in 59 prints by this important Norwegian artist, depicting themes of love and death in works such as *Madonna, The Sick Child,* and *Vampire.* (T)

Permanent Collection
Close to 14,000 objects, with representative holdings from both the Western and Asian traditions. Of special note are its collections of Chinese and Japanese paintings and ceramics; 20th-century sculpture; works of art on paper, including more than 150 etchings and lithographs by J.M. Whistler.
Architecture: Located in the University of Michigan's Alumni Memorial Hall building, a Neo-Classical structure built in 1910.

Admission: Free.
Handicapped accessible.
Hours: Tues.–Sat., 10–5;
Thurs., 10–9; Sun., 12–5.
Summer hours (Memorial
Day-Labor Day): Tues.–
Sat., 11–5; Thurs., 11–9,
Sun., 12–5. Closed Mon.
and major holidays.
Tours: For group tours
call (313) 647-2067.

Claude Monet, *The Breakup of the Ice (La Débacle)*, 1880.
Photo courtesy University of Michigan Museum of Art.

The Detroit Institute of Arts

5200 Woodward Ave., Detroit, MI 48202
(313) 833-7900 (general information); 833-2323 (ticket office)
http://www.dia.org

1998 Exhibitions

Thru Jan. 4
Splendors of Ancient Egypt
One of the largest exhibitions of ancient Egyptian treasures to visit the U.S.
in decades, featuring over 200 pieces dating back 4,500 years, including
statues, mummy cases, jewelry, wall carvings and ceramics. Catalogue. (T)

Thru Feb. 28
*Modern and Contemporary Masterpieces: Selections from the Permanent
Collection*
Highlights contemporary and sometimes controversial works, including
newly acquired works by Mike Kelley, Ellen Gallagher and Heather McGill.

Changing Spaces
Features 12 installation art projects by artists of international fame,
including Anish Kapoor, Mona Hatoum, and Carrie Mae Weems.

Thru Spring
Early Modern Masterpieces: Selections from the Permanent Collection
A selection of approximately 50 modern European and American paintings,
sculptures, and decorative arts.

Thru July 4
*A Renaissance Altarpiece Preserved: Techniques and Conservation of
Tobias and Three Archangels*
Documents the conservation of this painted wooden altarpiece from 15th
century Florence, which has been undergoing five years of critical
examination and treatment in the DIA's Conservation Services Laboratory.

Jan. 25-Apr. 5
A Celebration of Lithography: Nineteenth-Century Invention and Innovation
Two-part survey of great achievements in printmaking celebrates 200th anniversary of invention of lithography. Includes works by Goya, Delacroix, Gericault, Daumier, Manet, and Toulouse-Lautrec.

Apr.-June 14
Claes Oldenburg: Printed Stuff
Examines over 130 works created between 1959 and 1995 by this innovative American artist, revealing the connections between his prints, posters, drawings, and unique sculptures. Catalogue. (T)

May 7-Aug. 16
A Celebration of Lithography: 20th-Century Expansion and Exploration
Features lithographic works by 20th-century artists including Picasso, Bellows, Dine, Johns, Rauschenberg, and Rosenquist.

Aug. 23-Oct. 18
The Invisible Made Visible: Angels from the Vatican Collection
Traces the icongraphy of angels in various cultures from the 9th century B.C. to the 20th century A.D., including more than 100 works of art and artifacts never before seen outside the Vatican. (T)

Permanent Collection
Extensive holdings of African and Native American arts; European and American masterpieces from the Middle Ages to the present; decorative arts; graphic arts; theater arts; textiles; Asian and Near Eastern art; 20th-century decorative arts; period rooms. **Highlights:** Brueghel, *Wedding Dance*; Caravaggio, *Conversion of the Magdalen*; Degas, *Violinist and Young Woman*; van Eyck, *Saint Jerome in His Study*; Picasso, *Bather by the Sea*; Rembrandt, *The Visitation*; van Gogh, *Self-Portrait*; Whistler, *Arrangement in Gray: Portrait of the Painter* and *Nocturne in Black and Gold: The Falling Rocket*; Rachel Ruysch, *Flowers in a Glass Vase on a Marble Ledge*; German Expressionist paintings by Kirchner, Klee, Nolde; courtyard with Rivera's *Detroit Industry* fresco. **Architecture:** 1927 Italianate building by Paul Cret; two wings, 1966 and 1971, designed by Harley, Ellington, Cowin & Stirton. Michael Graves chosen in 1989 as Master Plan architect for renovation and proposed expansion.

Admission: Donation required. Suggested donation: adults, $4; children, students, $1. Handicapped accessible.
Hours: Wed.–Fri., 11–4; Sat.–Sun., 11–5. Closed Mon.–Tues., holidays.
Tours: Wed.–Sat., 1; Sun., 1, 2:30. For group tour reservations call (313) 833-7981.
Food & Drink: Kresge Café open Wed.–Fri., 11–3:30; Sat.–Sun., 11–4:30. Gallery Grill open Wed.–Fri., 11:30–2; Sun., 11–3, closed Sat.
Museum Shop: Offers gifts and museum souvenirs; (313) 833-7944.

Grand Rapids Art Museum

155 Division North, Grand Rapids, MI 49503
(616) 459-4677
http://www.gram.mus.mi.us

1998 Exhibitions

Thru Feb. 1
Perugino: Master of the Italian Renaissance
More than 30 paintings and watercolors by Renaissance artist Pietro
Perugino make their United States debut at this sole U.S. venue.

Thru Feb. 22
Inspired by Italy: Works from the Permanent Collection
Examines the influences of the land, light, and culture of Italy on
generations of artists.

Thru Feb. 28
The Faces of Perugia: A Photographic Essay
Explores the people and places of Perugia–Grand Rapids's sister-city–and
the surrounding environs of Umbria, Italy.

Thru June
The Renaissance City
Architectural models trace the evolution of classic Renaissance style,
focusing on 16th-century Italian architect Palladio and his influence on later
English and American styles.

Mar. 20-Aug. 16
*Public Sculpture in Grand Rapids 1969/1999: Alexander Calder and Maya
Lin*
Celebrates the new sculpture by Maya Lin and *La Grande Vitesse* stabile by
Calder, featuring maquettes, notes, and drawings.

Sharon Sandberg
A collection of still life paintings made during the last ten years, influenced
by the artist's travels to France and England.

May 16-July 31
Cover the Bases: West Michigan Whitecaps Program Cover Competition
Third annual exhibition of work with a baseball theme by local artists.

Aug. 1, 1998-June 8, 1999
Calder for Kids
The museum's hands-on gallery for children features the art of Alexander
Calder, with learning games and art making activities.

Oct. 16, 1998-Jan. 31, 1999
Mathias Alten
Retrospective exhibition of work by this well-known painter who worked in
Grand Rapids in the early 1900s.

American Art from the Permanent Collection
Paintings, drawings and prints from the museum's collection.

Permanent Collection

Old Master prints, drawings; American and European paintings, furniture, photographs, sculpture, decorative arts. **Highlights:** Chase, *The Opera Cloak*; Schmidt-Rottluff, *Harvest*; Pechstein, *Reflections*; Diebenkorn, *Ingleside*; Hartigan, *Riviera*; Calder, *Red Rudder in the Air;* Mathias Altens murals, *The Sources of Wealth,* and *The Uses of Wealth;* prints by Vlaminck, Miró, Braque, Matisse, Moore, Picasso; English, French, Italian, Asian furniture from the late 18th century to present; furniture by Nelson, Wright and Eames. **Architecture:** 1910 Beaux Arts Federal Building by James Knox Taylor.

Admission: Adults, $3; seniors, $1.50; students, $1; children 5 and under, members, Thurs., 5–9, free. Handicapped accessible.
Hours: Tues., Sun., 12–4; Wed., Fri., Sat., 10–4; Thurs., 10–9; closed Mon.
Programs for Children: Hands-on interactive gallery and other programs.
Tours: Call (616) 459-4677 for group reservations.

Pietro Perugino, *Madonna and Child.* From *Perugino: Master of the Italian Renaissance.* Photo courtesy Detroit Institute of Arts.

The Minneapolis Institute of Arts

2400 Third Ave. South, Minneapolis, MN 55404
(612) 870-3131; 870-3200 (recording)
http://www.artsMIA.org

1998 Exhibitions

Thru Jan. 4
Photographs from the Collection of Harry Drake
Examines 75 works by 25 major 20th-century photographers, including
Minor White, Brett Weston, and others.

Thru Jan. 25
New England Hearth and Home: A Passion for the Past
Fine and decorative arts from the collection of Bertram K. and Nina Fletcher
Little, including 115 objects from 17th- to 19th-century New England. (T)

New England Hearth and Home: Inherited and Collected
Features objects brought to Minnesota by early settlers.

Thru Feb. 8
Katherine Turczan
Large-scale portraits by this contemporary photographer examine the lives
of women in post-Communist Ukraine.

Thru Feb. 15
Color, Color, Who's Got the Color? Kaffe Fassett
Features 136 needleworks, garments, wall hangings, and quilts by textile
artist Fassett.

Thru Apr. 19
Starburst Splendor: Selections from the Minnesota Quilt Project

Thru Apr.
Dyeing to Please: From Surface Application to Total Immersion
Concerns techniques of dye application and the effects of the process on
ecomomics, specialized labor, and international trade.

Jan. 24-May 17
Fotografs of Flowers
Uses of flowers illustrated by 60 photographs from the museum's collection.
Includes works by Ansel Adams, Edward Steichen, and James Van Der Zee.

Feb. 22-May 3
*Jacob Lawrence: The Frederick Douglass and Harriet Tubman Series of
Narrative Paintings*
Scenes from the lives of two Abolitionist heroes, by the acclaimed painter of
the "migration series." Catalogue.

Mar. 6-Apr. 19
Roy Strassberg

Apr. 4-July 5
Netsuke: The Japanese Art of Miniature Carving
Explores this stylish and secular form of miniature sculpture that gained
popularity in 17th-century Japan.

May 16-Aug. 9
Artisans in Silver: Judaica Today
Presents contemporary hand-made Jewish ritual silver, including 54 objects
of various styles and techniques.

May 31-July 26
Turning Point: Monet's Débacles at Vétheuil
Examines a transitional series of paintings that Monet executed in the winter
of 1880, in which he depicts the elemental forces of nature in deserted
landscapes. (T)

Sept. 5, 1998-Feb. 1999
Memory of the Hand
Features sculptures by Rosalind Driscoll, who creates works of art for
people with limited or no eyesight.

Nov. 14, 1998-Jan. 17, 1999
Isn't S/He a Doll? Play and Ritual in African Sculpture
African conceptions of "dolls" challenge the Western notion of them as
playthings, featuring 212 sculptures from 24 countries.

Permanent Collection

African and Asian art; European and American paintings, prints, drawings,
sculptures, photographs, decorative art; period rooms; American textiles.
Highlights: Chinese bronzes, jades, silks; Greco-Roman Doryphoros;
American and British silver; works by Poussin, Rembrandt, van Gogh,
Degas, Goya, Bonnard; prints, drawings by Goya, Rembrandt, Watteau,
Blake, Ingres, Toulouse-Lautrec, Johns; photography by Stieglitz, Steichen,
Adams; sculpture by Picasso, Brancusi, Calder; nine period rooms.
Architecture: 1915 Neoclassical building by McKim, Mead, & White;
1974 wing by Kenzo Tange. New construction and reinstallation in
progress, scheduled to be completed in August 1998.

Admission: Free. Small fee for some exhibitions.
Hours: Tues.–Sat., 10–5; Thurs., 10–9; Sun., noon–5. Closed Mon., July 4,
Thanksgiving, Dec. 25.
Tours: Tues.–Sun., 2; Thurs., 7; Sat.–Sun., 1. American Sign Language
interpretation first Sun. of month. Call (612) 870-3140 for group tours.
Food & Drink: Studio Restaurant open Tues.–Sun., 11:30–2:30.
Museum Shop: Articles, a new shop, scheduled to open in July.

Minnesota Museum of American Art

Landmark Center Galleries, 75 W. 5th St., St. Paul, MN 55401
(612) 292-4355 (recording)
http://www.mtn.org/MMAA

1998 Exhibitions

NOTE: The Landmark Center galleries will be closed until Feb. 20 for major renovation and expansion.

Opens Feb. 21
Past/Present: The Permanent Collection
Focuses on works from the early decades of the 20th century.

Feb. 21-May 17
Half-Past Autumn: The Art of Gordon Parks
First retrospective of the works of this noted American artist who has overcome adversity to create works that express his message of hope. (T)

Gordon Parks, *Ethel Shariff in Chicago,* 1963. Collection of the artist. From *Half Past Autumn: The Art of Gordon Parks.* Photo courtesy of Corcoran Gallery of Art.

June 7-Aug. 9
Bearing Witness: Art by Contemporary African-American Women
Features works by contemporary artists that address issues of history, ethnicity, gender, class, religion, and marginalization.

Aug. 30-Nov. 29
Strong Hearts: Native American Visions and Voices
Portraits of contemporary life by Native American photographers.

Permanent Collection

Features American paintings, prints, and sculpture, including works by Thomas Hart Benton, Albert Pinkham Ryder, Charles Burchfield, Romare Bearden, Clementine Hunter, Grant Wood, and Donald Sultan. Contemporary Midwest works by Francis Yelvo, Patrick DesJarlait, and Hazel Belvo; recent acquisitions include Yi Kai, *Mixture Forever;* Ed Archie Noisecat, *Sea Monster* and *Otter.* **Highlights:** Childe Hassam, *The Pearl Necklace;* Jacob Lawrence, *Procession.* **Architecture:** 1902 Old Federal Courts Building, restored as Landmark Center; 1997 renovation by architect Joan Soranno and Hammel Green & Abrahamson.

Admission: Free. Handicapped accessible, including ramps, elevators, and braille signage.
Hours: Tues.–Sat., 11–4; Thurs. 11–7:30; Sun., 12–5. Closed Mon.
Programs for Children: Summer art classes and camp; Winter classes, Sat.; public school curriculum and tours.
Tours: Call (619) 292-4367 for information.

Walker Art Center

Vineland Place, Minneapolis, MN 55403
(612) 375-7622; 375-7585 [TDD]
http://www.walkerart.org

1998 Exhibitions

Continuing
Selections from the Permanent Collection
Presents a fresh look at art history,
including works by Johns, Nevelson,
Warhol, and lesser-known, emerging
artists.

Thru Jan. 4
Joseph Beuys Multiples
This post-World War II German artist saw
multiples as a means to effect social
change. Includes 300 objects that reflect
his ideas about nature, healing,
communication, energy, politics, and
teaching. (T)

Robert Colescott, *Exotique*, 1994. Photo
courtesy Walker Art Center.

Thru Jan. 18
The Architecture of Reassurance: Designing the Disney Theme Parks
Explores the architecture of one of the great postwar American icons:
Disneyland. Includes plans, drawings, paintings, and models. (T)

Jan. 25-Apr. 5
Robert Colescott: Recent Paintings
Includes 19 works from the past 10 years by this Arizona-based artist who
addresses issues of race, identity, power, gender, and human relations.

Feb. 22-May 24
100 Years of Sculpture: From the Pedestal to the Social
Examines a century of sculptural developments and the influence of
minimalism. Includes works by Rodin, Arp, Hepworth, Warhol, and
Oldenburg.

May 3-Nov. 15
Sculpture on Site
Commissioned installation works by local sculptors, involving issues of
shelter and mobility at the end of the century.

June 28-Sept. 20
Art Performs Life: Cunningham, Monk, Jones
Traces the role of performance in 20th-century art and the careers of three
great innovators: Merce Cunningham, Meredith Monk, and Bill T. Jones.

Dec. 19, 1998-Mar. 7, 1999
Yayoi Kusama in New York, 1958–1968
Includes 80 installations, paintings, and other works by this post-minimalist
Japanese artist, dating from her most influential years. (T)

Permanent Collection

Primarily 20th-century art of all major movements; over 11-acre outdoor sculpture garden containing works by modern and contemporary artists. **Highlights:** Johns, *Green Angel*; Marc, *The Large Blue Horses*; works by O'Keeffe, Nam June Paik, Rothko; Warhol, *16 Jackies*; Minneapolis Sculpture Garden: 40 works by established 20th-century masters and by leading contemporary artists. **Architecture:** 1971 building, 1983 addition, and 1988 Minneapolis Sculpture Garden by Barnes; 1992 expansion by Michael van Valkenburgh Associates, Inc.

Admission: Adults, $4; students with ID, youth 12–18, groups of 10 or more, seniors, $3 per person; members, children under 12, AFDC cardholders, free. Thurs., first Sat. of each month, free. Sculpture Garden free. Handicapped accessible. Signed interpretation, touch tours, and wheelchairs available.
Hours: Tues., Weds., Fri., Sat., 10–5; Thurs., 10–8; Sun., 11–5. Closed Mon., major holidays. Sculpture Garden: 6 am-midnight.
Programs for Children: Sunday Fun Workshops, Weekday Play, Art Lab.
Tours: Thurs., 2, 6; Sat.–Sun., noon, 2. Groups call (612) 375-7609.
Food & Drink: Gallery 8 Restaurant open Tues.–Sun., 11:30–3.
Museum Shop: Open during museum hours.

Mississippi Museum of Art

201 E. Pascagoula St., Jackson, MS 39201
(601) 960-1515
http://www.Instar.com/mma

1998 Exhibitions

Thru Feb. 15
Body and Soul: Contemporary Southern Figures
Explores the human figure and the forces that shape the human condition, through works of diverse media created by artists currently living in the South. Catalogue.

Mar. 7-July 26
Our Nation's Colors: A Celebration of American Masters
Highlights modernist American painting, with important works by Bellows, Cassatt, Henri, Eakins, Homer, Hopper, and O'Keeffe. Catalogue. (T)

Aug.-Oct.
Lois Mailou Jones and Her Students: An American Legacy of Seven Decades of American Art, 1930-1995
A tribute to Jones, an inspired teacher and artist from Washington, D.C., and 38 of her Howard University students whose works represent the struggles and triumphs of artists of color.

Permanent Collection

More than 3,100 works of art spanning thousands of years of art history. The MMA is home to the world's largest collection of art by and relating to

Mississippians and their culturally diverse heritage. Its collections are also notably strong in 19th and 20th century American landscape paintings, 18th century British paintings and furniture, Japanese prints, pre-Columbian ceramics, and Oceanic art.

Highlights: Collection Gallery.

Architecture: Building opened in 1978; includes galleries, sculpture garden, research library, and art school.

Admission: Adults, $3; seniors, children, students, $2; members, children under 3, free. Handicapped accessible.

Hours: Mon.–Sat., 10–5; Sun., 12–5. Closed major holidays.

Programs for Children: Offers programs and special tours year-round.

Edward Hopper, *Conference at Night,* 1949. From *Our Nation's Colors: A Celebration of American Painting.* Photo courtesy Mississippi Museum of Art.

Tours: Please contact the Education Department for information.

Food & Drink: Palette Restaurant open Mon.–Fri., 11:30–1:30.

Museum Shop: Offers hand-made gifts by local artists. Open Mon., 11–2; Tues.–Fri., 10–4; Sat., 12–4; Sun., 1–4.

The Nelson-Atkins Museum of Art

4525 Oak St., Kansas City, MO 64111
(816) 561-4000; (816) 751-1ART (recording); (816) 751-1263 [TDD]
http://www.nelson.atkins.org

1998 Exhibitions

Thru Jan. 4
Inventing the Southwest: The Fred Harvey Company and Native American Art
Retrospective of early American railroad travel and its effect on Native peoples and Native American art. (T)

Feb. 22-May 31
One Hundred Treasures: Prints from the Permanent Collection
A selection of 100 rare prints dating from the 15th through the 20th century.

May 9, 1998-Mar. 21, 1999
Ursula von Rydingsvard
An outdoor exhibition of sculpture by this German artist.

July 12-Sept. 6
Dürer to Matisse: Master Drawings from the Permanent Collection
Features a selection of more than 70 European drawings, including works by Dürer, Gainsborough, Degas, and Matisse.

The Art and Mystery of the Cabinetmaker, 1700-1950
Introduces visitors to the basic practices of furniture making. Includes furniture by cabinetmakers from around the world.

Oct. 11, 1998-Jan. 3, 1999
John Steuart Curry: Inventing the Middle West
Paintings, drawings, and watercolors by this American artist known, with Grant Wood and Thomas Hart Benton, as one of the trinity of Regionalism. (T)

Oct. 25, 1998-Jan. 10, 1999
Print Society 20th Anniversary Exhibition
Gifts to the museum from the Print Society over the past 20 years.

Permanent Collection
European and American paintings, sculptures, prints, decorative arts; American, Indian, Oceanic, pre-Columbian art; renowned collection of Asian art; modern sculpture. **Highlights:** Largest permanent U.S. display of Bentons; Bingham, *Canvassing for a Vote;* Caravaggio, *Saint John the Baptist;* Guercino, *Saint Luke Displaying a Painting of the Virgin;* de Kooning, *Woman IV*; Kansas City Sculpture Park; Oldenburg and van Bruggen, *Shuttlecocks;* Poussin, *The Triumph of Bacchus;* Rembrandt, *Youth with a Black Cap;* Renoir, *The Large Bather.* **Architecture:** 1933 Neoclassical building, designed by Thomas and William Wight.

Admission: Adults, $5; students, $2; children 6–18, $1; children under 5, free. Sat., free to all. Handicapped accessible. Elevators and wheelchairs available.
Hours: Tues.–Thurs., 10–4; Fri., 10–9; Sat., 10–5; Sun., 1–5. Closed Mon., Jan. 1, July 4, Thanksgiving, Dec. 24–25.
Programs for Children: Classes, tours, and more. Call the Creative Arts Center at (816) 751-1236 for information.
Tours: Offered 4 times daily. Call (816) 751-1238.
Food & Drink: Rozzelle Court Restaurant open Tues.–Thurs., 10–3; Fri., 10–3, 5–8; Sat., 10–3:30; Sun., 1–3:30.
Museum Shop: Open during museum hours.

The Saint Louis Art Museum

One Fine Arts Drive, Forest Park, St. Louis, MO 63110
(314) 721-0072
http://www.slam.org

1998 Exhibitions
Thru Jan. 4
Navajo Weavings from the Andy Williams Collection

Thru Jan. 11
Women Photographers: A Private Collection

Thru Jan. 18
The Art of Embroidery (Part One)

Thru Feb.
Currents 72: Shannon Kennedy

Thru May 17
Ancient Chinese Bronzes

Jan. 20-May 31
The Art of Embroidery (Part Two)

Jan. 27-May 10
Late-19th-Century American Watercolors and Drawings

Feb.-Apr.
Currents 73: Dan Peterman

Feb. 7-Apr. 5
Ancient Gold: The Wealth of the Thracians, Treasures from the Republic of Bulgaria
Over 200 masterpieces of gold and silver metalwork from ancient Thrace, located in central Europe between 4,000 B.C. and the 4th century A.D. (T)

Spring
Currents 74: Phil Robinson

May 9-Aug. 2
The Invisible Made Visible: Angels from the Vatican Collection
Traces the iconography of angels in various cultures from the 9th century B.C. to the 20th century A.D., including more than 100 works of art and artifacts never before seen outside the Vatican. (T)

June-Aug.
Sam Reveles Drawings

Sept. 12-Nov. 29
Masterpieces from Central Africa

Sept. 22-Nov. 22
Currents 75: Diana Thater

Oct. 1998-Jan. 1999
Seydou Keita

Nov. 1998-Jan. 1999
Currents 76: Gabriel Orozco

Permanent Collection
Encompasses art of many periods, styles, and cultures: African, Asian, Oceanic, American Indian, Pre-Columbian art; European Old Master paintings, drawings; American art from colonial times to the present; French Impressionism, Post-Impressionism, German Expressionism; 20th-century European art; decorative arts, including six period rooms. **Highlights:** Chagall, *Temptation*; Fantin-Latour, *The Two Sisters*; van Goyen, *Skating on the Ice near Dordrecht*; Smith, *Cubi XIV*; Vasari, *Judith and Holofernes*; Stella, *Marriage of Reason and Squalor*; Kiefer, *Breaking of the Vessels*; world's largest Max Beckmann collection. **Architecture:** 1904 building by Gilbert for World's Fair; 1977 renovation by Hardy Holzman Pfeiffer Associates; 1980 South Wing by Howard, Needles, Tammen, and Bergendorff; 1988 West Wing renovation by SMP/Smith-Entzeroth.

Admission: Free. Entrance fee for special exhibitions: Adults, $5; seniors and students, $4; children 6-12, $3; Tues., free. Members, free. Handicapped accessible; wheelchairs available.
Hours: Tues., 1:30–8:30; Wed.–Sun., 10–5. Closed Mon., Jan. 1, Thanksgiving, Dec. 25.
Tours: Thirty-minute tour, Wed.–Fri., 1:30; hour tour, Sat.–Sun., 1:30.

Yellowstone Art Museum

410 N. 27th St., Billings, MT 59101
(406) 256-6804
http://www.yellowstone.artmuseum.org

1998 Exhibitions
NOTE: The museum will re-open in February following a project of renovation and expansion.

Gary Bates, *Will-He-Drill*, 1987. Photo courtesy Yellowstone Art Museum.

Opens Feb. 27
Will James, Paintings and Drawings
Features works and memorabilia by this celebrated cowboy artist.

Feb. 27-June 7
Yellowstone Art Museum Inaugural Exhibition: A Survey of the Permanent Collection
Features modern and contemporary works by regional artists.

June 12-Aug. 23
Brad Rude: Original Nature
Focuses on this Montana-born artist who is known for his lively polychromed bronzes representing the "interconnectedness of all things."

Aug. 28-Oct. 25
New Realities: Hand-Colored Photographs
Survey of 70 hand-colored photographs from the 1840s to the present.

Nov. 1-Dec. 31
Paintings from the Isaac Brodsky Museum, St. Petersburg, Russia
Exclusive U.S. showing features 75 paintings from the late 19th and early 20th century by Russian artists.

Permanent Collection
Nearly 2,000 objects, in a variety of media, highlighting contemporary and regional art. Artists include Rudy Autio, Russell Chatham, Clarice Dreyer, Churck Forsman, Will James, Jaune Quick-to-See Smith, and Bill Stockton.

Highlights: John Buck/Deborah Butterfield, *Collaboration.* **Architecture:**
Turn-of-the-century brick building, the former Yellowstone County Jail,
renovated in 1964. Two new wings designed by architect Thomas Hacker,
completed in early 1998.

Admission: Adults, $3; seniors, students, $2; ages 6–12, $1. Handicapped
accessible.
Hours: Call for hours.
Programs for Children: Guided tours and exhibition-related creative
activities and events offered. Call for information.
Tours: Group tours available; call (406) 256-6804 for reservations.
Food & Drink: Cafe open after Feb. 1998. Call for hours.
Museum Shop: Open Tues.–Sun., offering gift items related to the Old and
New West. Call (406) 256-6886 for information.

Sheldon Memorial Art Gallery and Sculpture Garden

University of Nebraska, 12th and R Sts., Lincoln, NE 68588-0300
(402) 472-2461
http://sheldon.unl.edu

1998 Exhibitions

Thru Jan. 4
Christo and Jeanne-Claude: The Tom Golden Collection
Over 90 original drawings, collages, wrapped objects, photographs, and
prints document the projects of Christo over the past 37 years.

Thru Jan. 18
Van Der Zee, Photographer, 1886-1983
Selection of 80 black & white and hand-tinted photographs documenting the
Harlem Renaissance.

Thru Feb. 1
Contemporary Glass
Special holiday exhibition features works from the museum and local
collections.

Jan. 7-Mar. 22
Trains that Passed in the Night: The Railroad Photos of O. Winston Link
Photographs of the Norfolk and Western Railway steam-powered railroads.
Catalogue.

Jan. 9-Apr. 12
Weldon Kees and the Arts at Midcentury
Featuring 40 paintings and collages focusing on the artist's involvement
with the New York School painters in the mid-1940s.

Jan. 20-Mar. 29
The Grapes of Wrath *Family Album: The Photos of Horace Bristol*
Photographs from the artist's collaboration with writer John Steinbeck in
1938, which Steinbeck used as a major source for *The Grapes of Wrath.*

Mar. 31-May 31
Story: Language as Image
Features the work of 20th-century American artists who have focused on the expressive potential of language as an aesthetic vocabulary.

Mar. 24-June 29
Icons of Public Memory: Photographs from the Collection of the College of Journalism

Joseph Cornell, *Pipe Box*, c. 1960. Photo by John Spence, courtesy Sheldon Memorial Art Gallery.

Apr. 7-June 7
Sheldon Soho: Carol Haerer, The White Paintings
Features this Nebraska-educated artist's well-known series of white paintings, created in the 1960s and 1970s.

Apr. 15-June 29
The Human Factor: Figuration in Contemporary American Art

June 9-Aug. 30
Original Lithographs from the Collectors' Graphics
A selection of prints from this experimental workshop established in the early 1960s.

June 30-Aug. 30
The Photographs of Harold Edgerton
A recent donation of 61 prints taken with a stroboscope, a device that this Nebraska artist invented.

July 1-Aug. 30
Contemporary California Painting: The Mickey and Ruth Gribin Collection
Recently donated paintings consisting of work created in the Los Angeles area from the 1960s to the 1980s.

July 14-Sept. 20
German Expressionist Prints from the Permanent Collection
An in-depth survey of the European avant-garde movement.

Sept. 1-Nov. 1
Joan Mitchell
An intimate view of this important contemporary American painter, whose career spans over 40 years of artistic activity.

Sept.-Dec.
Different Voices: New Art from Poland
Features the work of over 20 Polish artists who have utilized textiles, fabrics, and weavings to create vital contemporary art.

Permanent Collection
Prominent holdings of American art from the 18th century to the present, with an emphasis on the 20th century, including paintings, sculpture, prints,

photographs, ceramic, and decorative arts. American Impressionism, early modernism, geometric abstraction, Abstract Expressionism, Pop, Minimalism, and contemporary art represented. **Highlights:** Outdoor Sculpture Garden, featuring 34 works by Lipchitz, Smith, Serra, and others. **Architecture:** 1963 Italian travertine marble building by Philip Johnson. Capital fund-raising campaign for physical expansion is currently in progress.

Admission: Donation suggested. Handicapped accessible, including elevators; guide animals permitted; sign interpreters available.

Hours: Tues.–Sat., 10–5; Thurs.–Sat. 7–9; Sun., 2–9. Closed Mon., major holidays.

Programs for Children: Annual public school tours; annual family day.

Tours: Call (402) 472-2461 for reservations (2 weeks in advance).

Food & Drink: Picnic areas available in campus-wide sculpture garden.

Museum Shop: Open Tues.–Sat., 10–5; Sun., 2–5.

Joslyn Art Museum

2200 Dodge St., Omaha, NE 68102
(402) 342-3300
http://www.joslyn.org

1998 Exhibitions

Thru Jan. 11
Midlands Invitational 1997: Photography
Third annual exhibition features work by artists in Nebraska and surrounding states.

Thru Feb. 8
Affinities of Form: Art of Africa, Oceania, and the Americas from the Raymond and Laura Wielgus Collection
Over 90 works highlight these rich and diverse cultures over 3,000 years.

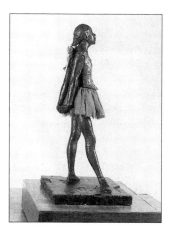

Includes ritual and domestic objects from Mali, Nigeria, Zaire, and the Americas. (last venue)

Thru July 19
Making Art Last: The Care and Conservation of Museum Collections
Focuses on the preservation and conservation of works of art.

Feb. 7-May 3
Degas and the Little Dancer
Focuses on the evolution of the famous bronze sculpture *Little Dancer, Fourteen Years Old* by the French Impressionist. (T)

Edgar Degas, *Little Dancer, Fourteen Years Old,* 1881.
Photo by Robert Irvin, courtesy Joslyn Art Museum.

Feb. 14-Apr. 12
Old Masters Brought to Light: European Paintings from the National Museum of Art of Romania
A rich collection of Old Master paintings from the 15th through the 17th centuries. Includes works by Rembrandt, El Greco, and Zurbarán never seen before in the U.S. (T)

Mar. 14-May 17
Life Cycles: The Charles E. Burchfield Collection
Surveys the work of this American painter, naturalist, and social critic through themes of American life, landscape, time, and memory. (T)

May 30-Sept. 6
The Trans-Mississippi Exposition Salon
Includes 24 paintings brought back to Omaha to celebrate the centenary of this Exposition and to illustrate concepts of modern art, both then and now.

June 7-Aug. 9
Joseph Beuys Multiples
This post-World War II German artist saw multiples as a means to effect social change. Includes 300 objects that reflect his ideas about nature, healing, communication, energy, politics, and teaching. (T)

Aug. 29-Oct. 25
Visions and Voices: Native American Paintings from the Philbrook Museum of Art
Explores the stylistic evolution of Native American art, from early flat-style easel paintings to more abstract works.

Permanent Collection
Works from antiquity to the present; major holdings of 19th- and 20th-century European and American art; Native American art; works by artist-explorers Bodmer, Catlin, Miller, Remington, documenting the movement to the American West. **Highlights:** Degas, *Little Dancer, Fourteen Years Old*; Pollock, *Galaxy*; Renoir, *Young Girls at the Piano*; Segal, *Times Square at Night*; Titian, *Man with a Falcon*; Monet, *Small Farm at Bordighera*; Storz Fountain Court. **Architecture:** Art Deco building, clad in Georgia Pink marble, by John and Alan McDonald opened in 1931. 1994 renovation and expansion, including a glass atrium which joins the original building to the complementary new wing, by Sir Norman Foster and Partners, of London.

Admission: Adults, $4; seniors, children 5–11, $2. Children under 5 and Sat., 10–noon, free. Group rates available. Handicapped accessible.
Hours: Tues., Wed., Fri., Sat., 10–5; Thurs., 10–8; Sun., 12–5. Closed Mon., holidays.
Programs for Children: Classes and camps throughout the year.
Tours: Wed., 1; Sat., 11, 2; Sun., 1; Call (402) 342-3300, ext. 206 two weeks in advance for group reservations.
Food & Drink: Café Durham open Tues.–Sat., 11–4; Sun., 12–4.
Museum Shop: Open during museum hours.

Currier Gallery of Art

201 Myrtle Way, Manchester, NH 03104
(603) 669-6144

1998 Exhibitions

Thru Feb. 2
New Hampshire Art Association 51st Annual Exhibition

Jan. 31-May 4
*Trashformations: Recycled Materials
in Contemporary American Art and
Design*

July 11-Sept. 21
*The Gloria Wilcher Memorial
Exhibition*

Oct. 10, 1998-Jan. 4, 1999
*Photography from the Currier
Gallery of Art*

Permanent Collection

European and American painting,
sculpture, and decorative arts from
the 13th century to the present.
Collection contains many significant
works by New Hampshire artists and
craftsmen including the Dunlap
family; European paintings by Joos
Van Cleve, Jan De Bray, Monet,
Rouault, Picasso, and Tiepolo; works
by American artists including

Samuel Miller, *Emily Moulton,* 1852. Photo
courtesy Currier Gallery of Art.

Bierstadt, Cropsey, Church, Hassam, Hartley, O'Keeffe, Sheeler, and Wyeth;
sculpture by Remington, Saint-Gaudens, Nevelson, Calder, Caro, Lachaise,
and Matisse. **Architecture:** 1929 museum building by Tilton and Githens
in the Beaux-Arts Italianate style; mosaics by Salvatore Lascari, listed on the
National Register of Historic Places; 1982 pavilions added by Hardy
Holzman Pfeiffer. The Zimmerman House, designed in 1950 by American
architect Frank Lloyd Wright, is the only Wright-designed residence in New
England open to the public; "Usonian" house includes original built-in and
freestanding furniture, textiles, and landscaping designed by Wright.

Admission: Adults, $5; seniors, students, $4; under 18, members, Sat. 10–1,
free. Zimmerman House (includes admission to museum): Adults, $7;
seniors, students, $5. Handicapped accessible.
Hours: Mon., Wed., Thurs., Sun., 11–5; Fri., 11–9; Sat., 10–5. Closed Tues.
Programs for Children: Offers classes and workshops.
Tours: Groups call (603) 626-4158 for reservations.
Food & Drink: The Currier Café open for lunch: Mon., Wed.–Sat., 11:30–
2; Coffee/pastries served 2–4; open Sun. for seasonal brunch. Closed Tues.
Museum Shop: Open during museum hours.

Hood Museum of Art

Wheelock St., Dartmouth College, Hanover, NH 03755
(603) 646-2808

1998 Exhibitions

Thru Jan. 4
Intimate Encounters: Love and Domesticity in 18th-Century France
Major exhibition of French 18th-century genre painting, including works by Watteau, Chardin, Boucher, and Fragonard. (T)

Thru Aug.
Sepik Compositions: Line and Form in the Art of Papua New Guinea
A selection of warrior's shields and ceremonial sago palm bark paintings representing ten different cultures of the Sepik River basin.

Albrecht Dürer, *Knight, Death, and Devil*, 1513. Gift of Jean K. Weil in memory of Adolph Weil, Jr., Dartmouth Class of 1935. Photo courtesy Hood Museum of Art, Dartmouth College.

Jan. 17-Apr. 12
American Paintings from the Hood Museum of Art, 1910-1960
Surveys a range of artistic responses to modern American life, featuring 30 paintings by artists including Sloan, O'Keeffe, Shahn, and Gottlieb.

Jan. 24-Apr. 12
Recent Acquisitions: Contemporary Art
A selection of contemporary paintings, drawings, sculptures, and photographs, including works by Brice Marden, Sally Mann, and others.

Romare Bearden: Collages and Prints
Features 15 works by renowned African-American artist Bearden (1914-1988), including examples from his *Mecklenberg County* series.

Apr. 25-July 5
Jasper Johns: Process and Printmaking
Examines the creative process behind the prints of this important American artist, featuring proofs and finished prints spanning his entire career. (T)

July 18-Oct. 4
Ursula von Rydingsvard: Sculpture and Drawings
Features this artist's large-scale cedar sculptures that resonate with a sense of history, recalling organic forms, landscapes, and man-made objects.

Oct. 17, 1998-Jan. 3, 1999
A Gift to the College: The Weil Collection of Old Master Prints
Approximately 75 prints, including woodcuts, engravings, and etchings by artists such as Dürer, Rembrandt, Mantegna, Canaletto, and Blake.

Opens Dec. 18
Willard Metcalf in Cornish, New Hampshire, 1909-1920
Features lyrical renderings of the New Hampshire landscape by this admired American Impressionist. Catalogue.

Permanent Collection

Represents nearly every area of art history and ethnography; strengths include African, Oceanic, and Native North American art; early American silver; 19th- and 20th-century American painting, European prints, and contemporary art. **Highlights:** Assyrian reliefs; Panathenaic Prize amphora by the Berlin painter; Orozco murals; Lorraine, *Landscape;* Eakins, *Portrait of John Joseph Borie;* Picasso, *Guitar on the Table;* recent acquisition of 120 outstanding European master prints. **Architecture:** 1985 building by Charles Moore and Chad Floyd of Centerbrook Architects.

Admission: Free. Wheelchair accessible; assisted listening devices available for lectures.
Hours: Tues.–Sat., 10–5; Sun., noon–5; Wed., 10–9. Closed Mon., holidays.
Programs for Children: Monthly Family Days with self-guiding materials including stories and games; studio art projects; occasional performances; monthly guided ArtVentures program. Call for details.
Tours: Most Sat., 2. Special Programs many Wed. evenings. For group tours call (603) 646-1469.
Food & Drink: Courtyard Café open during museum hours.
Museum Shop: Open Tues.–Fri., 10–4; Sat.–Sun., 12–4; Wed. until 9.

The Montclair Art Museum

3 South Mountain Ave., Montclair, NJ 07042
(973) 746-5555

1998 Exhibitions

Thru Jan. 4
Seagram Collection of American Urban Photography
Features urban landscape photography dating from 1890 to 1980, including works by Steiglitz, Steichen, and Abbott, on loan from the corporate art collection of Seagrams in New York.

Thru Jan. 4
Splendid Heritage
Survey of Native American masterworks from the Masco Corporation Collection, featuring beadwork and quillwork from the Plains, Prairie, Great Lakes, and Northeast.

Thru Jan. 4
Steve Wheeler and the Indian Space Painters
Retrospective of paintings and works on paper by this pioneer Native American artist associated with the New York-based Indian Space Painters of the late 1940s.

Thru Jan. 4
Carl Moon
Showcases 18 images of Native Americans by this American photographer.

Jan. 25-Apr. 26
Chase Collection of American Folk Art
Selection from Chase Manhattan Bank's collection of American folk art, including weather vanes, quilts, farm implements, trade signs, and decoys.

Jan. 25-Apr. 26
Morgan Russell: The Evolution of Synchromy in Blue-Violet
Traces the development of a seminal work of American modern art by pioneering, 20th-century artist Morgan Russell.

Feb. 22-Aug. 16
Grace Nicholson
Features masterpieces of Native American art, early documentary letters, and related photographs from the collection of this early 20th-century collector and dealer.

May 17-Aug. 16
Maurice Prendergast: Selections from the Williams College Museum of Art
A selection of works in various media by master watercolorist Maurice Prendergast (1859-1924), one of the first American artists to be influenced by Post Impressionism.

Sept. 13-Nov. 30
Shared Stories: Exploring Cultural Diversity
Features original works on paper from contemporary ethnic children's books by authors and illustrators of African-American, Asian-American, Latino, and Native American descent.

Sept. 13, 1998-Jan. 10, 1999
Masterworks on Paper from the Collection of the Montclair Art Museum
Features watercolors, gouaches, pastels, and drawings by Homer, Marin, Pollock, Motherwell, and many others.

Lois Mailou Jones
Retrospective of watercolors by this distinguished African-American artist, featuring views of Paris, Hong Kong, Washington, D.C., and other locales.

Permanent Collection
American paintings, sculptures, works on paper, costumes; Native American art. **Highlights:** 18th-century paintings by Copley, West, Peale, Stuart, Sully, Smibert; 19th-century landscapes by Cole, Durand, Kensett, Church, Moran, Bierstadt, Inness; other 19th-century paintings by Allston, Morse, Cassatt, Eakins, Sargent; 20th-century paintings by Sloan, Glackens, Henri, the Soyer brothers, Gorky, Motherwell, Albers; Henry Reed Collection of paintings and documents of Morgan Russell. **Architecture:** 1914 Neoclassical building by Albert B. Ross.

Admission: Adults, $5; seniors, students with ID, $4; children under 12, members, free. Sat., 11–2, free. Slightly higher admission fees may be charged in connection with specific exhibitions. Handicapped accessible.
Hours: Tues.–Wed., Fri.–Sat., 11–5; Sun., Thurs., 1–5. Closed Mon., holidays. Call for summer hours.

Stuart Davis, *Landscape in the Color of a Pear,* 1940. Photo courtesy Montclair Art Museum.

Programs for Children: Offers concerts, lectures, symposia, films, teacher-training sessions, demonstrations, art classes, workshops, and family events.
Tours: Sun., 2; call (973) 746-5555, ext. 25 or 21 to schedule a tour.
Museum Shop: Features Native American art and books.

Newark Museum
49 Washington Street, Newark, NJ 07101
(973) 596-6550

1998 Exhibitions
Thru Feb. 8
Crowning Glory: Images of the Virgin in the Arts of Portugal
Surveys the art of Portugal and the iconography of the Virgin through the centuries.

Thru Feb. 15
Newark Metametrics
Features installations by Newark-based architects.

Thru Mar. 1
The Printed Pot: Transfer-printed Tablewares, 1750–1990
Over 100 pieces of household pottery and porcelain trace the development of printed decoration on tableware.

Permanent Collection
Eighty galleries, including the newly restored Ballantine House; includes American painting and sculpture; Decorative Arts; arts of Africa, the Americas, and the Pacific; Classical Art; arts of Asia; and the sciences.
Highlight: Consecrated Tibetan Buddhist altar.

Admission: Free. Handicapped accessible, including elevator, cafe seating, and restrooms; call (973) 596-6615 for special needs.
Hours: Wed.–Sun., 12–5.
Programs for Children: Offers junior studios; garden, and program hall.
Tours: Groups call (973) 596-6615 for information and reservations.
Food & Drink: Englehard Court, open Wed.–Sun., 12–3:30.
Museum Shop: Unusual selection of posters, jewelry, books, and gifts.

Museum of New Mexico
Museum of Fine Arts
107 West Palace Ave. on the Plaza, Santa Fe, NM 87501
(505) 827-4468; recorded information (505) 827-6463
http://www.nmculture.org

1998 Exhibitions
Thru Feb. 2
Contemporary Photography
A selection of photographs from the museum's collections.

Thru Mar. 2
Recent Acquisitions
Features works from the permanent collection.

Thru Mar. 30
Sam Scott: A Retrospective
Emphasizes Scott's large paintings and vibrant abstractions.

Thru Apr. 13
The World of Flower Blue
Highlights the work of Native American watercolorist Pop Chalee (Flower
Blue) of Taos Pueblo, who was known for her blend of tradition and the
distinctive Santa Fe Indian School Studio style.

Thru June 8
Agnes Martin: Works on Paper
Features works on paper by this winner of the Golden Lion award at the
Venice Biennale, known for her works of austere force and mysterious
beauty.

Mar. 20-Sept. 4
Frederick O'Hara: Stony Silence
Expressionist prints from the 1940s and 1950s by this artist who engages
spiritual issues and abstractions of Native American themes.

Apr. 25-Sept. 8
Sniper's Nest: Art That Has Lived with Lucy R. Lippard
A selection of works dating from the 1960s to the 1980s, donated by the
artist.

May 1-Aug. 2
Land of Light: Photographs of Ghost Ranch
Images of the beautiful area in and around Abiquiu, N.M. by David
Scheinbaum and Janet Russek.

Permanent Collection
Twentieth-century American art, primarily by artists working in the
Southwest including O'Keeffe; photography, sculpture; extensive holdings
of American Indian art, including work by Taos and Santa Fe masters.
Architecture: 1917 building patterned after mission churches.

Museum of International Folk Art
706 Camino Lejo, Santa Fe, NM 87501
(505) 827-6350
http://www.state.nm.us/moifa

1998 Exhibitions

Ongoing
Multiple Visions: A Common Bond
Examples of folk art from more than 100 countries.

Familia y Fe/Family and Faith
Illuminates the importance of family and faith to New Mexican Hispanic culture, through textiles, jewelry, religious objects, and decorative arts.

Thru Jan. 4
Recycled, Re-Seen: Folk Art from the Global Scrap Heap
Industrial by-products and other waste materials are transformed into objects of meaning, devotion, utility, and beauty.

Opens Mar. 8
At Home Away From Home: Tibetan Culture in Exile
Examines the drama of living in exile, featuring paintings by Tibetan children now living in India and photographs from the Tibetan resettlement community of Santa Fe.

Museum of Indian Arts and Culture
710 Camino Lejo,
Santa Fe, NM 87501
(505) 827-6344

1998 Exhibitions

Ongoing
Here, Now and Always
Native Southwestern American peoples give voice to their story, featuring 1,500 weavings and other art objects.

Continuing
The Buchsbaum Gallery of Southwestern Pottery
Surveys Southwestern Indian ancestral, historical, and contemporary pottery styles from the museum's collections.

Cradleboards. Photo by Blair Clark, courtesy Museum of New Mexico.

Thru Summer
The Stories Woven In
Explores the relationship between Navajo weaving and oral traditions, including over 30 weavings, photographs, and symbolic fragments.

The Palace of Governors
105 West Palace Ave. on the Plaza, Santa Fe, NM 87501
(505) 827-6483
http://www.nmculture.org

1998 Exhibitions
Ongoing
Another Mexico: Spanish Life on the Upper Rio Grande
Presents an overview of life in New Mexico from the Colonial period, beginning with the Spanish presence in 1540, to the present.

Society Defined: The Hispanic Resident of New Mexico, 1790
Features artifacts and documents related to the detailed state census taken in 1790 by order of the Spanish crown.

Period Rooms
Includes the Governor Bradford L. Prince Parlor of 1893, the 1846 Mexican Governor's Office, and Northern New Mexico Chapel, with items dating from 1820-1880.

The Georgia O'Keeffe Museum
217 Johnson St., Santa Fe, NM 87501
(505) 995-0785
http://www.okeeffe-museum.org

1998 Exhibitions
The inaugural year of this new museum will feature rotating exhibitions from the permanent collection highlighting the work of Georgia O'Keeffe.

Permanent Collection
This newly opened museum showcases works by Georgia O'Keeffe (1887-1986) in the first U.S. museum dedicated to the work of an individual woman artist.

All five museums:
Admission: Adults, four-day pass to all five museums, $10; one-day pass, one museum, $5; youth under 17, Fri. eves. 5–8, free; Sun., $1 for New Mexico residents; Wed., free for New Mexico seniors (60+).
Hours: Tues.–Sun., 10–5. Closed Mon., major holidays.
Tours: Call (505) 827-6450 for information.

Albany Institute of History & Art

125 Washington Ave., Albany, NY 12210
(518) 463-4478
http://www.albanyinstitute.org

1998 Exhibitions

Thru Jan. 4
Contemporary Art from the Permanent Collection

Thru Apr. 12
Marion Weeber: Industrial Designer
Highlights jewelry, decorative arts, and stainless steel flatware created
between 1940 and 1980 by this Albany-born, New York industrial designer.

Jan. 17-Mar. 15
*The Figure in 20th-Century Sculpture: From the Collection of the Edwin A.
Ulrich Museum of Art*
Illustrates the movement away from sculpture's use as a means of
instruction to the freedom of expression by artists such as Rodin and Calder.

Jan. 17-Apr. 19
*Plein Air Sketching: 19th-Century American Drawings from the AIHA
Collection*
Explores the types of outdoor sketches and drawings made by 19th-century
American artists such as Thomas Cole, Frederic Church, and others.

Mar. 28-June 27
*Camille Pissarro in the Caribbean, 1850-1855: Drawings from the
Collection at Olana State Historic Site*
Features 46 drawings and oil sketches on paper by early French
Impressionist Camille Pissarro (1830-1903) and his friend Fritz Melbye.

Permanent Collection

Hudson River school landscape paintings; early Dutch limner portraits;
Albany-made silver; 18th- and 19th-century New York furniture, sculpture,
pewter, ceramics; 19th-century cast-iron stoves; work by contemporary
regional artists; Egyptian Gallery; paintings by Walter Launt Palmer; late-
19th- and early-20th-century architectural renderings; period room depicting
18th-century Dutch colonial *groote kamer*; sculpture by Erastus Dow
Palmer; textiles, costumes, and societal artifacts. **Architecture:** 1907
Classical Revival style building by Albert Fuller; 1894 Beaux Arts-style
William Gorham Rice mansion by Richard H. Hunt. Both buildings are
listed on the National Register of Historic Places.

Admission: Wed., free. Thurs.-Sun., Adults $3; seniors and students, $2;
children under 12, free. Handicapped accessible.
Hours: Wed.–Sun., noon–5. Closed Mon., Tues., major holidays.
Tours: Group tours: adults, $7; seniors and students, $6; reservations
required. Call (518) 463-4478.
Food & Drink: Luncheon Gallery open Labor Day through Memorial Day,
Mon.–Fri., 11:30–1:30.
Museum Shop: Open during museum hours.

Albright-Knox Art Gallery

1285 Elmwood Ave., Buffalo, NY 14222
(716) 882-8700
http://www.albrightknox.org

1998 Exhibitions

NOTE: During 1998, some parts of the Gallery will be closed for renovation. The permanent collection and selected special exhibitions will remain open to the public. Additional special exhibitions will be presented at the Anderson Gallery, located at Martha Jackson Place, Buffalo.

Thru Jan. 4
Dale Chihuly: Installations 1964-1996
Major exhibition of works by one of the world's foremost artists working in glass.
Imprints: The Photographs of David Plowden

Jan. 23-Mar. 1
Impressionism to Surrealism: European Paintings from the Albright-Knox Art Gallery

Jan. 30-Apr. 5
The Eye's Pop: Op Art from the Albright-Knox Art Gallery
On view at the Anderson Gallery, Buffalo.

Mar. 20-May 31
New Room of Contemporary Art: Nancy Rubins
New Room of Contemporary Art: Sophie Ristelhueber

Apr. 24-June 21
47th Western New York Exhibition
On view at the Anderson Gallery, Buffalo.

Sept. 11-Nov. 1
From Behind Closed Doors: Twentieth-Century Figuration from the Albright-Knox Art Gallery
On view at the Anderson Gallery, Buffalo.

Nov. 20, 1998-Jan. 17, 1999
Next to Nothing: Minimalist Works from the Albright-Knox Art Gallery
On view at the Anderson Gallery, Buffalo.

Permanent Collection
Sculpture from 3,000 B.C. to the present; 18th-century English and 19th-century French and American painting; noted holdings of Modern art.
Highlights: Gauguin, *Spirit of the Dead Watching* and *Yellow Christ*; Hogarth, *The Lady's Last Stake*; Kiefer, *The Milky Way*; Lichtenstein, *Picture and Pitcher*; Matisse, *La Musique*; Moore, *Reclining Figure*; Pollock, *Convergence*; Samaras, *Mirrored Room*; Segal, *Cinema*.
Architecture: 1905 Greek Revival building by Green; 1962 addition with sculpture garden by Gordon Bunshaft of Skidmore, Owings, and Merrill.

Admission: Adults, $4; seniors, students, $3; children 12 and under, free. Handicapped accessible.

Hours: Tues.–Sat., 11–5; Sun., 12–5. Closed Mon., Jan. 1, Thanksgiving, Dec. 25.

Programs for Children: Offered throughout the year. Call for details.

Tours: Wed.–Thurs., 12:15; Sat.–Sun., 1:30. Groups call (716) 882-8700.

Food & Drink: Garden Restaurant by Just Pasta open Tues.–Sat., 11:30–4:30; Sun., 11–4. Picnic areas available at Delaware Park, across the street.

Museum Shop: Offers a large selection of art-related books and gift items.

Herbert F. Johnson Museum of Art

Cornell University, Ithaca, NY 14853
(607) 255-6464
http://www.museum.cornell.edu

1998 Exhibitions

Thru Jan. 18
All-Stars: American Sporting Prints from the Collection of Reba and Dave Williams
Examines the growth of popular sports in 20th-century America. Features works by George Bellows, Winslow Homer, and Robert Rauschenberg. (T)

Jan. 10-Mar. 15
Richard Artschwager
Drawings, paintings, and sculptures by this influential postwar artist and distinguished Cornell University alumnus.

Jan. 17-Mar. 8
Art for Cornell: Highlights of the Collection

Jan. 24-Mar. 22
A Pictorialist Vision: Photographs of Herbert Turner

Mar. 14-May 17
Ruth Bernhard: Known and Unknown

Mar. 28-June 14
A Curator Collects: A Celebration in Honor of Martie Young

Mar. 28-May 10
Workers' Art Between the Wars

Permanent Collection

Paintings, sculptures, prints, drawings,
photographs, crafts, and textiles from 30

Benton Spruance, *Forward Pass,* 1944. From *All Stars: American Sporting Prints from the Collection of Reba and Dave Williams.* Photo by Dwight Primiano, courtesy American Federation of Arts.

centuries and six continents with strengths in Asian, American, and graphic arts. **Highlights:** Daubigny, *Fields in the Month of June;* Durand, *View of the Hudson Valley;* Giacometti, *Walking Man II;* DuBuffet, *La Bouche en Croissant*; Rauschenberg, *Migration;* Leoni, *Portrait of Angela Gratiani;*

Russell, *Synchrony No. 5;* Stieglitz, *The Steerage;* Tiffany blue vase.
Architecture: Highly sculptural building by I. M. Pei, built in 1973 of concrete and long panels of glass, with commanding views of Cornell University, Fall Creek gorge, and Cayuga Lake.

Admission: Free. Handicapped accessible.
Hours: Tues.–Sun., 10–5. Closed Mon., holidays.
Programs for Children: Workshops are scheduled throughout the year.
Tours: Call (607) 255-6464.
Food & Drink: Food services are available nearby on the Cornell campus.
Museum Shop: Gift items are on sale in the museum lobby.

Storm King Art Center

Old Pleasant Hill Rd., Mountainville, NY 10953
(914) 534-3115
http://www.skac.org

1998 Exhibitions
Thru Autumn 1999
The Fields of David Smith
Features approximately 25 major sculptures by one of the foremost American artists of the 20th century, in a setting resembling the artist's studio and home in upstate New York. Catalogue.

David Smith, *XI Books III Apples,* 1959. Photo by Jerry L. Thompson, courtesy Storm King Art Center.

Permanent Collection
A 400-acre sculpture park and museum in the Hudson River Valley collecting and exhibiting post-1945 sculpture. **Highlights:** Magdalena Abakanowicz, *Sarcophagi in Glass Houses*; site-specific works by Serra: *Schunnemunk Fork*; Armajani, *Gazebo for Two Anarchists: Gabriella Antolini and Alberto Antolini;* 13 sculptures by David Smith; Aycock, *Three-Fold Manifestation II*; Calder, *The Arch*; Nevelson, *City on The High Mountain*; Noguchi, *Momo Taro*; Snelson, *Free Ride Home*; di Suvero, *Mon Père, Mon Père.* **Architecture:** 1935 French Normandy-style building designed by architect Maxwell Kimball.

Admission: Adults, $7; seniors, $5; students, $3; members, children under 5, free. Partially handicapped accessible.
Hours: Apr. 1–Nov. 16: daily, 11–5:30. Special evening hours during June, July, and August, Sat., 11–8. Closed Nov. 17–Mar. 31.
Programs for Children: Call for details.
Tours: Daily, 2. May–Oct.: Sat.–Sun., 1, 2. Groups call (914) 534-3115 for reservations.
Food & Drink: Extensively landscaped picnic areas available.
Museum Shop: Open during museum hours.

Brooklyn Museum of Art

200 Eastern Pkwy., Brooklyn, NY 11238
(718) 638-5000
http://www.brooklynart.org

1998 Exhibitions

Thru Jan. 4
Monet and the Mediterranean
Sixty-five paintings created by
the French Impressionist during
his trips to the Italian Riviera,
the French Riviera, and Venice.
Explores the impact of the
Mediterranean on Monet's
established style. Catalogue.
(last venue)

Claude Monet, *Under the Pine Trees, Evening,* 1888.
From *Monet and the Mediterranean.* Photo courtesy
Brooklyn Museum of Art.

Thru Feb. 8
*Graphic Alert: AIDS Posters from the Collection of Dr. Edward C. Atwater,
AIDS Awareness 1997*
Sixty-three posters from around the world illustrate how graphic design has
been used to address a number of AIDS-related concerns.

Thru Feb. 15
*The Furniture of George Hunzinger: Invention and Innovation in
Nineteenth-Century America*
Examines the designs and entrepreneurial life of this innovative U.S.
furniture maker, featuring objects and original 19th-century patent drawings.

Feb. 27-Sept. 13
*Scattered Petals, Fallen Leaves, Shards of Glass—the Work of Bing Hu:
Working in Brooklyn*
Emerging Chinese-American artist Hu transforms objects and natural
materials found on the streets of her Brooklyn neighborhood into furniture.

Mar. 6-June 14
Joan Snyder: Working in Brooklyn
Highlights the past decade of Snyder's work involving abstract, figural, and
written elements in a combination of mediums and techniques. Catalogue.

Mar. 20-July 5
*Masters of Colors and Light: Homer, Sargent, and the American
Watercolor Movement*
Surveys the development of American watercolor painting from 1777 to the
mid-20th century, including works by Hassam, Demuth, and O'Keeffe.

Mar. 27-June 21
Sally Victor: Master Hatter, 1935-1965
Twenty-eight hats by the noted American milliner.

Apr. 3-Aug. 10
Mexican Prints from the Collection of Reba and Dave Williams
Explores the contribution of Mexican artists to the art of printmaking,
including works by Diego Rivera and Rufino Tamayo. Catalogue.

167

July 3-Oct. 25
The World of Martin Lewis in Prints and Photographs
The exuberant world of New York City in the years 1916-1947, reflected in the work of Lewis and other urban photographers.

Oct. 23, 1998-Jan. 24, 1999
The Qajar Epoch: 200 Years of Painting from the Royal Persian Courts
Examines the representational and monumental artistic traditions of the Qajar dynasty, which ruled present-day Iran from 1779 to 1924. Includes life-size paintings, illustrated manuscripts, lacquer works, and enamels. Catalogue.

Nov. 13, 1998-Apr. 4, 1999
Lewis Wickes Hine: The Final Years
Explores the last years of one of America's most important photographers, including examples from Hine's *Men at Work* project and rare landscapes.

Permanent Collection
Represents virtually the entire history of art, ranging from one of the world's foremost Egyptian collections to comprehensive holdings of American painting and sculpture; significant holdings of Greek, Roman, ancient Middle Eastern, and Islamic art; Asian, pre-Columbian, African, Oceanic art; European painting, sculpture; decorative arts; prints, drawings; American period rooms. **Highlights:** Assyrian reliefs; Egyptian female figure, 3500 B.C; Rodin Sculpture Gallery; Monet, *Doge's Palace;* Eakins, *William Rush Carving the Allegorical Figure of the Schuylkill.*
Architecture: Monumental Beaux Arts building designed by McKim, Mead & White in 1893; West Wing renovation, Arata Isozaki & Associates/James Stewart Polshek and Partners, 1993.

Admission: Donation suggested: adults, $4; seniors, $1.50; students, $2; children under 12 with adult, free. Handicapped accessible.
Hours: Wed.–Fri., 10–5; Sat., 10–9; Sun., 10–6. Closed Mon., Tues., major holidays.
Programs for Children: "Arty Facts" program, for ages 4–7, Sat. and Sun., 11, 2.
Tours: Call (718) 638-5000, ext. 221.
Food & Drink: Museum Café open Wed.–Fri., 10–4; Sat.–Sun., 10–4.
Museum Shop: Open Wed.–Fri., 10:30–5:30; Sun., 11–6.

Isamu Noguchi, *The Well,* 1982. Photo by John Bevens, courtesy Isamu Noguchi Garden Museum.

The Isamu Noguchi Garden Museum

32-37 Vernon Boulevard, Long Island City, New York 11106
(718) 204-7088
http://www.noguchi.org

Permanent Collection

The museum houses a comprehensive collection of artwork by American/
Japanese sculptor Isamu Noguchi (1904-1988) representing over 60 years of
his career. Thirteen galleries and a tranquil sculpture garden designed by the
artist on the site of his New York studio display over 250 works, including
stone, bronze, and wood sculptures; elements of dance sets designed for
Martha Graham; photo documentation and models for public projects and
gardens; and the artist's Akari lanterns. **Architecture:** Sculpture Garden
created in 1975 by Isamu Noguchi, next to the converted brick factory
building that was the artist's studio from 1961. An addition designed with
architect Shoji Sadao was opened in 1981.

Admission: Suggested donation: Adults. $4; seniors, students, $2.
Handicapped accessible, including assisted listening systems.
Hours: Apr.–Oct.: Wed.–Fri., 10–5; Sat.–Sun., 11–6. Closed Mon., Tues.
Programs for Children: Public school education program. Baby/child
backpack-carriers are available.
Tours: Daily, 2. Groups call (718) 721-1932 for reservations. Special touch
tours are available for visually-impaired groups.
Food & Drink: Café open Wed.–Sun., 12–4. Picnic areas available at
nearby Rainey Park or Socrates Sculpture Park.
Museum Shop: Open during museum hours. Call (718) 721-1932.

American Craft Museum

40 W. 53rd St., New York, NY 10019
(212) 956-3535

1998 Exhibitions

Thru Jan. 18

Four Acts in Glass: Installations by Chihuly, Morris, Powers, and Vallien
Four specially-designed installations by these masters of glass art.

Jan. 27-Mar. 22

Expressions in Wood: Masterworks from the Wornick Collection
Works by more than 40 artists from the U.S., Australia, and England
chronicle important woodworking craft artists of the last 40 years. (T)

Apr. 2-June 14

Twentieth-Century Porcelain from the Manufacture Nationale de Sèvres
Features works by Louise Bourgeois, Roberto Matta, and others, made at
this factory that has set the standard for ceramic design, production, and
craftsmanship for the past 200 years.

June 25-Sept. 6

Objects of Our Time
Recent work by 60 contemporary British artists, in celebration of the British Crafts Council's silver jubilee.

Ties That Bind: Fiber Art by Ed Rossbach and Katherine Westphal from the Daphne Farago Collection
Works by these two artists illustrate their shared attitudes, including reverence for the past, pushing boundaries, and a sense of playfulness. (T)

Sept. 17, 1998-Jan. 10, 1999

Transformation: Prix Saidye Bronfman Award 1977-1996
Reflects the changes that have taken place in Canadian craft over the past 20 years, including over 70 hand-crafted objects by some of Canada's finest craftspeople.

Sept. 17-Nov. 13

June Schwartz: Forty Years/Forty Pieces
Retrospective of 40 sculptural vessels and wall pieces examines Schwartz's technological innovations in metal enamelware in honor of her 80th birthday.

Nov. 19, 1998-Jan. 17, 1999

Wendy Ramshaw: Picasso's Ladies
Works inspired by the women in Picasso's paintings, by one of Britain's leading jewelry artists.

Bertil Vallien, *Drawing of Installation*, 1997. From *Four Acts in Glass: Installations by Chihuly, Morris, Powers, and Vallien.* Photo by Eva Heyd, courtesy American Craft Museum.

Permanent Collection

Documents the history and development of 20th-century craft in America, concentrating on objects created after World War II; significant objects in all craft disciplines: clay, enamel, fiber, glass, metal, mixed media, paper, plastic, wood; outstanding collections of contemporary jewelry, baskets, furniture, art quilts, and functional and sculptural works in all media.

Architecture: 1986 building by Fox & Fowle, Architects.

Admission: Adults, $5; students, seniors, $2.50; children under 12, free. Handicapped accessible. including ramps and elevators.
Hours: Tues.,Wed., Fri.–Sun., 10–6; Thurs., 10–8. Closed Mon., major holidays.
Programs for Children: Contact the Education Dept. for details.
Tours: Call (212) 956-3535 for information.
Museum Shop: Small selection of crafts and jewelry; open during museum hours and Mon., 10–6.

Cooper-Hewitt, National Design Museum

Smithsonian Institution, 2 E. 91st St., New York, NY 10128
(212) 860-6868
http://www.si.edu/ndm

1998 Exhibitions

Thru Jan. 11
Design for Life: A Centennial Celebration
Examines how design shapes three essential realms of public and private experience: activities and patterns of daily living, architecture and environmental space, and the communication of ideas.

Feb. 3-Apr. 12
The Jewels of Lalique
Over 200 rare pieces of Rene Lalique's jewelry and first works in glass in the period before WWI.

Feb. 10-May 10
Unlimited by Design
First major exhibition of products, services, and environments designed to meet the needs of all people throughout their life spans.

Feb. 24-May 31
Arquitectonica: The Times Square Project
Miami-based architectural firm's vision for a hotel, entertainment and retail complex in Times Square.

May 12-Sept. 6
The Cult of Performance: Design for Sports
Exhibition about design and contemporary sports equipment.

June 9-Oct. 11
Fountains: Splash and Spectacle
Explores function and design of European and American fountains from the Renaissance to the present.

June 21-Oct. 25
Under the Sun: An Outdoor Exhibition of Light
Explores the power of the sun as a catalyst for design both practical and visionary.

June 23-Oct. 19
Concerned Theatre Japan: The Graphic Art of Japanese Theatre
Explores how Japan's theater world was at the center of major aesthetic and social movements, serving as a vehicle for innovations in graphic design.

Oct. 6, 1998-Jan. 10, 1999
The Architecture of Reassurance: Designing the Disney Theme Parks
Explores the architecture of one of the great postwar American icons: Disneyland. Includes plans, drawings, paintings, and models. (T)

Nov. 10, 1998-Apr. 11, 1999
National Design Museum Triennial
New exhibition program presents critical overview of developments in
contemporary design every three years.

Permanent Collection
Covers 3,000 years of design history in cultures around the world. Major
holdings include drawings, prints, textiles, furniture, metalwork, ceramics,
glass, woodwork, wall coverings. **Highlights:** Egyptian, Islamic,
Mediterranean, and Near Eastern textiles from the 3rd to 15th centuries;
large group of Homer drawings; 19th-century jewelry by Castellani and
Giuliano. **Architecture:** 1902 Carnegie mansion by Baab, Cook, and
Willard. 1997 renovation by Polshek & Partners Architects.

Admission: Adults, $5; students and seniors, $3; members, children under
age 12, free. Free admission Tues., 5–9. Handicapped accessible.
Hours: Tues., 10–9; Wed.–Sat., 10–5; Sun., noon–6. Closed Mon. and
Federal holidays.
Tours: Call (212) 860-6321 for reservations.
Food & Drink: Cafe to open in 1998.
Museum Shop: Books, objects d'art, ceramics, jewelry, toys. Open during
museum hours.

Dia Center for the Arts

548 W. 22nd St., New York, NY 10011
(212) 989-5566
http://www.diacenter.org

1998 Exhibitions
Thru Jan. 4
Fred Sandback:
Sculpture
Old and new work by
this American artist,
including sculptures
using steel rods and
yarn.

Dan Graham, *Rooftop Urban Park Project,* 1991. Photo
by Bill Jacobson, courtesy Dia Center for the Arts.

Thru June 14
Richard Serra, Torqued
Ellipses
Showcases the first
sculptures to be completed in the artist's new series. Serra's large-scale
works, which shape space, are made by unprecedented methods of rolling
steel.

Tracey Moffatt, Badlands
Newly-commissioned works by the young Australian photographer.

Dan Flavin (1962/63, 1970, 1996)
Works by this late artist include his early experiments with the use of
florescent lights and a more recent site-specific installation.

Feb.-Dec.
Robert Irwin
The artist continues his preoccupation with the use of light to shape space and determine experience in a site-specific installation.

Permanent Collection
No permanent collection. The Center features long-term site-specific installations by contemporary artists, who are given an entire floor to create a major piece. **Architecture:** Four-story renovated warehouse; recently renovated additional space located at 545 W. 22nd St.

Admission: Adults, $4; students, seniors, $2; children under 10, members, free. Handicapped accessible, including elevator.
Hours: Thurs.–Sun., 12–6. Closed Mon.–Wed.
Programs for Children: Offers various programs for schools; call (212) 989-5566, ext. 119 for information.
Tours: Call (212) 989-5566, ext. 127 for information.
Food & Drink: Rooftop café serves coffee, pastries, and other refreshments.
Museum Shop: Book store open during museum hours.

The Frick Collection

1 East 70th St., New York, NY 10021
(212) 288-0700

1998 Exhibitions
Thru April
Robert Adam: The Creative Mind
Examines the role of drawing in this 18th-century Scottish architect's thinking process, featuring 65 drawings, models, objects, and books.

June 23-Aug. 30
Fuseli to Menzel: German Drawings in the Age of Goethe from a Private German Collection
Oct. 13, 1998-Jan. 17, 1999
French and English Drawings of the 18th and 19th Centuries from the National Gallery of Canada

Permanent Collection
Includes works by Goya, Ingres, Rembrandt, Renoir, Titian, van Dyck; Renaissance sculptures; Renaissance and French 18th-century furniture.
Highlights: Bellini, *Saint Francis in Ecstasy*; della Francesca, *St. John the Evangelist*; van Eyck, *Virgin with Child, with Saints and Donor*; Holbein, *Sir Thomas More* and *Thomas Cromwell*; Rembrandt, *Self-Portrait*; Stuart, *George Washington*. **Architecture:** Handsome 1913–1914 Frick residence by Thomas Hastings; 1931–1935 additions by John Russell Pope; 1977 garden by Russell Page.

Admission: Adults, $5; seniors, students, $3. Children under 16 must be accompanied by adult; children under 10 not admitted. Handicapped accessible, including ramps and elevators; aids for the hearing-impaired and wheelchairs available.

Hours: Tues.–Sat., 10–6; Sun., 1–6. Closed Mon., holidays.

Tours: "The Frick Collection: An Introduction," a twenty-minute audiovisual presentation, is shown in the Music Room hourly, Tues.–Sat., 10:30–4:30, and Sun., 1:30–4:30.

Museum Shop: Offers books, catalogues, cards, and reproductions.

The Solomon R. Guggenheim Museum

1071 Fifth Ave., New York, NY 10128
(212) 423-3500
http://www.guggenheim.org

1998 Exhibitions

Thru Jan. 7

Robert Rauschenberg: A Retrospective
Surveys the prolific career of one of the most acclaimed American artists of the 20th century. Includes nearly 400 works from the late 1940s to the present. Catalogue. (T) (Also on view at the Guggenheim Soho location.)

Jan. 16-May 3

Frankenthaler: The Early Years
Surveys the innovative color stain paintings created by American artist Helen Frankenthaler between 1952 and 1960.

Jan.-June

In the Footsteps of Impressionism: Robert Delaunay's Series

Feb.-June

China: 5,000 Years
Spans the entire history of Chinese art, from neolithic to modern. (Also on view at the Guggenheim Soho location.)

June-Sept.

The Art of the Motorcycle

The Last Dogaressa: Peggy Guggenheim's Years in Venice

Oct. 1998-Jan. 1999

Rendez-Vous: The Centre Georges Pompidou, Paris & the Guggenheim Collections in Dialogue

Permanent Collection

Nineteenth- and twentieth-century works including contemporary and avant-garde paintings; paintings by Appel, Bacon, Bonnard, Cézanne, Chagall, Davis, Dubuffet, Gris, Kokoschka, Louis, Marc, Miró, Modigliani, Mondrian, Manet, Monet, Picasso, Pollock, Renoir, Rousseau, Seurat,

Soulages, Villon, Warhol; sculptures by Archipenko, Arp, Brancusi, Pevsner, Smith. **Highlights:** Cézanne, *Man with Crossed Arms*; Gris, *Still Life*; noted collection of works by Kandinsky, Klee, Louis, Saraband; Mondrian, Composition; Picasso, Mandolin and Guitar; Pissarro, *The Hermitage at Pontoise.* **Architecture:** 1959 building by Frank Lloyd Wright; 1992 wing by Gwathmey Siegel & Associates. Guggenheim SoHo: Loft building in SoHo Cast Iron District; museum space designed by Arata Isozaki, 1993.

Admission: Adults, $10; seniors, students, $7; accompanied children under 12, members, free. Special 7-day combination pass for both museum locations: Adults, $15; seniors, students, $10. Handicapped accessible; wheelchairs available. TDD (212) 423-3607.
Hours: Sun.–Wed., 10–6. Fri.– Sat., 10–8. Closed Thurs., Dec. 25.
Tours: Call (212) 423-3652 for information; group tours require reservations three weeks in advance.
Food & Drink: Guggenheim Museum Café, open Mon.–Wed., 9–6; Fri.–Sun., 9–8; closed Thurs.
Museum Shop: Open Sun.–Wed., 10–6; Thurs., 10–4; Fri.–Sat., 10–8.

Robert Rauschenberg, *Crocus,* 1962. From *Robert Rauschenberg: A Retrospective.* Photo courtesy Solomon R. Guggenheim Museum.

Guggenheim Museum SoHo
575 Broadway (at Prince St.), New York, NY 10012
(212) 423-3500 (recording)

1998 Exhibitions
Thru Jan. 4
Robert Rauschenberg: A Retrospective
Surveys the prolific career of one of the most acclaimed American artists of the 20th century. Includes nearly 400 works from the late 1940s to the present. Catalogue. (T)

Feb.-June
China: 5,000 Years
Spans the entire history of Chinese art, from neolithic to modern.

Oct. 1998-Jan. 1999
L'Art en France: 1960 to the Present

Admission: Adults, $8; seniors, students, $5; under 12, members, free.
Hours: Sun.,Wed.–Fri., 10–6; Sat., 11–8. Closed Mon., Tues., Thanksgiving, Dec. 25.
Museum Shop: Open Sun.–Fri., 11–6; Sat., 11–8.

International Center of Photography

Uptown
1130 Fifth Ave. (at 94th St.), New York, NY 10128
http://www.icp.org

1998 Exhibitions

Thru Feb. 1
Images from the Machine Age: Selections from the Daniel Colwin Collection

June 27-Sept. 6
Mathew Brady's Portraits: Images as History, Photography as Art
More than 100 images from the career of this key figure in American photography span the history of the medium in 19th-century America. (T)

Midtown
1133 Avenue of the Americas (at 43rd St.), New York, NY 10036
(212) 860-1778

1998 Exhibitions

Thru Feb. 22
Weegee's World: Life, Death, and the Human Drama
Explores the dark and gritty urban world of this important 20th-century news photographer and filmmaker.

Jeffrey A. Wolin, *Rena Grynblat, b. 1926, Warsaw, Poland.* From *Written in Memory: Portraits of the Holocaust,* traveling from International Center of Photography. Photo courtesy ICP.

Permanent Collection
More than 12,500 prints, including works by Abbott, Capa, Eisenstadt, Vishniac, "Weegee" (Arthur Fellig); archives include audio- and videotape recordings and cameras, housed in the Midtown facility. **Architecture:** 1915 Neo-Georgian building by Delano & Aldrich.

Admission: Adults, $4; students, seniors, $2.50. Midtown location is handicapped accessible, assistance provided.
Hours: Tues., 11–8; Wed.–Sun., 11–6. Closed Mon.
Programs for Children: Family Days, workshops, and community programs throughout the year.
Tours: By appointment; call (212) 860-1777, ext. 154.
Museum Shop: Open during museum hours.

The Jewish Museum

1109 Fifth Ave., New York, NY 10128
(212) 423-3200
http://www.thejewishmuseum.com

1998 Exhibitions

Thru Jan. 11
Facing the New World: Jewish Portraits in Colonial and Federal America
Rare early-American Jewish portraits, created from 1700 through the 1830s by artists such as Gilbert Stuart and Rembrandt Peale.

Eleanor Antin, Still from video installation of *Vilna Nights,* 1993. Photo by Becky Cohen, courtesy Jewish Museum, New York.

Thru June 28
Holidays! Jewish Seasons and Celebrations
This interactive exhibition for children and families introduces visitors to five major Jewish holidays. Includes related objects and photographs.

Feb. 15-May 10
Still More Distant Journeys: The Artistic Emigrations of Lasar Segall
The work of Segall (1891-1957), who is considered to be integral to the development of both German Expressionism and Brazilian modernism.

Apr. 26-Aug. 16
Chaim Soutine: 1913–1943
Major exhibition of 50 works by this expressive French painter, focusing on his years in Paris until his death during WWII. Examines the role of Soutine and other Jewish artists in the development of modern art in Paris. (T)

June 14-Oct. 4
George Segal
A selection of 20 monumental sculptures by this American artist known for his life-size figures placed in the banal environment of everyday life. (T)

Nov. 1998-Mar. 1999
Allegories: The Paintings of Ben Shahn, 1943-1962
Features approximately 60 allegorical and mythological paintings created by Shahn in a style he referred to as "personal realism." Catalogue.

Permanent Collection

Over 27,000 artworks and artifacts covering 4,000 years of Jewish culture. Paintings, graphics, sculptures inspired by the Jewish experience; Jewish ceremonial art; archaeological artifacts; objects from Central European homes and synagogues brought to the museum after the Holocaust; Israeli art; contemporary art; National Jewish Archive of Broadcasting. **Highlights:** Israeli archaeological artifacts, textiles; paintings by Chagall, Shahn, Weber; multimedia installation by Eleanor Antin. **Architecture:** 1908 Warburg mansion by Gilbert; 1959 sculpture court; 1963 List Building; 1993 renovation and expansion by Roche, Dinkeloo & Associates.

Admission: Adults, $7; students, seniors, $5; members, children under 12, free. Tues. after 5, free. Handicapped accessible, including tours for visitors with hearing disabilities; call (212) 423-3225 for more information.
Hours: Sun.–Mon., Wed.–Thurs., 11–5:45; Tues., 11–8. Closed Fri., Sat., major legal and Jewish holidays.
Programs for Children: Interactive exhibition, Sun. art workshops, storytelling, and other programs; call (212) 423-3225 for details.
Tours: Call (212) 423-3225 for reservations.
Food & Drink: Café Weissman open during museum hours.
Museum Shop: Cooper Shop, located at 1109 Fifth Avenue, features gifts, books, and museum reproductions. Celebrations: The Jewish Museum Design Shop, located at 1 E. 92nd St., features ceremonial objects and gifts.

The Metropolitan Museum of Art

Fifth Ave. at 82nd St., New York, NY 10028
(212) 879-5500; 535-7710 (recording)
http://www.metmuseum.org

1998 Exhibitions
Thru Jan. 11
The Private Collection of Edgar Degas
More than 250 works from this French Impressionist's personal collection. Includes paintings, watercolors, and prints by such late-19th-century masters as Cézanne, van Gogh, Manet, Ingres, and Degas himself.

Filippino Lippi and His Circle
Features 80 drawings by this 15th-century Italian draftsman. Also includes works by Botticelli, Raphael, and other Florentine artists.

Thru Jan. 25
John La Farge in the Metropolitan Museum of Art
Explores the career of this 19th-century Gilded Age artist, through paintings, watercolors, book illustrations, and stained-glass windows.

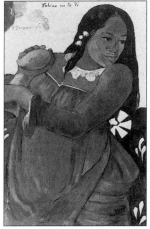

Paul Gauguin, *Woman of the Mango (Vahine no te vi)*, 1892. Cone Collection, Baltimore Museum of Art. From *The Private Collection of Edgar Degas*. Photo courtesy Metropolitan Museum of Art.

Thru Feb. 8
Jackson Pollock: Early Sketchbooks and Drawings
Traces the development of Pollock's art, with works on paper created between 1937 and 1941 by this important Abstract Expressionist painter.

King of the World: A Mughal Manuscript from the Royal Library, Windsor Castle
A rare exhibition of the treasured illustrated manuscript, *The Padshahnama*, which was commissioned by the Mughal Emperor Shah-Jahan in 1639. (T)

Klee Landscapes
Features imaginary and natural landscapes in all media by innovative Swiss artist Paul Klee (1879-1940).

Thru Feb. 22
Richard Pousette-Dart (1916-1992)
Paintings and works on paper by this American Abstract Expressionist painter trace his evolution from Cubism to his later mythic style of universal interconnectedness. Catalogue.

Thru Mar. 1
Master Hand: Individuality and Creativity among Yoruba Sculptors
Examines the parameters of individual creativity and innovation within this African artistic tradition. Includes 40 sculptures, masks, and vessels.

Flowers Underfoot: Indian Carpets of the Mughal Era
Features 50 Indian rugs dating from the late-16th through the 18th century.

Thru Mar. 22
Gianni Versace
A tribute to the late designer who so successfully married the worlds of high fashion and popular culture, focusing on the influences of historical styles and modern abstract art on Versace's creations.

Attributed to Onabanjo, *Magbo Headdress,* 20th century. Collection Indianapolis Museum of Art. From *Master Hand: Individuality and Creativity Among Yoruba.* Photo courtesy Metropolitan Museum of Art.

Thru Mar. 29
The Human Figure in Transition, 1900-1945: American Sculpture from the Museum's Collection
Demonstrates both conservative and radical tendencies in the depiction of the human body in early-20th-century American sculpture. Includes works by Hoffman, Lachaise, Nadelman, and others.

Thru Spring
The Gods of War: Sacred Imagery and the Decoration of Arms and Armor
Explores the use of sacred images and symbolism in the decoration of armor from cultures around the world, including works from Europe, India, Tibet, and China.

Thru Sept. 27
The Resonant Image: Uses of Tradition in Japanese Art
Explores the enduring themes of Japanese art in works of various media, including paintings, prints, ceramics, lacquers, textiles, and tea utensils.

Feb. 10-May 3
Paul Strand, circa 1916
Over 50 extremely rare
prints reflect Strand's period
of transition from soft-focus
pictorial style to a bold and
distinctively American
modernism. (T)

Feb. 26-May 24
*Augustin Pajou, Royal
Sculptor*
Presents all aspects of this
gifted 18th-century French
sculptor's career, including
monumental marble figures,
portrait busts, drawings, and
terrracotta models.
Catalogue. (T)

Paul Strand, *Abstraction, Twin Lakes,
Connecticut,* 1915–16. Ford Motor Co.
Collection, Metropolitan Museum of Art.

Mar. 3-May 17
When Silk Was Gold: Central Asian and Chinese Textiles
Features 64 examples of Central Asian and Chinese textiles, including
tapestries, embroideries, and brocades dating from the 11th to the 14th
century. Catalogue. (T)

Mar. 10-June 7
Pierre-Paul Prud'hon
Retrospective of the career of Pierre-Paul Prud'hon, who was active during
the years of the French Revolution, the Empire, and and the Restoration. (T)

Mar. 17-June 14
Charles-Honoré Lannuier
Examines the career of this Parisian-trained cabinetmaker who introduced
le style antique—the Greco-Roman revival popular in Republican and early
Empire France—to America in the early 1800s.

Paris Porcelain for the American Market
Features examples of classically inspired French porcelains that graced
fashionable American tables, including dinner ware and decorative vases.

Mar. 31-Aug. 16
American Ingenuity
Demonstrates how the 20th-century American sportswear tradition has
evolved into a standard of modern dress.

May-Sept.
The Paintings of Judith Rothschild: An Artist's Search
Focuses on the lesser-known paintings created between 1945 and 1991 by
this American artist known for her small collages and colorful abstractions.

June 4-Sept. 6
Sir Edward Burne-Jones
Presents over 200 diverse works by this pivotal 19th-century British Pre-
Raphaelite artist, in celebration of the centenary of his death. Includes
paintings, watercolors, drawings, tapestries, stained glass, and jewelry.

Sept. 15, 1998-Jan. 3, 1999
From Van Eyck to Bruegel: Early Netherlandish Paintings in the Metropolitan Museum of Art
Reexamines one of the formative schools of European painting, featuring nearly 100 paintings seen together for the first time. Catalogue.

Sept. 16, 1998-Jan. 31, 1999
Jade in Ancient Costa Rica
Features approximately 100 pre-Columbian jade objects dating from 300 B.C. to 700 A.D., including personal ornaments and functional tools.

Opens Oct.
Heroic Armor of the Italian Renaissance: Filippo Negroli and His Contemporaries
Features Negroli's unique style of Renaissance armor inspired by heroic deeds of antiquity, created in his Milan workshop between 1530 and 1550.

Oct. 13, 1998-Jan. 3, 1999
Degas Photographs
Presents 35-40 photographs made by the French artist in the mid-1890s. Includes figure studies, intimate interior views, and self-portraits.

Oct. 19, 1998-Jan. 17, 1999
Sacred Visions: Early Painting in Tibet
Examines the development of painting styles in Tibet, featuring 60 paintings dating from the late 11th through the early 15th century. Catalogue.

Nov. 16, 1998-Feb. 21,1999
Anselm Kiefer: Works on Paper, 1969-1987
Surveys the ideas and themes of the first two decades of this German artist's career, featuring 54 works on paper including mixed-media, collages, watercolors, gouaches, and photographs.

Permanent Collection
One of the largest and most comprehensive museums in the world, covering every culture and period in depth. **Highlights:** Babylonian Striding Lions; Temple of Dendur; grand drawing room in American wing; Astor Court Chinese rock garden; Song dynasty Tribute Horses; Cantor Roof Garden sculpture (May 1–Oct. 30); Brown collection of musical instruments; Louis XIV bedroom; Bingham, *Fur Traders Descending the Missouri*; Brueghel the Elder, *The Harvesters*; Church, *Heart of the Andes*; Degas, *Dance Class*; van Eyck, *Crucifixion*; El Greco, *View of Toledo*; Leutze, *Washington Crossing the Delaware*; Matisse, *Nasturtiums* and *Dance*; Picasso, *Gertrude Stein*; Rembrandt, *Aristotle Contemplating the Bust of Homer*; Velázquez, *Juan de Pareja*; Vermeer, *Young Woman with a Water Jug*. **Architecture:** 1880 building by Vaux and Mould; 1902 central pavilion by Hunt; 1913 wings by McKim, Mead, and White; 1975 Lehman Wing, 1979 Sackler Wing, 1980 American Wing, 1982 Rockefeller Wing by Roche, Dinkeloo, & Associates; 1987 Lila Acheson Wallace Wing for 20th-century art.

Admission: Donation suggested: adults, $8; seniors, students, $4; members, children under 12 accompanied by adult, free. Entrance fee for selected exhibitions. Handicapped accessible.
Hours: Tues.–Thurs., Sun., 9:30–5:15; Fri.–Sat., 9:30–8:45. Closed Mon., Jan. 1, Thanksgiving, Dec. 25. Certain galleries are operating on an alternating schedule; call (212) 570-3791 for information.
Programs for Children: Offers lectures, films, tours, and workshops throughout the year. Call for details.
Tours: Daily; call museum for information.
Food & Drink: Cafeteria open Tues.–Thur., Sun., 9:30–4:30; Fri.–Sat., 9:30–8:30. Café open Tues.–Thurs., Sun., 11:30–4:30; Fri.–Sat., 11:30–9; Great Hall Balcony Bar open Fri.–Sat., 4–8:30; with music, 5–8; Restaurant open Tues.–Thurs., Sun., 11:30–3; Fri.–Sat., 11:30–10 .
Museum Shop: Offers books, cards, and museum reproductions.
Branch: The Cloisters, Fort Tryon Park, New York, (212) 923-3700. Open Tues.–Sun, 9:30-5:15. Closes at 4:45 from Nov.–Feb.

The Pierpont Morgan Library

29 East 36th St., New York, NY 10016
(212) 685-0008

1998 Exhibitions

Thru Jan. 4
Medieval Bestseller: The Book of Hours
One hundred manuscript and printed examples of prayer books from mid-thirteenth to the mid-sixteenth century.

Cultural Curios: Literary and Historical Witnesses
Relics such as the pine box Thoreau built to house his journals and Dickens' cigar case.

On Wings of Song: A Celebration of Schubert and Brahms
Manuscripts, letters, and other original documents.

Thru Mar. 1
Deadly Enemies: Aaron Burr and Alexander Hamilton
Letters of each man assailing the character of the other, as well as observations on the aftermath of the infamous event.

Jan. 14-May 3
British Drawings and Watercolors in the Morgan Library
First major survey of the Library's collection of British drawings.

Jan.-April
"The Seal upon Thy Heart": Glyptic Art of the Ancient Near East, c. 3500-2100 B.C.E.
Near Eastern cylinder seals from Mesopotamia reflecting political, social, and cultural developments of that time.

May 20-Aug. 30
a.k.a. Lewis Carroll
Personal items of Charles L. Dodgson, author of *Alice in Wonderland*.

May 13-Aug. 30
A Century in Retrospect: Music Manuscripts from the Paul Sacher Foundation
Manuscripts of 20th century composers including Britten and Strauss.

Sept. 25, 1998-Jan. 8, 1999
Master Drawings from the Morgan Library, the State Hermitage Museum, and the Pushkin State Museum of Fine Arts
First opportunity for Americans to view 120 western European drawings from the 15th to the 20th century. (T)

Sept. 1998-Jan. 1999
Russian Illustrated Books and Bindings
Includes the only known copy in America of the Moscow 1663 Bible in Church Slavonic.

Pierpont Morgan: An American Life
Letters, manuscripts, photographs, and other documents from the Library's archives, most of which have never been shown publicly.

Nov. 1998-Jan. 1999
Charles Dickens: A Christmas Carol
Display of the author's manuscript and other items relating to the work.

Johann Gutenberg & Johann Fust, *Biblia Latina*, Mainz, c. 1455. Photo by David A. Loggie, courtesy Pierpont Morgan Library.

Permanent Collection

Medieval and Renaissance illuminated manuscripts; printed books; bindings from the 5th to the 20th century; European drawings; autograph manuscripts; early children's books; original music manuscripts; ancient Near Eastern seals; Gilbert and Sullivan archive; Chinese, Egyptian, Roman objects d'art. **Highlights:** Three Gutenberg Bibles; Carolingian covers of Lindau Gospels; drawings by Mantegna, Dürer, Rubens, Rembrandt, Degas; paintings by Memling, Perugino, Botticelli and Francia; autograph manuscripts including Milton's *Paradise Lost*, Dickens' *A Christmas Carol*; original manuscript of Saint-Exupéry's *The Little Prince*. **Architecture:** 1906 Italian Renaissance revival building by Charles F. McKim; 1928 west wing; 1852 Victorian brownstone, The Morgan House; 1991 Garden Court by Voorsanger & Associates.

Admission: Suggested contribution: adults, $5; students, seniors, $3. Handicapped accessible.
Hours: Tues.–Fri., 10:30–5; Sat., 10:30–6; Sun., 12–6. Closed Mon.
Tours: Walk-in exhibition and historic tours offered daily. Call 212 685-0008 ext. 390 for more information.
Food & Drink: Charming space in Morgan Court Café open Tues.–Fri., 11–4; Sat., 11–5; Sun. noon–5.
Museum Shop: Selection of reproductions, cards, and various gift items.

El Museo del Barrio

1230 Fifth Ave., New York, NY 10029
(212) 831-7272

1998 Exhibitions

Thru Mar. 29
Taíno: Pre-Columbian Art and Culture from the Caribbean
Comprehensive exhibition of 135 objects examining themes in ancient
Taíno culture, including chiefs and their regalia, spiritual ecstasy, religion,
cosmology, and the subsistence of daily life.

Permanent Collection

Over 8,000 objects trace the development of Latin American art and
celebrate this cultural heritage.

Admission: Suggested donation: Adults, $4; students, seniors, $2;
children under 12, members, free.
Hours: Wed.–Sun., 11–5. Closed Mon., Tues., holidays.
Programs for Children: Family Days, art workshops, and other
programs.
Tours: Call (212) 831-7272 for information.

The Museum for African Art

593 Broadway, New York, NY 10012
(212) 966-1313

1998 Exhibitions

Thru Apr. 19
African Faces, African Figures: The Arman Collection
More than 180 beautiful and rare objects represent the diverse regions and
cultures of Africa. Includes various types of masks, reliquary and power
figures. Catalogue.

May 22-Aug. 11
Hidden Treasures of the Tervuren Museum
A selection of 125 Central African masks, sculptures, and other objects
originally collected to increase European understanding of the area called
the Kongo, now known as Zaire. Catalogue. (T)

Permanent Collection

No permanent collection. **Architecture:** 1860s building. Interior
renovation by Maya Lin and David Hotson, 1992.

Admission: Adults, $5; students, seniors, children, $2.50; members, free.
Handicapped accessible.
Hours: Tues.–Fri., 10:30–5:30; Sat.–Sun., 12–6. Closed Mon., holidays.
Tours: Group tours available; call (212) 966-1313, ext. 118 for
information.

The Museum of Modern Art

11 W. 53rd St., New York, NY 10019
(212) 708-9400
http://www.moma.org

1998 Exhibitions

Thru Jan. 20
*On the Edge:
Contemporary Art
from the Werner and
Elaine Dannheisser
Collection*
More than 80
paintings, sculptures,
video installations,
photographs and
drawings.

Joan Miró, *The Family,* 1924. Gift of Mr. and Mrs. Jan Mitchell. Photo by Soichi Sunami, courtesy Museum of Modern Art.

Thru Jan. 4
*Egon Schiele: The
Leopold Collection,
Vienna*
Oils, gouaches, watercolors and drawings by the Austrian expressionist.

Feb. 15-May 12
Fernand Léger
Features 120 paintings spanning Léger's career from his "tubist" paintings of 1911-12 to his later series of construction works in the 1950s. (T)

Feb. 19-May 19
Alvar Aalto: Between Humanism and Materialism
Retrospective of drawings, models, and objects by this renowned 20th-century Finnish architect, town planner, and designer.

Feb. 26-May 26
Chuck Close
Surveys the full spectrum of this American artist's remarkable career, including over 90 paintings, drawings, prints, and photographs featuring his early gray-scale works and later colorful patchwork paintings. Catalogue. (T)

June 21-Oct. 13
Pierre Bonnard
Features 90 paintings by Pierre Bonnard (1867-1947), who is best-known for his depictions of intimate interior scenes. (T)

June 25-Oct. 6
Alexander Rodchenko
Retrospective of works by this Russian Constructivist artist who created a new art for the new society envisioned by the Bolshevik Revolution.

July 2-Sept. 22
Tony Smith: Part and Whole
Examines the architectural designs, abstract paintings, and sculptures of this postwar American vanguard artist.

July 9-Sept. 22
Yayoi Kusama in New York: 1958–1968
Includes 80 installations, paintings, and other works by this post-minimalist
Japanese artist, dating from her most influential years. (T)

Oct. 28, 1998-Feb. 2, 1999
Jackson Pollock: A Retrospective
Reexamines the challenging and influential work of this American Abstract
Expressionist painter, featuring over 120 paintings and 60 works on paper.

Permanent Collection
Masterpieces of modern art by nearly every major artist of this century:
paintings, sculptures, prints, drawings, illustrated books, architectural
designs, photographs, films. **Highlights:** Boccioni, *The City Rises*;
Cézanne, *The Bather*; Chagall, *I and the Village*; van Gogh, *Portrait of
Joseph Roulin* and *Starry Night*; Hopper, *House by the Railroad*; Matisse,
The Blue Window, nine-panel *The Swimming Pool*; Mondrian, *Broadway
Boogie-Woogie*; Monet, *Poplars at Giverny* and *Water Lilies*; Picasso, *Les
Demoiselles d'Avignon* and *Three Musicians*; Rauschenberg, *Bed*;
Rousseau, *The Sleeping Gypsy*; sculpture garden. **Architecture:** 1939
building by Goodwin and Stone; 1984 expansion and renovation by Pelli
and Gruen.

Admission: Adults, $9.50; seniors, students with ID, $6.50; members,
children under 16 accompanied by adult, free. Fri., 4:30–8:30, donation
suggested. Handicapped accessible, including touch tours for the sight-
impaired, and sign language tours; wheelchairs available.
Programs for Children: Offers extensive workshops and family programs.
Hours: Sat.–Tues.,Thurs., 10:30–6; Fri., 10:30–8:30. Closed Wed.
Tours: Mon.–Fri., 1, 3; Thurs.–Fri., 3, 6, 7.
Food & Drink: Sette MoMA open daily, 12–3; 5–10:30. Closed Wed.
Closed Sun. eve. Reservations required, call (212) 708-9710. Garden Café
open daily, 11–5; Thurs., Fri., 12–7:45, live jazz Fri. eve.
Museum Shop: The MOMA bookstore and MOMA Design Store.

Beaded Turtle
Amulets (Teton Sioux,
South Dakota). Photo
by David Heald,
courtesy National
Museum of the
American Indian.

National Museum of the American Indian

George Gustav Heye Center, Smithsonian Institution
One Bowling Green, New York, NY 10004
(212) 825-6922
http://www.si.edu/cgi.bin/nav.cgi

1998 Exhibitions

Ongoing
All Roads are Good: Native Voices on Life and Culture
A selection of more than 300 objects chosen by 23 Native Americans for their artistic, spiritual, and personal significance.

Thru Jan. 4
To Honor and Comfort: Native Quilting Traditions
Over 40 quilts demonstrate the cultural and economic significance of quilts in tribal communities throughout North America and Hawaii.

Thru March 1
Creation's Journey: Masterworks of Native American Identity and Belief
Features 165 objects of beauty, rarity, and historical significance, dating from 3,200 B.C. through the 20th century.

Feb. 15-May 3
Memory and Imagination: The Legacy of Maidu Indian Artist Frank Day
Features 50 rarely seen paintings by this self-taught Native American artist who depicted customs of his California tribe. Also includes related objects, photographs, and artworks by other contemporary Maidu artists.

Oct. 25, 1998-Jan. 3, 1999
The Flag in American Indian Art
Works from the late 19th to early 20th century illustrate how the Lakota, Navajo, Kiowa, and other Native artists recast the traditional patriotic symbol to express their own heritage. (T)

Permanent Collection

The George Gustav Heye Center, which opened in 1994, is named for the collector who assembled more than one million Indian artifacts in the course of his travels through the Americas. The National Museum of the American Indian, Smithsonian Institution, will ultimately include a museum on the National Mall in Washington, D.C., as well as a research and preservation facility in Suitland, MD. **Architecture:** Landmark 1907 Alexander Hamilton U.S. Custom House, designed by Cass Gilbert, one of the finest examples of Beaux-Arts architecture in New York.

Admission: Free. Handicapped accessible, including elevators.
Hours: Daily, 10–5; Thurs., 10–8. Closed Dec. 25.
Programs for Children: Offers on-going programs; call (212) 825-6922.
Tours: Walk-in tours daily. Call (212) 825-8096 for group reservations.
Museum Shop: Gallery shop offers Native American art, books, and gifts; museum shop for children; both open daily, 10–4:45; Thurs., 10–7:45.

The New Museum of Contemporary Art

583 Broadway, New York, NY 10012
(212) 219-1355
http://www.newmuseum.org

1998 Exhibitions

Thru Feb. 22
Mona Hatoum
Surveys the mixed-media work of this
Palestinian artist, including video, sculpture,
and installations from the 1980s to the
present. Catalogue.

Thru Jan. 18
Cardoso Flea Circus
Documents the recreation of a miniature flea
circus by artist Maria Fernanda Cardoso.

Doris Salcedo, *Atrabiliarios*
(detail), 1992. Photo courtesy New
Museum of Contemporary Art.

Mar. 19-May 31
Doris Salcedo
Features new works by this Colombian sculptor who explores the
phenomenon of violence in her country through everyday objects and
architectural fragments. Catalogue.

June 18-Sept. 13
Martin Wong
Mid-career survey features over 20 paintings that explore urban poverty,
prison, and the machismo of New York street life. Catalogue.

Bili Bidjocka and Los Carpinteros
Presents site-specific mixed media works by emerging international artists.

Sept. 29-Dec. 20
Faith Ringgold: The French Collection/The American Collection
Recent quilt paintings combine a revisionist view of the early-20th-century
School of Paris with a fictional biography of an African American artist
and model living in Paris during the 1920s. Catalogue. (T)

Permanent Collection

To maintain a constant focus on recent art, the "semi-permanent" collection
consists of works retained for a 20-year period. **Architecture:** 1896 Astor
building by Cleverdon and Putzel. Renovation in 1997 by Kiss + Cathcart
Architects.

Admission: Adults, $4; seniors, artists, students, $3; children under 12,
free. Sat., 6–8, free. Handicapped accessible, including elevator.
Hours: Wed., Thurs., Fri., Sun., 12–6; Sat., 12–8. Closed Mon.–Tues.,
some holidays; call (212) 219-1355 for information.
Programs for Children: Offers exhibition-related workshops.
Tours: Group visits are available for adults and school groups from grades
7–12; call (212) 614-1222 for information.

The Studio Museum in Harlem

144 W. 125th St., New York, NY 10027
(212) 864-4500

1998 Exhibitions

Thru Mar. 15
Transforming the Crown: African, Asian, and Caribbean Artists in Britain, 1966-1996
30-year survey exhibition features over 100 works by about 50 British artists. Includes paintings, sculptures, photographs, installations, video, and works on paper.

Thru June 14
Sculpture Garden Exhibition
This marks the second exhibition for the nation's first museum sculpture garden dedicated to the exhibition and study of sculpture by artists of African descent.

Romare Bearden, *Jammin' at the Savoy*. Photo courtesy Studio Museum in Harlem.

Apr. 1-Sept. 20
Norman Lewis: Black Paintings, 1944-1977
Examines this artist's contributions to abstract expressionism and modernism through 75 paintings and works on paper emphasizing black as a color and thematic symbol.

Oct. 7, 1998-Feb. 28, 1999
From the Studio: Artists-in-Residence, 1997-1998

Wrights of Passage: The 30th Anniversary Artists-in-Residence Exhibition
Celebrates the 30th anniversary of the Artist-in-Residence program.

Permanent Collection

Art of the African Diaspora, including works by African, Caribbean, African-American, and Latino artists; James van der Zee archives of 1920s–1940s photographs of Harlem. **Highlight:** Sculpture Garden dedicated to works by sculptors of African descent. **Architecture:** 19th-century building, renovated by Max Bond in 1982.

Admission: Adults, $5; students, seniors, $3; children under 12, $1; members, free. Handicapped accessible, including ramps and elevators.
Hours: Wed.–Fri., 10–5; Sat.–Sun., 1–6. Closed Mon.,Tues., major holidays.
Programs for Children: Programs throughout the year, including special tours and workshops; annual children's art exhibition. Call for details.
Tours: Guided tours available: Tues.–Sat.; reservations required; call (212) 864-4500, ext. 230.
Food & Drink: Focus Café open Sat.– Sun., 1–6.
Museum Shop: Offers jewelry, textiles, and gifts from the U.S., Africa, and the Caribbean.

Whitney Museum of American Art

945 Madison Ave., New York, NY 10021
(212) 570-3676 (information)
http://www.echonyc.com/~whitney

1998 Exhibitions

Thru Jan. 11
Richard Diebenkorn
The most comprehensive survey to date of this contemporary, late
American artist's career, featuring over 150 paintings and works on paper,
including his celebrated *Ocean Park* series, figurative works, and early
abstractions. Catalogue. (T)

Thru Jan. 18
The Warhol Look/Glamour Style Fashion
Explores art, fashion, and glamour in the films and paintings of the infamous
20th-century century American artist and icon, Andy Warhol.

Fashion and Film
Traces the interrelationship of fashion and film from theater advertisements
(1910-1930) through the heyday of the Hollywood studio (1930-1950s) and
the rise of the super model (1960-present).

Jan. 10-Apr. 15
Collection in Context: 1948
Features works from the museum's collection that embody the disruptive
energy of the year 1948, including works by Hopper, Noguchi, and Grosz.

Jan. 15-Apr. 19
Arthur Dove: A Retrospective
Surveys the career of this 20th-century American Modernist, including over
80 paintings, assemblages, pastels, and charcoal drawings spanning the
years 1909–1946. Catalogue. (T)

Feb. 12-May 10
Bill Viola
Surveys the work of this influential contemporary artist, including 15 major
video installations and drawings from the 1970s to the present. (T)

Peter Blume,
*Light of the
World,* 1932.
Collection of
Whitney
Museum of
American Art.

May 28-Aug. 30
Andrew Wyeth
Highlights the landscape paintings of this significant American artist.

June 4-Oct. 19
Charles Ray
Mid-career survey of this internationally recognized artist, encompassing conceptual photographs, furniture, mannequins, and other work from the 1970s to the present. (T)

Sept. 17, 1998-Jan. 10, 1999
Mark Rothko
This retrospective reveals the depth of Rothko's career, with an emphasis on his surrealist and classic periods. Includes 100 works on canvas and paper dating from the 1920s to 1970. Catalogue. (T)

Oct. 1, 1998-Jan. 10, 1999
Bob Thompson
Features narrative works by this noted African-American artist known for his figurative abstract expressionist compositions and his association with the New York downtown art scene of the 1950s.

Dec. 17, 1998-Mar. 21, 1999
Duane Hanson
Examines the work of this 20th-century American artist known for his life-size and life-like plastic figures of ordinary people. (T)

The Great American Nude

Dec. 17, 1998-Apr. 4, 1999
Secret Cinema: The History of the American Stag Film

Permanent Collection

Comprehensive holdings of 20th-century American art; includes works by Calder, Dove, de Kooning, Lichtenstein, Nevelson, Pollock, Rothko, Stella, Warhol. **Highlights:** Bellows, *Dempsey and Firpo*; Calder, *Circus*; Hartley, *Painting, Number 5;* Henri, *Gertrude Vanderbilt Whitney;* Hopper, *Early Sunday Morning*; Johns, *Three Flags;* Lachaise, *Standing Woman.* **Architecture:** 1966 building by Marcel Breuer.

Admission: Adults, $8; seniors, students, $6; children under 12 accompanied by adult, free. Thurs., 6–8, free. Handicapped accessible.
Hours: Wed., Fri.–Sun., 11–6; Thurs., 1–8. Closed Mon., Tues., holidays.
Tours: Wed.–Sun., various times. Call (212) 570-7710.
Food & Drink: Sarabeth's at the Whitney open Tues., noon–3:30, Wed., 11–4:30; Thurs., 11:30–4:30 (cafe until 7:30); Fri., 11–4:30; Sat.–Sun., 10–4:30. Closed Mon.
Branches: Champion in Fairfield County, One Champion Plaza, Stamford, CT; Philip Morris, 120 Park Ave., New York, NY.

Neuberger Museum of Art

Purchase College, State University New York, 735 Anderson Hill Rd.,
Purchase, NY 10577
(914) 251-6133
http://www.neuberger.org

1998 Exhibitions

Thru Jan. 11
Anamnesia, an Installation by Margot Lovejoy
Uses video and rear screen projection to interpret social themes.

Dance Depictions
Includes photographic portrayals of Martha Graham by Barbara Morgan
and drawings of Isadora Duncan by Abraham Wallkowitz.

Thru Jan. 18
Edward Albee and Roy R. Neuberger Select
Paintings, sculpture, drawings, and African art from collections of the
playwright and the museum's founding patron.

Basically Black and White
Paintings by seven artists based on their concentration on dark and light
tonalities.

Thru Apr. 26
A Modernist Salon
Selections from permanent collection that trace American and European
modernism from the turn of the century to 1960s.

Jan. 25-Apr. 26
Jazz Club
Multi-cultural, multi-media approach to jazz music using ceramics,
drawings, paintings, and an installation.

Feb. 8-June 7
Elizabeth Catlett Sculpture: A Fifty Year Retrospective
Sculpture retrospective of a prominent African-American artist.

May 10-Aug. 21
Revelations: Arthur Robbins and Fred Scheback
Expressionistic paintings by friends who worked on urban subjects.

June 14-Sept. 6
Glass Houses
Large-scale environments by selected artists who work in glass.

June 21-Sept. 6
Paintings by a Purchase College Professor

Sept. 13, 1998-Jan. 3, 1999
Maurice Prendergast
Paintings by American modernist noted for agitated silhouettes and rich
color.

Permanent Collection

Twentieth-century American and European paintings, sculpture, photographs, prints, drawings; 19th- and 20th-century African art; ancient art. **Highlights:** Works by Avery, Frankenthaler, Diebenkorn, Hopper, Prendergast, Lawrence, O'Keeffe, de Kooning, Moore, Calder, Pollock. **Architecture:** 1974 building by Philip Johnson.

Admission: $4 requested donation.
Accessibility: Designated parking, handicapped entrance, wheelchairs available.
Hours: Tues.–Fri., 10–4; Sat.–Sun., 11–5. Closed Mon., holidays.
Programs for Children: Special events and workshops.
Tours: Tues.–Fri., 10–3; Sat., 11–4. Groups call (914) 251-6110.
Food & Drink: Museum Café Tues.–Fri., 11:30–2:30; Sat.–Sun., 12–4.
Museum Shop: Distinctive crafts, jewelry, children's gifts.

Milton Avery, *March with Green Hat,* 1948. Photo by Jim Frank, courtesy Neuberger Museum of Art.

Memorial Art Gallery of the University of Rochester

500 University Ave., Rochester, NY 14607
(716) 473-7720

1998 Exhibitions

Thru Jan. 25
New Russian Art: Paintings from the Christian Keesee Collection
Features 45 works produced in the late 1980s and early 1990s during the disintegration of the Soviet Empire. (T)

Mar. 1-May 3
Blurring the Boundaries: Installation Art from the San Diego Museum of Contemporary Art
Encompasses media such as painting, sculpture, video, and performance.

May 23-Sept. 20
Dale Chihuly Seaforms and Transparent Motives
Sculptures and drawings by the glass artist.

Permanent Collection

Work from antiquity to the present; strong in medieval and 17th-century European art; 19th- and early 20th-century French and American paintings, American folk art, European and American prints and drawings. Works by El Greco, Hals, van Dyck, Rembrandt, Corot, Monet, Cézanne, Degas, Braque, Matisse, Cole, Cassatt, Homer, Benton, and Sloan.
Highlights: Egyptian 5th-dynasty *Portrait of King Ny-user-ra*; Monet, *Waterloo Bridge, Veiled Sun;* Homer, *Artist's Studio in an Afternoon Fog.*
Architecture: 1913 Italian Renaissance building by Foster, Gade and Graham; 1927 addition by McKim, Mead and White; 1987 sculpture pavilion by Handler, Grosso.

Henry Moore, *Working Model for Three Piece No. 3: Vertebrae.* Photo by Richard P. Wersinger, courtesy Memorial Art Gallery, University of Rochester.

Admission: Adults, $5; college students with ID, seniors, $4; children 6–18, $3; children under 5, free; Tues., 5–9, $2. Members, UR students, free. Handicapped accessible, through main entrance on University Ave. Auditorium equipped with an induction loop system; signed tours available. Call 716 473-7720 ext. 3027 (TDD 473-6152).
Hours: Tues., noon–9; Wed.–Fri., 10–4; Sat., 10–5; Sun., noon–5. Closed Mon., major holidays.
Programs for Children: The Dorothy McBride Gill Education Center includes interactive displays similar to those found in childrens' museums.
Tours: Tues., 7:30; Fri., Sun., 2. Call (716) 473-7720.
Food & Drink: Cutler's Restaurant open Tues.–Sat. for lunch and light afternoon fare, Sun. for brunch, and Tues. and Sat. for dinner.
Museum Shop: Open during regular gallery hours and Wed.–Sat., until 5.

Munson-Williams-Proctor Institute

310 Genesee Street, Utica, NY 13502
(315) 797-0000

1998 Exhibitions

Thru Jan. 4
Warp & Weft: Cross-Cultural Exchange in Navajo Weavings from Rockwell Museum
Selected pieces date from 1870s to 1970s and demonstrate continuing vitality of the craft among Navajo women.

Thru Aug. 16
Helen Elizabeth Munson Williams, A Victorian Collector
Includes American Hudson River School landscapes, European Barbizon School scenes, and American decorative arts.

Mar. 15-Sept. 13
Soul of Africa: African Art from the Han Coray Collection
More than 200 outstanding works from Central and West Africa assembled between 1916 and 1928, including masks, sculptures, and objects. (T)

Oct. 24, 1998-Jan. 3, 1999
Seeing Jazz
Artistic responses to jazz through a collection of paintings, sculpture, drawings, collages, and photographs. Catalogue.

Permanent Collection:

Chiefly 18th-, 19th-, and 20th-century American paintings, drawings, sculptures, and photographs. **Highlights:** Proctor watch, thimble, manuscript, and rare book collections; Thomas Cole, *The Voyage of Life.*
Architecture: 1958–60 building by Philip Johnson, 1995 connecting wing to Fountain Elms, a mid-nineteenth century house-museum featuring exhibition galleries and four Victorian-era period settings.

Admission: Free. Handicapped accessible.
Hours: Tues.–Sat., 10–5; Sun., 1–5. Closed Mon.
Museum Shop: Open during regular museum hours.

Mint Museum of Art

2730 Randolph Rd., Charlotte, NC 28207
(704) 337-2000; 333-MINT (recording); (704) 337-2096 [TDD]
http://www.mintmuseum.org

1998 Exhibitions

Thru Jan. 4
ARTcurrents 25: Randy Shull
Shull combines the language of furniture and sculptural tableaux to create hybrid forms and whimsical furniture pieces.

Thru Feb. 15
If the Shoe Fits... Ladies Fashionable Footwear, 1830-1990
Explores 160 years of shoe fashion, with designs by American and European manufacturers.

Thru Feb. 22
Billy Ray Hussey: North Carolina Folk Visionary
The first major exhibition of the imaginative clay figures of this North Carolina artist, featuring 50 objects made over the past decade.

Jan. 24-Apr. 5
Picasso to O'Keeffe: Twentieth-Century Still Life Paintings from the Phillips Collection
Chronicles the evolution of the modern still life tradition in America and Europe, with works by Picasso, Bonnard, Man Ray, and others.

Mar. 14-May 10
Projections: The Photomontage of Romare Bearden
Innovative works marking the artist's transition from pure abstraction in the 1950s to his concern with civil rights and his use of collage in the 1960s.

Apr. 25-June 21
Imari: Japanese Porcelain for European Palaces
Over 100 examples of 18th- and early 19th-century porcelain, copied in Europe from designs used in Japanese royal palaces. (T)

Permanent Collection

Important holdings of American and European paintings; furniture and decorative arts; African, pre-Columbian, and Spanish Colonial art; an internationally acclaimed collection of porcelain and pottery; regional crafts and historic costumes. **Architecture:** 1835 Federal-style building by Strickland; 1967 Delhom Gallery by Odell & Associates; 1985 Dalton Wing by Clark, Tibble, Harris, and Li.

Admission: Adults, $4; seniors, $3; students, $2; children 12 and under, members, free. Tues., second Sun. of month, free. Handicapped accessible, including ramps, elevators, and braille signage.
Hours: Tues., 10–10; Wed.–Sat., 10–5; Sun., noon–5. Closed Mon., Jan. 1, Dec. 25.

Programs for Children: Family Days, art day camps, DIGS I and II (schools), and exhibition scavenger hunts, offered throughout the year.
Tours: Daily, 2; call (704) 337-2032 for group reservations.
Food & Drink: Picnic areas available in front of museum.
Museum Shop: Open during museum hours.

Reynolda House, Museum of American Art
2250 Reynolda Rd., Winston-Salem, NC 27106
(910) 725-5325

1998 Exhibitions
Apr. 3-Aug. 2
Mary Cassatt: Three Paintings from the Metropolitan Museum of Art
Features three Impressionist works by this 19th-century American artist, including *The Cup of Tea, Mother and Child,* and *Young Mother Sewing.*

Permanent Collection
Extraordinary collection of 18th-, 19th-, and 20th-century American paintings, prints, and sculpture. Includes works by John Singleton Copley, Gilbert Stuart, Frederic Church, Mary Cassatt, Thomas Eakins, Andrew Wyeth, Jacob Lawrence, and many others. **Highlights:**

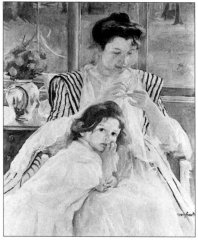

Mary Cassatt, *Young Woman Sewing.* Collection Metropolitan Museum of Art. Photo courtesy Reynolda House Museum of American Art.

Costume collection. **Architecture:** Former home of Katharine Smith and Richard Joshua Reynolds, founder of R.J. Reynolds Tobacco Company, built in 1914-1917; designed by architect Charles Barton Keen of Philadelphia; renovations in 1992.

Admission: Adults, $6; seniors, $5; children, $3; college students, free. Handicapped accessible, including elevator.
Hours: Tues.–Sat., 9:30–4:30; Sun., 1:30–4:30. Closed Mon.
Programs for Children: Offered throughout the year, including the Summer enrichment program. Call for information.
Tours: Groups call (910) 725-5325 for reservations and information.

Southeastern Center for Contemporary Art (SECCA)

750 Marguerite Dr., Winston-Salem, NC 27106
(910) 725-1904

1998 Exhibitions

Thru Jan. 4

Sherri Wood
Features non-functional quilts of improvised and spontaneous designs by this North Carolina-based artist.

Reconstruction: The Art of William Christenberry
Features drawings, paintings, sculpture, and installations that evoke the South of the artist's boyhood memory and adult inquiry.

Jan. 17-Mar. 29

Divining Nature
Group exhibition features works in a variety of media that use biblical and pre-biblical sources for spiritual inspiration.

Jan. 24-Mar. 29

Artist and the Community: Maya Lin: Topologies
Highlights the work of this accomplished artist, including the creation of a major public landscape project and an exhibition focusing on the theme of man's relationship with the environment.

Apr. 11-July 5

Accounts Southeast: Evicted Sentiments
Several Southern photographers who use traditional documentary processes to record images of the Southern landscape and a vanishing way of life.

Apr. 18-July 5

Schematic Drawing
Group exhibition presents the work of contemporary artists who create an intersection between the tactile and the conceptual.

July 18-Sept. 30

Transience: Group Photography Show

Artist and the Community: Inigo Manglano-Ovalle

Oct. 24, 1998-Feb. 1999

Vincent Desiderio

Admission: Adults, $3; seniors, students, $2; children under 12, members, free. Handicapped accessible, except second floor; braille signage.
Hours: Tues.–Sat., 10–5; Sun., 2–5. Closed Mon., holidays.
Programs for Children: Creative Center for children's programs; contact Programs Dept. at (910) 725-1904, ext. 14 for information.
Tours: Call for information.
Food & Drink: Picnic areas available on grounds.
Museum Shop: Focuses on contemporary crafts and designs.

Weatherspoon Art Gallery

The University of North Carolina
Spring Garden & Tate Sts., Greensboro, NC 27412
(910) 334-5770
http://www.uncg.edu/wag/

1998 Exhibitions

Ongoing
Henri Matisse: Prints and Bronzes from the Cone Collection
Six early bronze sculptures, as well as lithographs from the 1920s, when the artist resided in Nice.

Collection Highlights
Twentieth-century American art, including works by Rauschenberg, Calder, and De Kooning.

Thru Jan. 18
Art on Paper: Thirty-third Annual Exhibition
Annual exhibition sponsored by Dillard, a ResourceNet Company, showcasing a variety of nationally-known artists.

Thru Mar. 1
Saul Baizerman's Lifetime Project: The City and the People (1920-1953)
Series of bronze figurines by this modernist sculptor best known for the hammered-copper reliefs he created from 1933 until his death in 1957.

Saul Baizerman, *The City and the People,* 1963 installation. Photo courtesy Saul Baizerman Collection, Weatherspoon Art Gallery.

Feb. 1-Apr. 5
Falk Visiting Artist: Byron Temple
Selection of ceramic and porcelain objects by Kentucky-based potter.

Feb. 8-Apr. 5
Artist/Author: Contemporary Artists' Books
Surveys contemporary artists' book production, including fanzines, assemblies, visual poetry, sketchbooks, illustrated books, and collaborations with the commercial world. (T)

Mar. 22-Sept. 20
Exploring the Elements with Drawings from the Weatherspoon Collection

Apr. 26-July 26
Wild/Life
Explores how contemporary artists relate to animals in the wild, addressing issues of technology, animal rights, and fetishes as kitsch remnants of popular culture.

July 12-Sept. 27

The Times in the 1950s: Selected Photographs from the New York Times *Picture Library*

Focuses on American postwar images, featuring themes concerning politics, urban and suburban expansion, space exploration, and others.

Aug. 23-Oct. 18

Inescapable Histories: Mel Chin

Sculptures and installations dating from the 1970s to the present by this innovative artist known for his broad range approach to global concerns.

Oct. 25, 1998-Jan. 17, 1999

Falk Visiting Artist Exhibition

Nov. 8, 1998-Jan. 17, 1999

Art on Paper: Thirty-fourth Annual Exhibition

Showcases works on paper by a wide variety of nationally recognized and local artists.

Permanent Collection

More than 4,500 works on paper, paintings, and sculptures, focusing primarily on 20th-century American art. Asian art collection of Dr. Lenoir Wright. **Highlights:** The Cone Collection of Matisse prints and bronzes, which is shown on a rotating basis; important works by de Kooning, Calder, Rauschenberg, and Warhol. **Architecture:** Anne and Benjamin Cone Building, designed by internationally acclaimed architect Romaldo Giurgola, opened in 1989. Weatherspoon Sculpture Courtyard showcases selections of American sculpture from 1900 to the present.

Admission: Free. Handicapped accessible, including ramps, elevators, and braille map upon request.

Hours: Tues., Thurs., Fri., 10–5; Wed., 10–8; Sat.–Sun., 1–5.

Programs for Children: Monthly Saturday workshops; Halloween program. Call (910) 334-5770 for details.

Tours: First Sunday of every month, 2. Groups call (910) 334-5770.

Food & Drink: Shops and eateries within easy walking distance.

Museum Shop: The Inside Corner, open Tues.–Fri., 11–2; Sun., 2–4. Hours may vary; call ahead at (910) 334-5770.

Head of a Woman in the Guise of a Goddess, Roman, c. 1st century A.D. From *Art for the People: Recent Museum Acquisitions.* Photo courtesy North Carolina Museum of Art.

North Carolina Museum of Art

2110 Blue Ridge Rd., Raleigh, NC 27607
(919) 833-1935
http://www2.ncsu.edu/ncma

1998 Exhibitions

Thru Jan. 4
Art for the People: Recent Museum Acquisitions
Features recent acquisitions including works by such artists as Pieter
Aertsen, John Singleton Copley, Elizabeth Murray, and Gerhard Richter.

Feb. 21-May 17
Georg Baselitz: Portraits of Elke
Recognized as one of the most important artists of post-WWII Europe,
Baselitz has created depictions of his wife since the 1960s. Includes
paintings, drawings, watercolors, and prints. (T)

Mar. 8- May 21
Sacred and Fatal: The Art of Louise Bourgeois
Now in her 80s, Bourgeois has summarized her oeuvre in the statement
"Self-expression is sacred and fatal." Includes installations, sculptures, and
drawings spanning the entire career of this significant 20th-century artist.

July 26-Oct. 18
*Closing: The Life and Death of an American Factory: Photographs by Bill
Bamberger*
Documents the 1993 demise of the White Furniture Co. of Mebane, N.C.

Sept. 29, 1998-Apr. 18, 1999
*Saints and Sinners, Darkness and Light: Caravaggio and his Dutch and
Flemish Followers in America*
Examines the artistic contributions of northern European followers of the
great 17th-century Italian painter.

Permanent Collection

The paintings and sculpture in the state's art collection represent more than
5,000 years of artistic heritage from ancient Egypt to the present. Also
represented are collections of African, Oceanic, and New World art;
Egyptian, Greek and Roman art; 20th-century art; and Jewish ceremonial
art. **Highlights:** Renaissance and Baroque paintings, with works by Van
Dyck, Rubens and Botticelli; American paintings with works by John
Singleton Copley, Winslow Homer and Georgia O'Keeffe. **Architecture:**
International Style building of 1983 by Edward Durell Stone & Assoc., New
York, and Holloway-Reeves, Raleigh.

Admission: Free. Handicapped accessible.
Hours: Tues.–Sat., 9–5; Fri., 9–9; Sun., 11–6. Closed Mon.
Tours: Daily, 1:30; call (919) 833-1935, ext. 2145 for group reservations.
Food & Drink: Museum Café open Mon.–Fri., 11:30–2:30; Sat.–Sun., 11–
3; Fri., 5:30–8:30.
Museum Shop: Open Tues.–Sat., 10–4:45; Sun., 11–5:45.

Cincinnati Art Museum

953 Eden Park Dr., Cincinnati, OH 45202
(513) 721-5204
http://www.cincy.am.org/CAM

1998 Exhibitions

Thru Feb. 22
Charles Sheeler in Doylestown: American Modernism and the Pennsylvania Tradition
Visits rural America and the Shaker culture through the images of Doylestown, Pennsylvania and the historic barns of Bucks County.

Thru May 3
From Dürer to Dine: New Acquisitions of Prints and Drawings
A selection of over 60 recent acquisitions, including works by Tissot, Constable, and Dali.

The Photographs of Ralston Crawford
Examines the photography career of this artist known for his painting and lithography.

Mar. 15-May 24
Designed for Delight: Alternative Aspects of Twentieth-Century Decorative Arts
Over 200 decorative objects explore the major stylistic movements from art nouveau and art deco to post-war and postmodern. Catalogue. (T)

May 23-Sept. 20
Faster Than a Speeding Bullet: Harold Edgerton's Photographs
Works by this recognized scientist who invented the strobe flash, enabling him to photograph frozen passages of time.

June 21-Oct. 11
A Stroke of Genius: 200 Years of Lithography
Celebrates the 200th anniversary of the invention of this printmaking medium, featuring works by Delacroix, Manet, and Rauschenberg.

June 28-Aug. 23
Sandy Skoglund: Reality Under Seige
The first major retrospective of this sculptor, photographer, and installation artist. Features *Radioactive Cats*, *Peaches in a Toaster*, and other works. (T)

Sept. 1998-Jan. 1999
Chaim Soutine, 1913–1943
Major exhibition of 50 works by this expressive French painter, focusing on his years in Paris until his death during WWII. Examines the role of Soutine and other Jewish artists in the development of modern art in Paris. (T)

Nov. 22, 1998-Jan. 17, 1999
The Cecil Family Collects: Four Centuries of Decorative Arts from Burghley House
Features 120 crafted works from one of the oldest private collections in Great Britain.

Permanent Collection

Art of ancient Egypt, Greece and Rome; Near and Far Eastern art; furniture, glass, silver, costumes and folk art; paintings by European old masters such as Titian, Hals, Rubens and Gainsborough; 19th century works by Cezanne, van Gogh, Cassatt and Monet; 20th century works by Picasso, Modigliani, Miro and Chagall; American works by Cole, Wyeth, Wood, Hopper and Rothko as well as major artists from the 1970s and 1980s. **Highlights:** The only collection of ancient Nabateanen art outside of Petra, Jordan; renowned Herbert Greer French collection of old master prints; European and American portrait miniatures. **Architecture:** 1886 Romanesque building by James MacLaughlin; early 1890s Greek Revival addition by Daniel Burnham; 1930 Beaux Arts wings by Garber & Woodward; 1937 addition by Rendings, Panzer & Martin; 1965 International Style addition by Potter, Tyler, Martin & Roth; 1993 renovation by Glaser & Associates.

Chaim Soutine, *Tree at Vence,* c. 1929. Collection Galerie Cazeau-Béraudière. From *Chaim Soutine, 1913–1943.* Photo courtesy The Jewish Museum, New York.

Admission: Adults, $5; seniors, students, $4; children under 18, free. Groups, $4 each. Handicapped accessible, including parking, ramp, and elevators.
Hours: Tues.–Sat., 10–5, Sun., 12–6. Closed Mon., except holidays.
Tours: Groups of 10–60: Tues.–Sat., 10–3. Call (513) 721-5204, ext. 291 for reservations at least four weeks in advance.
Food & Drink: Museum Café open Tues.–Sat., 10–3; Sun., 12–3.

The Contemporary Arts Center

115 E. 5th St., Cincinnati, OH 45202
(513) 345-8400

1998 Exhibitions

Thru Jan. 11
Millenium Eve Dress
Attire for the new millenium, by various artists including Judith Shea, Dale Chihuly, and Beverly Semmes.

Thru Jan. 18
Roy Lichtenstein: Man Hit by the 21st Century
Recent artistic expressions, including 70 preliminary sketches and collage studies, by one of the founding fathers of the American Pop Art movement.

Jan. 24-Mar. 29
Michael Ray Charles, 1989–97
Powerful images speak out about the issue of race, borrowing from pop culture representations of African Americans from the late 1800s to the 1940s. Includes over 60 paintings, works on paper, and source materials.

Jan. 24-Mar. 22
The Human Hammer Meets the Two-Headed Woman: Banner Paintings from the Great Midway
Circus sideshow banner paintings from the early 1900s to the present, displaying a wide variety of styles and unusual subject matter.

Apr. 4-June 14
Unbuilt Cincinnati
Works from architectural firms, city planners, and individual architects that were proposed for the city of Cincinnati over the last century but never built.

Apr. 4-June 7
Presumed Innocence
Presents images by contemporary artists that address how media and technology have undermined traditional concepts of childhood.

June 20-Aug. 23
A Good Chair is a Good Chair: The Furniture of Donald Judd
A 20-year survey of furniture designed by this pioneer of Minimalism.

June 20-Aug. 30
Richard Artschwager
A series of highly refined wooden shipping crates that forces us to ask questions about what is contained and why these crates are in the gallery.

House of Wax
Explores the properties of wax as an art material.

Permanent Collection
Continually changing exhibitions highlight recent painting, sculpture, photography, architecture, multimedia installations, and experimental, conceptual, and video art.
Admission: Adults, $3.50; seniors, students, $2; children under 12, Mon., free.
Hours: Mon.–Fri., 10–6; Sat.–Sun., 12-5.
Programs for Children: 5-part Schools Project program focuses on visual literacy and critical thinking for students.
Tours: Call (513) 345-8400 for information.
Museum Shop: Open during museum hours.

Taft Museum. Photo by Tony Walsh.

Taft Museum

316 Pike St., Cincinnati, OH 45202
(513) 241-0343

1998 Exhibitions

Thru Jan. 4
A Christmas in Naples
An 18th-century Neapolitan nativity.

Thru Feb. 8
*Dutch Drawings and Watercolors
from the Kharkiv Museum of Art*
Dutch works on paper from the 17th-19th centuries.

Feb. 27-Apr. 26
*Charles Meryon and Jean-Francois Millet: Etchings of Urban and Rural
Ninteenth-Century France*
Duality of change from agrarian to urban and industrial society captured in
Meryon's city views and Millet's images of peasant life.

May 8-31
Fifth Annual Artists Reaching Classrooms Student Art Exhibition

June 19-Oct. 11
East Meets West: Chinese Export Art and Design
Places museum's collection of Chinese export ceramics of the Qing dynasty
into a broader collection of materials and expressions.

Dec. 10, 1998-Feb. 14, 1999
Cincinnati Collects African American Art
Paintings, works on paper, and sculpture from the 18th century to present.

Permanent Collection

The collections of Charles Phelps and Anna Simon Taft include European
master paintings, European decorative arts, and Chinese ceramics.
Highlights: Gothic ivory *Virgin and Child* from the Abbey Church of St.
Denis, Turner's *Europa and the Bull*, Whistler's *At the Piano*, Rembrandt's
Portrait of a Man Rising from His Chair. **Architecture:** Former Baum-Taft
House, designed ca. 1820 by an unknown architect. Federal style mansion,
opened to the public in 1932, is a National Historic Landmark. Interior,
featuring 1850 entrance murals by Robert S. Duncanson, decorated in period
style with early 19th-century New York furnishings. Franco-Dutch formal
garden, memorializing those who served in World War II.

Admission: Adults, $4; seniors, students, $2; children 18 and under, free;
free Wednesdays. Handicapped accessible; sensory tours available.
Hours: Mon.–Sat., 10–5; Sun., 1–5. Closed Jan. 1, Thanksgiving, Dec. 25.
Programs for Children: Saturday family programs, art daycamps, other
special tours and programs.
Tours: Call (513) 241-0343.
Museum Shop: Items related to museum's collection of old master
paintings, porcelains, decorative arts, and American federal furniture.

The Cleveland Museum of Art

11150 East Blvd., Cleveland, OH 44106-1797
(216) 421-7340
http://www.clemusart.com

1998 Exhibitions

Thru Jan. 4

Manet, Monet, Whistler: Three Masterpieces
Features Claude Monet's *La Japonaise (Camille Monet in Japanese Costume)* of 1876, Edouard Manet's *Street Singer* of 1862, and J.A.M. Whistler's *The White Girl (Symphony in White, No. 1)* of 1862.

When Silk Was Gold: Central Asian & Chinese Textiles from the Cleveland and Metropolitan Museums of Art
Features 64 examples of Central Asian and Chinese textiles, including tapestries, embroideries, and brocades dating from the 11th to the 14th century. Catalogue. (T)

Thru Jan. 8

Catherine Wagner Photographs: Investigating Matter

Thru Mar. 1

People Working: Photographs by Lee Friedlander
Fifty images by a sensitive contemporary photographer reflect the diversity of Cleveland's people at work.

Industry and Photography: Selections from the Permanent Collection
Examines the influences of the industrial revolution and the advent of photography on the course of the 19th century to the present.

Thru May 19

Joel Sternfield Photographs: New Portraits

Opens Feb. 7

Archival Photographs from the Cleveland Museum of Art

Feb. 8-Apr. 12

Papal Treasures: Early Christian, Renaissance, and Baroque Art from the Vatican Collections
Features precious manuscripts, liturgical objects, vestments, paintings, and sculpture, including works by Bernini and Caravaggio.

Mar. 21-May 28

Abelardo Morell Photographs

Apr. 5-July 12

American Master Drawings from the Permanent Collection
Comprehensive survey of American drawings and watercolors, including 120 works from major artistic movements from 1780 to the present.

May 10-July 5

Gifts of the Nile: Ancient Egyptian Faience
Over 150 works covering 3,000 years explore the use of this non-clay ceramic medium, which the ancients compared to the moon and stars. (T)

May 30-Aug. 13
Andrea Modica Photographs: Treadwell, New York

Aug. 9-Sept. 27
Buddhist Treasures from Nara
About 80 pieces of early Buddhist art, including sculpture, painting, metalwork, and calligraphy from ancient and classical Japan.

Aug. 15-Oct. 22
Mark Klett Photographs
Features color and black & white images of Japan.

Aug. 16-Nov. 15
Jasper Johns: Process and Printmaking
Examines the creative process behind the prints of this important American artist, featuring proofs and finished prints spanning his entire career. (T)

Oct. 24, 1998-Jan. 7, 1999
Thomas Joshua Cooper Photographs
Features black & white landscapes.

Nov. 1, 1998-Jan. 10, 1999
Cleveland Collects Contemporary Art
Survey of key artists and trends that have defined contemporary art during the last 30 years, drawn from local collections.

Dec. 13, 1998-Feb. 21, 1999
Mediterranean: Photographs by Mimmo Jodice
Includes recent work by this Neopolitan photographer, influenced by his five-year voyage through Europe and the Near East.

Permanent Collection

More than 30,000 works of art which range over 5,000 years, from ancient Egypt to the present, and include masterpieces from Europe, Asia, Africa and the Americas. **Highlights:** Chinese paintings from the Song, Ming, Qing dynasties; Warring States Period *Cranes and Serpents*; Cambodian Krishna Govardhana; the Guelph Treasure (medieval German liturgical objects in precious metal, enamel, ivory); alabaster mourners from tomb of Philip the Bold; 18th-century French decorative arts, including silver tureen by Meissonnier; sculpture garden; Caravaggio, *Crucifixion of Saint Andrew*; Kline, *Accent Grave*; Monet, *Water Lilies*; Picasso, *La Vie*; Rubens, *Portrait of his Wife, Isabella Brant*; Ryder, *Death on a Pale Horse*; Turner, *Burning of the Houses of Parliament*; Zurbarán, *Holy House of Nazareth*; Mount, *The Power of Music,* Kiefer, *Lot's Wife.* **Architecture:** 1916 Beaux Arts building by Clevland's Hubbell and Benes; major expansion in 1958; 1971 expansion by Marcel Breuer; 1983 wing houses the Ingalls art library.

Admission: Free. Handicapped accessible.
Hours: Tues., Thurs., Fri., 10–5:45; Wed., 9–4:45; Sat., 9–4:45; Sun., 1–5:45. Closed Mon., Jan. 1, July 4, Thanksgiving, Dec. 25.
Tours: Groups call (216) 421-7340, ext. 462, during museum hours.
Food & Drink: Museum Café open Tues., Thurs., Fri., 10–4:30; Wed., 10–8; Sat., 10–4:15; Sun., 1–4:45.

Columbus Museum of Art

480 E. Broad St., Columbus, OH 43215
(614) 221-6801; 221-4848 (recording)
http://www.columbusart.mus.oh.us

1998 Exhibitions

Thru Jan. 4
From Temples and Tombs: Recent Archeological Discoveries from Israel
A two-part exhibition of 1st- through 6th-century stone ossuaries, ceramic
vessels, glass objects, gold jewelry, and Roman sculpture from recent
excavations. Includes *Akeldama Tombs: Treasures of the Jerusalem
Aristocracy* and *Roman Sculpture from Bet Shean.*

Thru May 30
Dig It!
An interactive exhibition that allows children to learn more about Israel and
its antiquities. Focuses on language, arts, and the archeological process.

Thru Jan. 11
Animation! A Celebration of Cartoon Magic
Production cels and drawings trace the development of film animation from
its early days to the present .

Thru Feb. 15
DRESSed-Up Photography
Haute couture garments by famous designers are reflected in images by
equally famous fashion photographers.

Thru Feb. 22
Family Documents: Photographs by Doug Dubois and Sheron Rupp
Large color prints contrast the efforts of two contemporary photographers to
document the lives of their family members.

Jan. 23-Apr.
Claes Oldenburg: Printed Stuff
Examines over 130 works created between 1959 and 1995 by this innovative
American artist, revealing the connections between his prints, posters,
drawings, and unique sculptures. Catalogue. (T)

Jan. 27-Aug. 23
Brief Jade Collection
Examines the relationship of Chinese culture to jade and its connoisseurship,
with objects dating from prehistoric China through the modern age.

Mar. 21-May 31
Couture/Ready-to-Wear
Explores the differences between couture from some of the world's most
famous designers and examples of their ready-to-wear garments.

Apr. 17-June 21
Gabriel Münter: The Years of Expressionism, 1903-1920
More than 100 works by one of the major artists of German Expressionism,
showing her important role in the development of early 20th-century art. (T)

July 10-Sept. 13
George Bellows: Love of Winter
Interpretations of winter created between 1908 and 1915 by this important
20th-century artist from Columbus. Catalogue. (T)

Autumn
Eye Spy: Adventures in Art
Objects in architectural settings that relate to the time and place they were
made in an interactive exhibition for children and families.

Photograms
Unique, camera-less images created with photosensitive paper. Includes
"rayographs" from *Les Champs Delicieux*, a 1922 portfolio by Man Ray.

Oct. 9, 1998-Jan. 3, 1999
Chihuly Over Venice
Chandeliers made by Dale Chihuly in cooperation with glass masters of
Finland, Ireland, and Mexico for installation over the canals of Venice. (T)

Permanent Collection
European and American collections from 1850 to 1945, including
Impressionist, Post-Impressionist, German Expressionist, Cubist, Fauvist
works; 16th- and 17th-century Dutch and Flemish painting; pre-Columbian
and South Pacific art; Oriental ceramics. Galleries arranged chronologically,
focusing on artistic movements in different countries from the Renaissance
to the modern era. **Highlights:** Monet, *View of Bennecourt*; Degas, *Houses
at the Foot of a Cliff* and *Dancer at Rest*; Renoir, *Christine Lerolle
Embroidering*; a group of 11 works by Klee; Bellows paintings, lithographs;
Boucher, *Earth*; Ingres, *Raphael and the Fornarina*; O'Keeffe, *Autumn
Leaves*; Rubens, *Christ Triumphant over Sin and Death*; 350 coverlets by
Ohio and Midwest artists; sculpture by Archipenko, Maillol, Manzù, Moore.
Architecture: 1931 Italian Renaissance revival building, based on drawings
by Charles Platt; 1974 new wing; 1979 Sculpture Garden and Park.

Admission: Donation suggested: adults, $3; seniors &students, $2; children
under 12 and members, free. Thurs. evenings, free. Handicapped accessible.
Hours: Tues., Wed., Fri.–Sun., 10-5:30; Thurs. 10-8:30. Closed Mon., Jan.
1, July 4, Thanksgiving, Dec. 25.
Programs for Children: Children's studio space/education center offers
ongoing programming.
Tours: Usually available Fri. at noon, Sun. at 2. Groups call (614) 221-
6801, 30 days ahead.
Food & Drink: The Palette Café open Tues.–Sun., 11:30–2.
Museum Shop: Offers crafts, books, gifts, and educational materials.

Wexner Center for the Arts

The Ohio State University
1871 N. High St., Columbus, OH 43210
(614) 292-3535
http://www.cgrg.ohio.state.edu/wexner

1998 Exhibitions

Thru Jan. 4

Alexis Smith: My Favorite Sport
Witty and provocative collages, paintings, and installations celebrate the myth and mystique of American sports.

Staging Surrealism: A Succession of Collections 2
Explores the imagery, themes, and obsessions of the Surrealist movement of the 1920s and 1930s, featuring works by Magritte, Dalí, Ernst, and Tanguy.

Lorna Simpson: Interior/Exterior, Full/Empty
Features the first film project by this artist/photographer, shot on location in Columbus.

Lorna Simpson, *Still,* 1997. Photo by Nancy Robinson Watson, courtesy Miami Art Museum, Sean Kelly, New York, and Wexner Center for the Arts.

Jan. 31-Apr. 12

Gerhard Richter: Wexner Prize Exhibition
Examines the artist's 40-year investigation of the relationship between painting and photography.

Eva Hesse: Area
An installation created in 1968 by this artist known for her role in the development of process and minimal art. Includes drawings and notebooks.

Brice Marden: Work Books
A selection of drawings from the 1960s to the 1990s provide insight into this artist's creative process.

Fabrications
Commissioned, full-scale projects by outstanding talents in the fields of architecture and design that address the processes, materials, and technology of the constructed world.

May 10-Aug. 16

Barbara Bloom: Residency Award Project
A new installation by this artist known for her multimedia investigations of visual perception and invisibility.

Body Mécanique: Artistic Explorations of Digital Realms
Work in a variety of media by selected international artists who examine the subject of the human body and its relationship to technological realms.

Permanent Collection

A multidisciplinary contemporary arts center with active performing and media arts programs, as well as exhibitions. Artists' residencies and commissioned works are emphasized. Permanent indoor or outdoor installations by Maya Lin, Sol LeWitt, and Barbara Kruger. **Architecture:** Designed by Peter Eisenman and Richard Trott, the 1989 building is one of the most challenging public buildings to be built in recent years. Its deconstructivist program reflects the city's history as it recalls the forms of earlier buildings on the same site. Landscape design by Laurie Olin.

Admission: Adults, $3; students, seniors, $2; members, OSU students & faculty, children under 12, free. Free to all Thurs., 5–9. Handicapped accessible, including ramps and other services; call (614) 292-3535.
Hours: Tues.–Wed., Fri.–Sun., 10–6; Thurs., 10–9. Closed Mon.
Programs for Children: Family Days, Young Arts programs, and programs for teachers.
Tours: Thurs., Sat., 1. Call (614) 292-6982 for group information.
Food & Drink: Wexner Center Café, call (614) 292-2233.
Museum Shop: Open during museum hours.

The Dayton Art Institute

456 Belmonte Park North, Dayton, OH 45405
(513) 223-5277

1998 Exhibitions

Thru Feb. 1
In the Spirit of Resistance: African-American Modernists and the Mexican Muralist School
Powerful exhibition of 90 works traces the influence of prominent Mexican muralists on the work of eight African-American Modernists during the 1930s through 1950s, including Lawrence, Biggers, and Catlett. (T)

Mar. 7-June 7
Eternal China: Splendors from Ancient Xian
Major exhibition of 90 works from Xian, China, featuring life-size terracotta horsemen from the Qin dynasty (221-206 B.C.) and other objects unearthed in archeological excavations. Catalogue. (T)

Oct. 24, 1998-Jan. 3, 1999
In Praise of Nature: Ansel Adams and Photographers of the American West
Examines how the American West has been depicted through the photographic medium, from the romanticism of the 19th century to the realism of the 20th century. Includes works by Adams, Lange, and Weston.

Permanent Collection

American, European, Asian, Oceanic, African art; Art of Our Time (contemporary art); ancient art. **Highlights:** Greco-Roman *Aphrodite Pudica*; Dicke Wing of American Art: Hopper, *High Noon*; Cassatt,

Portrait of a Woman; O'Keeffe, *Purple Leaves*; Warhol, *Russell Means*; Berry Wing of European Art: Monet, *Water Lilies*; Rubens, *Two Study Heads of an Old Man*; Preti, *St. Catherine of Alexandria*; Experiencenter, where visitors experience art by seeing and doing. **Architecture:** Listed on the National Register of Historic Places, 1930 Italian Renaissance Revival style building by Edward B. Green, modeled after Vignola's Villa Farnese; 1997 renovation and expansion.

Admission: Free. Some fees for special exhibitions. Handicapped accessible.
Hours: Daily, 10–5; Thurs., 10–9.
Programs for Children: EXPERIENCENTER, a hands-on interactive gallery; family days, art classes, and other programs. Call for details.
Tours: Sat., Sun., 1. Call (513) 223-5277 for information.
Food & Drink: Cloister Café open for lunch and midday refreshments.
Museum Shop: Open during museum hours. Additional shop located in the Town & Country Shopping Center, open during mall hours.

Allen Memorial Art Museum

Oberlin College, 87 N. Main St., Oberlin, OH 44074
(440) 775-8665
http://www.oberlin.edu/wwwmap/allen-art

NOTE: The nearby Weltzheimer/Johnson House, a Usonian house designed by Frank Lloyd Wright between 1948 and 1950, is open to the public the first Sun. and third Sat. of each month, 1-5. Tickets may be purchased at the museum.

1998 Exhibitions
Continuing
The Body as Historical Subject

Thru Jan. 4
The Grand Tour: Representations and Recollections of Italy, 1750-1850

Thru Jan. 11
Intellectual History of the Meiji Period

Jan. 20-Mar. 15
Buddhist Art

Spring
Rembrandt's Portrait of Joris de Caullery in Context

Claude Monet, *Garden of the Princess, Louvre,* 1867. Photo courtesy Allen Memorial Art Museum, Oberlin College, R.T. Miller, Jr. Fund, 1948.

Spring
Women in Modern Culture

Apr. 7-May 31
The Romantic Project in Europe, 1790-1830

Apr. 14-June 14
Technology and Contemporary American Culture

Autumn
Time-based Media

Permanent Collection
More than 14,000 objects ranging over the entire history of art. Outstanding holdings of 17th-century Dutch and Flemish painting, Old Master and Japanese ukiyo-e prints, early 20th-century art, contemporary American art. Early works by Domenichino, Monet, Mondrian, Picasso, Warhol, Oldenburg. **Highlights:** Monet, *Garden of the Princess, Louvre*; Rubens, *The Finding of Erichthonius*; Terbrugghen, *St. Sebastian Attended by St. Irene*; Modigliani, *Nude with Coral Necklace*; Kirchner, *Self Portrait as Soldier*; Gorky, *The Plough and the Song* **Architecture:** Landmark 1917 building by Cass Gilbert; 1976 addition by Venturi, Rauch and Associates, decorative ironwork by Philadelphian Samuel Yellin.

Admission: Free. Handicapped accessible (ramp entrance, Lorain Street).
Hours: Tues.–Sat, 10–5; Sun., 1–5. Closed Mondays and major holidays.
Programs for Children: Range of programs includes Family Days and KIDZHIBIT, which allows children to create art and organize exhibitions.
Tours: Call (440) 775-8048 for information.
Museum Shop: Uncommon Objects, located at 39 S. Lorain Street.

The Toledo Museum of Art

2445 Monroe St., Box 1013, Toledo, OH 43697
(419) 255-8000; (800) 644-6862
http://www.toledomuseum.org

1998 Exhibitions

Thru Jan. 4
Medieval Manuscripts from the Collection
Works of art created in Europe between 1100 and 1500 that are both beautiful and informative historical documents.

Geoffrey Beene
Innovative clothing by this designer who has been at the cutting edge of fashion for over 30 years. (T)

Thru Mar. 22
Bound to be Interesting: Unusual and Impressive Book Bindings
Features the remarkable binding materials found on books, ranging from a medieval chain binding to 20th-century perforated aluminum.

Feb. 15-May 10
Intimate Encounters: Love and Domesticity in 18th-Century France
Major exhibition of French 18th-century genre painting, including works by
Watteau, Chardin, Boucher, and Fragonard. (T)

Mar. 22-June 28
Modern Books: The Three "Rs"—Reading, wRiting, and Redesigning
Explores a range of collaboration between authors, artists, and publishers,
featuring texts by Virgil and King, and images by Picasso, Matisse, and
Hockney.

July 5-Aug. 9
Toledo Area Artists 80th Annual Exhibition
Works in all media by current and past residents of the Toledo area.

Oct. 25, 1998-Jan. 3, 1999
Soul of Africa: African Art from the Han Coray Collection
More than 200 outstanding works from Central and West Africa assembled
between 1916 and 1928, including masks, sculptures, and objects. (T)

Permanent Collection
Traces the history of art from ancient Egypt to the present: European and
American paintings, sculpture; extensive glass collection; graphic arts;
photographs; tapestries; decorative arts. **Highlights:** Chase, *The Open Air
Breakfast;* Cole, *The Architect's Dream;* El Greco, *Agony in the Garden*;
Rembrandt, *Man in a Fur-lined Coat*; Rubens, *The Crowning of Saint
Catherine.* **Architecture:** 1912 Neoclassical building by Edward Green;
1992 addition by Frank Gehry.

Admission: Free. Entrance fee for selected exhibitions. Handicapped
accessible; wheelchairs, strollers available.
Hours: Tues.–Thurs., Sat., 10–4; Fri., 10–9; Sun., 1–5. Closed Mon., holidays.
Programs for Children: Call (419) 255-8000 for information.
Tours: Call (419) 255-8000 for information.
Food & Drink: Museum Café open Tues.–Sat.,10–2; Fri. dinner,
5:30–8:30; Sun., 1–4.
Museum Shop: Open during museum hours.

The Butler Institute of American Art

524 Wick Ave., Youngstown, OH 44502
(216) 743-1711

1998 Exhibitions
Jan.-Mar.
Harvey and Françoise Rambach Collection

Feb. 8-Mar. 15
David Rothermel

Mar. 15-May 3
Julian Stanczak

May 17-July 26
Ben Schonzeit

May 24-July 26
Gregory Perillo

Permanent Collection
More than 10,000 works by
American artists, from the
colonial period to the
present. Includes
significant holding of
Ashcan School artists.
Lester F. Donnell Gallery of
American Sports Art

Winslow Homer, *Snap the Whip*, 1872. Photo courtesy Butler
Institute of American Art.

includes athletic images by Bellows, Grooms, and Warhol. **Highlights:**
Homer, *Snap the Whip*; important works by West, Copley, Cassatt. Unique
collection of Western art by Bierstadt, Remington, and others.
Architecture: Landmark 1919 McKim, Mead and White building. Several
additions, including post-modern 1987 West Wing with Butler Sculpture
Garden and Terrace.

Admission: Free. Handicapped accessible, including ramps and elevators.
Hours: Tues., Thurs., Fri., Sat., 11–4; Wed., 11–8; Sun., 12–4. Closed
Mon., holidays.
Programs for Children: Art classes and tours throughout the year.
Tours: Call (330) 743-1711 for information.
Museum Shop: Open during museum hours.

Gilcrease Museum

1400 Gilcrease Museum Road, Tulsa, OK 74127
(918) 596-2700
http://www.gilcrease.org

1998 Exhibitions
Feb. 8-May 10
Thomas Moran
First-ever retrospective of this 19th-century painter best known for his
western landscapes. Includes the paintings *Grand Canyon of the
Yellowstone, Chasm of the Colorado,* and *Mountain of the Holy Cross.* (T)

June 26-Sept. 7
Gilcrease Rendezvous 1998
Featuring painter Steve Hanks of New Mexico and wildlife sculptor Sandy
Scott of Colorado.

July 2-Oct. 27
Euchee Custom Ways
Documents the traditional culture of the Euchee (Yuchi) people.

Nov. 6-Dec. 6
American Art in Miniature 1998
Annual exhibition of artworks no
larger than 9 by 12 inches.

Nov. 13, 1998-Jan. 3, 1999
Modotti and Weston:
Mexicanidad
Looks at Mexican history and
culture as presented in the images
of these two great photographers.
(T)

Permanent Collection
Comprehensive collection of art of
the American West. Presents saga
of man in North America from
pre-Columbian era through the

Thomas Moran, *Wyoming Falls,*
Yellowstone River, 1872. Photo courtesy
Gilcrease Museum.

20th century. **Highlights:** John Wesley Jarvis, *Black Hawk and His Son
Whirling Thunder.* **Architecture:** Original building designed to resemble an
Indian Longhouse, renovated in 1987 by John Hilberry and Associates.
Areas of the museum grounds are landscaped with historic theme gardens.

Admission: Suggested donation, adults, $3; families, $5. Partially
handicapped accessible, including ramps and some braille signage.
Hours: Tues.–Sat., 9–5; Sun., holidays, 11–5; Memorial Day through Labor
Day: Mon., 9–5; Closed Dec. 25.
Tours: Daily, 2. Special tours can be arranged at least 2 weeks in advance;
call (918) 596-2705.
Food & Drink: Rendezvous Restaurant open Tues.–Sat., 11–2.
Museum Shop: Open during museum hours.

The Philbrook Museum of Art

2727 S. Rockford Rd., Tulsa, OK 74114-4104
(918) 749-7941; (800) 324-7941

1998 Exhibitions

Thru Jan. 11
Contemporary Prints from the Philbrook Collection
Broad range of works by such artists as Lowell Nesbitt, Robert Motherwell,
Fritz Scholder, and Luis Jimenez.

Thru Feb. 1
People of the Prairie
Beadwork, clothing and implements of prarie people including the Osage,
Ponca, Otoe-Missoura, and Kaw (Kanza).

Thru Mar. 8
The Bacone School of Native American Painting
Showcases beauty of the Bacone flat-style painting.

Thru Apr. 5
The British Etching Revival
Etchings by 20th-century British artists emulate the Old Masters in the face of the technological advances of the Industrial Revolution.

Jan. 18-Mar. 15
Scott Fraser Paintings

Feb. 8-Apr. 12
J.M.W. Turner, "That Greatest of Landscape Painters": Watercolors from London Museums
Watercolors by the 19th-century visionary painter drawn from three London collections.

Near Turner's Point of View: Paintings by J.M.W. Turner and Thomas Moran
Related exhibition organized to coincide with national tour of the monographic exhibition from the National Gallery of Art.

May 17-July 12
Old Masters Brought to Light: European Paintings from the National Museum of Art of Romania
A rich collection of Old Master paintings from the 15th through the 17th centuries. Includes works by Rembrandt, El Greco, and Zubarán never seen before in the U.S. (T)

Strozzi's St. Francis in Ecstasy": An Acquisition in Focus
Important drawings, prints and paintings by Strozzi and his contemporaries.

Sept. 6-Nov. 1
A Taste for Splendor: Treasures from the Hillwood Museum
Features a selection of paintings and decorative arts from the legendary collection of Marjorie Merriweather Post. (T)

Permanent Collection

Collections include Italian painting, sculpture; Native American basketry, pottery, paintings; 18th- and 19th-century European paintings; 19th- and 20th-century American art; African sculpture. **Architecture:** 1927 Villa Philbrook by Edward Buehler Delk; 1990 wing by Urban Design Group in association with Michael Lustig.

Admission: Adults, $5; seniors, students, groups of 10 or more, $3 per person; children 12 and under, members, free. Handicapped accessible.
Hours: Tues.–Sat., 10–5; Thurs., 10–8; Sun., 11–5. Closed Mon., major holidays.
Programs for Children: Family and children's programs offered year round.
Tours: Call (918) 748-5309, preferably two weeks in advance.
Food & Drink: la Villa Restaurant Tues.–Sun., 11–2; Thurs. cocktails, 5–7.
Museum Shop: Open regular museum hours.

Portland Art Museum

(formerly the Oregon Art Institute)
1219 S.W. Park Ave., Portland, OR 97205
(503) 226-2811
http://www.pam.org

1998 Exhibitions

Thru Jan. 18
Dale Chihuly: The George R. Stroemple Collection and Chihuly Over Venice
Chandeliers made by Dale Chihuly in cooperation with glass masters of Finland, Ireland, and Mexico for installation over the canals of Venice. (T)
Vitreographs: Prints Made from Glass

Mar. 8-Aug. 16
Splendors of Ancient Egypt
One of the largest exhibitions of ancient Egyptian treasures to visit the U.S. in decades, featuring over 200 pieces dating back 4,500 years, including statues, mummy cases, jewelry, wall carvings, and ceramics. Catalogue. (T)

June 2-Sept. 6
The Hands of Rodin: A Tribute to B. Gerald Cantor (T)

Sept. 20, 1998-Jan. 1, 1999
Monet: Late Paintings of Giverny from the Musée Marmottan
Blockbuster exhibition features 22 paintings by Claude Monet (1846-1926). Includes lesser-known later works featuring the flower and water gardens of Monet's property in the rural village of Giverny. (T)

Permanent Collection

Nineteenth- and 20th-century works; Northwest Native American art; Kress collection of Renaissance and Baroque paintings; Cameroon sculptures; Elizabeth Cole Butler collection of Native American art. **Highlights:** Pre-Han *Standing Horse*; Brancusi, *Muse*; Monet, *Water Lilies*; Renoir, *Two Girls Reading*; Tlingit *Wolf Hat*; new Vivian and Gordon Gilkey Center for the Graphic Arts. **Architecture:** 1932 building by Belluschi; 1989 and 1995 renovation.

Admission: Adults, $6; seniors, students age 16 and over, $4.50; students age 15 and under, $2.50; children under 5, free. Handicapped accessible.
Hours: Tues.–Sun., 10–5; first Wed.,Thurs., 10–9. Closed Mon.
Programs for Children: Family Museum Sunday, contact the museum for upcoming events.
Tours: Call (503) 226-2811, ext. 889 for information.
Museum Shop: Open during museum hours.

Brandywine River Museum

Brandywine Conservancy, Route 1, Chadds Ford, PA 19317
(610) 388-2700
http://www.brandywinemuseum.org

1998 Exhibitions

Thru Jan. 11
A Brandywine Christmas

Images of Snow White
Examines variations of the Grimm fairy tale, including original illustrations and first edition books from the late-19th century to the present.

Donald Pywell: Golden Impressions of Andrew Wyeth
Creative goldsmith Donald Pywell uses precious metals and jewels to interpret famous images created by Andrew Wyeth.

N.C. Wyeth Studio. Photo by Michael Kahn, courtesy Brandywine River Museum.

Jan. 24-Mar. 29
N.C. Wyeth and His Grandson: A Legacy
Examines the family tradition of illustration begun by N.C. Wyeth and continued into the present day by his grandson, Jamie Wyeth.

Permanent Collection

American art with special emphasis on the art of the Brandywine region. 19th- and 20th-century landscapes by Cropsey, Doughty, Moran, Trost Richards; 19th-century trompe l'oeil works by Cope, Harnett, Peto; illustrations by Darley, Pyle, Parrish, Gibson, Dunn. **Highlights:** Paintings by three generations of Wyeths; Andrew Wyeth gallery. **Architecture:** 1864 grist mill renovated in 1971 by James Grieves; 1984 addition by Grieves features glass-walled lobbies with spectacular views of the river and countryside.

Admission: Adults, $5; seniors, $2.50; students with ID, children, 6–12, $2.50; members, children under 6, free. Handicapped accessible.
Hours: Daily, 9:30–4:30; Dec. 26–30, 9:30–6. Closed Dec. 25.
Tours: Groups call (610) 388-8366.
Food & Drink: Charming restaurant, open daily, 11–3. Closed Mon., Tues., Jan.–Mar.

Institute of Contemporary Art

University of Pennsylvania, 118 S. 36th St., Philadelphia, PA 19104
(215) 898-7108
http://www.upenn.edu/ica

1998 Exhibitions

Thru Jan. 4
Art From Korea
Work of four Korean artists
chosen for their use of
international artistic styles
that deal with cultural issues
of their homeland.
Catalogue.

Institute of Contemporary Art, Philadelphia.

Jan. 17-Mar. 8
Glenn Ligon: Unbecoming
Focusing on Ligon's use of stencils in literary text paintings, the exhibition
includes drawings, paintings, prints, installations, and archival materials
connected by the artist's autobiographical search for his identity as an
African American and as a gay man.

Mar. 21-May 3
Susan Hiller: Belshazzar's Feast
London-based, American artist uses impartial observation to record the
human tendency to invest objects and events with meaning, resulting in
installations of narrative everyday objects.

May 16-July 3
Stacy Levy
Merging art and science, Levy explores unseen environmental aspects such
as wind patterns, tides, water quality, and forest growth. Includes a site-
specific installation.

Permanent Collection

No permanent collection. **Architecture:** New ICA boasts a 10,000 sq. ft.,
two-story exhibition gallery, auditorium, garden, archival library, and
cascading public spaces in a Neo-Industrial style building, completed in
1991 by Adele Naude-Santos and Jacob/Wyper Architects.

Admission: Adults, $3; artists, seniors, students $2; children under 12,
PENNcard holders, free. Sun., free, 10–noon. Handicapped accessible.
Hours: Wed.–Sun., 10–5; Thurs., 10–7. Closed Mon. and Tues.
Programs for Children: Special education programs and workshops
available. Call for dates and descriptions.
Tours: Thurs., 5:15. Groups call (215) 898-7108.
Food and Drink: No cafe, but second-floor terrace open to guests who may
purchase lunch from nearby vendors.
Museum Shop: Museum catalogues, prints, and other merchandise on sale
in lobby.

Museum of American Art of the Pennsylvania Academy of the Fine Arts

Broad & Cherry Sts., Philadelphia, PA 19102
(215) 972-7600
http://www.pafa.org/~pafa

1998 Exhibitions

Continuing
Two Centuries of Collecting at the Museum of American Art
Comprehensive survey of the Museum's 18th- to 20th-century collection combines paintings and sculpture with interpretive components.

Thru Feb. 8
People's Choice
Diverse group of local dignitaries and "everyday" people choose works from the permanent collection to commemorate 125th anniversary of the laying of the building's cornerstone on Dec. 7, 1872.

Jan. 10-Apr. 19
April Gornik: Graphic Works
Select drawings and prints coincides with exhibition of this noted contemporary landscape artist at the University of the Arts.

Jan. 10-Apr. 12
Kate Moran
Work of multi-media artist and Pennsylvania Academy graduate.

Mid.-Feb.-Apr. 19
Pop/Abstraction
Investigates abstract qualities of 1960s Pop Art and its shared aesthetics with Minimalism and contemporary production.

June 13-Aug. 16
Morgan Russell: The Evolution of Synchromy in Blue Violet
More than 40 paintings and drawings of this seminal figure in American modernism.

Maxfield Parrish, *Princess Parizade Bringing Home the Singing Tree.* Gift of Mrs. Francis P. Garvin. Photo courtesy Pennsylvania Academy of the Fine Arts.

June 13-Sept. 13
Darwin Nix
Recent paintings and graphics by Philadelphia-based abstract artist.

Late Sept. 1998-mid-Jan. 1999
"Golden Age" Illustration
Turn-of-the-century graphics from Museum's permanent collection.

Oct. 3, 1998-Jan. 10, 1999
Maxfield Parrish
Retrospective explores artistic influences of this Pennsylvania Academy alumni, as well as qualities of his work that have contributed to the "rediscovery" of Parrish by many contemporary artists.

Permanent Collection

Paintings, sculptures, works on paper spanning more than three centuries of American art. **Highlights:** Diebenkorn, *Interior with Doorway;* Eakins, *Portrait of Walt Whitman;* Graves, *Hay Fever;* Henri, *Ruth St. Denis in the Peacock Dance;* Hicks, *The Peaceable Kingdom;* Homer, *Fox Hunt;* Peale, *The Artist in His Museum;* Pippin, *John Brown Going to His Hanging;* Rush, *Self-Portrait;* Wyeth, *Young America.* **Architecture:** Philadelphia's finest example of High Victorian Gothic and a National Historic Landmark, designed in 1876 by Frank Furness and George Hewitt; restorations in 1976 by Hyman Myers and 1994 by Tony Atkin & Associates.

Admission: Adults, $5.95; seniors, students, $4.95; children under 12, $3.95; members, children under 5, free. Handicapped accessible.
Hours: Mon.–Sat., 10–5; Sun., 11–5. Closed holidays.
Programs for Children: Saturday workshops throughout the year; Tues. and Thurs. activities during summer.
Tours: Call (215) 972-7600.
Food & Drink: Café open Mon.–Fri., 8:30–3; Sat., 10-3; Sun., 11-3.
Museum Shop: Offers variety of gift items, art books, cards, hand-crafted jewelry, and gifts for children.

Philadelphia Museum of Art

26th St. & Benjamin Franklin Pkwy., Philadelphia, PA 19130
(215) 763-8100
http://pma.libertynet.org

Branches: The Rodin Museum, 22nd St. & Benjamin Franklin Pkwy., Philadelphia, Pa. 19104, (215) 763-8100. Fleisher Art Memorial, 719 Catharine St., Philadelphia, Pa. 19147, (215) 684-4015. Fairmount Park Houses, Cedar Grove and Mt. Pleasant, Philadelphia, Pa. (215) 684-7820.

1998 Exhibitions

Thru Jan. 4
Best Dressed: A Celebration of Style
Most comprehensive costume exhibition ever mounted by Museum, with over 200 costumes and accessories covering some three centuries of fashion.

Robert Capa: Photographs
Includes 160 modern and 40 vintage gelatin silver prints of one of this century's greatest photographers recognized for his coverage of five wars.

Apr. 4-May 31
Recognizing Van Eyck
Investigates relationship
between two painted
versions of *St. Francis
Receiving the Stigmata,*
which remains one of the
great unsolved mysteries in
the history of art. (T)

Sept. 20, 1998-Jan. 3, 1999
Delacroix: The Late Work
The later work of painter
Eugène Delacroix (1798-
1863), major artist of the
Romantic movement. (T)

Thru July 31
*Recent Acquisitions in
Asian Art*

Jan van Eyck, *Saint Francis of Assisi Receiving the Stigmata,*
c. 1438–40. Photo by Joe Mikuliak, courtesy Philadelphia
Museum of Art, John G. Johnson Collection.

Chinese calligraphy, Japanese painting, Southeast Asian sculpture and
Persian miniatures.

Thru Aug. 31
The Spirit of Korea
Showcases Museum's Korean Art Collection, including Koryo Dynasty
celadon wares, Buddhist and secular subjects in paintings and sculpture, and
furniture.

Thru July 31
Frolicking Animals
Paintings, ceramics, and decorative arts of Japan from permanent collection.

Dec. 26, 1998-Feb. 28, 1999
Jasper Johns: Process and Printmaking
Examines the creative process behind the prints of this important American
artist, featuring proofs and finished prints spanning his entire career. (T)

Permanent Collection

Significant works from many periods, styles, cultures in diverse media.
Architectural installations and period rooms include a 12th-century French
Romanesque facade and portal; 16th-century carved granite Hindu temple
hall; Japanese tea house, temple and garden; Robert Adams's drawing room
from Lansdowne House. Modern sculpture with major Brancusi collection;
German folk art; Kretzschmar von Kienbusch collection of arms and armor.
Highlights: Cézanne, *Large Bathers*; Duchamp, *Nude Descending a
Staircase*; van Eyck, *Saint Francis Receiving the Stigmata*; van Gogh,
Sunflowers; Picasso, *The Three Musicians*; Poussin, *Birth of Venus*; Renoir,
The Bathers; Rubens, *Prometheus Bound*; Saint-Gaudens, *Diana*; van der
Weyden, *Crucifixion with the Virgin and Saint John.* **Architecture:** 1928
Greek revival building by the firm of Horace Trumbauer, and Zantzinger,
Borie, and Medary; 1940 Oriental Wing; 1992–95 Reinstallation of
European collection, Jeffrey D. Ryan of Jackson & Ryan Architects.

Admission: Adults, $7; senior citizens, students with ID, children 5–18, $4. Handicapped accessible; wheelchairs available, TDD 215 684-7600.

Hours: Tues.–Sun., 10–5; Wed., 10–8:45. Closed Mon., holidays.

Programs for Children: Family Day each Sunday, with programs that include a studio session; $1 for member's children, $2 for children of nonmembers. Parents may attend programs free.

Tours: Tues.–Sun., hourly, 11–3. Call (215) 684-7923 for information.

Food & Drink: Restaurant open Tues.–Fri., 12–3; Wed., 5–7:30; Sat., 12–5; Sun., 11-4. Espresso Cafe open Sat.–Sun., noon. Cafeteria open Tues.–Fri., 8:30–3:30; Sat.–Sun., 10–4.

Museum Shop: Tues.–Sun. 10–4:45; Wed. evenings until 8:45.

University of Pennsylvania Museum of Archeology and Anthropology
33rd and Spruce Streets, Philadelphia, PA 19104
(215) 898-4000
http://www.upenn.edu/museum

1998 Exhibitions

Thru Jan. 18
The Fragrance of Ink: Korean Literati Paintings of the Choson Dynasty (1392-1910) from the Korea University Museum
Traditional paintings from Korea's last dynasty, created on silks, scrolls, screens, and fans, depict landscapes, figures, animals, and plants.

Thru June
Roman Glass: Reflections on Cultural Change
More than 200 examples of Roman glass and associated materials dating from the first century B.C. through the sixth century A.D.

Thru Mar. 1
Always Getting Ready: Yup'ik Eskimo Subsistence in Southwest Alaska
Explores the culture of the Yup'ik people of Alaska, including their concept of *upterrlainarluta*—being over-prepared.

Left to right: Bottle, 1st–2nd century A.D., Long-necked flask, late 1st century A.D., Loop-handled oil lamp, late 4th century A.D. From *Roman Glass: Reflections on Cultural Change.* Photo courtesy University of Pennsylvania Museum of Archeology and Anthropology.

Mar. 14, 1998-Jan. 3, 1999
Treasures of the Chinese Scholar
Selections of "scholar art" dating from the Han Dynasty of 206 B.C. through the Qing Dynasty of the 20th century, including calligraphy, painting, works in wood, lacquer, ivory, stone, horn, and metal.

Mar. 21-June 20
Egypt: Antiquities from Above
Features photographs concerning the theme of Egyptian antiquities.

Opens Oct. 17
Canaan and Ancient Israel
Examines the archeological evidence of the development of personal identity in the Holy Land during the Bronze and Iron Ages (3000–500 B.C.), featuring over 500 artifacts from Israel, Jordan, and Lebanon.

Permanent Collection
The museum is dedicated to the understanding of cultural diversity and the exploration of the history of mankind. The collection includes ancient Egyptian and Mesopotamian antiquities dating back as far as 2600 B.C., including a 12-ton granite Sphinx of Ramesses II and a bull-headed lyre from Ur; classical Greek pottery and coins; African gallery features West African masks and Benin bronze collection; Mayan stele and other objects from Mesoamerica; monumental Chinese sculptures and Buddhist art from Asia; several exhibitions exploring Native American cultures.

Admission: Adults, $5; students, seniors, $2.50; members, children under 6, PENNcard holders, free. Handicapped accessible.
Hours: Tues.–Sat., 10–4:30; Sun., 1–5. Closed Mon., holidays.
Programs for Children: Offers workshops, programs associated with special exhibitions. Pyramid Shop features toys and books.
Tours: Most Sat., Sun., 1:30. Call (215) 898-4015 for information.
Food & Drink: Café open Tues.–Sat., 10–3:30; Sun., 1–4. Closed Mon.
Museum Shop: Open during museum hours, closes Sun. at 4:30. Pyramid Shop for children open Tues.–Fri., 10–2:30; Sat., 11–4:30; Sun., 1–5.

The Carnegie Museum of Art

4400 Forbes Ave., Pittsburgh, PA 15213
(412) 622-3131
http://www.clpgh.org

1998 Exhibitions
Thru Jan. 11
Wish You Were Here: Tokens and Mementos
Souvenirs of people, places, and events spanning four centuries, highlighting mementos from the city of Pittsburgh.

Pittsburgh Delineated: Prints & Drawings from the Collection of Bruce and Sheryl Wolf
Documents the evolution of Pittsburgh from a small rural site to an industrial city, including works by Armor, Pennell, and Laboureur.

Thru Jan. 25
Pittsburgh Revealed: Photographs Since 1850
Photographic journal of life and events in Pittsburgh, including over 400 vintage images by more than 100 photographers.

Thru Mar. 22
Architecture and Exhibition Design of A. James Speyer
Comprehensive survey of the career of this Pittsburgh-born artist. Includes architectural models, drawings, and photographs. Catalogue.

Feb. 28-May 24
Michael Lucero: Sculpture 1976-1994
Features 47 works by this ceramic sculptor who expands traditional Western ideas of art by integrating diverse non-Anglo cultures. Catalogue. (T)

Permanent Collection
French Impressionist and Post-Impressionist paintings; 19th- and 20th-century American art; contemporary American and European paintings, sculpture; American, English, Continental furniture, silver, ceramics; Asian and African art; monumental architectural casts. **Highlights:** Baumgarten, *The Tongue of the Cherokee*; Serra, *Carnegie*; Kiefer, *Midgard*; Bonnard, *Nude in Bathtub*; Homer, *The Wreck*; de Kooning, *Woman VI*; Monet, *Water Lilies*; de Saint-Germain, *Long Case Clock*; Meissen, *Covered Beaker*; film and video program; sculpture court. **Architecture:** 1896–1907 Beaux Arts Carnegie building by Longfellow, Alden and Harlow; 1974 Bauhaus-style Sarah Scaife Galleries by Edward Larrabee Barnes.

Admission: Adults, $6; seniors, $5; students, children 3–18, $4; members, free. Handicapped accessible; wheelchairs available.
Hours: Tues.–Sat., 10–5; Sun., 1–5; Mon., 10–5, July–Aug. only; Fri., 10–9, June–Aug. only.
Tours: Call (412) 622-3289.
Food & Drink: Museum Café open Tues.–Fri., 11:30–2. Closed weekends. Coffee Bar open Tues.–Sat., 10–4; Sun., 1–4.
Museum Shop: Open during museum hours.

The Frick Art Museum
7227 Reynolds St., Pittsburgh, PA 15208
(412) 371-0600

1998 Exhibitions
Thru Jan. 25
Treasures of Asian Art: Masterpieces from the Mr. and Mrs. John D. Rockefeller, III Collection
Features over 80 objects dating from the 8th century B.C. to the 18th century A.D. illustrating the artistic traditions of South and East Asia.

May 3-July 24
For the Imperial Court: Qing Porcelain from the Percival David Foundation of Chinese Art, London
A remarkable collection of porcelain from the Qing period (1644-1911), including 65 works that provide insight into the customs and preoccupations of the imperial court and the Qing elite. Catalogue. (T)

Nov. 20-Jan. 10
William Sydney Mount: American Genre Painter
Examines visions of everyday life through paintings, oil sketches, drawings, and prints by this 19th-century American genre painter. Catalogue. (T)

Permanent Collection
Rare 14th- and 15th-century Florentine and Sienese paintings by Duccio, Sassetta, Giovanni de Paolo; portrait by Rubens; landscape by Boucher, devotional altarpiece by Jean Bellegambe; Dutch genre scene on panel by Jan Steen; 16th-century tapestries; Chinese porcelains; Renaissance bronzes; terra-cotta bust by Houdon; 18th-century French salon room; 17th-century English country-house room.

Jingdezhen porcelain bowl, Qing dynasty, c. 1862–1908. From *For the Imperial Court: Qing Porcelain from the Percival David Foundation of Chinese Art.* Photo courtesy American Federation of Arts.

Architecture: 1970 Renaissance-style building by Pratt, Schafer, and Slowik.

Admission: Free. Handicapped accessible.
Hours: Tues.–Sat., 10–5:30; Sun., noon–6. Closed Mon.
Tours: Wed., Sat.–Sun., 2. Call (412) 371-0606 to arrange group tours.
Food & Drink: Frick Café open Tues.–Sat., 10–5:30; Sun., noon–6.

The Andy Warhol Museum

117 Sandusky Street, Pittsburgh, PA 15212
(412) 237-8300
http://www.clpgh.org/warhol/

Permanent Collection
The Andy Warhol Museum, opened in May 1994, is a collaborative project of the Carnegie Institute, the Dia Center for the Arts, and The Andy Warhol Foundation for the Visual Arts. Covers the entire range of Warhol's works, including 1950s illustrations and sketchbooks, 1960s Pop paintings of consumer products and celebrities; portraits and works from the 1970s and 1980s; and collaborative paintings made with younger artists. Extensive archival holdings of working and source material, time capsules, video and audiotapes, scripts, diaries, and correspondence. **Architecture:** Former industrial warehouse built in 1911, with terracotta facade of ivory-colored Classical ornament; renovated by New York architect Richard Gluckman.

Admission: Adults, $5; seniors, $4; students with ID, children over 3, $3; members, free.
Hours: Wed., Sun., 11–6; Thurs.–Sat., 11–8. Closed Mon.–Tues.
Tours: Call (412) 237-8300 two weeks in advance for group reservations.
Food & Drink: Café open during museum hours.

James A. Michener Art Museum
138 S. Pine St., Doylestown, Bucks County, PA 18901
(215) 340-9800

1998 Exhibitions

Ongoing
Outdoor Sculpture Program
Features a variety of styles and materials by regional and national sculptors.

Thru Feb. 8
New Realities: Hand-colored Photography, 1839 to the Present
Explores the myriad techniques used to create color and surface in works
that blur the line between photography and the other visual arts.

Thru Mar. 8
Masterpieces of Photography from the Merrill Lynch Collection
Works by artists such as Bourke-White, Sherman, Steiglitz, and Weston.

Feb. 21-May 10
Doylestown Hospital 75th Anniversary Exhibition
Includes a re-creation of a 1920s-era doctor's office, a series of photographs
focusing on healing, and a survey of diagnostic imagery.

Mar. 21-June 7
*Contemporary Prints from the Rutgers Center for Innovative Print and
Paper*
Politically conscious works explore the concerns of minorities in American
culture, featuring prints created at this learning center.

May 23-Aug. 2
Bucks County Invitational II: Contemporary Woodworkers
Focuses on regional artists including Jeffrey Greene and Robert Whitley.

Permanent Collection
Traces the history of Bucks County art from colonial times to the present.
Collection features 19th- and 20th-century American art, including
Impressionist and Abstract Expressionist paintings; James A. Michener
memorabilia, celebrating his career as a writer, public servant, and
philanthropist; Nakashima Reading Room, featuring classic furniture by
local woodworker George Nakashima. **Highlights:** Thomas Hicks, *Portrait
of Edward Hicks*; 22-foot mural by Pennsylvania impressionist painter
Daniel Garber.

Admission: Adults, $5; seniors, $4.50; students, $1.50; children under 16,
members, free. Handicapped accessible, including ramps, elevators,
parking, and aids for the hearing impaired.
Hours: Tues.–Fri., 10–4:30; Sat.–Sun., 10–5.
Programs for Children: Studio and gallery workshops, family programs,
and other programming throughout the year.
Tours: Call (215) 340-9800, ext. 126 for information.
Food & Drink: Espress Café open Tues.–Sat., 10–4:30.
Museum Shop: Features crafts from Bucks County. (215) 340-9800.

Museum of Art, Rhode Island School of Design

224 Benefit St., Providence, RI 02903
(401) 454-6500
http://www.risd.edu/museum

1998 Exhibitions

Thru Jan. 11
Ties That Bind: Fiber Art by Ed Rossbach and Katherine Westphal from the Daphne Farago Collection
Works by these two artists illustrate their shared attitudes, including reverence for the past, pushing boundaries, and a sense of playfulness. (T)

Thru Apr. 26
Selections from the Nancy Sayles Day Collection of Modern Latin-American Art
A selection of 20th-century works by artists who wish to reconcile indigenous and international influences on the culture of the hemisphere.

Sistrum, c. 664–525 B.C. Egyptian Dynasty 26. Photo by Del Bogart, courtesy Museum of Art, Rhode Island School of Design, Helen M. Danforth Acquisition Fund.

Thru Apr. 5
Working the Stone: Process and Progress of Lithography
Explores the 200-year history of this printmaking process, literally "writing on stone."

Feb. 6-Apr. 19
Geoffrey Beene
Innovative clothing by this designer who has been at the cutting edge of fashion for over 30 years. (T)

Feb. 20-June 14
African-American Art from the Museum's Collection
Works ranging from 19th-century landscape paintings to recent photographs and prints. Includes work by Van Der Zee, Lawrence, DeCarava, and Saar.

Aug. 24, 1998-Jan. 3, 1999
Gifts of the Nile: Ancient Egyptian Faience
Over 150 works covering 3,000 years explore the use of this non-clay ceramic medium, which the ancients compared to the moon and stars. (T)

Permanent Collection

Greek and Roman art; Asian art; masterpieces of European and American painting, sculpture from the early Middle Ages to the present; French Impressionist painting; American furniture, decorative arts. **Architecture:** Includes the Pendleton House, First decorative arts wing built in the United

States; 1897 Neo-Romanesque building; 1906 Colonial Revival addition by Stone, Carpenter & Wilson; 1926 Georgian addition by William Aldrich; The Daphne Farago Wing, dedicated to the display and interpretation of contemporary art, by Tony Atkin & Associates, opened in 1993.

Admission: Adults, $5; seniors, $4; college students with ID, $2; children 5–18, $1; under 5, free. Handicapped accessible. Aids are available.
Hours: Wed.–Sun., 10–5; Fri., 10–8. Closed Mon., Jan. 1, July 4, Thanksgiving, Dec. 25.
Programs for Children: Workshops, after-school activities, and family programs throughout the year.
Tours: Call (401) 454-6534.
Museum Shop: Open during museum hours. (401) 454-6540.

Gibbes Museum of Art
135 Meeting St., Charleston, SC 29401
(803) 722-2706

1998 Exhibitions
Thru Jan. 4
The Concrete Jungle: A Selection from the Robert Marks Collection of Photographs
Images of urban life in the city of New York by this photojournalist and author from Charleston.

Light Days/Dark Nights: The Carolina Photographs of Doris Ulmann
Features 40 photographs by a New York-based artist known for her views of rural Southern life.

Artists of the Boston Art Club, 1854-1950
Presents works by more than 50 American artists who exhibited in Boston during the formative years of the city's art institutions.

Joseph de Clorivere, *Mary Ann Belinda O'Keefe (Mrs. William White)*, 1806. From *Tiny Jewels: A Selection from the Miniature Portrait Gallery*. Photo courtesy Gibbes Museum of Art.

Thru Apr. 12
Local Artists Embracing the Far East: The Motte Alston Read Japanese Print Collection
Examines the development of the museum's collection and local artists who were influenced by Japanese prints.

Thru June 28
Tiny Jewels: A Selection from the Miniature Portrait Collection
Highlights how individuals used miniatures as jewelry in the 18th and 19th centuries.

The Poetry of Place: Landscapes of Thomas Coram and Charles Fraser
Examines the Carolina Lowcountry landscape tradition as seen in the work
of these two artists who worked in Charleston during the Federal period.

Jan. 23-Mar. 15
Rediscovering the Landscape of the Americas
Works by 72 artists from Canada, Mexico, and the U.S. address a variety of
social, political, environmental, and aesthetic issues through landscapes.

Permanent Collection
Over 7,000 objects ranging from paintings, prints, and drawings to
photography, sculpture, and miniature rooms. Significant collection of
American paintings, reflecting Charleston's history and culture from the
Colonial South to the present. **Highlights:** Japanese print collection;
Elizabeth Wallace miniature rooms; and portrait miniatures.

Admission: Call for rates. Members, free. Handicapped accessible,
including elevators.
Hours: Tues.–Sat., 10–5; Sun.–Mon., 1–5.
Programs for Children: Programs throughout the year. Call for details.
Tours: Available by appointment.
Museum Shop: Open during museum hours.

Greenville County Museum of Art

420 College St., Greenville, SC 29601
(864) 271-7570

1998 Exhibitions
Continuing
Women, Women, Women: Artists, Objects, Icons
A collaboration with the local Emrys foundation, featuring work by and
about women.

Thru Jan. 4
Eric Carle: From Head to Toe
Illustrations from the recent children's book by this acclaimed author, best
known for his classic *The Very Hungry Caterpillar*.

Thru Jan. 11
Bobby Neel Adams: Broken Wings
Horrifying and uplifting images of land mine victims by this New York-
based photographer.

Feb. 4-Mar. 29
Martin Mull: 20/20
Expressionist paintings coincide with the release of the artist's latest book.

Apr. 22-June 21
Consuelo Kanaga: An American Photographer
Retrospective of the career of this photojournalist (1894-1978), including
over 100 silver gelatin prints featuring portraits of African Americans, urban
and rural views, and still lifes. Catalogue. (T)

Sept.-Oct.
Shaman's Fire: The Late Paintings of David Hare
Although known primarily as a sculptor, Hare (d. 1992) devoted himself to painting during the last decade of his career.

Ralph Gibson
The work of this New York-based photographer (b. 1939).

Permanent Collection
Southern-related art and contemporary art; the collection contains at least one example from every major movement in American art from the early 1700s to the present day. Artists represented include Washington Allston, George Healy, Georgia O'Keeffe, and Jasper Johns. **Architecture:** Modernistic, reinforced concrete 1974 building with four floors of galleries, by Craig, Gaulden & Davis.

Admission: Free. Handicapped accessible.
Hours: Tues.–Sat., 10–5; Sun., 1–5. Closed Mon., major holidays.
Programs for Children: Including school tours and gallery treasure hunts.
Tours: For information call (864) 271-7570.
Museum Shop: Open during museum hours.

The Knoxville Museum of Art

1050 World's Fair Park Dr., Knoxville, TN 37916
(423) 525-6101
http://www.esper.com/kma

1998 Exhibitions
Thru Jan. 4
The Spirit of Ancient Peru
More than 150 objects documenting ancient Peruvian cultures from the Moche, Chimu, and Inca civilizations until the arrival of the Spanish.

Mantle (detail), Paracas Culture, c. 100 B.C.–200 A.D. From *The Spirit of Ancient Peru.* Photo courtesy Knoxville Museum of Art.

Thru Jan. 18
Objects of Personal Significance
Paintings and works on paper by contemporary women artists, including Betye Saar, Janet Fish, and Jaune Quick-to-See Smith.

Thru May 10
Awakening the Spirits: Art by Bessie Harvey
First retrospective of one of East Tennessee's most acclaimed artists, whose creations of folk art recount the struggles of Africans in America.

Feb. 13-May 31
Ansel Adams: The Man Who Captured the Earth's Beauty
Includes 24 vintage photographs taken between 1930 and 1960 by this artist whose name is synonymous with the beauty and grandeur of the West.

Opens Feb. 27
Masterworks of American Art from the Munson-Williams-Proctor Institute
Illustrates the development of American art from 1900 to 1970, with works by Henri, Hopper, Dove, Man Ray, and others.

Apr. 24-Aug. 2
Witness and Legacy: Contemporary Art About the Holocaust
Major exhibition of recent work by 22 American artists explores the links between the Holocaust and artistic creativity with compelling stories.

Sept. 4, 1998-Jan. 3, 1999
Trashformations: Recycled Materials in Contemporary American Art and Design
Features 80 works that show the use of recycled and discarded materials in contemporary art, including sculpture, textiles, jewelry, and furniture.

Dec. 18, 1998-Feb. 28, 1999
India: A Celebration of Independence, 1947-1997
Features 240 photographs that show the changing cultural awareness in India over the past 50 years. (T)

Permanent Collection

Small permanent collection, focusing on 20th-century American art, in all media, during and after the 1960s. **Architecture:** Steel and concrete building faced in Tennessee pink marble, by renowned museum architect Edward Larrabee Barnes of New York, opened in 1990.

Admission: Free. Suggested donation: Adults, $4; seniors, $3; students 13-17, $2; children 12 and under, $1. Handicapped accessible.
Hours: Tues.–Thurs., Sat., 10–5; Fri., 10–9; Sun., noon–5. Closed Mon.
Programs for Children: ARTcade interactive gallery; summer art camp.
Tours: Special exhibition tours, Sun., 3; Call (423) 525-6101, ext. 226.
Museum Shop: Two shops, open during museum hours.

Dixon Gallery and Gardens

4339 Park Avenue, Memphis, TN 38117
(901) 761-5250

1998 Exhibitions

Thru Feb. 22
An American Tradition: The Pennsylvania Impressionists
A collection of American Impressionist paintings spanning four decades,
including nearly 50 paintings by 15 artists who were inspired by the natural
beauty in and around Bucks County, PA.

Feb. 8-May 3
Margaret Mee: Return to the Amazon
Botanical drawings made by this explorer (1909-1988) during her travels to
the rain forest. (T)

May 3-June 28
British Delft from Colonial Williamsburg
Explores the various roles these ceramics played in 17th- and 18th-century
England and Colonial America, through over 160 examples. (T)

Permanent Collection
Fine arts museum specializing in French and American Impressionist and
Post-Impressionist paintings; Stout Collection of 18th-century German
porcelain, one of the finest in the world. **Architecture:** Georgian-style
residence and gallery complex, surrounded by 17 acres of beautiful gardens,
including formal English gardens, open vistas, and woodland areas.

Admission: Adults, $5; seniors, $4; students, $3; Children ages 3–11, $1.
Hours: Tues.–Sat., 10–5; Sun., 1–5. Closed Mon., but gardens open with
half-price admission.

Memphis Brooks Museum of Art

Overton Park, 1934 Poplar, Memphis, TN 38104
(901) 722-3500
http://www.brooksmuseum.org

1998 Exhibitions
Thru Feb. 1
Jewels of the Romanovs: Treasures of the Russian Imperial Court
Extraordinary pieces from the Romanov collection, including representative
portraits, costumes, religious artifacts, and modern jewelry. Catalogue.

Feb. 1-Mar. 29
Lasting Impressions: The Drawings of Thomas Hart Benton
Drawings and watercolors by this noted 20th-century narrative artist.

Apr. 12-June 7
French Painting of the Ancient Regime from the Collection of the Blaffer Foundation
Reveals the breadth of subject matter and genre painting in 18th-century France, including religious, allegorical, portraiture, landscape, and still life paintings by Mignard, Fragonard, Chardin, and others. Catalogue.

June 28-Sept. 6
Nancy Graves: Excavations in Print
The first comprehensive examination of the artist's graphic work, including her "Pilchuck" and "Full Plate" series, in which she experiments with embossing organic material directly on paper. (T)

Sept. 20-Nov. 29
Duane Hanson
Examines the work of this 20th-century American artist known for his life-size and life-like plastic figures of ordinary people. (T)

Nov. 26, 1998-Jan. 17, 1999
Treasures of Deceit: Archeology and the Forger's Craft
Explores how art historians and scientists determine whether a work of art is genuine. Viewers are encouraged to examine objects. (T)

Permanent Collection

Spans twenty centuries of art, including core collections of Italian and Northern Renaissance and Baroque paintings and 18th- and 19th-century English and American portraiture; works by French Impressionists and contemporary American artists; selection of 17th- and 18th-century European decorative arts and Doughty ceramics. **Architecture:** 1916 Beaux Arts building by James Gamble Rogers; 1973 and 1990 renovations and expansions; 1993–94 gallery renovation.

Admission: Free. Occasional fees for special exhibitions. Handicapped accessible; wheelchairs available.
Hours: Tues.–Fri., 9–4; Sat., 9–5; Sun., 11:30–5. Closed Mon., July 4, Dec. 25, Jan. 1.
Programs for Children: Programs throughout the year. (901) 722-3515.
Tours: Sat., 10:30, 1:30; Sun., 1:30. Groups call (901) 722-3515.
Food & Drink: Brushmark Restaurant, Tues.–Sun., 11:30–2:30; selected Thurs., 5-8.
Museum Shop: Open museum hours. Features jewelry by local artisans.

Austin Museum of Art

Downtown
823 Congress Ave., Austin, TX 78701
(512) 495-9224
http://www.amoa.org

1998 Exhibitions
Thru Jan. 26
A Commitment to Abstraction: Ten in Texas

Feb. 7-May 10
Southwestern Bell Collection: Contemporary Masters

Aug. 29-Oct. 25
Modotti and Weston: Mexicanidad
Looks at Mexican history and culture as presented in the images of these two great photographers. (T)

Admission: Adults, $3; seniors, students, $2; Thurs., $1; children under 12, free. Wheelchair accessible.
Hours: Tues.–Sat., 11–7; Thurs., 11–9; Sun., 1–5. Closed Mon., holidays.
Programs for Children: Art School offers classes for all ages.
Tours: Call the Education Dept. at (512) 458-8191, ext. 238. Reservations required for groups.
Museum Shop: Open during museum hours; also Mon., 11–7.

Austin Museum of Art—Laguna Gloria
3809 W. 35th St., Austin, TX 78703
(512) 458-8191

1998 Exhibitions
Thru Jan. 4
Works from the Ceramics Collection of the San Angelo Museum of Art

Jan. 10-Feb. 28
William Wegman: A Full Retrospective
Surveys the career of this American photographer known for using his pet dogs as models for human issues and stories.

Mar. 14-May 30
Texture (Annual Family Exhibition)

June 13-Aug. 9
Art in Process Part II

Luis Jimenez, *Lagartos (Alligators)*, 1996. Photo courtesy Austin Museum of Art–Laguna Gloria.

Permanent Collection

Changing exhibitions of 20th-century American art. Objects from the small permanent collection are not always on exhibit. Outdoor sculpture from the permanent collection is displayed on the grounds. **Architecture:** 1916 historic landmark Mediterranean-style villa by Page.

Admission: Adults, $2; seniors, students, Thurs., $1; children under 12, free.
Hours: Tues–Sat., 10–5; Thurs., 10–9; Sun., 1–5. Closed Mon., holidays.
Tours: Call (512) 458-8191 for reservations.

Archer M. Huntington Art Gallery

The University of Texas at Austin
23rd & San Jacinto, Austin, TX 78712
(512) 471-7324
http://www.utexas.edu/cofa/hag

1998 Exhibitions
Thru Feb. 27
The Human Condition: Elgin W. Ware, Jr./Texas Medical Association Collection Exhibition
Explore medical themes through over 30 prints ranging from Albrecht Dürer engravings to Eric Avery linoleum cuts.

Jan. 16-Mar. 8
Aligning Vision: Alternative Currents in South American Drawing
Explores the development of drawing as a mode of expression in South America during the past 30 years. Includes 137 drawings and 4 installations by 46 artists. (T)

Mar. 27-May 10
Print Study Exhibition, Spring Semester
Features a selection of works from the museum's collection of more than 12,000 prints and drawings.

Jorge de la Vega, *La Tormenta (The Storm)*, 1962. Gift of Barbara Duncan, 1974. From *Aligning Vision: Alternative Currents in South American Drawing*. Photo by George Holmes, courtesy Archer M. Huntington Art Gallery.

Other Worldly Visions: Persian and Indian Paintings from the Arthur M. Sackler Gallery at the Smithsonian Institution
Examines portraiture, imagery, and the role of calligraphy in paintings from India and Iran created during the 16th and 17th centuries.

June 12-Aug. 16
American Masters: Sculpture from Brookgreen Gardens
Explores several of America's foremost traditional and figurative sculptors of the last 150 years, including Saint-Gaudens and Nadelman.

Permanent Collection
Two locations on the University campus offer over 12,000 works, including examples of 20th-century American art, Western American art, contemporary Latin American art, and European painting, sculpture, and antiquities. **Highlights:** Gutenberg Bible, on display at the Harry Ransom Center, located at 21st & Guadalupe.

Admission: Free. Handicapped accessible, including ramp and elevator.
Hours: Mon.–Fri., 9–5; Thurs., 9–9; Sat.–Sun., 1–5.
Programs for Children: Programs offered to grades K–12, including the Art Enrichment and Expanding Horizons programs for 4th–6th grades.
Food & Drink: Cafeterias nearby in Fine Arts building, Thompson Conference Center, or Dobie Mall (across from Harry Ransom Center).
Museum Shop: Located at guard desk; offers books and catalogues.

Dallas Museum of Art

1717 N. Harwood, Dallas, TX 75201
(214) 922-1200, (214) 922-1355 [TDD]
http://www.unt.edu/dfw/dma

1998 Exhibitions
Thru Jan. 10
Faces of a New Nation: Colonial American Portraits
Explores development of American portraiture from its colonial roots through the revolutionary era. Features recent acquisition of a pair of portraits by John Singleton Copley.

Thru Jan. 12
Stitches in Time: American Quilts from the Permanent Collection
Includes examples of quilts made in New England, the mid-Atlantic, and Texas that emphasize bold coloration and diversity of technique.

Thru Feb. 1
The Search for Ancient Egypt
Bronze, bone, wood, textile, and other objects excavated from Egypt and Nubia dating from the early dynastic through the Ptolemaic periods. (T)

Jan. 11-Apr. 5
Linda Ridgway: A Survey, The Poetics of Form
First large-scale presentation of one of Dallas's most respected sculptors.

Jan. 25-Mar. 29
Jasper Johns: Process and Printmaking
Examines the creative process behind the prints of this important American artist, featuring proofs and finished prints spanning his entire career. (T)

Mar. 28-May 17
Claude Monet at Vétheuil: A Turning Point
Examines a transitional series of paintings that Monet executed in the winter of 1880, in which he depicts the elemental forces of nature in deserted landscapes. (T)

June 14-Sept. 13
That Earlier, Wilder Image: Oil Sketches by American Landscape Painters, 1830-1880
Examines how artists including Thomas Cole, Asher Durand, Frederic Church, and others used oil sketches to create easel paintings, to market themselves, and to promote their careers.

Permanent Collection
Arts of Africa, Asia and the Pacific; contemporary paintings and sculpture; ancient American art. **Highlights:** Wendy and Emery Reves Collection of impressionist paintings, sculpture and decorative arts.
Architecture: 1984 minimalist building of Indiana limestone and 1993 addition by Edward Larrabee Barnes; 1985 recreated Mediterranean villa housing Reves collection.

John Singleton Copley, *Sarah Sherburne Langdon,* 1767. Photo courtesy Dallas Museum of Art, The Eugene and Margaret McDermott Art Fund, 1996.

Admission: Free. (Fees for some special exhibitions.) Handicapped accessible, including elevators, ramps, wheelchairs, and braille signage.
Hours: Tues., Wed., Fri., 11–4; Thurs., 11–9; Sat.–Sun. and holidays, 11–5. Closed Mon.
Programs for Children: Family art activities and installations; Drop-in Art, Sat. 1-3:30.
Tours: A Closer Look, Tues.–Fri., 1; Sat.–Sun., 2; Gallery Talk, Wed., 12:15; private tours call (214) 922-1331.
Food & Drink: Atrium Café open Tues., Wed., Fri., 11–3:30, Thurs. 11–8:30, Sat.–Sun., 11–4:30. Seventeen Seventeen Restaurant open Tues.–Thurs., 11–2, 6–10; Fri.–Sat., 11–2, 6–11; Sun. brunch, 11–2. For reservations call (214) 880-9018. Picnic areas available in Sculpture Garden.
Museum Shop: Open during museum hours.

Amon Carter Museum

3501 Camp Bowie Blvd., Fort Worth, TX 76107
(817) 738-1933
http://www.cartermuseum.org

1998 Exhibitions

Thru Jan. 18
A Passion for Birds: Eliot Porter's Photography

Thru Feb. 8
Masterworks of the Photography Collection: Visions of Public America

Jan. 24-May 10
Imagining the Open Range: Erwin E. Smith, Cowboy Photographer

Feb. 14-June 7
Masterworks of the Photography Collection: Transforming Nature

May 16-Aug. 15
Selections from the Permanent Collection

Aug. 22-Oct. 17
Views of Texas

Charles Demuth, *Chimney and Water Tower*, 1931. Photo courtesy Amon Carter Museum.

Oct. 31, 1998-Jan. 24, 1999
From the Mind's Eye: American Self-Taught Artists of the Twentieth Century

Permanent Collection

Art of the American West including works by Remington and Russell; 19th- and 20th-century painting, sculpture, graphic art by Davis, Demuth, Harnett, Homer, Marin, Nadelman, O'Keeffe. **Highlights:** Comprehensive collection of American photography; Heade, *Thunderstorm over Narraganset Bay*; Lane, *Boston Harbor*; Remington, *A Dash for the Timber*. **Architecture:** 1961 building by Philip Johnson.

Admission: Free. Handicapped accessible, including parking spaces.
Hours: Tues.–Sat., 10–5; Sun., 12–5. Closed Mon., holidays.
Programs for Children: Education programs for all ages, year-round.
Tours: Tues.–Sun., 2. Groups call (817) 737-5913 two weeks in advance.
Museum Shop: Recently expanded product line offers books, cards, and other items related to American art.

Kimbell Art Museum

3333 Camp Bowie Blvd., Fort Worth, TX 76107
(817) 332-8451
http://www.kimbellart.org

1998 Exhibitions

Thru Jan. 11
Impressionist and Modern Masterpieces: The Rudolf Staechlin Family Foundation Collection of Basel, Switzerland
A tribute to one of Europe's pioneer collectors of modern art, featuring 26 paintings by artists such as Gauguin, van Gogh, and Cézanne.

Thru Jan. 25
Hidden Treasures of the Tervuren Museum: Masterpieces from the Royal Museum for Central Africa, Belgium
A selection of 125 Central African masks, sculptures, and other objects originally collected to increase European understanding of the area called the Kongo, now known as Zaire. Catalogue. (T)

Thru Mar. 1
For the Imperial Court: Qing Porcelain from the Percival David Foundation of Chinese Art, London
A remarkable collection of porcelain from the Qing period (1644-1911), including 65 works that provide insight into the customs and preoccupations of the imperial court and the Qing elite. Catalogue. (T)

Feb. 8-Apr. 26
Renoir's Portraits: Impressions of an Age
Selection of portraits by the French Impressionist, including some of the artist's best-known and most-loved figure paintings. Catalogue. (T)

May 3-July 19
Ancient Gold: The Wealth of the Thracians, Treasures from the Republic of Bulgaria
Over 200 masterpieces of gold and silver metalwork from ancient Thrace, located in central Europe between 4,000 B.C. and the 4th century A.D. (T)

May 31-Aug. 23
King of the World: A Mughal Manuscript from the Royal Library, Windsor Castle

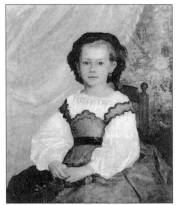

Auguste Renoir, *Mademoiselle Romaine Lacaux,* 1864. Collection Cleveland Museum of Art. From *Renoir's Portraits: Impressions of an Age.* Photo courtesy Kimbell Art Museum.

A rare exhibition of the treasured illustrated manuscript, *The Padshahnama*, which was commissioned by the Mughal emperor Shah-Jahan in 1639. (T)

June 21-Sept. 13
Design as Art: Towards Modernism, 1880-1940
The development of design, including decorative, applied, and graphic arts, from the Arts and Crafts movement to De Stijl, Bauhaus, and Art Deco.

Permanent Collection

European painting and sculpture through the early 20th century; Asian paintings, sculptures, ceramics; Meso-American, African, ancient Mediterranean art. Recent acquisitions include Jacopo Bassano, *Franciscan Friar*, and Claude Monet, *Weeping Willow*. **Highlights:** Caravaggio, *Cardsharps*; Cézanne, *Man in a Blue Smock*; Duccio, *Raising of Lazarus*; Fra Angelico, *Saint James Freeing Hermogenes*; Guercino, *Portrait of a Lawyer*; Houdon, *Portrait of Aymard-Jean de Nicolay* ; de La Tour, *Cheat with the Ace of Clubs*; Mantegna, *Holy Family with Saint Elizabeth and the Infant Saint John the Baptist;* Matisse, *L'Asie*; Mondrian, *Composition No. 8*; Monet, *Pointe de la Heve at Low Tide*; Picasso, *Man With a Pipe* and *Nude Combing Her Hair*; Poussin, *Venus and Adonis*; Rembrandt, *Portrait of a Young Jew*; Rubens, *The Duke of Buckingham;* Ruisdael, *A Stormy Sea*; Titian, *Madonna and Child with Saint Catherine and the Infant Saint John the Baptist.* **Architecture:** One of Louis Kahn's finest creations, designed between 1967 and 1972, set in a park environment with reflecting pools.

Admission: Free. (Certain traveling exhibitions may have a fee.) Handicapped accessible. Hearing-impaired workshops held regularly.
Hours: Tues.–Thurs., Sat., 10–5; Fri., 12–8; Sun., 12–5. Closed Mon., holidays.
Programs for Children: Children's workshops throughout the year.
Tours: Call (817) 332-8687 for information and group reservations.
Food & Drink: Buffet restaurant open Tues.–Thurs., Sat., 11:30–4; Fri., 12–4, 5:30–7:30; Sun., 12–4. Reservations recommended for 8 or more; (817) 332-8451.
Museum Shop: Offers a wide range of books. (817) 332-8451, ext. 236.

Modern Art Museum of Fort Worth

1309 Montgomery St. at Camp Bowie Blvd., Fort Worth, TX 76107
(817) 738-9215
http://www.mamfw.org

1998 Exhibitions

Thru Jan. 18
Georg Baselitz: Portraits of Elke
Recognized as one of the most important artists of post-WWII Europe, Baselitz has created depictions of his wife since the 1960s. Includes paintings, drawings, watercolors, and prints. (T)

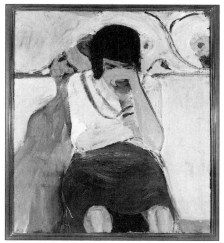

Richard Diebenkorn, *Girl with Flowered Background,* 1962.
Photo courtesy Modern Art Museum of Fort Worth.

Feb. 8-Apr. 12
Richard Diebenkorn
The most comprehensive survey to date of this contemporary, late American artist's career, featuring over 150 paintings and works on paper, including his celebrated *Ocean Park* series, figurative works, and early abstractions. Catalogue. (T)

Permanent Collection
Surveys all major developments in 20th-century figurative and abstract art, focusing on American and European art after 1945. International collection of contemporary photography. Contemporary sculpture outside on museum grounds. Includes 3,000 paintings, sculptures, photographs, drawings, and prints ranging from Pollock and Motherwell to Rothenberg and Sherman. **Highlights:** Picasso, *Reclining Woman Reading* and *Head of a Woman*; Rothko, *Light Cloud, Dark Cloud*; Still, *Untitled;* Guston, *Wharf;* Kiefer, *Quaternity;* Richter, *Emma* and *Ferrari;* Warhol, *Twenty-five Colored Marilyns;* extensive collection of works by Motherwell. **Architecture:** 1901 gallery; 1954 first museum building by Bayer; 1974 addition with garden courtyard and solarium by Ford & Associates.

Admission: Free. Handicapped accessible (ramp and chair lift).
Hours: Tues.–Fri., 10–5; Sat., 11–5; Sun., 12–5. Closed Mon., holidays.
Programs for Children: Learning to Look tours and a variety of classes offered year-round.
Tours: Free. For group tour reservations call (817) 738-9215 at least two weeks in advance.
Museum Shop: Extensive collection of books relating to modern art.

The Modern at Sundance Square
410 Houston St., Fort Worth, TX 76102
(817) 335-9215
http://www.mamfw.org

Admission: Free. Handicapped accessible.
Hours: Mon.–Thurs., 11–6; Fri.–Sat., 11–10; Sun., 1–5.
Opened in 1995 as an annex of the Modern Art Museum of Fort Worth, to exhibit selections of modern and contemporary American and European art and small-scale traveling exhibitions. Located downtown in the historic 1929 Sanger Building, with 1995 renovation by architect Ames Fender.

Contemporary Arts Museum

5216 Montrose Blvd., Houston, TX 77006
(713) 526-0773; 526-3129 (recording)
http://www.camh.org

1998 Exhibitions

Thru Jan. 11
Alexis Rockman: Dioramas
Recent work by this New York-based artist who incorporates actual objects into his paintings of real and imagined flora and fauna.

Thru Feb. 1
Ann Hamilton
A site-specific installation by this artist known for her large-scale, material-laden installations that contain elements such as work clothes or teeth.

Jan. 16-Mar. 1
David McGee: Black Comedies and Night Music
Autobiographical figurative works by this Houston-based painter address the dilemmas and rewards of being a young African-American man.

Feb. 12-May 17
Robert Rauschenberg: A Retrospective
Surveys the prolific career of one of the most acclaimed American artists of the 20th century. Includes nearly 400 works from the late 1940s to the present. Catalogue. (T)

Robert Rauschenberg, *Glacier (Hoarfrost)*, 1974. From *Robert Rauschenberg: A Retrospective*. Photo by Allen Mewbourn, courtesy Menil Collection.

Mar. 6-Apr. 19
Houston Photography Now
Celebrates several of the most exciting contemporary photographers working in the Houston area.

Apr. 24-June 14
DeWitt Godfrey
Installation of two- and three-dimensional works created specifically for the museum by this artist who explores the relationship of materials to the natural world.

June 6-July 26
James Turrell: Spirit and Light
Presents a survey of Turrell's work since 1966, including light projections, aquatint prints, and documentation of the *Roden Crater*, a site-specific installation in Arizona.

Permanent Collection

No permanent collection. **Architecture:** 1972 stainless-steel parallelogram building by Gunnar Birkerts and Associates; 1997 renovation by William F. Stern & Associates.

Admission: Free. Handicapped accessible, including ramp, elevator, and parking.
Hours: Tues., Wed., Fri., Sat., 10–5; Thurs., 10–9; Sun., 12–5. Closed Mon., Jan. 1, July 4, Thanksgiving, Dec. 25.
Tours: Call the Education Dept. at (713) 284-8257 for information.
Food & Drink: The Education Resource Center offers coffee and tea.
Museum Shop: Open during museum hours.

The Menil Collection

1515 Sul Ross, Houston, TX 77006
(713) 525-9400
http://www.menil.org

1998 Exhibitions

Thru Jan. 4
Joseph Cornell
Features approximately 50 boxes and collages by this American artist who was a close follower of Surrealism.

Thru Jan. 11
Surrealism
Comprehensive overview of the evolution of surrealism from 1910 through 1970, featuring 75 works by Dalí, Duchamp, Ernst, Magritte, and others.

Joseph Cornell, *Soap Bubble Set (Système de Descartes)*, c. 1954–56. Photo by R. Marionneaux, courtesy Menil Collection.

Thru Mar. 29
The Drawings of Théophile Bra
Visionary drawings express this French, 19th-century sculptor's dreams and mystical experiences.

Feb. 12-May 17
Robert Rauschenberg: A Retrospective
Surveys the prolific career of one of the most acclaimed American artists of the 20th century. Includes nearly 400 works from the late 1940s to the present. Catalogue. (T)

Permanent Collection

The Menil Collection opened in 1987 to house the art collection of Houston residents John and Dominique de Menil. Considered one of the most important privately assembled collections of the 20th century, The Menil Collection includes masterpieces from antiquity; the Byzantine world; the tribal cultures of Africa, Oceania, and the American Pacific Northwest; and the 20th century. **Highlights:** In Feb. 1995, The Menil Collection, in collaboration with Dia Center for the Arts, New York, opened the Cy Twombly Gallery, a satellite space designed by Renzo Piano that houses a permanent installation devoted to the work of the American artist Cy Twombly. **Architecture:** Designed by a joint venture of Renzo Piano Building Workshop and Richard Fitzgerald & Associates.

Admission: Free. Handicapped accessible.
Hours: Wed.–Sun., 11–7. Closed Mon., Tues., holidays.
Tours: Call (713) 525-9400.
Museum Shop: The Menil Collection Bookstore is located at 1520 Sul Ross; open Wed.-Fri. 11-6; Sat.-Sun. 11-6:45. Tel. (713) 521-3814.

The Museum of Fine Arts, Houston

1001 Bissonnet St., Houston, TX 77005
(713) 639-7300
http://mfah.org

1998 Exhibitions

Ongoing

African Gold: Selections from The Glassell Collection
Objects created by the Akan peoples of the Ivory Coast and Ghana, as well as works from the Fulani of Mali and the Swahili of Kenya.

Bayou Bend Collection and Gardens
Art and antiques trace the evolution of style in America from the colonial period to the mid-19th century.

Impressionist and Modern Paintings: The John A. and
Audrey Jones Beck Collection
Represents all of the avant-garde movements in Paris, including masterpieces by Bonnard, Derain, Kupka, Matisse and Monet among others.

Thru Jan. 25

Southwestern Bell Presents American Images: The SBC Collection of 20th Century American Art
Selection of approximately 80 masterworks that highlight major movements in American art. Catalogue.

Thru Feb. 1

The Dark Mirror: Picasso and Photography
Exhibition of little-known photographic works of Pablo Picasso, the most famous artist of the 20th century and the herald of Cubism. Catalogue.

Thru Apr. 12
The Body of Christ in the Art of Europe and New Spain, 1150-1800
European painting, printmaking, and decorative arts focus on the figure of Christ, including works by Botticelli, Dürer, Tintoretto and Zurbarán.

Jacob Armstead Lawrence, *Builders in the City*, 1993. From *Southwestern Bell Presents American Images: The SBC Collection of 20th-Century Art.* Photo courtesy Museum of Fine Arts, Houston.

Jan. 9-Mar. 8
Classical Sensibilities: Images by Alain Gerard Clement and George Dureau
Relates, through classically inspired themes, the work of two contemporary photographers.

Feb. 12-May 17
Robert Rauschenberg: A Retrospective
Surveys the prolific career of one of the most acclaimed American artists of the 20th century. Includes nearly 400 works of art from late 1940s to the present. Catalogue. (T)

May 31-Aug. 23
Intimate Encounters: Love and Domesticity in 18th-Century France
Major exhibition of French 18th-century genre painting, including works by Watteau, Chardin, Boucher, and Fragonard. Catalogue. (T)

Oct. 18, 1998-Jan. 10, 1999
A Grand Design: The Art of the Victoria and Albert Museum
Presents the history of a museum through a comprehensive exhibition of 250 masterworks from the V&A's immense collections, spanning 2,000 years of artistic achievement. Catalogue. (T)

Nov. 12, 1998-Jan. 31, 1999
Tobi Kahn: Metamorphoses
Approximately 30 paintings and 15 shrine sculptures with photographs of monumental sculptures in situ by this New York artist. Catalogue.

June 20, 1998-Aug. 15, 1999
Bearing Witness: Contemporary Works by African-American Women Artists
Diverse grouping of work by 25 contemporary artists explores topics such as history, ethnicity, gender, and age. Catalogue.

Permanent Collection
Works ranging from ancient to modern: Straus collection of Renaissance and 18th-century art; Beck collection of Impressionist and Post-Impressionist art; Target collection of American photography. **Highlights:** Greek bronze youth; The Bayou Bend Collection of 17th- to 19th-century furniture, silver, ceramics, paintings; Brancusi, *A Muse*; Cézanne, *Portrait of the Artist's Wife*; van Gogh, *The Rocks*; Goya, *Still Life with Fish*;

Pollock, *Number 6*; van der Weyden, *Virgin and Child*; Noguchi sculpture garden. **Architecture:** 1924 building by William Ward Watkin; 1926 east and west wings; 1958 and 1974 additions by Mies van der Rohe. New building that will double existing gallery space currently being designed by Rafael Moneo, scheduled to be completed in 1999.

Admission: Adults, $3; seniors, college students with ID, $1.50; members and children under 18, free. Thurs., free. Handicapped accessible.
Hours: Tues.–Sat., 10–5; Thurs., 10–9; Sun., 12:15–6. Closed Mon., major holidays.
Programs for Children: Postcard or Discovery tours, self-guided, Tues.–Sun.
Tours: Daily, noon. Call (713) 639-7324 for groups.
Food & Drink: Café Express offers variety of hot and cold entrees.
Museum Shop: Comprehensive selection of art books and periodicals as well as art-related gifts.

Marion Koogler McNay Art Museum

6000 N. New Braunfels Ave., San Antonio, TX 78209
(210) 824-5368
http://www.mcnayart.org

1998 Exhibitions
Thru Feb. 15
Reflections on Nature: Small Paintings by Arthur Dove (T)

Jan. 27-Apr. 5
O'Keeffe and Texas
This pioneering modern artist once called Texas her "spiritual home," and the influences of her early years are examined in this unique exhibition.

Georgia O'Keeffe, *Evening Star, No. V,* 1917. Bequest of Helen Miller Jones. Photo courtesy McNay Art Museum and The Georgia O'Keeffe Foundation.

Jan. 27-Mar. 22
Georgia O'Keeffe: The Canyon Suite
A series of 28 watercolors by this extraordinary American artist.

Mar. 3-May 3
Watercolor Masterpieces from the McNay Collection
Features works by Demuth, Picasso, Dufy, and others, in conjunction with the Texas Watercolor Society's Watercolor Month.

Mar. 24-May 31
Eugene Berman
Features stage designs by this influential American artist.

May 2-25
Impressionist Prints from the McNay Collection
Features works by Cassatt, Degas, Manet, Cézanne, and others.

June 22-Sept. 13
The Garden Setting: Nature Designed

July 7-Aug. 30
Kent Rush: A Retrospective
Surveys the 30-year career of this Texas-based artist, featuring paintings, prints, photographs, and collages. Catalogue.

Oct. 6, 1998-Jan. 17, 1999
Stages in the Creative Process

Nov. 3, 1998-Jan. 3, 1999
Gabrielle Münter: The Years of Expressionism, 1903-1920
More than 100 works by one of the major artists of German Expressionism, showing her important role in the development of early-20th-century art. (T)

Permanent Collection
Art of the 19th and 20th centuries including French post-impressionist paintings; American paintings before World War II; European and American art after World War II; medieval and Renaissance European sculpture and painting; 19th- and 20th-century prints and drawings and theatre arts. **Architecture:** Spanish-Mediterranean style residence by Atlee B. and Robert M. Ayres, built 1926–1928.

Admission: Free; fees for some special exhibitions. Handicapped accessible, including ramps and elevators.
Hours: Tues.–Sat., 10–5; Sun., noon–5. Closed Mon., Jan. 1, July 4, Thanksgiving, Dec. 25.
Programs for Children: Family Day: May 20.
Tours: Call (210) 805-1722 for information and group reservations.
Museum Shop: Open during museum hours.

San Antonio Museum of Art
200 W. Jones Ave., San Antonio, TX 78215
(210) 978-8100
http://www.samuseum.org

NOTE: Parts of the collection will be in storage and the galleries closed until October 1998, at which time the Nelson A. Rockefeller Center for Latin American Art will open to the public. Please call ahead to confirm.

1998 Exhibitions
Thru Jan. 4
El Alma del Pueblo: Spanish Folk Art and its Transformation in the Americas
Explores the nature of Spanish folk art—its role in past and present Spanish society and its modification in Mexico and the Latin communities of the United States. (T)

Opens Oct.

The Nelson A. Rockefeller Center for Latin American Art
Grand opening of this new wing, featuring the museum's extensive collection of 2,000 Latin American art objects. Includes Spanish Colonial paintings, contemporary art from Mexico and South America, folk art, and pre-Columbian antiquities.

Permanent Collection

Contains some of South Texas's best collections of 18th- and 19th-century European and American paintings; Modern and Contemporary art, including New York School abstract paintings and sculpture; contemporary Texas art; recently expanded Asian

Mask, Mixtec Culture, Mexico, c. 1300–1520 A.D. Photo courtesy San Antonio Museum of Art, The Nelson A. Rockefeller Center for Latin American Art.

galleries contain Chinese ceramics, bronzes, archaic jades, Japanese, East Asian, and Korean art; Egyptian and Classical collection spans 5,000 years, including ancient Greek, Roman, and Byzantine antiquities; collection of Latin American art, including Spanish Colonial/Republican, modern/contemporary, folk art, and Pre-Columbian art. **Highlights:** Works by Copley, West, Stuart; Roman sarcophagi; heroic statue of Roman Emperor Marcus Aurelius; Mesoamerican art, Andean ceramics, stone objects from Aztec, Mixtec, and Toltec periods; important group of 17th- and 18th-century Guatemalan *estofado* images of Santa Teresa de Avila; Contemporary works by Frankenthaler, Guston, Stella, and Hoffman. **Architecture:** Historic 1884 Lone Star Brewery building, renovated in 1981; 1990 Ewing Halsell Wing; Nelson A. Rockefeller Center for Latin American Art, scheduled to open in October 1998.

Admission: Adults, $4; seniors, students, $2; children ages 4–11, $1.75; members, children 3 and under, Tues. 3–9, free. Handicapped accessible.
Hours: Mon., Wed., Sat., 10–5; Tues., 10–9; Sun., 12–5; Closed Thanksgiving, Dec. 25.
Programs for Children: Art workshops, Sun., 1–4; Family day first Sun. of each month, with workshops and tours. Call for more information.
Tours: Call (210) 978-8138 for group reservations and information.
Food & Drink: Picnic areas available in the Luby Courtyard.
Museum Shop: Open during museum hours.

The Chrysler Museum of Art

245 W. Olney Rd., Norfolk, VA 23510
(804) 664-6200; (804) 622-ARTS (recording)
http://www.whro.org/cl/cmhh

1998 Exhibitions

Thru Jan. 4
*Masterpieces of Impressionism: Paintings by Claude Monet from the
Museum of Fine Arts, Boston*

Thru Feb. 9
Commonwealth and Community: The Jewish Experience in Virginia

Thru Nov.
China Trade Porcelain
Features examples of Chinese porcelain from the museum's collection.

Jan. 31-Mar. 22
*Photographs of the Civil Rights Movement from the Collection of the
Chrysler Museum of Art*

Mar. 6-May 17
The Photographs of James Abbe
Retrospective of Virginia native's photographs of cinematic, theatrical, and
political celebrities of the 1920s and 1930s, including portraits of Mary
Pickford, Rudolph Valentino, and Josef Stalin.

Apr. 9-June 14
Written in Memory: Portraits of the Holocaust (T)

June-Sept.
Tokens of Affection: Victorian Photographic Jewelry
The first exhibition to survey photographic portrait jewelry created during
the mid-19th century. Includes decorative and functional objects.

Oct. 1998-Jan. 1999
The Collaborative Work of Gwen Akin and Allan Ludwig

The first retrospective survey of the
entire collaborative work of these
artists. Themes include the passage of
time, effects of decay, loss of memory
and the inevitable mortality of all
living things.

Permanent Collection

Art of many civilizations, styles,
historical periods. European painting
and sculpture, 14th–20th centuries;
19th–20th century American painting
and sculpture; Glass Galleries

Edgar Degas, *Dancer with Bouquets*, c. 1895–1900.
Photo courtesy Chrysler Museum of Art.

including the finest selection of Tiffany creations; decorative arts; one of the finest photography collections in the world; Greek, Roman, Egyptian, pre-Columbian, African works and Asian bronzes. **Highlights:** Degas, *Dancer with Bouquets*; Renoir, *The Daughters of Durand-Ruel*; Gauguin, *The Loss of Innocence*; Bernini, *Bust of the Savior*; Cassatt, *The Family*; Matisse, *Bowl of Apples*; John Northwood, *The Milton Vase*; Christian Boltanski, *Reserve of Dead Swiss*; Veronese, *The Virgin Appearing to Saints Anthony Abbott and Paul the Hermit.* **Architecture:** 1933 building; 1967 Houston Wing; 1976 Centennial Wing; 1989 renovation and expansion by Hartman-Cox; 1997 Educational Wing and the James H. Ricau Collection of Sculpture.

Admission: Adults, $4; students and seniors, $2; members, Wed., free. Handicapped accessible. Wheelchairs, reserved parking, and ramp entrance. **Hours:** Tues.–Sat., 10–5; Sun., 1–5. Closed Mondays. **Programs for Children:** Contact the education dept. at (757) 664-6268. **Tours:** Call (757) 664-6269 for information about museum, and (757) 664-6283 about Historic Houses. **Food & Drink:** Palettes Restaurant open Tues.–Sat., 11–4:30; Sun., 12–4:30. **Museum Shop:** Open during museum hours. Call (757) 664-6297.

Virginia Museum of Fine Arts

2800 Grove Ave., Richmond, VA 23221
(804) 367-0844
http://xroads.virginia.edu/~VAM/VMFA

1998 Exhibitions
Thru Jan. 4
God, Hero, and Lover: Representations of Krishna in Indian Painting
Some 16 miniature paintings and one large painted textile show the many facets of Krishna's complex nature and the impact of this deity on India's artists from 17th-19th centuries.

Thru Jan. 11
William Blake: Illustrations of The Book of Job
Complete set of engraved illustrations of the Book of Job accompanied by preliminary drawings for the engravings, and a selection from the New Zealand set of watercolors.

Thru Jan. 25
American Dreams: Paintings and Decorative Arts from Warner Collection
Work by such painters as Thomas Cole, Edward Hopper, Winslow Homer, James McNeill Whistler, Jamie Wyeth, and Georgia O'Keeffe. Only site for extraordinary exhibition that celebrates the struggles, beauty and visions of a growing nation. Catalogue.

Mar.-Apr.
Hallowed Ground: Preserving America's Heritage
Photographic images of Virginia's northern Piedmont. Catalogue. (T)

Mar.-Oct.
From the Looms of India:
Textiles from the
Permanent Collection
Sampling of India's textile
production from the 17th
to mid-19th centuries.

May-July
India: A Celebration of
Independence, 1947-1997
Features 240 photographs
that show the changing
cultural awareness in India
over the past 50 years. (T)

John Singer Sargent, *Capri 1878.* From *American Dreams:*
Paintings and Decorative Arts from the Warner Collection.
Photo courtesy Warner Collection of Gulf States Paper Corp.
and Virginia Museum of Fine Arts.

July 14-Sept. 20
Gabriele Münter: The Years of Expressionism, 1903-1920
More than 100 works by one of the major artists of German Expressionism,
showing her important role in the development of early 20th-century art. (T)

Nov. 17, 1998-Jan. 31, 1999
Designed for Delight: Alternative Aspects of 20th Century Decorative Arts
Over 200 decorative objects explore the major stylistic movements from art
nouveau and art deco to post-war and postmodern. Catalogue. (T)

Permanent Collection

Comprehensive holdings dating from ancient times to the present:
Byzantine, Medieval, African art; extensive Himalayan collection;
American painting since World War II; Art Nouveau and Art Deco works.
Highlights: Statue of Caligula; Mellon collections of English sporting art
and French Impressionist, Post-Impressionist works; Fabergé Easter eggs
from the Russian Imperial collection; Goya, *General Nicolas Guye*; Monet,
Irises by the Pond; sculpture garden; Classical and Egyptian galleries.
Architecture: 1936 building by Peebles and Ferguson; 1954 addition by
Lee; 1970 addition by Baskerville & Son; 1976 addition by Hardwicke
Associates; 1985 addition by Holzman.

Admission: $4; special fees for some exhibitions. Handicapped accessible.
Hours: Tues.–Sun., 11–5; Thurs. 11–8. Closed Mon.
Programs for Children: Classes, family open houses, events and programs.
Tours: Tues.–Sat., hourly, 11:30–2:30. For reservations call (804) 367-0859
three weeks in advance.
Food & Drink: Arts Café open Tues.–Sat., 11–4; Sun., 1–4.
Museum Shop: Wide array of goods including museum reproduction
jewelry, lacquerwares, textiles, pottery, posters, and items for children.

Frye Art Museum

704 Terry Avenue, Seattle, WA 98104
(206) 622-9250
http://www.fryeart.org

1998 Exhibitions

Jan. 23-Mar. 15
The Circle of Lyon: 7 French Painters of Reality

Mar. 6-May 3
David Ligare Paintings: Viewpoint

May 22-July 19
Alphonse Mucha: The Flowering of Art Nouveau
Major exhibition includes 180 posters, decorative panels, illustrations, and
paintings by Art Nouveau artist Alphonse Mucha (1860-1939). (T)

July 3-Aug. 30
*Another Look:
Paintings of Pieter van
Veen*

Aug. 6-Sept. 27
*Jessica Dunne:
Monotypes*

Sept. 18-Nov. 8
*That's Art! Celebrating
a Century of Comics*

**Nov. 6, 1998-Jan. 3,
1999**
Walt Kuhn: An Imaginary History of the West

Alexander Max Koester, *Ducks*. Photo courtesy Frye Art Museum.

Permanent Collection

Collection of 1,200 paintings, including early-19th- and 20th-century
American paintings; French Impressionist paintings; Alaskan and Northwest
regional art; extensive collection of 19th-century German art. **Highlights:**
Works by Renoir, Pissaro, Eakins, Hartley, Prendergast, and Wyeth.
Architecture: Museum founded in 1952 by Charles and Emma Frye; 1997
renovation by Olson/Sundberg Architects.

Admission: Free. Handicapped accessible; call ahead for special needs.
Hours: Tues.–Sat., 10–5; Sun., 12–5; Thurs., 10–9. Closed Mon.,
Thanksgiving, Dec. 25, Jan. 1.
Programs for Children: Offers art education workshops for all ages.
Tours: Group tours available with reservations; call (206) 622-9250.
Food & Drink: Gallery Café open Tues.–Sat., 11–4; Sun., 12–4; Thurs.,
11–7:30.
Museum Shop: Open during museum hours.

Henry Art Gallery

15th Ave. NE and NE 41st St., University of Washington
UW Box 353070, Seattle, WA 98195
(206) 543-2280; (206) 543-2281
http://www.henryart.org

1998 Exhibitions

Thru Jan. 4
Young and Restless
Performance-based works by 17 young women artists who, through the use of video, explore female social and sexual identity.

Thru Feb. 1
Roni Horn: To Place(s)
American sculptor explores a sense of isolation through minimalist works inspired by the poetry of Emily Dickinson.

Thru July 19
Unpacking the Collection: 70 Years of Collections at the Henry
Explores the reasons and methods for developing an art collection, in celebration of the Henry Art Gallery's 70th anniversary.

Herbert Bayer, *Lonely Metropolitan,* 1925. Photo by Richard Nicol, courtesy Henry Art Gallery.

Feb. 19-May 3
THINKING PRINT: Books to Billboards, 1980-95
Surveys contemporary printed art, featuring innovations in printmaking traditions and new formats such as billboards, subway posters, and T-shirts.

Permanent Collection

Focuses on art from the 19th century to the present, including paintings, prints, ceramics, and video. **Highlights:** The Joseph and Elaine Monsen Photography Collection; plus 16,000-piece costume and textile collection. **Architecture:** Original 1927 Tudor Gothic building designed by Carl Gould. Recent expansion and renovation designed by Charles Gwathmey quadrupled the museum's space.

Admission: Adults, $5; seniors, $3.50; students, members, UW staff, children under 13, Thurs. 5–8, free. Handicapped accessible; call (206) 543-6450 or TDD (206) 543-6452 for more information.
Hours: Tues., Fri.–Sun., 11–5; Wed.–Thurs., 11–8. Closed Mon., July 4, Thanksgiving, Dec. 25, Jan. 1.
Programs for Children: Offers family programs and workshops throughout the year; call the Education Dept. at (206) 616-8782 for details.
Tours: Contact the Education Dept. for information and reservations.
Food & Drink: Henry Café open during museum hours, closing 30 minutes before galleries; outdoor seating available during the summer.
Museum Shop: Henry Museum Shop open during museum hours.

Seattle Art Museum

100 University St., Seattle, WA 98101
(206) 625-8900; 654-3100 (recording)
http://www.sam.trpl.org

1998 Exhibitions

Continuing
Aboriginal Australian Art
Symbolic bark paintings, dramatic acrylic canvases, and wood sculptures represent complex cultural tales from age-old Aboriginal history and law.

Thru Jan. 4
Leonardo Lives: The Codex Leicester and Leonardo da Vinci's Legacy of Art and Science
A review of Leonardo's influence through the ages, exploring the relationship of science to art.

Thru Feb. 22
Homage to Film Noir
Exhibition of 1940s period objects, book covers, posters, film stills, and original photographs by director David Lynch.

Thru May
Pier Table by Charles-Honoré Lannuier
Ornate marble table top, circa 1910, on loan from Stanford University.

Thru June 21
A Passion for Possession: African Art
Proposed purchases of new art for the museum. Visitors may vote on which works should be acquired.

Thru Aug. 2
Documents Northwest: The PONCHO series: Richard Marquis

Jan. 8-Mar. 22
Elizabeth Peyton
Paintings based on newspaper and fan photographs of people the artist admires, including grunge-rock pioneer Kurt Cobain.

Feb. 19-May 10
Native Visions: Northwest Coast Art, 18th Century to the Present
Examples of Northwest Coast art demonstrate how this tradition is constantly evolving by the inclusion of individual inspirations. (T)

Agayuliyararput (Our Way of Making Prayer): The Living Tradition of Yup'ik Masks
A major presentation of Eskimo material, featuring 100 Yup'ik masks and ceremonial objects.

Apr. 23, 1998-Apr. 1999
Documents International
Exhibition about the theme of "Identity" co-curated by local schoolchildren.

June 11-Aug. 30
Thomas Moran
First-ever retrospective of this 19th-century painter best known for his western landscapes. Includes the paintings *Grand Canyon of the Yellowstone, Chasm of the Colorado,* and *Mountain of the Holy Cross.* (T)

July 30, 1998-Feb. 1999
Anne Gerber Exhibition: Cindy Sherman
Works by the modern photographer known for her self-portraits in costume.

Oct. 15, 1998-Jan. 17, 1999
The Search for Ancient Egypt
Bronze, bone, wood, textile and other objects excavated from Egypt and Nubia dating from the early dynastic through the Ptolemaic periods. (T)

Seattle Asian Art Museum
Volunteer Park
1400 East Prospect St., Seattle

1998 Exhibitions
Ongoing
Arts of Korea
Colorful folding screens, including examples of folk paintings and an embroidered Choson dynasty palace screen, accompanied by recently acquired ceramics of the Three Kingdoms period (57 B.C.–A.D. 668).

Thru Nov. 16
A Sack-full of Tigers: Diversity and Diffusion in Japanese Painting of the 19th Century
Works reflecting the social and emotional turbulence at the close of the Edo period, as the Meiji Restoration marked the end of feudal rule and the beginning of modern Japan.

Dec. 1998-Aug. 1999
Romantic Modernism (Nihon-ga)
Japanese works from the late-19th into the 20th century.

Permanent Collection
Over 20,000 objects, from ancient Egyptian sculpture to contemporary American painting. Internationally known for its collections of Asian, African, Northwest Coast Native American, and modern Pacific Northwest art; other holdings include ancient Mediterranean, medieval and early Renaissance, Baroque, early and late 20th-century art. **Highlights:** Classical coins; 18th-century European porcelain; Chinese jades and snuff boxes. **Architecture:** Downtown: 1991 building by Robert Venturi.

Admission: Suggested admission: adults, $6; seniors, students, $4; members and children 12 and under (accompanied by adult), free. First Thurs. of each month, free. Tickets from one branch are valid for admission at the second branch for a one-week period. Handicapped accessible.

Hours: Tues.–Sun., 10–5; Thurs., 10–9. Closed Mon., except some Mon. holidays.
Programs for Children: *Growing Up With Art* program; Teacher Resource Center open Thur., 2–8; Fri., 2–5; Sat., 1–5, at SAAM Volunteer Park.
Tours: Available for the museum and special exhibitions. Call (206) 654-3123. Signed-language tours are available; call (206) 654-3124 [TDD].
Food and Drink: Café open museum hours. Tea Garden at Asian Art Museum.

Milwaukee Art Museum

750 N. Lincoln Memorial Dr., Milwaukee, WI 53202
(414) 224-3200; (414) 224-3220 (recording)
http://www.mam.org

1998 Exhibitions

Thru Jan. 4
New Wisconsin Photography II
Features new images by relatively new young artists. Catalogue.

Thru Jan. 18
Strung, Woven, Knitted, and Sewn: Beadwork from Europe, Africa, Asia, and the Americas
Objects include 17th century English pictures and baskets, African ornaments and masks, clothing and moccasins of several American Indian Tribes, and masks from Mexico, along with contemporary beadwork.

Thru Feb. 15
Jorge Tacla Drawings
Intensely personal works on paper in all media by Chilean-born artist tracing progression from figurative to abstract forms. Catalogue.

Thru Mar. 1
Gabriele Münter: The Years of Expressionism, 1903-1920
More than 100 works by one of the major artists of German Expressionism, showing her role in the development of early 20th-century art. (T)

Thru Mar. 8
French Posters and Prints: The Cutglass Collection
Color prints and posters by French artists such as Eugene Grasset, Alphonse Mucha, and others. Catalogue.

Feb. 27-Apr. 26
Currents 27: Andreas Gursky
First U.S. museum exhibition for contemporary German photographer who explores interweavings of culture and nature in his work. Catalogue.

May 9-Aug. 9
Harley-Davidson: 95 Years of Photography
Photographs shown in conjunction with Milwaukee-based motorcycle company's 95th anniversary.

Mar. 13-May 10
Sean Scully: Works on Paper, 1975-1996
Large-scale abstract canvases and accompanying watercolors by the Irishborn American. Catalogue. (T)

Mar. 20-May 24
It's Only Rock 'n' Roll: Rock 'n' Roll Currents in Contemporary Art
Explores the influences of four decades of rock and roll music and culture on contemporary art, featuring works by artists such as Warhol, Basquiat, Mapplethorpe, and Rauschenberg. Catalogue. (T)

May 22-Aug. 16
Recent Acquisitions
Annual exhibition of acquisitions in all media.

June 12-Aug. 23
Making Marks: Drawing in the 20th Century from Picasso to Kiefer
Includes works by Pablo Picasso, Wassily Kandinsky, Georgia O'Keeffe, Stuart Davis, and many others. Catalogue.

Permanent Collection

Includes over 20,000 18th- to 20th-century works of European and American art, decorative art, and photography, including works by German Expressionists, American Ashcan School artists. **Highlights:** Archive of Prairie School architecture; Bradley collection of early modern and contemporary art; Fragonard, *Shepherdess*; Johnson, *The Old Stage Coach*; Zurbarán, *Saint Francis*. **Architecture:** 1957 building by Eero Saarinen; 1975 addition by David Kahler. Addition under construction by Santiago Calatrava. Planned opening in Dec. 1999.

Admission: Adults, $5; seniors, students, $3; children under 12, members, free. Handicapped accessible, use the East entrance (facing lake). During construction call 414-224-3200 for updated information.
Hours: Tues., Wed., Fri., Sat., 10–5; Thurs., 12–9; Sun., 12–5. Closed Mon.
Tours: Call (414) 224-3225, ext. 271, for information.
Food & Drink: Café open Tues.–Wed., Fri., 11–3; Thurs., Sun., 12–4; Sat., 11–4.
Museum Shop: Offers art books, catalogues, cards, and other unique gifts.

Buffalo Bill Historical Center

720 Sheridan Ave., Cody, WY 82414
(307) 587-4771
http://www.truewest.com/BBHC

1998 Exhibitions
May 15-Aug. 9
Powerful Images: Portrayals of Native America
Exhibition, organized by "Museums West," a consortium of western museums in North America, will travel throughout 1998 and 1999 to member institutions.

Permanent Collection
With four museums in one, the Buffalo Bill Historical Center contains the largest collection of western Americana in the world. The Buffalo Bill Museum contains personal and historical memorabilia of William F. "Buffalo Bill" Cody; Plains Indian Museum displays

Ghost Dance Shirt. Photo courtesy Buffalo Bill Historical Center, Cody, Wyoming.

materials reflecting artistic expression of Arapaho, Blackfeet, Cheyenne, Crow, Shoshone, Sioux, and Gros Ventre Tribes; Whitney Gallery of Western Art features paintings and sculpture of Bierstadt, Catlin, Miller, Moran, Remington, Russell, Sharp, and Wyeth; Cody Firearms Museum presents story of firearms in the U.S. **Architecture:** 1927 log building; 1959 Whitney Gallery and 1969 Buffalo Bill Museum by George Tresler; 1979 Plains Indian Museum by Adrian Malone; 1991 Cody Firearms Museum by Luckman Assoc. 237,000-square-foot complex also contains a research library.

Admission: Adults, $8; seniors, $6.50; students, $4; children, $2; under 6, free.
Hours: June–Sept.: daily, 7 a.m.–8 p.m.; Call for off-season hours, which vary.
Programs for Children: Workshops offered during peak season, occasionally during off-season.
Tours: Call for information regarding organized school groups.
Food & Drink: Restaurant open June–Sept.: daily, 7 a.m.–8 p.m. Hours vary during off-season.
Museum Shop: Open during museum hours.

SELECTED MUSEUMS
OUTSIDE THE UNITED STATES

Museum Guggenheim Bilbao, Spain,
opened in 1997. Photo by Aitor Ortiz.

National Gallery of Australia

Parkes Place, Canberra, ACT 2601, Australia
(61) (6) 240 6411
http://www.nga.gov.au

1998 Exhibitions

Thru Feb. 15
Rembrandt: A Genius and His Impact
Works by Rembrandt and his followers, demonstrating the artist's impact on the Golden Age of Dutch Painting. Includes paintings, drawings, and prints.

Apr. 25-June 21
Everyday Art: Australian Folk and Vernacular Arts
Australian decorative arts from 1790 to the present, acknowledging indigenous and non-indigenous traditions.

Leon Bakst, *Costume Design for an Odalisque (from Scheherazade)*, 1910. From *The Russian Ballet of Serge Diaghilev*. Photo courtesy National Gallery of Australia.

Thru Mar. 8
Picasso and the Vollard Suite
Etchings and engravings created by Picasso in the 1930s, revealing themes such as the Spanish Civil War, erotica, and bullfighting.

Mar. 7-May 17
New Worlds From Old: Australian and American Landscape Painting of the 19th Century
Compares the traditions of these former British colonies during a period when landscape became a focus. Includes works by Frederic Church, Thomas Cole, Winslow Homer, Augustus Earle, and John Glover. (T)

June 6-Aug. 9
Edo Women: The Feminine Image in Japanese Art
Examines depictions of women in woodblock prints, paintings, and kimonos dating from the Edo period (1603-1868) to the beginning of this century.

Sept. 5-Nov. 15
The Russian Ballet of Serge Diaghilev
A stunning look at the Ballets Russes, its marriage between theater and the development of artistic expression, and the impact of productions such as *Cleopatra*, *Petrouchka*, and *The Song of the Nightingale*.

Permanent Collection
Concentrated on the development of 20th-century art in Europe, the United States, and Australia; major artists represented include Picasso, Matisse, Rubens, Monet, Kiefer, and Kounellis. Other collections include Aboriginal and Torres Strait Islander Art, the Asian collection, and the Sculpture Garden. **Highlights:** Jackson Pollock, *Blue Poles*; *Aboriginal Memorial* by Ramingining Artists; Brancusi, *Birds in Space*. **Architecture:** 1982 building by Edward Madigan Torzillo & Briggs. A new wing, designed by Andrew Andersons of Peddle Thorpe, is under construction.

Admission: Adults, Aus$3; students, free (except certain major exhibitions). Handicapped accessible, including ramps and elevators.
Hours: Daily, 10–5. Closed Good Friday and Dec. 25.
Programs for Children: School excursions and workshops.
Tours: Call (61) (6) 240 6519 for information.
Food & Drink: The Gallery Brasserie, daily, 10–4:30; The Mirrabook Outdoor Restaurant, daily, 12–2:30, Sept.–June; The Sculpture Garden, located near Lake Burley Griffin, is a popular picnic spot.
Museum Shop: Open daily, 10–5; (61) (6) 240 6420.

The Queensland Art Gallery

Southbank, South Brisbane, Queensland 4101, Australia
(61) (7) 3840-7303
http://www.slq.qld.gov.au/qag

1998 Exhibitions
Thru Jan. 26
Gainsborough to Gilbert & George: British Art from the Collection
Focuses on the museum's collection of British art in all media, coinciding with the 50th anniversary of the British Council in Australia. Catalogue.

Observed and Contrived: Recent International Photography from the Collection
Features photojournalist works and constructed tableaux, by artists from the Asia-Pacific region, England, and the U.S.

Contemporary Vessels and Jewels: Australian Fine Metalwork
Reflects the diverse nature of contemporary metalwork.

Thru Feb. 22
Francesco Conz and the Intermedia Avant-Garde
A selection of the 120 Fluxus-related works recently acquired by the museum. Includes works by Conz, Nam June Paik, George Brecht, and other avant-garde artists and performers.

Feb. 20-Apr. 13
Emily Kngwarreye—Alhalkere—Paintings from Utopia
Surveys the career of one of Australia's greatest artists, featuring more than 100 paintings and batiks created between 1970 and her death in 1996.

Permanent Collection

Includes contemporary art from Australia, Asia, Europe, and America; traditional and contemporary Aboriginal works; historical works from Australia, Asia, and Europe. **Highlights:** Picasso, *La Belle Hollandaise*; Rubens, *Portrait of a Young Lady;* Sidney Nolan, *Mrs. Fraser and Convict.* **Architecture:** 1982 award-winning building by Robin Gibson.

Admission: Free; some fees for special exhibitions. Handicapped accessible.
Hours: Daily, 10–5. Closed Good Friday and Dec. 25.
Tours: Mon.–Fri., 11, 1, 2; Sat.–Sun., 11, 2, 3. For group reservations, call (61) (7) 3840-7255.
Food & Drink: Gallery Bistro, open daily, 10–4:30.
Museum Shop: Open daily, 10–5.

Museum of Contemporary Art

Circular Quay, The Rocks, Sydney, NSW, Australia 2000
(61) (2) 241-5876
http://www.mca.com.au

1998 Exhibitions

Thru Feb.
The Seppelt Contemporary Art Award 1997
Representative works from five finalists for this award that recognizes an Australian or New Zealand artist.

Thru Mar. 29
Yves Klein
Approximately 70 works survey this extraordinary figure of post-war avant-garde art, known for his performance events and paintings with nature.

Permanent Collection

Wide-ranging collection of over 4,000 contemporary works by Australian and international artists. **Architecture:** 1991 building by Peddle Thorpe, Architects, with spectacular views of the harbor and Opera House.

Admission: Adults, Aus$8; concessions, Aus$5; families, Aus$18. Handicapped accessible.
Hours: Daily, 10–6. Closed Dec. 25.
Tours: Mon.–Sat., 12, 1, 2; Sun., public holidays, 1, 2, 3.
Food & Drink: MCA Café open weekdays, 11–5:30; Sun., public holidays, 9–5:30.

Graphische Sammlung Albertina
Augustinerstrasse 1, A–1010 Vienna, Austria
(43) (1) 534 830

1998 Exhibitions
NOTE: During the major renovation and expansion of the museum exhibitions will take place at the Akademiehof, 1010 Wien, Makartgasse 2.

Thru Jan. 11
Nature and the Heroic Life
Features German and Swiss drawings from the time of Goethe.
Georg Ehrlich

Feb. 4-Apr. 5
Expressionist Art: Acquisitions and Donations for the Albertina— Part II
Hans Striegl

Apr. 29-June 21
Dieter Rom

May 6-June 21
Drawings from Five Decades: Gustav Peichl

July 13-Aug. 23
Facsimile

July 17-Aug. 23
Anton Watzl

Permanent Collection
One of the most important print and drawing collections in the world, including masterpieces by Raphael, Dürer, Rembrandt, Rubens; European drawings, prints from the 15th century to the present; special collections of architectural drawings, posters, miniatures, illustrated books. **Highlights:** Dürer, *Young Hare*; Dürer, *The Large Piece of Turf*; Raphael, *The Virgin with the Pomegranate*; Michelangelo, *Seated Male Nude*; Rubens, *Rubens' Son Nicholas*; Greuze, *Head of a Girl*; Schiele, *Male Nude with Red Loincloth*.

Admission: ÖS 10.
Hours: Mon.–Thurs., 10–4; Fri., 10–1.

Kunsthistorisches Museum
Burgring 5, 1010 WIEN, Austria
(43) (1) 525 24 404

1998 Exhibitions
Continuing
A Century of Austrian Archaeological Excavations at Ephesos

Thru Apr. 14
Breughel-Breughel: A Family of Painters from Antwerp around 1600
This comprehensive survey of 150 paintings and works on paper examines the individual contributions of the two sons of Pieter Brueghel the Elder.

May 26-Sept. 27
Henry Moore
Sculptures and drawings by Moore (1898-1986), whose "primitive" style explores the 20th-century view of the human form. Includes thematic presentations of his "Lying Figures" and "Mother-Child Groups."

Pieter Breughel the Younger, *The Misanthrope.* Collection Koninklijk Museum. From *Brueghel-Breughel: A Family of Painters from Antwerp around 1600.* Photo courtesy Kunsthistorisches Museum.

Permanent Collection
Houses one of the richest collections of art in the world. The painting collection contains many outstanding works by the Flemish, Dutch, German, Italian, Spanish, and French schools including masterpieces by Dürer, Rubens, Rembrandt, and Titian. **Highlights:** The Brueghel collection; impressive Egyptian-Oriental, Classical Antiquity collections.
Architecture: The Museum itself was built between 1871 and 1891 by the Emperor Franz Joseph for the collections it still houses today. Together with its companion across the square, the Natural History museum, and the Hofburg, it was planned as part of the Imperial Forum on the Ringstrasse which was, however, never completed. The architects were Gottfried Semper and Carl Hasenauer. In accordance with the style of Historicism prevalent in the late 19th century, they chose the Neo-Renaissance style for the interior and exterior decorations of this palatial building.

Admission: Adults, ATS 95; children, senior citizens, students, ATS 60. Handicapped accessible.
Hours: Tues.–Sun., 10–6; Thurs., 10–9; Closed Mon.
Programs for Children: Special guided tours for children. Call for information.
Tours: Call (43) (1) 525 24 416 for information.
Food & Drink: Coffee-shop in Cupola Hall, open museum hours.
Museum Shop: Two shops, open during museum hours.

Musées Royaux des Beaux-Arts de Belgique

Musée d'Art ancien & Musée d'Art moderne
3, Rue de la Régence, 1000 Brussels, Belgium
(32) (2) 508 32 11
http://www.fine-arts-museum.be

1998 Exhibitions
Mar. 6-June 28
René Magritte
Retrospective commemorating the centenary of the birth of this Belgian master of surrealism, including many rarely seen works.

Permanent Collection
Musée d'Art ancien: 14th–18th centuries. Works from Flemish, Dutch, German, Italian and French schools, including Van der Weyden, Memling, Brueghel the Elder, Massys, Rubens, Van Dyck, Cranach, Hals, Rembrandt, Lorrain, Guardi, Ribera; 19th-century works from Belgian School and Impressionism. **Highlights:** Bruegel the Elder, *La Chute d'Icare (The Fall of Icarus).*
Musée d'Art moderne: 20th century; abstract art, CoBrA, Cubism, Dada, Expressionism, Fauvism, Futurism, Surrealism.

René Magritte, *La Lecture défendue,* 1936. Photo courtesy Musées Royaux des Beaux-Arts de Belgique.

International scope with emphasis on Belgian art. Works by Braque, Bacon, Calder, Chagall, Dalí, de Chirico, Delvaux, Ernst, Magritte, Segal.
Architecture: Musée d'Art ancien housed in 1880 building by Balat; Musée d'Art moderne housed in a 1984 below-ground addition by R. Bastin.

Admission: Free. Handicapped accessible; special entrance.
Hours: Tues.–Sun, 10–12, 1–5. Closed Mon., Jan. 1, May 1, Nov. 1 & 11, Dec. 25.
Tours: Call (32) (2) 508 32 11 for reservations and information.
Food & Drink: Cafeteria open 10:30–4:30.
Museum Shop: Books, posters, videos, postcards, etc. Open 10:30-4:30

Canadian Centre for Architecture

1920 Baile St., Montréal, Québec, H3H 2S6, Canada
(514) 939-7000; 939-7026 (recording)
http://cca.qc.ca

1998 Exhibitions
Thru Feb. 1
Other Soundings: Works by John Hejduk, 1953-1997

Thru May 31
Toy Town

Mar. 4-May 24
Montréal–Métropole, 1888-1931

June 16-Sept. 27
The American Lawn: Surface of Everyday Life

Permanent Collection
World-acclaimed study center devoted to the art of architecture. The research collection and archive includes some 165,000 volumes on the history and theory of architecture; 22,000 architecture-related prints and drawings from the 15th-century to the present; 50,000 architectural photographs; archives of work by significant architects. **Architecture:** The 1989 award-winning building designed by Peter Rose is integrated with the historical Shaughnessy House (1874) and a Sculpture Garden (designed by Melvin Charney) that illustrates the history of architecture in Montréal.

Admission: Adults, $5; seniors, students, $3; children under 12, members, free. Group rates available. Handicapped accessible.
Hours: Oct.–May: Wed., Fri., 11–6; Thurs., 11–8; Sat., Sun., 11–5. June–Sept.: Tues.–Sun., 11–6; Thurs., 11–9. Closed Mon.
Programs for Children: Youth and family workshops.
Tours: Guided architectural tours of the museum and Shaughnessy House, Sun. Call (514) 939-7026 for more information.
Museum Shop: Offers a selection of current architectural publications. Open during museum hours.

Musée des Beaux-Arts de Montréal

1379-80 Sherbrook Street West, Montréal, Quebec, H36 2T9, Canada
(514) 285-1600; 285-2000 (recording)
http://www.mmfa.qc.ca

1998 Exhibitions
Thru Mar. 29
Montreal Women Artists
Paintings and works on paper showcasing women who were active in Montreal during the 1920s.

Thru May 31
Complicity

Jan. 29-Apr. 19
Husband and Wife: The Prints of John J.A. Murphy and Cecil Butler
Engravings by a couple whose work celebrates such themes as lovers, the family, the search for paradise lost, and the beauty of the human form.

Feb. 26-May 24
Jacques Hurtubise: Four Decades
The first retrospective of this Quebec painter (born in 1939) whose work balances Expressionism and geometric form.

Mar. 12-May 31
Emanuel Hahn and Elizabeth Wyn Wood: Tradition and Innovation in Early Twentieth-century Canadian Sculpture

Apr. 30-July 19
Ancient Gold Jewelry
Over 100 superb examples of Greek, Etruscan, Roman, and Near Eastern gold jewelry dating from the seventh to first centuries B.C. (T)

May 8-Sept. 27
Budding Sculptors

May 14-July 12
The Spirit of Montmartre

June 18-Oct. 18
Alberto Giacometti
Major exhibition of sculptures, paintings, and drawings from one of the greatest sculptors of the 20th century.

June 19, 1998-June 6, 1999
Flying Colours

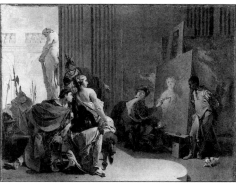

Giovanni Battista Tiepolo, *Apelles Painting the Portrait of Campaspe*, c. 1725-26. Photo by Marilyn Aitken, courtesy Musée des Beaux-Arts de Montréal.

Aug. 13-Oct. 25
A Survey of British Prints (1815-1950) in the David Lemon Collection

Nov. 5, 1998-Jan. 10, 1999
Keith Haring
Major retrospective of this American artist whose bold graphics marked the 1980s, and who died of AIDS in 1990 at the age of 31. Includes paintings, sculptures, drawings, objects, and accompanying photographs and videos.

Nov. 19, 1998-Feb. 14, 1999
Duane Michaels

Dec. 17, 1998-Feb. 21, 1999
René Derouin: Frontiers, Frontières, Fronteras

Permanent Collection

Canada's oldest and one of its most important arts institutions, the Museum has assembled one of Canada's finest encyclopedic collections, totalling over 25,000 objects, from antiquity to the present. Includes Decorative Arts, Canadian art, prints and drawings, Old Master paintings, Modern and Contemporary art, ancient textiles, English porcelain, and the world's largest collection of Japanese incense boxes. **Architecture:** 1912 Benaiah Gibb Pavilion by Edward & W. S. Maxwell; 1939 Norton wing annex; 1976 pavilion by Fred Lebensold; 1991 Jean-Noël Desmarais Pavilion, incorporating facade of 1905 apartment building, by Moshe Safdie and Associates, Inc.

Admission: Temporary exhibitions: adults, $10; students, seniors, $5; children 3–12, $2; family groups, $20; groups of 20 or more, $8 per person. Permanent collection only: free at all times. Handicapped accessible, including ramps and elevators. Wheelchairs available upon request.
Hours: Tues.–Fri., 11–6; Wed., 11–9 for special exhibitions. Closed Mon.
Programs for Children: Esso-Sundays Self-serve Cart, including activity cards, drawing materials and games, encourages appreciation of the arts.
Food & Drink: Café open museum hours.
Museum Shop: Features reproduction art works and elegant stationery.

Le Musée du Québec

Parc des Champs-de-Bataille, Quebec, G1R 5H3, Canada
(418) 643-2150
http://www.mdq.org

1998 Exhibitions

Thru May 24
Le Bestiaire: The Imaginary Animals of Pellan

June 4-Sept. 6
Rodin
Exclusive North American venue for this major exhibition of the sculpture of Auguste Rodin (1840-1917). Includes over 70 works by this great artist. Special tickets required.

July 24-Sept. 20
Whistler: Impressions of an American Abroad (T)

Auguste Rodin, *Le Penseur (The Thinker)*, c. 1880. Photo courtesy Musée des Beaux-Arts de Montréal and Musée du Québec.

Permanent Collection

Over 20,000 works from the early 17th century to the present, reflecting Québec's cultural heritage. Includes paintings, sculptures, drawings, prints, photographs, gold and silver works, and decorative arts. **Highlights:** Largest collection of Québec art in Canada. **Architecture**: Three linked pavilions, including the Great Hall; the 1860s Charles-Baillairgé pavilion; neoclassical 1933 Gérard Morisset Pavilion. The heritage building housed the former Québec City prison.

Admission: Adults, $5.75; seniors, $4.75; students, $3.75; children under 16, free. Special exhibition rates during the Rodin exhibition: Adults, $10; seniors, $9; students, $7; children under 16, free. Handicapped accessible; ramps, elevators, and wheelchairs available.

Hours: Summer (June 1–Sept. 8): Daily, 10–5:45; Wed., 10–9:45. Winter (Sept. 8–May 31): Tues.–Sun., 11–5:45; Wed., 11–8:45.

Programs for Children: Call (418) 643-4103 for information.

Tours: Call (418) 643-4103 for information. Reservations required.

Food & Drink: Café open during museum hours. Call (418) 644-6780 for reservations.

Museum Shop: Open during museum hours.

National Gallery of Canada

380 Sussex Dr., Ottawa, Ontario, K1N 9N4, Canada
1-800-319-ARTS; (613) 990-1985
http://national.gallery.ca

1998 Exhibitions

Apr. 3-July 12
Pablo Picasso: Masterworks from the Museum of Modern Art
Approximately 125 works of painting, sculpture, drawings, and prints give an overview of the 20th-century master's career. (T)

Permanent Collection

Most extensive collection of Canadian art in the world; European, Asian, Inuit, American art; international collection of contemporary film, video; Canadian silver; indoor garden court, water court. **Highlights:** Paintings and sculpture by Cranach the Elder, Grien, Bernini, Murillo, Poussin, Rubens, Rembrandt, West, Chardin, Turner, Constable, Degas, Pissarro, Monet, Cézanne, Klimt, Ensor, Matisse, Picasso, Braque, Moore, Bacon, Pollock, Newman; photography by Cameron, Atget, Evans, Sander, Weston, Model, Arbus; completely reconstructed 19th-century Rideau Convent Chapel.

Architecture: 1988 building by Moshe Safdie.

Arthur Lisner, *A September Gale, Georgian Bay,* 1921.
Photo courtesy National Gallery of Canada, Ottawa.

Admission: Free. Fees for special exhibitions; students, children under 18, members, free. Handicapped accessible.

Hours: Apr.–Sept 1998, daily 10–6, Thurs. until 8. Effective Apr. 3-July 12, extended hours. Sept. 1998 to May 1999: Wed.–Sun., 10–5, Thurs. until 8.

Programs for Children: Workshops, guided tours, lunchroom.

Tours: Daily, 11, 2. Groups call (613) 993–0570 three weeks in advance.

Food & Drink: Café l'Entrée, 11:30-5, open until 8 on Thurs.; Cafeteria des Beaux-Arts open 10–4.

Museum Shop: Selection of art books and handcrafted gifts.

Art Gallery of Ontario

317 Dundas St. West, Toronto, Ontario, M5T 1G4, Canada
(416) 977-6648
http://www.ago.on.ca

1998 Exhibitions

Jan. 28-Apr. 12
At the Threshold of the Visible
Contemporary works.

Feb. 5-Apr. 26
Julia Margaret Cameron
Works by this innovative 19th-century British photographer.

Feb.-May
Andy Warhol

Apr.-Aug.
Displacements: 3 Sculptors
Contemporary works.

June 10-Sept. 13
Victorian Faerie Painting
Examines the late-19th-century craze for supernatural and fairy subjects, reflected in painting, literature, theater, romantic ballet, and a fashion for spiritualism. Includes paintings, watercolors, and book illustrations. (T)

Permanent Collection

Founded in 1900, features more than 20,000 works of European, American, and Canadian art since the Renaissance, including Impressionist, Post-Impressionist, Modernist, and contemporary works; Inuit art.

Highlights: European masterworks by Hals, Rembrandt, Rubens, Chardin, Gainsborough, Degas, Pissarro; world's largest public collection of sculpture by Henry Moore; Canadian works by Krieghoff, Legare, Peel, Plamondon; religious carvings, paintings; the Klamer Collection, other Inuit holdings.

Architecture: Original quarters in The Grange, an 1817 brick Georgian-style private home fully restored and furnished to the 1830s period; 1936 expansion, Walker Memorial Sculpture Court; 1974 Henry Moore Sculpture Centre and Sam and Ayala Zacks Wing; 1977 Canadian Wing and Gallery School; 1993 additions and renovation by Barton Myers, Architect, Inc., in joint venture with Kuwabara Payne McKenna Blumberg Architects.

Admission: Suggested donation: $5. Handicapped accessible.
Hours: Tues.–Sun., 10–5:30; Wed., 10–10. Closed Mon, except holidays.
Programs for Children: Off the Wall! dress up in period costumes, and other interactive art activities, Wed., 5:30–8:30; Sat., 11–5; Sun., 1–5. Also, Family Sundays.
Tours: Call (416) 979-6601 for information. Signed tours available.
Food & Drink: Agora Restaurant open Wed.–Fri., 12–8:30; Sat.–Sun., 12–5. Café Medici offers indoor and outdoor seating; call for hours.
Museum Shop: Open Wed.–Fri., 10–9; Sat.–Tues., 10–6.

The Power Plant

231 Queens Quay West, Toronto, Ontario M5J 2G8, Canada
(416) 973-4949
http://www.culturenet.ca/powerplant

1998 Exhibitions
Jan. 16-Mar. 15
Evidence: Photography and Site
Nine international photographers explore the subject of the evidence of human presence in the urban environment, with a challenge to the notion of objective truth. (T)

Power Plant, Ontario. Photo by Cheryl O'Brien.

Catherine Richards: Charged Hearts
Interactive exhibition mixes physical nature with the digital technology of cyberspace, joining actual and virtual objects.

Apr. 3-June 14
Threshold
Works in a variety of media engage the senses and create a threshold from the physical world to a more speculative and incorporeal dimension.

Permanent Collection
No permanent collection. Devoted solely to the exhibition and interpretation of contemporary art. **Architecture:** Red brick power plant, built in 1926 and active until 1980, when the building was renovated by Peter Smith of Lett/Smith Architects. Opened to the public in 1987.

Admission: Adults, $4; seniors, students, $2; members and children 12 and under, free. Handicapped accessible.
Hours: Tues.–Sun., 12–6; Wed., 12–8. Closed Mon. except holidays.
Programs for Children: Children's tours available; call (416) 973-4932.
Tours: Sat.–Sun., 2, 4; Wed., 6:30; Groups, call (416) 973–4932.
Food & Drink: Restaurants located nearby at the Queens Quay Terminal.
Museum Shop: None, but publications available at the Gallery Desk.

Vancouver Art Gallery

750 Hornby Street, Vancouver, British Columbia V6Z 2H7, Canada
(604) 662-4700
http://www.vanartgallery.bc.ca

1998 Exhibitions

Thru Jan. 11
Gordon Smith: The Act of Painting
Highlights the diversity of style in 100 works by this British Columbia artist.

Thru Jan. 18
The New Spirit: Modern Architecture in Vancouver, 1938-1963
Examines the modernist architectural tradition, in which the exterior should reflect the interior activity of the building.

Thru Feb. 15
Shu Jinshi: Tao of Rice Paper
A site-specific installation by this Berlin-based Chinese artist who uses large volumes of rice paper in non-traditional ways.

Jan. 28-May 5
Kate Craig: A Survey
Traces the career of this significant Vancouver artist, from early works under the persona of Lady Brute to recent video and audio installations.

Jan. 31-Apr. 13
The Symbolist Prints of Edvard Munch: The Vivian and David Campbell Collection
The technical experimentations of Munch's graphic work is underscored in 59 prints by this important Norwegian artist, depicting themes of love and death in works such as *Madonna*, *The Sick Child*, and *Vampire*. (T)

Edvard Munch's The Scream and Popular Culture
Explores how the mass media have used the iconography of one of Munch's most famous images to express social and political commentary.

Feb. 28-June 14
Pan Tian Shou
Features works by this 20th-century master of Chinese brush painting.

Mar. 21-June 7
Emily Carr: Art in Process
Examines the working processes of British Columbia's most famous painter, through 40 preparatory and finished works. Catalogue.

May 6-Sept. 7
Fast Forward: New South Korean Art
Recent work by six internationally recognized South Korean artists.

June 4-Oct. 12
Down From the Shimmering Sky: Masks of the Northwest Coast
Traces the historical references of the mask in British Columbia cultures, featuring masks by contemporary First Nations artists who incorporate political and social issues.

July-Oct
The Destabilized Landscape
Features works that address issues of land, identity, and colonization.

Sept. 1998-Jan. 1999
Gathie Falk
Retrospective of the career of this Canadian artist, from her performance and funk ceramic works of the 1960s to her later paintings and installations.

Oct. 2, 1998-Jan. 11, 1999
Candian Abstract Painting of the 1960s and 1970s
Features the hard-edge work of Gathie Falk's contemporaries.

Vancouver: New Painting
A selection of work by contemporary British Columbia painters, highlighting a return to the hard-edge modernism of the late 1960s.

Permanent Collection
Contemporary and international art, featuring works by Canadian and local British Columbia artists. **Highlights:** The world's foremost collection of paintings by Emily Carr.

Admission: Winter: adults, $7.50; seniors, $5; students, $3.50; Thurs. eves., pay what you can. Summer: adults, $9.50; seniors, $7; students, $5.50; Thurs. eves., $3. Handicapped accessible.
Hours: Winter: Wed., Fri., 10–6; Thurs., 10–9; Sat., 10–5; Sun., 12–5; Closed Mon., Tues. Summer: Mon.–Fri., 10–6; Thurs., 10–9; Sat., 10–5; Sun., holidays, 12–5.
Programs for Children: Super Sunday, 3rd Sun. of every month.
Tours: Call Public Programs office (604) 662-4717 two weeks in advance.
Food & Drink: Gallery Café features West Coast cuisine.
Museum Shop: Open during museum hours.

And If You Can, Be Sure To Visit...

Edmonton Art Gallery
2 Sir Winston Churchill Sq., Edmonton, Alberta, Canada T5J 2C1
(403) 422-6223

Glenbow
130 9th Ave., SE, Calgary, Alberta, Canada T2G 0P3
(403) 268-4100

Canadian Museum of Civilization
100 Laurier St., Hull, Quebec, Canada J8X 4H2
(819) 776-7000

Royal Ontario Museum
100 Queen's Park, Toronto, Ontario, Canada M5S 2C6
(416) 586-5551

National Gallery in Prague

Hradcanské nám 15, Prague 012, 119 04, Czech Republic
(420) (2) 20 51 31 80
http://www.czech.cz/NG

Admission: 70, -Kc, reduction 40, -Kc; free on the first Fri. of each month.
Hours: Tues.–Sun., 10-6.

St. George's Abbey

Jirske namesti 33, Prague 1-Hrad, Czech Republic
(420) (2) 57 32 05 36; (420) (2) 53 52 40

1998 Exhibitions
May 26-Aug. 30
Antonín Kern
Czech painter (1710-1747).

Permanent Collection
Early Bohemian art; Gothic panel
paintings; Gothic sculpture;
Baroque painting and sculpture;
Rudolfine art. **Architecture:** A
former Benedictine abbey founded
in 973, attached to the earlier St.
George's Basilica, 921.

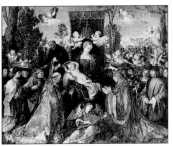

Albrecht Dürer, *Coronation.* Photo by Vladimir
Fyman, courtesy National Gallery in Prague.

Sternberg Palace

Hradcanské namesti 15, Prague 1-Hradcany, 119 04, Czech Republic
(420) (2) 20 51 46 34-7

1998 Exhibitions
Sept. 17-Dec. 13
Collection of Heinrich Julius from Braunsweig

Permanent Collection
European art from the 14th through 18th centuries, including works by
Gossaert, Dürer, Cranach, Brueghel, El Greco, Tiepolo, Canaletto,
Rembrandt, and Rubens. **Architecture:** Baroque palace, c. 1697–1707,
Giovanni Battista Alliprandi.

Convent of St. Agnes of Bohemia

U Milosrdnych 17, Prague 1-Stare Mesto, 110 00, Czech Republic
(420) (2) 24 81 06 28; (420) (2) 24 81 08 35

1998 Exhibitions
Thru Apr. 27
Magister Theodoricus
Works by the court painter of Emperor Charles IV.

Nov. 28, 1998-Apr. 1999
Josef Navrátil
Czech painter (1798-1865).

Permanent Collection
Czech painting and sculpture from the 19th-century including works from
the schools of Classicism, Romanticism, Realism, and Symbolism.
Architecture: The first convent for nuns of the order of St. Clare north of
the Alps. Founded in 1232 by St. Agnes of Bohemia, daughter of Premyslid
King Otakar I. The building is one of the eariest examples of the
penetration of Cisterian-Burgundian-Gothic style into Bohemia.

Zbraslav Chateau
Zbraslav n. Vltavou, Ke Krnovu 2, Prague 5, Czech Republic
(420) (2) 79 83 19-0; (420) (2) 59 11 88-9

Permanent Collection
Permanent exhibitions of Czech sculpture and Asian art from the Museum's
extensive collection. **Architecture:** The Chateau received its current
Baroque appearence when it was rebuilt according to the design of Giovanni
Santinni and FM Kanka. The centerpiece of the complex consists of a royal
hunting lodge, dating from 1268, and a Cisternian monastery founded by
Wencelas II in 1292.

Kinsky Palace
Staromestke namesti 12, Prague 1-Stare
Mesto, Czech Republic
(420) (2) 24 81 07 58

Permanent Collection
Collection of prints, old drawings, 19th- and
20th-century drawings. **Architecture:**
Kinsky Palace was built between 1775 and
1765 in the late-Baroque Classical style by
Alselmo Lurago according to an earlier design
by K.I. Dientzenhofer.

Veletrzni Palace
Dukelskych hrdinu 47, Prague 7-
Holesovice, Czech Republic
(420) (2) 24 30 10 24

J. Wámus, *Sradlina.* Photo courtesy
National Gallery in Prague.

Permanent Collection
A collection of world modern art with an emphasis on Czech artists.
Architecture: The building was constructed according to the plans of
Oldrich Tyl and Josef Fuchs between 1925-1929. It was used for various
purposes until 1974 when a fire destroyed much of the interior. After
extensive reconstruction that closely followed the original design, the
National Gallery in Prague's Center for Modern and Contemporary Art
opened here December 1995. With 25,000 square meters, it is the largest
site for modern art in Europe.

Louisiana Museum of Modern Art

Gl. Strandvej 13, DK-3050 Humlebaek (nr. Copenhagen), Denmark
(45) 4919 0719; (45) 4919 0991 (recording)
http://www.louisiana.dk

1998 Exhibitions

Thru Jan. 25
Alberto Savinio
Best known for his writing, Savinio (1891-1952) also gained recognition as
a composer and painter. Like his brother Giorgio de Chirico, Savinio was an
eager advocate of the metaphysical style of painting.

Thru Feb. 8
The Louisiana Exhibition 1997: New Art from Denmark and Scania

Jan. 23-Apr. 26
Francis Bacon
Works by this
innovative 20th-
century British
painter who was torn
between the nihilism
of existentialism and
his belief in art as a
means of survival.

Left to right: Martial Raysse, *Souviens-toi de Tahiti en septembre 61*, 1963. César, *Le Grand pouce*, 1968. Photo courtesy Louisiana Museum of Modern Art.

Permanent Collection

Works by 20th-century masters Giacometti, Moore, and Picasso; postwar
U.S. and European art by Baselitz, Dubuffet, Dine, Kiefer, Kirkeby, Warhol;
Constructivism, Cobra. **Highlights:** Sculpture by Calder, Arp, Serra.
Architecture: Spectacular waterfront setting; airy modern building by
Jorgen Bo and Vilhelm Wohlert; Landscape architects: Norgaard &
Holscher.

Admission: Adults, 53dkk; children, 15 dkk. Handicapped accessible.
Hours: Daily, 10–5; Wed., 10–10.
Tours: Call (45) 49 19 0719 for reservations.
Food & Drink: Café open daily 10–4:30; Wed., 10–9:30.

British Museum

Great Russell St., London, WC1B 3DG, England
(44) (171) 636-1555; (44) (171) 580-1788 (recording)
http://www.british.museum.ac.uk

1998 Exhibitions
Ongoing
Arts of Korea
Overview of the development of Korean art, a precursor to the new Korean Gallery scheduled to open in the year 2000.

Thru Jan.
Cartier: 1900–1939
Nearly 300 pieces of jewelry, accessories, and presentation designs.

Thru Jan. 4
Ogawa Toshu
Modern Japanese Calligraphy.

Hogarth and his Times: Serious Comedy
Looks at the varied reactions to 18th-century prints by William Hogarth.

The Schilling Bequest of German Renaissance Drawings

Thru Feb.
Modern Chinese Calligraphy

Thru Mar. 1
Writing Arabic

Permanent Collection
One of the largest museum collections in the world, tracing the history of human activity from prehistoric times to the present day. Includes antiquities from Egypt, Western Asia, Greece and Rome; Prehistoric and Romano-British, Medieval, Renaissance, Modern and Oriental collections; prints and drawings; coins and medals. **Highlights:** Parthenon sculptures; the Rosetta Stone; Sutton Hoo treasures; Portland vase. **Architecture:** Neoclassical mid-19th-century building by Robert Smirke.

Admission: Free. Themed evenings, £5. Most galleries handicapped accessible; touch tours available. During 1998-2000 major building work may affect some areas. Phone in advance of visit.
Hours: Mon.–Sat., 10–5; Sun., 2:30–6. Themed evenings with special programs: first Tues. of every month, except Jan. and Aug., 6–9. Call (44) (171) 323-8605 for details. Closed major holidays.
Programs for Children: During Christmas and summer holidays.
Tours: Call (44) (171) 323-8599 for information.
Food & Drink: Café, Mon.–Sat., 10–4:30; Sun., 2:30–5:45.
Museum Shop: Giftshop and bookshop open during museum hours.

Courtauld Gallery

Somerset House, Strand, London WC2R ORN, England
(44) (171) 873-2526

Note: The Gallery will be closed through early autumn 1998 for architectural refurbishment. The gallery shop will remain open.

Permanent Collection

Important collection of western European art from the 14th century to the present. Courtauld Collection of Impressionists and Post-Impressionists, including works by Bonnard, Cézanne, Degas, Gauguin, Manet, Modigliani, Monet, Pissaro, Van Gogh. Old Master paintings; including works by Rubens, Tiepolo, van Dyck. Fry Collection includes works by Roger Fry, Vanessa Bell, Duncan Grant. **Highlights:** Cézanne, *Lac d'Annecy, The Card Players*, *Mont Ste. Victoire;* Manet, *Le Déjeuner sur l'Herbe*; Renoir, *La Loge*; Monet, *Antibes*. **Architecture:** 1776–80 Neoclassical "Fine Rooms" of Somerset House by Sir William Chambers; 1987–90 renovation by Firmstone & Co.

Admission: Adults, £4; concessions, £2. Handicapped accessible; sign language interpreted tours available; parking for wheelchair users by prior arrangement, call (44) (171) 873 2531.
Hours: Mon.–Sat., 10–6; Sun., 2–6; last tickets, 5:20. Closed Jan. 1, Good Friday, Dec. 24-26.
Programs for Children: Free gallery trail.
Tours: Group tours available for up to 25 persons; call (44) (171) 873-2549 for reservations.
Food & Drink: Coffee shop open Mon.–Sat., 10–5:30; Sun., 2–5:30.
Museum Shop: Books, posters, cards, and gifts.

Hayward Gallery

South Bank Centre, Belvedere Road, London SE1 8X2, England
(44) (171) 928-3144; (44) (171) 261-0127 (recording)
http://www.hayward-gallery.org.uk

1998 Exhibitions

Thru Jan. 4
Objects of Desire: The Modern Still Life
Traces the development of the 400-year-old tradition of still life painting, including 130 works by more than 70 European and American artists.

Permanent Collection

Base for Arts Council Collection of postwar British art, but no permanent collection on view. **Architecture:** 1968 building by Greater London Council Department of Architecture and Civic Design.

Admission: Adults, £5; concessions, £3.50; children under 12, accompanied by an adult, free. Group rates available, call (44) (171) 960-4249. Call 928-3144 for details of handicapped accessibility.
Hours: Daily, 10–6; Tues.–Wed., 10–8. Closed between exhibitions.
Tours: Call (44) (171) 928-3144 for information.
Food & Drink: Café open gallery hours.

The National Gallery

Trafalgar Square, London WC2N 5DN, England
(44) (171) 747 2885

1998 Exhibitions
Thru Jan. 18
Hogarth's Marriage à la Mode
Paintings and engravings from this series, one of the artist's "modern moral subjects," in celebration of the 300th anniversary of Hogarth's birth.

Thru Feb. 1
Making & Meaning: Holbein's Ambassadors
Celebrates the 500th anniversary of Holbein's birth, featuring his famous and newly conserved painting depicting two ambassadors at the court of King Henry VII.

Jan. 14-Mar. 15
Recognising Van Eyck
Investigates relationship between two painted versions of *St. Francis Receiving the Stigmata*,

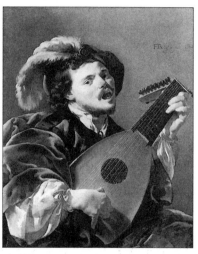

Hendrick ter Brugghen, *A Man Playing a Lute.* From *Masters of Light: Dutch Painting in Utrecht During the Golden Age.* Photo courtesy National Gallery, London.

which remains one of the great unsolved mysteries in the history of art. (T)

Feb. 25-May 4
Working After the Masters: Anthony Caro
Sculptures based on old master paintings by this distinguished British artist. Includes several new works based on *van Gogh's Chair.*

Apr. 3-May 31
Henry Moore and the National Gallery
Explores the sculptor's association with the Gallery in celebration of the centenary of Moore's birth.

May 6-Aug. 2
Masters of Light: Dutch Painting from Utrecht during the Golden Age
Reveals the splendid accomplishments of painters working in Utrecht during its height as an artistic center in the early 17th century. (T)

July 15-Oct. 11
Through Canaletto's Eyes
Examines the creative process behind the artist's paintings of Venice.
Includes drawings and prints made between 1720 and 1756.

Sept. 18-Dec. 13
Jonathan Miller...On Reflection
Examines technical and allegorical aspects of the subject of reflections and
mirrors in paintings, featuring works by Van Eyck and Velázquez.

Nov. 11, 1998-Jan. 31, 1999
Signorelli in British Collections
Surveys the career of the lesser-known Italian Renaissance artist Luca
Signorelli through paintings and drawings in British collections.

Permanent Collection

National collection of Western European painting from 1260 to 1900. All
2,300 pictures are on display except those on loan or in restoration.
Highlights: van Eyck, *The Arnolfini Marriage*; Rubens, *The Judgement of
Paris*; Renoir, *Umbrellas*; Piero della Francesca, *Baptism of Christ*; Seurat,
The Bathers, Asnières; Velázquez, *The Rokeby Venus*; Leonardo da Vinci,
Virgin of the Rocks; Titian, Tintoretto. **Architecture:** 1838 Neoclassical
building by William Wilkins; 1975 northern extension by PSA; 1991
Sainsbury Wing by Venturi, Scott Brown Associates.

Admission: Free. Charge for some special exhibitions. Handicapped
accessible, including lifts; wheelchairs available.
Hours: Mon.–Sat., 10–6. Sun., 12–6; Open until 8 on Wed. Closed Jan. 1,
Good Friday, Dec. 24–26.
Programs for Children: Call (44) (171) 747 2885 for details.
Tours: Mon.–Fri., 11:30, 2:30; Wed., 6, 6:30; Sat., 2, 3:30. Free. Groups
call (44) (171) 747-2424.
Food & Drink: Pret à Manger Café in main building; Brasserie in
Sainsbury Wing, open Mon.–Sat, 10–5:30; Sun., noon–5:30.
Museum Shop: Open Mon.–Sat., 10–5:30; Wed. until 7:30; Sun., 12–5:30.

National Portrait Gallery

St. Martins Gallery, London WC2H 0HE, England
(44) (171) 306-0055
http://www.npg.org.uk

1998 Exhibitions

Thru Jan.
Glenys Barton
A retrospective of the work of this ceramic artist.

Mary Wollstonecraft and Mary Shelley
Biographical exhibition will examine the lives and achievements of both
women through portraiture, engravings, drawings and manuscripts.

Thru Feb. 1
Henry Raeburn
A major retrospective of this 18th-century Scottish artist.

Permanent Collection
More than 9,000 portraits of famous Britons in a variety of media, including paintings, drawings, sculptures, miniatures, caricatures, silhouettes, and photographs.

Admission: Free. Handicapped accessible.
Hours: Mon.–Sat., 10-6; Sun., 12-6.
Programs for Children: Ongoing educational program. Call ext. 251.
Tours: Aug. only. Call (44) (171) 306-0055 for information.
Museum Shop: Two gallery shops.

Royal Academy of Arts

Burlington House, Piccadilly, London WIV ODS, England
(44) (171) 439-7438
http://www.royalacademy.org.uk

1998 Exhibitions

Thru Feb. 8
Victorian Faerie Painting
Examines the late-19th-century craze for supernatural and fairy subjects, reflected in painting, literature, theater, romantic ballet, and a fashion for spiritualism. Includes paintings, watercolors, and book illustrations. (T)

Jan. 22-Apr. 13
Art Treasures of England: The Regional Collections
Major exhibition celebrates the art treasures of England's regional museums acquired from the 17th century to the present. Includes works by Titian, Canaletto, Hogarth, Turner, Courbet, Bacon, and others.

Mar. 19-June 14
Icons From Moscow
Explores the great artistic flowering that took place in Moscow from the 14th to the 16th centuries. Features 60 icons and 16 manuscripts.

June 7-Aug. 16
230th Summer Exhibition
Works by distinguished British artists and architects.

Sept. 17, 1998-Jan. 1, 1999
Picasso: The Ceramicist
Examines the ceramic arts of this revolutionary 20th-century artist. Includes over 80 unique pieces, in addition to paintings, sculptures, and prints.

Oct. 22, 1998-Jan. 17, 1999
Charlotte Salomon
Explores this Berlin-born artist's autobiographical series "Life? or Theatre?" in which she created a multi-layered drama, combining painting, music, and text, before her untimely death in the Nazi Holocaust.

Permanent Collection

Works by Constable, Gainsborough, Michelangelo, Turner; *The Marriage Feast of Eros and Psyche* (ceiling painting); Ricci, *Juno and Jupiter on Olympus, The Triumph of Galatea, Diana and Attendants,* and *Bacchus and Ariadne;* West, *The Graces Unveiling Nature (ceiling painting);* Kauffman, *Genius, Painting, Composition, and Design;* Reynolds, *Self-Portrait;* Gainsborough, *Self-Portrait;* landscapes, sketches. **Highlights:** works by Constable, Michelangelo. **Architecture:** 1660 Burlington House, remodeled (1717) in Palladian style by the 3rd Lord Burlington; 1815 renovation by Samuel Ware for Lord George Cavendish; bought by the British government in 1854 and leased to the Academy in 1866. Interior features are Palladian and include ornate ceiling paintings.

Admission: Varies from £5–£7 depending on exhibition; reduced rates for seniors, students, children. Handicapped accessible; wheelchairs available.
Hours: Daily, 10–6. Last admission, 5:30.
Programs for Children: Offers educational programs around special exhibitions; call (44) (171) 300 5733 for details.
Tours: Call (44) (171) 439 4996 for information.
Food & Drink: Restaurant open daily, 10–5:30; Courtyard Café open during summer months; coffee shop.
Museum Shop: Offers cards, gifts, and artists' equipment.

Tate Gallery

Millbank, London SWIP 4RG, England
(44) (171) 887-8000

1998 Exhibitions

Thru Jan. 4
The Age of Rossetti, Burne-Jones and Watts: Symbolism in Britain 1860-1910
Focuses on these important Victorian painters and examines what constituted a specifically British form of Symbolism.

Feb. 12-May 17
Bonnard
Features 90 paintings by Pierre Bonnard (1867-1947), who is best-known for his depictions of intimate interior scenes. (T)

June 18-Sept. 6
Patrick Heron

Oct. 15, 1998-Jan. 17, 1999
John Singer Sargent
Examines this major American portrait painter (1856-1925) who settled in Edwardian London.

Permanent Collection

Houses the national collection of British painting from the 16th century to the present day; also the national gallery for modern art, encompassing British, European, and American painting and sculpture and works on paper since 1945. **Highlights:** 1987 Clore Gallery houses the Turner Bequest, comprising the paintings, watercolors, drawings and sketchbooks of J.M.W. Turner; works by Bacon, Blake, Cézanne, Constable, Degas, Dalí, Gainsborough, Giacometti, van Gogh, Hogarth, Lowry, Moore, Picasso, Rodin, Rothko. **Architecture:** 1897 Neoclassical building overlooking the Thames by Sidney J. R. Smith; Clore Gallery by James Stirling, Michael Wilford and Assoc.

Admission: Free; fees for special exhibitions. Handicapped accessible.
Hours: Mon.–Sat., 10–5:50; Sun., 2–5:50. Closed Good Friday, May Day, Bank Holidays, Dec. 24–26.
Tours: Call (44) (171) 887-8725 for information.
Food & Drink: Coffee shop open Mon.–Sat., 10:30–5:30; Sun., 2–5:15. Restaurant open Mon.–Sat., 12–3; closed Sun. Groups call (44) (171) 887-8725.

Tate Gallery St. Ives
(44) (173) 679-6226
Works by artists associated with St. Ives, Cornwall, from the collection.

Tate Gallery Liverpool

Albert Dock, Liverpool L3 4BB, England
(44) (151) 709-3223; (44) (151) 709-0507 (recording)

1998 Exhibitions
Not available at press time.

Permanent Collection
National Collection of Modern Art, see description under Tate Gallery London. **Architecture:** 1846 Albert Dock warehouse, converted to gallery space by James Stirling in 1988.

Admission: Permanent collection: free. Fee for some special exhibitions: adults, £2.50; concessions, £1; families, £5. Handicapped accessible.
Hours: Tues.–Sun., 10–6. Closed Mon., except Bank Holiday Mondays.
Tours: Daily, 2.
Food & Drink: Coffee shop open museum hours.

Victoria and Albert Museum

South Kensington, London SW7 2RL, England
(44) (171) 938-8500; (44) (171) 938-8441 (recording)
http://www.vam.ac.uk

1998 Exhibitions

Thru Jan. 18
Carl Larsson
Interior decoration by the artist responsible for what has become
recognized as Swedish modern design.

Thru Mar. 29
Colours of the Indus: Costume and Textiles of Pakistan
Exquisite textile traditions from the 1850s to the present day.

Apr. 9-July 26
Poster Exhibition
Examines posters as an art form.

Autumn 1998
Grindling Gibbons
Decorative woodcarver famous for carvings of spectacular cascades of
lifelike flowers, fruits, and leaves.

Oct. 8, 1998-Jan. 1999
Aubrey Beardsley
Charts Beardsley's career as an illustrator and designer of books and posters
and their reflection of artistic and cultural concerns of 1890s.

Permanent Collection

The most important decorative arts museum in the world, known fondly as
the "attic," including enormous collections of applied art in all media.
Highlights: The Raphael Gallery houses seven cartoons by Raphael which
are among the greatest surviving works of Renaissance Art in the world;
world's greatest collection of Constables and the national collection of
watercolors; Devonshire Hunting Tapestries; Dress Collection showing the
history of fashion from 1500 to today; Asian collection; medieval treasures;
Renaissance sculpture, Victorian plasters; Jewelry Gallery; 20th Century
Gallery. **Architecture:** 1891 building by Captain Francis Fowke; 1899–
1909 south front by Aston Webb.

Admission: Full price, £5.00; concessions, £3.00; students, youth under 18,
handicapped and their covers, unwaged, free. Handicapped accessible;
use Exhibition Road entrance. Tours available for the visually impaired.
Hours: Tues.–Sun., 10–5:50; Mon., 12–5:50. Closed Dec 24-26.
Programs for Children: Activities for families every Sunday with special
events over school holidays. Tel. (44) (171) 938 8638 for further details.
Tours: Mon.–Sat., 11, 12, 2, 3; Sun., 1, 3.
Food & Drink: Milburns Restaurant, Tues.–Sun., 10–5; Mon., 12–5.
Museum Shop: Two shops stock a collection of art and design, books,
gifts, stationery, and specially commissioned jewelry, ceramics, and textiles.
Open daily until 5:30.

Whitechapel Art Gallery

Whitechapel High St., London E1 7QX, England
(44) (171) 522-7888

1998 Exhibitions
Jan. 16-Mar. 15
Thomas Schutte

Mar. 27-May 31
The Open

June 12-Aug. 16
Peter Doig

Aubrey Williams

Permanent Collection
No permanent collection. Temporary exhibitions of works by modern and emerging artists. **Architecture:** 1901 vernacular structure, 1984-5 renovation.

Admission: Free. Special charges for some exhibitions. Handicapped accessible, including lift; audio tape and large print information available; BSC interpreted talks; workshops for people with visual impairment or mobility needs.
Hours: Tues.–Sun., 11–5; Wed., 11–8. Closed Mon.
Programs for Children: Workshops accompanying exhibitions. Teacher's packs available.
Tours: Call (44) (171) 522-7888.
Food & Drink: Café open Tues.–Sun, 11–4:30; Wed., 11–6.
Museum Shop: Zwemmer Art books, open during gallery hours.

Museum of Modern Art, Oxford

30 Pembroke St., Oxford OX1 1BP, England
(44) (1865) 722 733

1998 Exhibitions
Thru Mar. 22
Yoko Ono

Permanent Collection
No permanent collection. Internationally acclaimed as center for the display of twentieth century visual culture.

Admission: Adults, £2.50; concessions, £1.50. Wed., 11–1; Thurs., 6–9, free. Handicapped accessible.
Hours: Tues.–Sun., 11–6; Thurs., 11–9; Closed Mon.
Programs for Children: Contact the Education Dept.
Food & Drink: Café open Tues.–Sat., 9–5; Sun., 2–5.

Musée des Beaux-Arts de Lyon

Palais St. Pierre, 20 place des Terreaux, 69001 Lyon, France
(33) (4) 78 28 07 66; (33) (4) 72 10 17 40
http://www.mairie-lyon.fr

1998 Exhibitions

Thru Jan. 11
Barye: Claws and Teeth
Features 90 works in stone, bronze, and wax by noted French sculptor Antoine-Louis Barye (1795-1875), who specialized in scenes of animal combat. Includes the famous *Lion and Serpent*, watercolors, and drawings.

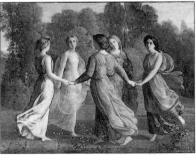

Janmot, *Le poème de l'ame.* Photo courtesy Musée des Beaux-Arts de Lyon.

Please Touch!
This tactile exhibition for seeing and non-seeing visitors traces the history of sculpture in Europe, from prehistory to the late-19th century.

Apr. 3-June 28
Matisse, from the Collection of the Centre Georges Pompidou
A selection of nearly 100 works by French master Henri Matisse (1869-1954), including paintings, drawings, sculptures, and cut-outs.

Oct.-Dec.
Drawings of Pierre Puvis de Chavannes from the Collection of the Museum of Lyon
Features some of the 19th-century French Symbolist artist's most beautiful drawings, in honor of the centenary of his death.

Rodin: The Bust of Madame Fenaille
A variety of works highlighting this portrait bust by late-19th-century French sculptor Auguste Rodin.

Permanent Collection

French, Flemish, Dutch, Italian, and Spanish paintings; Impressionist and modern art; Puvis de Chavannes murals; medieval sculpture; Islamic collection; works by regional artists; drawings, prints, furniture, and numismatics. **Architecture:** 1659 former Benedictine abbey; 19th-century restoration and modernization; renovations to the South wing and the Church of St. Peter scheduled to be completed in April 1998.

Admission: Adults, 25 F; concessions, 13 F; children under 18, free. Handicapped accessible, including tours for the sight- and hearing-impaired.
Hours: Wed.–Sun., 10:30–6.
Programs for Children: Workshops, tours, and other activities.
Tours: Call (33) (4) 72 10 17 40 for information.
Food & Drink: Cafeteria scheduled to open in April 1998.
Museum Shop: Bookshop open during museum hours; gift shop open Tues.–Sun., 10:30–7.

Musée d'Art Moderne et d'Art Contemporaine

Promenade des Arts, 06300 Nice, France
(33) (4) 93 62 61 62

1998 Exhibitions
Thru Mar.
The Sixties: Beauborg and Nice
Works from the Musée National d'Art Moderne present explanations of New Realism, Pop Art, and Assemblage.

Permanent Collection
Collection of French and American avant-garde artists from the 1960s to the present. Includes works by the Nice School of the New Realists and International Fluxus. American modernism by Warhol, Rauschenberg, Lichtenstein, Oldenburg, and Dine. **Highlights:** Large collection of works by Yves Klein, Arman Cesar, and other Nice artists; sculpture garden with works by Calder, Borofsky, and Sandro Chio.

Admission: Adults, 25 F; students, 15 F; guided visit, 20 F; reduced fees, 10 F. Handicapped accessible.
Hours: Wed.–Mon., 11–6; Fri., 11–10. Closed Tues., holidays.
Tours: Wed., 4. Group reservations required two weeks in advance at a cost of 20 F.
Food & Drink: Café Sud, noon-midnight; Grand Café des Arts, 10am-midnight.

Matisse Museum

164, ave des Arènes de Cimiez, 06000, Nice, France
(33) (4) 93 81 08 08

1998 Exhibitions
Thru Feb. 22
Artists' Books
Includes works by Markus Lépertz, Robert Mangold, and others.

Spring
Furniture of Nature
Explores the decorative value of furniture in the art of Matisse, who saw furniture as not merely a prop, but a model.

Summer
Matisse and Fashion
Examines Matisse's love of clothes and fabrics, and his influence on the couturiers of today. Includes both the paintings and the garments and textiles represented in the works.

Sept.
September of Photography
Presents modern and contemporary works in celebration of Photography
Month in Nice.

Autumn
Three Works of Study
Educational exhibition presents three works in the collection with
documents and photographs that trace their origin and evolution.

Winter
Drawings of Today
Traces the 20th-century development of the medium of drawing, not only as
a complement to painting or sculpture, but as a work of art in its own right.

Permanent Collection

Works donated by Matisse, his family, and others span every period of the
painter's life. **Highlights:** Oil paintings: *Portrait de Mme Matisse*, 1905;
Odalisque au Cofret Rouge, 1926; *Fauteuil Rocaille*, 1946; *Nature morte
aux grenades*, 1947; Paper cut-outs: *Nu bleu IV, La Vague*, 1952, *Fleurs et
Fruits,* 1953; Bronzes; life-sketch for *La Danse*; Vence Chapel Chasubles.
Architecture: Magnificent 17th-century Italian villa with trompe l'oeil
decoration; 1993 renovation and expansion by Jean-François Bodin.

Admission: Adults, 25 F; groups of 15 or more, 15 F; curatorial staff from
museums, children under 18, free. Handicapped accessible.
Hours: Oct.–Mar.: Wed.–Mon., 10–5; Apr.–Sept.: Wed.–Mon., 10–6.
Closed Tues., Jan. 1, May 1, Dec. 25.
Programs for Children: Workshops, Sept.–June; call (33) (4) 93 82 18 12.
Tours: Call (33) (4) 93 81 08 08 for information.
Food & Drink: Picnic areas available in adjacent park.
Museum Shop: Offers books relating to Matisse and his contemporaries.

Galeries Nationales du Grand Palais

3 Avenue du Général Eisenhower, 75008 Paris, France
(33) (1) 44 13 17 17

1998 Exhibitions

Thru Jan. 5
The Iberians
The ancient inhabitants of Spain (5th to 2nd century B.C.) are examined in
this exhibition of over 350 objects, including stone sculptures, painted
ceramics, and gold jewelry. (T)

Thru Jan. 12
Prud'hon, or The Dream of Happiness
Retrospective of the career of Pierre-Paul Prud'hon, who was active during
the years of the French Revolution, the Empire, and the Restoration. (T)

Thru Jan. 26
Georges de la Tour (1593-1652)
Presents over 30 original works by one of the great painters of the Grand Siècle. Also includes related works copied or made by his followers.

Mar. 21-June 30
Art in the Time of the Accursed Kings
Examines art during the reign of Philippe le Bel and his sons.

Apr. 11-July 20
Delacroix: The Late Work
The later work of painter Eugène Delacroix (1798-1863), major artist of the Romantic movement. (T)

Eugène Delacroix, *Still Life with Flowers and Fruit,* 1848. From *Delacroix: The Late Work.* Photo by Graydon Wood, courtesy Philadelphia Museum of Art, John G. Johnson Collection.

Admission: Varies with exhibition. Handicapped accessible; ramps and elevators.
Hours: Thurs.–Mon., 10–8; Wed., 10–10. Closed Tues., holidays.
Tours: Groups call (33) (1) 44 13 17 17 for reservation.
Food & Drink: Cafeteria open museum hours.
Museum Shop: Offers catalogues, cards, and gift items.

Galerie Nationale du Jeu de Paume

1, Place de la Concorde, 75008 Paris, France
(33) (1) 47 03 12 50

1998 Exhibitions
Thru Apr. 12
Arman Retrospective

May 18-Aug. 30
Collections from the Musee National d'Art Moderne, Centre Georges Pompidou at Jeu de Paume

Sept. 14-Nov. 22
Pierre Alechinsky, retrospective

Dec. 7, 1998-Feb. 1999
Jean-Pierre Raynaud

Permanent Collection
No permanent collection. **Architecture:** 1861 building; 1990 renovation.

Admission: 38 F. Handicapped accessible; including ramps and elevators.
Hours: Tues., 12–9:30; Wed.–Fri., 12–7; Sat.–Sun., 10–7. Closed Mon.
Programs for Children: On request in English with reservations.
Tours: Tues., 3; Wed.–Thurs., 1; Fri.–Sat., 3; Sun., 11.
Food & Drink: Café du Jeu de Paume open museum hours.
Museum Shop: Bookshop specializes in contemporary art, cinema.

Musée du Louvre

Rue de Rivoli, 75001 Paris, France
(33) (1) 40 20 53 17; (33) (1) 40 20 51 51 (recording)
http://www.louvre.fr

1998 Exhibitions

Thru Jan. 5
A Mission in Persia
Examines the history and activities of the French Scientific Delegation to Persia, founded in 1897, featuring paintings, drawings, photographs, and archeological artifacts from the museum's Iranian collections.

Copperplate Engravings from the Old Low Countries, 15th–16th Century
Explores more than 100 rare, limited-edition works created in this print medium from its beginnings in 1430 through 1555.

Thru Jan. 19
Augustin Pajou, Royal Sculptor
Presents all aspects of this gifted 18th-century French sculptor's career, including monumental marble figures, portrait busts, drawings, and terracotta models. (T)

Feb. 13-May 11
The Lemme Collection of Roman Paintings from the 17th and 18th Centuries
Features a selection of 130 religious, mythological and portrait paintings recently donated to the museum from this cohesive collection of late baroque works.

The Virgin and Child of Issenheim: A Masterpiece of the Late Middle Ages
Highlights this wooden sculpture of the Madonna, long-celebrated and often imitated for its opulent beauty, and presents new questions of its authorship.

Augustin Pajou, *Pluto Holding Cerberes Enchained.*
From *Augustin Pajou, Royal Sculptor.* Photo courtesy Musée du Louvre.

Apr. 30-June 29
Francesco Salviati, or La Bella Maniera
Examines the career of this talented and innovative 16th-century Italian draughtsman, who was one of the first artists to work in the Mannerist style.

Apr. 30-July 27
Capital Visions
Explores the theme of the hidden face in modern culture, and examines all aspects of the face in the Western imagination, featuring more than 60 works from all time periods.

June 19-Sept. 21
Bassano and His Sons
Traces the success of this prolific dynasty of 15th-century Venetian artists, featuring paintings and drawings by Jacopo Bassano and his four sons.

The Appearance of the Skies: Astronomy in the Islamic World
Examines the science of astronomy and the study of astrology in the Islamic world, featuring manuscripts and objects that attempted to explain astral phenomena.

Permanent Collection
One of the largest collections in the world; 25,000–30,000 works on display, divided into seven departments: Oriental antiquities; Egyptian antiquities; Greek, Roman, and Etruscan antiquities; paintings, sculpture, objects of art, and graphic art through the mid-19th century. **Highlights:** Leonardo, *Mona Lisa (La Joconde)*; *Hera of Samos (570 B.C.)*; *Venus de Milo* (c. 100 B.C.); *Winged Victory of Samothrace; Winged Bulls of Khorsabad; The Squatting Scribe*; *The Sceptre of Charles V;* Michelangelo, *the Slaves*. **Architecture:** 800-year-old building, originally palace of French kings; changed and enlarged over the centuries. The original building was a medieval fortress; moats of this early building, ca. 1200, can be visited. It became the first museum in Europe in 1793. Central Glass Pyramid (1989) by I. M. Pei acts as museum entrance and reception area. North wing of the palace, formerly the Ministry of Finance, restored as a museum space and opened in 1993. Further renovation underway in the Ancient Palace, Denon wing, and Sully wing.

Admission: Adults, 45 F until 3; 20 F after 3 and all day Sun.; children under 18, free. Handicapped accessible.
Hours: Permanent collections: Thurs.–Sun., 9–6. Evening openings Mon. and Wed., 9–9:45. Closed Tues., public holidays. Pyramid Hall open Mon., Wed.–Sun., 9–9:45. Exhibition rooms under the Pyramid, 10–10.
Tours: In French and English; groups call (33) (1) 40 20 51 77.
Food & Drink: Restaurant Le Grand Louvre, cafeteria and bar located under the pyramid; Café Marly.
Museum Shop: Pavilion under the pyramid offers several shops featuring books, jewelry, decorative objects, and art reproductions.

Musée National d'Art Moderne– Centre National d'Art et de Culture Georges Pompidou

(Centre Beaubourg)
75191 Paris CEDEX 04, France
(33) (1) 44 78 12 33; (33) (1) 44 78 49 19
http://www.cnac-gp.fr

1998 Exhibitions
Note: The museum will be closed for renovation for the next two years.

Permanent Collection
Outstanding collection of major 20th-century movements, including Impressionism, Cubism, abstract art, Surrealism, Pop Art. Artists include Brancusi, Braque, Chagall, Dali, Dubuffet, Léger, Kandinsky, Klein, Matisse, Mondrian, Picasso, Pollock, Rouault, Tàpies, Warhol. **Highlights:** Niki de Saint-Phalle courtyard fountain sculptures; Braque, *Woman with Guitar*; Matisse, *The Sadness of the King*; Picasso, *Harlequin*. **Architecture:** 1977 building by Renzo Piano and Richard Rogers.

Musée d'Art Moderne de la Ville de Paris

11 ave du President Wilson, 75116 Paris, France
(33) (1) 53 67 40 00

Permanent Collection
Specifically Parisian and European, thanks to the generosity of artists and collectors who contributed to the collection. From Fauvism and Cubism to Contemporary Art, Abstract Art, New Realism, Arte Povera. It reflects currents that determined 20th-century art, including diverse media such as sculpture, installations, photography and video. Its primary focus and committment is to the art of today. **Highlights:** Matisse, *La Danse*; Dufy, *La Fee Electricité*; a large collection of works by Robert Delaunay; Raoul Dufy, Jean Fautziez; Gleizes; Villon. **Architecture:** Constructed for the International Exposition in 1937. It occupies the east wing of the Palace of Tokyo. It was inaugurated as a museum in 1961.

Hours: Tues.–Fri., 10–5:30; Sat.–Sun., 10–6:45. Closed Mon.
Handicapped accessible, including elevators.
Tours: Daily.
Food & Drink: Cafeteria, open museum hours.

Musée d'Orsay

62 rue de Lille 75343 Paris cedex 07, France
(33) (1) 40 49 48 14
http://www.musee-orsay.fr

1998 Exhibitions

Thru Jan. 4
Collages and Photomontages of Victorian England
A selection of watercolors, photographs, and works on paper from an album
composed between 1868 and 1871 by Georgiana Berkeley.

Jean-Paul Laurens (1838-1921), Painter of History
Examines contributions to late-19th-century art by this celebrated artist of
the Third Republic. Includes paintings, drawings, and decorative tapestries.

Thru Jan. 18
The Havermeyer Collection: When America Discovered Impressionism...
A selection of 40 works, including pastels and decorative objects, from this
important collection. Features works by Cassatt, Manet, and Courbet.

Feb. 2-May 17
Manet and the Impressionists at the Gare Saint-Lazare
Examines the heroic symbol of the Saint-Lazare station and its influence on
Impressionist artists in Baron Haussmann's late-19th-century Paris. (T)

Permanent Collection

Impressionist works from by Manet, Monet, Renoir, Degas, van Gogh,
Cézanne, Gauguin, Daumier, Derain, Pissarro, Seurat, Toulouse-Lautrec,
Marquet; vast collection of 19th-century Neoclassicism; several outstanding
works by Rodin. **Highlights:** Daumier, *Caricatures* (busts); Degas, *Au Café,*
dit l'Absinthe; Gauguin, *Arearea, Le Bel Ange*; *Autoportrait au Christ*
Jaune; Van Gogh, *Bedroom at Arles, La Nuit Etoilie*; Ingres, *La Source*;
Manet, *Le Dejeuner sur l'Herbe (Luncheon on the Grass);* Millet, *The*
Gleaners; Courbet, *L'Origine du Monde*; Monet, *La Cathédrale de Rouen*
(five paintings); Renoir, *Bal du Moulin de la Galette (Dance at the Moulin*
de la Galette); Toulouse-Lautrec, *Jane Avril*; Whistler, *Whistler's Mother.*
Architecture: Railway station built in 1900 by Victor Laroux; building
renovation by architectural firm ACT and the Italian architect Gae Aulenti,
inaugurated in December 1986.

Admission: Adults, 40 F; reduced fee, 30 F. Fees subject to change.
Handicapped accessible, including elevators and braille signage.
Hours: Tues.–Sat., 10–6; Thurs., 10–9:45; Sun., 9–6. June 20–Sept. 20:
opens at 9. Closed Mon.
Programs for Children: Activities available. Call for details.
Tours: Group reservations, call (33) (1) 45 49 16 15.
Food & Drink: Restaurant open for lunch, 11:30–2:30; for dinner,
Thurs., 7–9; Café de Hauteur open 10–5; Mezzanine Café open 11–5.
Museum Shop: Open Tues.–Sun., 9:30–6:30; Thurs. until 9:30.

Musée des Arts Décoratifs

Palais du Louvre, 107 rue de Rivoli, 75001 Paris, France
(33) (1) 44 55 57 50
http://www.ucad.fr

Note: The museum is in the process of complete renovation as part of the Grand Louvre project. There will be a reopening of the Medieval-Renaissance collections in late Jan. 1998. The reopening of all other collections is scheduled for 1999.

1998 Exhibitions

Feb. 28-Apr. 12
Chinese Cloisonné Enamels
Over 200 Chinese cloisonné enamels from the 15th century to the present, including a donation that D. David-Weill made to the museum in 1923.

June 14-Sept. 27
Spirit of the Clown—Hippolyte Romain
An exhibition of toys from the museum's collection.

Oct. 13-Dec. 27
Autour de Line Vautrin
A selection of jewels.

Permanent Collection
Furniture, glassware, silver, and jewelry, from the Middle Ages to the present. Part of the Union Centrale des Arts Decoratifs, which includes the Fashion and Advertising Museums, as well as several libraries and schools. **Highlights:** decorative arts from the reigns of Louis XIII-XVI; recreated 1920s apartment of Jeanne Lanvin.

Musée de la Mode et du Textile

1998 Exhibitions
Opens Jan. 27
Exoticisms, Drawings, and Costumes
Works from Ezio Frigerio for the Bayadère

Mar.-Apr.
Exoticism in India—Contemporary Painters

June-Sept.
Exoticism in Thailand

Permanent Collection
The museum's collection explores major trends in fashion through the ages. Includes costumes from the 17th through 19th centuries, fashion accessories, and rare fabric samples. Also on view are major contributions and prototypes from 20th-century haute couture artists, including Chanel, Schiaparelli, Dior, and Lacroix.

Admission: Call for fees. Handicapped accessible.
Hours: Tues.–Fri., 11–6; Sat.–Sun., 10–6; Wed. until 10. Closed Mon.
Programs for Children: Visits and workshops available by appointment.
Tours: Call (33) (1) 44 55 59 26 for information.
Museum Shop: 105 rue de Rivoli. Open daily, 10–7; Wed. until 10.

Musée Picasso

Hotel Salé, 5 rue de Thorigny, 75003 Paris, France
(33) (1) 42 71 25 21
http://www.oda.fr/aa/musee-picasso

Permanent Collection

Extraordinary and enormous
collection of paintings, drawings,
prints by Picasso that cover
many periods of his career,
emphasizing later works; works
by other artists from Picasso's
own collection. **Architecture:**
Housed in an elegant mansion
designed in 1656 by Jean
Boullier for Pierre Aubert, Lord
of Fontenay, in the ancient
Marais section, near La Place des
Vosges. The house had an
eventful history, serving as the

Pablo Picasso, *Verre, Bouteille de Vin, Paquet de Tabac.*
Photo courtesy Musée National Picasso.

Embassy of the Republic of Venice in the late 17th century, expropriated by
the State during the Revolution, and in 1815 housing a boys school which
Balzac attended. It subsequently housed other educational institutions and a
bronzesmith's studio before opening in 1985 as the Musée Picasso.

Admission: Adults, 30 F; youths (18–25), 20 F; children under 18, free.
Sun.: 20 F. Handicapped accessible.
Hours: Apr. 1–Sept. 30: Wed.–Mon., 9:30–6; Oct. 1–Mar. 31: Wed.–Mon.,
9:30–5:30. Closed Tues., Dec. 25, Jan. 1.
Tours: Reservations required for groups. Call 42 71 70 84 for information.

And If You Can, Be Sure To Visit...

Musée Marmottan
2 rue Louis-Bouilly, 75016 Paris, France

Orangerie des Tuileries
Place de la Concorde, 75001 Paris, France

Musée du Petit Palais
Ave. Winston Churchill, 75008 Paris, France

Musée Rodin
Hôtel Biron, 77 rue de Varenne, 75007 Paris, France

Berlinische Galerie

Museum of Modern Art, Photography, and Architecture
Martin-Gropius–Bau, Stresemannstrasse 110, D-10963 Berlin,
Germany
(49) (30) 25 486 0

1998 Exhibitions
Not available at press time.

Permanent Collection
Features Dadaist works, modern art, Berlin Secession, Russian avant-garde, photography, architecture after 1945. **Highlights:** Höch, *The Journalists*; Dix, *Portrait of the Poet*; Grosz, *Self-Portrait*; Gabo, *Torso Construction*; *Hell, It's Me*; Middendor, *Natives of the Big City, Salomé, Judith and Holofernes*; Killisch, *The Artist's Atelier*; Sonntag, *Little Oedipus Head*. **Architecture:** 1881 Renaissance revival building, modeled on Schinkel's destroyed Bauakademie, by Martin Gropius and Heino Schmieden, destroyed in 1945; 1978–86 reconstruction by W. Kampmann.

Admission: DM 6; groups, seniors, students, DM 3. Special exhibits: DM 8; groups, seniors, students, DM 4. Handicapped accessible.
Hours: Tues.–Sun., 10–8. Closed Mon.
Food & Drink: Café open during museum hours.

Kunst-und Ausstellungshalle der Bundesrepublik Deutschland

Friedrich-Ebert Allee 4, 53113 Bonn, Germany
(49) (228) 9171-200
http://www.kah-bonn.de

1998 Exhibitions
Thru Jan. 11
Kunsthalle Bremen in Bonn: Masterpieces from 500 Years
Important works dating from the 17th century, including paintings, engravings, sculpture and photographs by artists such as Dürer, Rembrandt, Delacroix, and Beckmann.

Thru Apr. 19
Arctic-Antarctic
Display of scientific, multi-media installations presenting the latest polar research and contrasting the scientific and fictional aspects of the Poles.

Feb. 13-Apr. 13
100 Years of Art on the Move: The Berlinische Galerie Comes to Bonn
Works ranging from the Berlin Dada movement, through Eastern European Constructivism, to contemporary and conceptual art.

Mar. 27, 1998-Jan. 10, 1999
Gene Worlds
Fascinating genetic discoveries and their importance for both our real world
and our imagination, in the context of cultural history.

May 15-Aug. 23
The Iberians
The ancient inhabitants of Spain (5th to 2nd century B.C.) are examined in
this exhibition of over 350 objects, including stone sculptures, painted
ceramics and gold jewelry. (T)

May 29-Sept. 27
The Great Collections VII: Petit Palais, Paris
Over 180 masterpieces from the 19th century, including paintings, drawings,
sculptures, and decorative arts. Artists represented include Delacroix, Ingres,
Corot, Rodin, and Cézanne.

Dec. 14, 1998-May 5, 1999
The Great Collections VII: Vatican
Continues the *Great Collections* series, with works on loan from the
Vatican.

Permanent Collection
No permanent collection. Changing exhibitions of visual arts, cultural
history, and science and technology. **Architecture:** 1992 building by
Viennese architect Gustav Peichl.

Admission: Adults, DM 8; concessions, DM 4. Group rates available.
Handicapped accessible, including ramps and entry buttons.
Hours: Tues.-Sat., 10-7. Closed Mon.
Programs for Children: Workshops designed to accompany exhibitions.
Tours: Tues.–Sun., 3; Sun., 11. Call (49) (228) 9171-247 for information.
Food & Drink: Restaurant open Tues.–Wed., 10–9; Thurs–-Sun., 10–8.
Rooftop sculpture garden open as weather permits.
Museum Shop: Bookshop offers catalogues, cards and gifts.

Museum für Moderne Kunst

Domstrasse 10, D-60311 Frankfurt am Main, Germany
(49) (69) 212 30447
http://www.frankfurt.de/mmk/

1998 Exhibitions
Jan. 30-May 10
Change of Scene XIII
Features contemporary works by Gertsch, Kassebӧhmer, Dumas, Richter,
Gibson, Schnyder, Speer, and Boetti.

June 19, 1998-Jan. 1999
Change of Scene XIV

Permanent Collection

Features contemporary art, including Pop Art, and other works from the 1960s to the present. Shows rotate every six months. **Architecture:** 1991 building by Hans Hollein.

Admission: Adults, DM 7; concessions, DM 3,50. Handicapped accessible, including ramp and elevator.
Hours: Tues.–Sun., 10–5; Wed., 10–8. Closed Mon.
Tours: Call (49) (69) 212 35844 for information.
Food & Drink: Café open during museum hours.
Museum Shop: Open during museum hours.

Hamburger Kunsthalle

Glockengießerwall, D-20095 Hamburg, Germany
(49) (40) 2486 2612

1998 Exhibitions
Thru Jan. 25
Max Liebermann—The Realist
Comprehensive overview of the realist works of Liebermann (1847-1935), whose work was viewed as controversial and even dangerous in the first decades of the German Empire. Catalogue.

Philipp Otto Runge: Die Scherenscnitte

Jan. 9-Feb. 22
Karl Kluth: Paintings, 1921-1968

Jan. 23-Apr. 5
Lyonel Feininger: Retrospective Drawings
Retrospective of drawings and watercolors by this American artist.

Caspar David Friedrich, *Der Wanderer über dem Nebelmeer*, 1818. Photo courtesy Hamburger Kunsthalle.

Feb. 6-Apr. 19
Emil Schumacher: Retrospective

May-July
Een Lust Voor Het Oog
Features flower and still life painting from the Netherlands.

Aug. 7-Oct. 27
Max Beckmann: Landscape after Foreign Lands

Oct. 9, 1998-Jan. 3, 1999
Kandinsky, Malevitch, and the Russian Avant-Garde

Permanent Collection
Paintings from Gothic to contemporary; 19th- and 20th-century sculpture; drawings, graphics. **Highlights:** paintings by Meister Bertram, *The Creation of the Animals*; Rembrandt, *Simeon and Anna Recognize Jesus as the Lord*; Claude, *The Departure of Aeneas from Carthage*; Friedrich, *The Sea of Ice*; Runge, *Morning*; Beckmann, *Ulysses and Calypso*; Hockney, *Doll Boy*.
Architecture: 1869 building by Hude und Schirrmacher; 1919 annex; building by Oswald Mathias Ungers opened February 1997.
Admission: DM 6. Additional fees for some exhibitions. Handicapped accessible.
Hours: Tues.–Sun., 10–6; Thurs., 10–9. Closed Mon.
Tours: Call (49) (40) 2486 3180 for information.
Food & Drink: Café Liebermann open 10–5; Thurs., 10–8.

Haus der Kunst

Prinzregenstrasse 1, 80538 Munich, Germany
(49) (89) 21127 0

1998 Exhibitions
Thru Jan. 11
Christian Boltanski

Thru Jan. 20
Ellsworth Kelly–The Retrospective
Juliao Sarmento–Joel Shapiro

Jan-Apr. 13
Albert Renger-Patzsch
A retrospective of this artist's work.

Jan. 30-Apr. 26
The Age of the Pre-Raphaelites
Examines the Symbolist movement in Great Britain.

Feb. 6-May 3
Böcklin–De Chirico–Ernst: A Journey Toward the Unknown (T)

May 15-July 12
Emil Schumacher: A Retrospective

Admission: Varies by exhibition, approx. DM 10-15. Handicapped accessible.
Hours: Tues.–Fri., 10–10; Sat.–Mon., 10–6.
Programs for Children: Guided tours and workshops.
Tours: Call (49) (89) 2112 7115 for information.
Food & Drink: Self-service café open museum hours.
Museum Shop: Well-equipped bookshop open museum hours.

Kunsthalle der Hypo-Kulturstiftung

Theatertinerstrasse 15, D-80333 Munich, Germany
(49) (89) 22 44 12

1998 Exhibitions

Thru Jan. 11
Cobra
Features work by Karel Appel and other members of the art group Cobra, founded in Paris in 1948.

Jan. 30-Apr. 13
Carl Rottmann, Court Painter
Retrospective of 150 paintings, watercolors and drawings by this artist who was well-known in the time of King Ludwig I for his series of landscapes for the royal residence in Munich.

Apr. 30-Aug. 16
Pablo Picasso and His Collection
A selection works from the personal collection of this important 20th-century artist. Includes works by Cézanne, Modigliani, Ernst, and Miró.

Permanent Collection

No permanent collection.

Admission: Varies by exhibition, approx. DM 8-10. Discounts for students, children, groups.
Hours: Daily, 10–6; Thurs., 10–9.

Staatsgalerie Stuttgart

Konrad-Adenauer Strasse 30-32, 70173 Stuttgart, Germany
(49) (711) 212 4050

1998 Exhibitions

Thru Jan. 11
Johann Heinrich Füssli: Paradise Lost
Features the 18th-century paintings of Johann Heinrich Füssli in illustration of John Milton's literary masterpiece.

Thru Jan. 25
The Way of the World
Features allegorical prints of the Mannerist period.

Feb. 7-June 1
Paul Gauguin—Tahiti
Works by this late-19th-century colorist painter, whose rejection of Western civilization and its naturalistic art traditions led him to the South Seas.

Mar. 5-June 1
Sternstuden: Kulturstiftung der Länder Förderungen 1988-1998, Jubiläumsausstellung

Summer-Autumn
Marc Chagall
Features the imaginative and colorful art of this 20th-century painter.

Permanent Collection
Early German, Dutch and Italian Painting; 19th-century French painting and Swabian Classicism; large collection of European modern art, including Fauve, Expressionist and Constructivist works; American Abstract Expressionism, Pop Art, and Minimalism; More than 400,000 prints and drawings from the 15th century to the present day. **Highlights:** Works by Hals, Rembrandt, Corot, Cézanne, Monet, Matisse, Picasso, Schlemmer, Baselitz, Warhol. **Architecture:** 1843 Old Staatsgalerie by G.G. Barth; 1984 New Staatsgalerie by James Stirling.

Admission: Adults, DM 5; concessions, DM 3. Handicapped accessible.
Hours: Wed., Fri.–Sun., 10–5; Tues, Thurs., 10–8. Closed Mon. Handicapped accessible.
Programs for Children: Children's tours, Fri., 3.
Tours: Call (49) (711) 212 4057 for information.
Food & Drink: Café Fresko in New Staatsgalerie, open Tues.–Sun., 10–2.
Museum Shop: Open during museum hours.

Irish Museum of Modern Art

Royal Hospital Kilmainham, Dublin 8, Ireland
(353) (1) 612 9900

1998 Exhibitions
Thru Feb. 27
Kiki Smith–Sculpture and Drawings

Thru Mar. 22
Andy Warhol

Thru Mar.
Once is Too Much
A collaborative project between artists and women's groups to address issues of violence against women.

Jan.-June
The Collection: The Madden/ Arnholz Prints

Mar. 31-June
Brian Cronin

Apr. 8-July 3
The Glen Dimplex Artists Award

Irish Museum of Modern Art.

June-Oct.
Outsider Art

July 1998-Feb. 1999
Selections from the Museum's Collection

July-Nov.
William Scott

Nov. 1998-Feb. 1999
Hughie O'Donoghue

Ilya Kabakov

Permanent Collection
Comprises works by 20th-century and contemporary artists and has been
developed through aquisitions, long term loans, and donations since the
museum was established in 1991. Works from the Collection are shown in a
series of changing displays. **Architecture:** Unusually fine 17th-century
hospital, founded by James Butler of Kilkenny Castle; 1986 restoration.

Admission: Free. Handicapped accessible.
Hours: Tues.–Sat., 10–5:30; Sun., Bank holidays, 12–5:30. Closed Mon.
Programs for Children: Workshops and exhibitions of children's artwork.
Tours: Wed., Fri., 2:30; Sat., 11:30. Call (1) 612-9900 for reservations.
Food & Drink: Coffee shop open Mon.–Sat., 10–5; Sun., 12–5.

National Gallery of Ireland

Merrion Square W., Dublin 2, Ireland
(353) (1) 661 5133

1998 Exhibitions
Jan. 1–31
Turner Watercolours
Works by Joseph Mallord
William Turner (1775-1851).

Permanent Collection
National collection of Irish Art,
17th–20th centuries; national
collection of European Old
Master paintings, 14th–20th
centuries, with works by Fra
Angelico, Mantegna,
Rembrandt, Claude, David,
Rubens, and Van Dyck. Also a
fine collection of Irish, British
and Continental watercolors,

Nicolas Poussin, *Lamentation over the Body of Christ,* c.
1655-60. Photo courtesy National Gallery of Ireland.

prints, and drawings. **Highlights:** Caravaggio, Vermeer, Poussin.
Architecture: 1864, Dargan Wing by Francis Fowke; 1903, Milltown Wing
by Thomas Newenham Deane; 1968, Modern Wing by Frank du Berry;
1996 renovation of Modern Wing, renamed The North Wing.

Admission: Free. Handicapped accessible, including ramps and lifts.
Hours: Mon.–Sat., 10–5:30; Thurs., 10–8:30; Sun., 2–5.
Programs for Children: Contact the Education Dept. at 661 5133.
Tours: Free public tours: Sat., 3; Sun., 2:15, 3, 4. Other tours may be
booked by writing the Education Dept. two weeks in advance. Tours for
visually and hearing impaired, including the use of Tactile Picture Sets
available by writing the Education Dept.
Food & Drink: Fitzer's Restaurant serves Mediterranean style menu.
Museum Shop: Open during gallery hours. (1) 678 5450.

The Israel Museum, Jerusalem

Givat Ram (Ruppin Road across from Knesset)
Jerusalem, Israel
(972) (2) 6708811
http://www.imj.org.il/main

1998 Exhibitions
Thru Jan. 3
Harold Edgerton: In a Flash
Works by this recognized scientist who invented the strobe flash, enabling
him to photograph frozen passages of time.

Thru Jan.
Connection: New Works by Israeli Artist Belu-Simion Fainaru
The Vera and Henry Mottek Collection of Artists' Books
Israel Hirshberg
Propaganda and Vision: Soviet and Israeli Art, 1930-1955

Thru Feb. 19
Yehudit and Holofernes by Klimt—Visiting Masterpiece

Thru May 2
Louie Cahan
Brides, Betrothals, and Marriage Ceremonies in Harat, Afghanistan

Thru June 30
Rodin, from the Collection

Jan. 13-May 9
Condition Report: Israeli Photography

Jan. 31-Apr. 30
Benny Efrat

Feb. 3-May 2
Peramin Collection—Russian and Jewish Art

Benno Kalev—Collections and Collectors (Israeli Art)

Feb. 23-June 1
Whitney Museum and Israeli Art

Feb. 24-Dec. 31
Earth (Young Wing)

Apr. 25-Oct. 13
Watercolor—Israeli Art—Ticho House

May 14-Oct. 31
Pilgrimages to the Holy Tombs

May 21-Aug. 29
History of Watercolor—Israeli Art

May 21-Oct. 31
The East—Israeli Art in Relation to Israeli History

June 16-Sept. 13
Sigmar Polke

Sept. 15, 1998-Feb. 15, 1999
Marcel Janko

Oct. 1-Dec. 31
Skins and Jan Fabre

Oct. 4, 1998-Jan. 31, 1999
Merzbacher Collection

Nov. 24, 1998-Feb. 2, 1999
Avigdor Arikha

Shrine of the Book. Photo by David Harris, courtesy Israel Museum, Jerusalem.

Permanent Collection

This national museum includes Judaic art from the Israelite period to the present day; archaeological collections from the prehistoric period to Medieval; Israeli and international art, from old masters to masterpieces of modern art. **Highlights:** The Dead Sea Scrolls, oldest surviving biblical texts in the world (discovered 1947); world's largest collection of Jewish ceremonial art; illuminated Passover manuscripts; and wedding contracts; interior of a 17th century Venetian synagogue; Rothschild 18th-century French salon; Cézanne, *Landscape*; Picasso, *Woman*; sculptures by Moore, Rodin, Lipchitz. **Architecture:** Set on a 22-acre hilltop overlooking Jerusalem, the 1965 building integrates six separate glass and stone pavilions separated by beautiful rising paths and esplanades: the Bezalel Art Wing; the magnificent Billy Rose Sculpture Garden, designed by Isamu Noguchi in a series of semicircular terraces divided by stone walls; and the white-domed Shrine of the Book, by Frederick Kiesler and Armand Bartos, which houses the Dead Sea Scrolls and a new permanent exhibition, *A Day at Qumran.*

Admission: Adults, NIS 26; seniors and students, NIS 20; Children, NIS 12; families, NIS 75. Handicapped accessible, including ramp and elevators.
Hours: Mon, Wed., Thurs., Sun., 10–5; Tues., 4–10; Fri. and holiday eves., 10–2; Sat. & holidays, 10–4. Shrine of the book, also open Tues. 10–10.
Programs for Children: Includes Youth-Wing; multimedia exhibitions.
Tours: Mon., Wed., Thurs., Sun., 11; Tues., 4:30; Fri., 11. Shrine of the Book: Mon., Wed., Thurs., Sun., 1:30; Tues., 3; Fri., 12:45.
Food & Drink: Restaurant and outdoor café with full menu; kiosk for light meals.
Museum Shop: Open during museum hours.

Museo Nazionale del Bargello

Via del Proconsolo 4, 50125 Florence, Italy
(39) (55) 23 88 606

1998 Exhibitions
June-Dec.
Aquisitions and Donations, 1992-1997

Permanent Collection
Treasure house of Italian sculpture; ceramics, Renaissance medals, sacred goldworks, seals, and coins. **Highlights:** Donatello, *St. George, David* (marble), and *David* (bronze); Michelangelo, *Bruto, Bacco, Toudo Pitti,* and *Apollo-David*; Giambologna, *Mercury*; works by Brunelleschi, Ghiberti, Desiderio da Settignano, Mino da Fiesole, Luca della Robbia, Verrocchio. **Architecture:** 1280 medieval palace by Arnolfo di Cambio; 1860 restoration by Francesco Mazzei.

Admission: Adults, 8,000 lire; children under 18, seniors over 60, free.
Hours: Tues.–Sat., 8:30–1:50; Sun., 2–4. Closed June 1, May 1, Dec. 25.

Galleria degli Uffizi

Loggiato degli Uffizi 6, 50121 Florence, Italy
(39) (55) 23 88 5
http://www.uffizi.firenze.it

1998 Exhibitions
Thru May
The Restoration of Perseus
Visitors can witness the restoration and conservation of a painting from the collection. Includes an interactive multimedia exhibition.

Winter
The Feroni Collections
Features paintings donated to the museum that have not previously been on view to the public.

Permanent Collection
One of the world's most important collections of Italian painting, including galleries of the Sienese School, Giotto, Botticelli, Leonardo, Pollaiuolo, Lippi, Michelangelo and Florentine masters, Raphael, Andrea del Sarto, Titian, Caravaggio; also salons of Rembrandt, Rubens. **Highlights:** Botticelli, *Birth of Venus*; Da Fabriano, *Adoration of the Magi;* Giotto, *Madonna and Child;* Leonardo, *Annunciation*; Michelangelo, *Holy Family*; Raphael, *Madonna of the Goldfinch;* Titian, *Venus of Urbino.* **Architecture:** 1560–81 building by Giorgio Vasari and others, created by Francesco I de' Medici to house key Medici collections.

Admission: 12,000 lire. Ticket sales stop 45 minutes before closing.
Hours: Tues.–Sat., 9–7; Sun., holidays, 9–2. Closed Mon.
Food & Drink: Snack bar and terrace café open museum hours.

Vatican Museums

Viale Vaticano, 00120 Città del Vaticano, Italy
(39) (6) 69 88 3333
http://www.christusrex.org/wwwl/vaticano

1998 Exhibitions
Not available at press time.

Permanent Collection
One of the world's most spectacular collections. **Highlights:** Newly restored Sistine Chapel; Chapel of Nicholas V, *Mars of Todi; Apollo Belvedere*; *Laocoön*; *Belvedere* torso; tapestries of the Old School from Raphael's cartoons; School of Athens and Raphael rooms; Gallery of Maps; works by Giotto, Leonardo, Raphael, Titian and Caravaggio in the painting gallery.

Admission: Adults, 15,000 lire; student card holders, 10,000. Handicapped accessible.
Hours: Weekdays, last Sun. of month: 8:45–1:45; no entrance after 1. Apr. 1–June 14, Sept. 1–Oct. 31, Mon.–Fri., 8:45–4:45; Sat., 8:45–1:45; no entrance after 4. Closed Jan. 1, Jan. 6, Feb. 11, Mar. 19, Easter Sun. and Mon., May 1, Ascension Thurs., Corpus Christi Thurs., June 29, Aug. 15–16, Nov. 1, Dec. 8, 25, 26.
Food & Drink: Cafeteria open during museum hours.

Palazzo Grassi S.P.A.

San Samuele 3231, 30124 Venice, Italy
(39) (41) 52 35 133
http://www.palazzograssi.it

1998 Exhibitions

Thru Jan. 11
German Expressionism, Art and Society

Permanent Collection
No permanent collection. **Architecture:** 1986 renovation of the 18th-century Grassi family palazzo on the Grand Canal by Gae Aulenti and Antonio Foscari.

Admission: 13,000 lire; seniors, children, 8,000 lire. Handicapped accessible.
Hours: Daily, 10–7. Closed Dec. 24, 25, and Jan. 1.
Food & Drink: Cafeteria open daily, 9–6:30.

Peggy Guggenheim Collection

Palazzo Venier dei Leoni, 701 Dorsoduro, 30123 Venice, Italy
(39) (41) 52 06 288
http://www.guggenheim.org

1998 Exhibitions

Feb.-May
Art of This Century: The Woman

May-Sept.
Max Ernst: The Attirement of the Bride

Oct. 1998-Jan. 1999
Peggy Guggenheim's Centenary Celebration

Permanent Collection

Focus on Cubism, Futurism, European abstract art, Constructivism, De Stijl, Surrealism, early American Abstract Expressionism; postwar European artists also represented. **Highlights:** Picasso, *The Poet* and *On the Beach*; Kandinsky, *Landscape with Red Spots*; Léger, *Men in the City*; Mondrian, *Composition*; Brancusi, *Maiastra*; de Chirico, *The Red Tower*. Sculpture garden of works by Duchamp-Villon, Giacometti, Arp, Moore and Ernst. **Architecture:** The Collection is housed in the Palazzo Venier dei Leoni, an unfinished Venetian palazzo on the Grand Canal acquired by Peggy Guggenheim in 1949. In 1993, a new wing housing the Museum Shop, the Museum Café and temporary exhibitions rooms was inaugurated.

Admission: 12,000 lire; students, 8,000 lire.
Hours: Wed.–Mon., 11–6. Closed Tues., Dec. 25.
Tours: Call (39) (41) 52 06 288 for information.
Food& Drink: Tables overlook sculpture garden. (39) (41) 522 8688.
Museum Shop: Offers books, posters, cards, and gifts. (39) (41) 520 6288.

Bridgestone Museum of Art

10-1 Kyobashi 1-chome, Chuo-ku, Tokyo 104, Japan
(81) (3) 3563-0241

Permanent Collection

Modern European and Japanese art; European paintings from the 19th to the early 20th centuries; Impressionists; Post-Impressionist and Ecole de Paris works by Signac, Gauguin, van Gogh, Rouault, Matisse, Picasso, Modigliani; Japanese paintings in the Western style from the Meiji period to the present. Housed on the second floor of the Bridgestone corporate headquarters building.

Admission: Adults, ¥500; high school/college students, ¥400; elementary school students, ¥200.
Hours: Apr.–Oct.: daily, 10–6. Nov.–Feb.: daily, 10–5:30.

National Museum of Western Art, Tokyo

7-7 Ueno-koen, Taito-ku, 110 Tokyo, Japan
(81) (3) 3828-5131
http://www.nmwa.go.jp

NOTE: The Main Wing is closed for construction until spring 1998.

1998 Exhibitions
Sept. 15-Dec. 6
Claude Lorrain
Focuses on the ideal landscape in 90 works by the 17th-century French artist and his contemporaries.

Permanent Collection
Old Master paintings of the 15th to the 19th centuries; 20th-century paintings, sculptures, drawings, and prints; sculpture by Rodin; paintings by Delacroix, Courbet, Millet, Daumier, Boudin, Manet, Monet, Degas, Pissarro, Renoir, Cézanne, Gauguin, van Gogh, and Signac; 20th-century works by Picasso, Léger, Ernst, Miró, Dubuffet, and Pollock. **Highlights:** Rodin, *The Kiss, The Thinker, The Gates of Hell*; The Matsukata Collection of modern French paintings. **Architecture:** Main wing by Le Corbusier, 1959; new wing designed in 1979 by the Kunio Maekawa Studio.

Admission: Adults, ¥420; high school/college students, ¥130; children, ¥70. Second and fourth Sat. of every month, free. Handicapped accessible.
Hours: Tues.–Sun., 9:30–5; Fri., 9:30–7. Last admission 30 mins. before closing. Closed between exhibitions, Mon., Dec. 28–Jan. 4.
Tours: For information, call (81) (3) 3828-5131.
Food & Drink: Café Seiyoken, daily, 10–4.

Rijksmuseum Amsterdam

Stadhouderskade 42, Amsterdam, The Netherlands
(31) (20) 673 21 21

1998 Exhibitions
Thru Jan. 18
Medieval Illustrated Histories: The Hausbook and its Master

Thru Mar. 3
On Country Roads and Fields
The depiction of landscape in the 18th and 19th centuries.

Thru Mar. 29
Chapeau Chapeaux!
An exhibition of 150 hats made between 1750 and 1950.

Jan. 24-Apr. 19
Ornamental Prints

Apr. 18-Oct. 11
One Century Old
Textiles and costumes from around the year 1900.

Apr. 25-July 26
Dutch Drawings from the 17th Century

Dec. 12, 1998-Mar. 14, 1999
Adriaen de Vries
Sculpture, prints, and drawings.

Anton Mauve, *Riders in the Snow in the Woods of The Hague*. From *On Country Roads and Fields*. Photo courtesy Rijksmuseum.

Permanent Collection
Unrivaled collection of 15th- to 19th-century paintings including Rembrandt, Vermeer, Hals; sculpture and applied arts; Dutch history; Asiatic art; alternating exhibitions. **Highlights:** Hals, *The Merry Drinker*; Rembrandt, *The Night Watch* and *The Jewish Bride*; *The Draper's Guild*; Vermeer, *Young Woman Reading a Letter* and *The Kitchen Maid*. **Architecture:** 1885 Renaissance Revival building by P. J. H. Cuypers.

Admission: Adults, NLG 12.50; students and children 6–18, NLG 5. Handicapped accessible. Wheelchairs available; free admission to those persons accompanying wheelchair users and blind visitors.
Hours: Daily, 10–5. Closed Jan. 1.
Tours: Reservations required four weeks in advance; (31) (20) 673 21 21.
Food and Drink: Self-service restaurant open during museum hours.
Museum Shop: Open during museum hours.

Stedelijk Museum

Paulus Potterstraat 13, 1071 CX Amsterdam, The Netherlands
(31) (20) 5732 911
http://www.stedelijk.nl

1998 Exhibitions
Feb. 14-Apr. 13
Russian Dissident Art from the Dodge Collection

June 27-Aug. 23
From the Corner of the Eye

Sept. 12-Oct. 4
World Wide Video Festival
Features new multimedia installations by contemporary artists.

Permanent Collection
Modern and contemporary art, with a concentration in work after 1945; includes paintings, sculptures, drawings, prints, photographs, graphic

design, and applied arts, with works by Beckmann, Chagall, Cézanne, Kirchner, Matisse, Mondrian, Monet, Picasso; unique collection of Malevich and major postwar artists including Appel, de Kooning, Newman, Judd, Stella, Lichtenstein, Warhol, Nauman, Long, Kiefer, Polke. **Architecture:** 1895 Neo-Renaissance building by A.W. Weissman; 1954 addition by J. Sargentini and F.A. Eschauzier.

Kasimir Malevich, *Girls in a Field*, 1928-32. Photo courtesy Stedelijk Museum.

Admission: Adults, Fl. 7.50; seniors, groups of 15 or more, children 7–16, Fl. 3.75; children 6 and under, free. Fee for special exhibitions. Handicapped accessible.
Hours: Daily, 11–5. Summer hours, Apr. 1–Sept. 30: 10–6.
Tours: Call (31) (20) 5732 911 for reservations two weeks in advance.
Food & Drink: Restaurant open during museum hours.
Museum Shop: Open during museum hours.

Van Gogh Museum

Paulus Potterstraat 7, 1071 CX Amsterdam, The Netherlands
(31) (20) 570 5200

1998 Exhibitions

Thru Jan. 11
Auguste Préault (1810-1879)
Romanticism in bronze.

Feb. 6-Apr. 19
Utagawa Kuniyoshi (1797-1861)
Prints and paintings.

May 1-Sept. 6
Vincent van Gogh: The Drawings of the van Gogh Museum
Focuses on works created in Antwerp and Paris, 1885-1888. Drawings exhibited will be rotated at the end of June due to their vulnerability.

May 15-Aug. 30
Symbolism and British Art
Features work by Rossetti, Burne-Jones, and other 19th-century artists.

Permanent Collection

More than 200 paintings and almost 500 drawings from each period of van Gogh's life; background materials; works of contemporaries, including Toulouse-Lautrec, Gauguin, Fantin-Latour, Monet, Sisley, Isaac Israëls and many others. **Highlights:** Works by van Gogh: *The Potato Eaters; Still-life with Sunflowers; Self-Portrait with Old Felt Hat; Bedroom at Arles* and *Wheatfield with Crows.* **Architecture:** 1973 building by Gerrit Rietveld and I. van Dillen.

Admission: Adults, Fl. 12,50; children ages 5–17, Fl. 5. Group rates available. Handicapped accessible, including elevators and wheelchairs.
Hours: Daily, 10–5; closed Jan. 1.
Tours: Call (31) (20) 570 5200 for information.
Food & Drink: Café open daily, 10-4:30; terrace open summer months.
Museum Shop: Open daily, 10–4:30; (31) (20) 570 5944.

Mauritshuis

Korte Vijerberg 8, 2513 AB The Hague, The Netherlands
(31) (70) 302 34 56

1998 Exhibitions

Thru Mar. 29
Princely Patrons: The Collection of Frederik Hendrik of Orange and Amalia van Solms in The Hague
16th–17th-century works by Rembrandt, Rubens, Jordaens, and others.

July 3-Oct. 11
Gerard ter Borch and the Peace at Münster
Portrays the 1648 treaty that ended the Eighty Years' War between Spain and the Netherlands.

Permanent Collection

Dutch and Flemish paintings of the 15th–17th centuries. Many works previously held in the collection of Stadholder-Prince Willem V, including Rembrandt, *Portrait of the Artist as a Young Man;* Rubens, *Adam and Eve in Paradise,* and Vermeer, *View of Delft.* Other works by van Ruisdael, van der Weyden, Hals, Jordaens, Van Dyck, and Memling. **Highlights:** Works by Vermeer; Picture Gallery of Stadholder-Prince Willem V. **Architecture:** City palace commissioned by Count Johan Maurits van Nassau Siegen, former governor of Dutch Brazil; 17th-century Dutch classical style palace designed by Jacob van Campen and built under supervision of Pieter Post, 1634–1644.

Admission: Adults, NLG 10; Children under 17, seniors, NLG 5.
Hours: Tues.–Sat., 10–5; Sun., holidays, 11–5; Closed Mon.
Tours: Call (31) (70) 302 34 35 for guided tour reservations.
Food & Drink: Coffee machine; Cafés and restaurants located nearby.
Museum Shop: Open during museum hours.

Kröller–Müller Museum

Houtkampweg 6, P.O. Box 1, 6730 AA Otterlo, The Netherlands
(31) (318) 59 10 41; (31) (318) 59 12 41

Permanent Collection

Painting by Corot, Fantin Latour, van Gogh, Seurat, Signac, Ensor, Picasso, Léger, Gris, Mondrian; sculpture by Rodin, Maillol, Lipchitz, Moore, Hepworth, Snelson, Rickey, Oldenburg, Serra, Merz, Penone; 60-work sculpture park. **Architecture:** 1938 building by Henry van der Velde; 1977 wing by Wim Quist.

Admission: Contact the Hoge Veluwe National Park (includes museum); (31) (318) 59 16 27. Handicapped accessible.
Hours: Tues.–Sun., holidays, 10–5. Closed Mon. and Jan. 1.
Tours: By appointment; call (31) (318) 59 12 41 for information.
Food & Drink: Self-service restaurant open during museum hours.
Museum Shop: Offers books, catalogues, prints, and postcards.

Museum Boijmans Van Beuningen Rotterdam

Museumpark 18–20, 3015 CX Rotterdam, The Netherlands
Telephone: (31) (10) 44 19 400
http://www.boijmans.rotterdam.nl

1998 Exhibitions

Thru Jan. 11
The Utensil: The Seventeenth-Century Inn
An exhibition resulting from a collaboration with social history students at Rotterdam's Erasmus University.

Thru Mar. 8
Paul Beckman
Features various installations of the Rotterdam artist's latest work, including console tables and a bedroom. Catalogue.

Max Ernst
Bronzes by the artist, with photographs of Ernst and his friends. Catalogue.

Max Ernst en de Animatiefilm
Examines the influence of Max Ernst on film animation.

Jorge Pardo
Works and an installation by this contemporary American West Coast artist.

Thru Mar. 15
Around Raphael
Italian drawings and prints from the first half of the 16th century.

The Master of the Small Landscapes
Prints and drawings illustrate the development of the characteristic Dutch landscape in the late 16th century.

Permanent Collection

Old Masters, sculpture, drawings, paintings, applied art, industrial design, modern and contemporary art. **Highlights:** Bosch, *The Prodigal Son.* **Architecture:** 1935 building by A. van der Steur; 1972 addition by A. Bodon; 1991 pavilion by H. J. Henket.

Admission: Adults, Fl. 7.50; seniors, children, groups of 15 or more, Fl. 4.00 per person. Additional charges for some special exhibitions. Handicapped accessible.
Hours: Tues.–Sat., 10–5; Sun. and holidays, 11–5. Closed Mon.
Tours: Mon.–Fri.; call (31) (10) 44 19 471 for information.
Food & Drink: Café Restaurant open Tues–Sat., 9:30 am–9:30pm; Sun., 10:30–5:30.

Astrup Fearnley Museum of Modern Art

Dronningens GT. 4, Oslo, Norway
(47) (22) 93 60 60
http://netvik.no/storgata/af-museet

R.B. Kitaj, *The Jewish Rider,* 1984-85. Photo courtesy Astrup Fearnley Museum of Modern Art.

1998 Exhibitions
Jan. 10-Mar. 23
R. B. Kitaj: Retrospective

Apr. 23-June 7
Olivier Debré in Norway

Aug. 19-Oct. 4
Gerhard Richter: New World

Permanent Collection

The collection consists of post-war works with an emphasis on Norwegian and international artists, including pieces by Francis Bacon, Lucian Freud, Anselm Kiefer, Gerhard Richter, Gary Hume, Knut Rose, Bjorn Carlsen, Olav Christopher Jenssen, and Odd Nerdrum; the latest addition to the museum is a sculpture hall featuring works by Willem de Kooning, Damien Hirst, and Richard Deacon. **Highlights:** Anselm Kiefer, *Zweistromland* (*High Priestess*), Odd Nerdum paintings, Gerhard Richter, *River,* Damien Hirst, *Mother and Child Divided.* **Architecture:** 1993 modern building by well-known Norwegian architect LPO A/S; situated in the oldest part of Oslo with buildings dating back to the 17th century.

Admission: Adults, NOK 30; children over 7, students, NOK 15; group reductions Handicapped accessible, including ramp and elevator.
Hours: Tues.–Sun., 12–4; Thurs., 12–7; closed Mon.
Programs for Children: Tours available upon request.
Tours: Sat.–Sun., 1. Call (47) (22) 93 60 47 for reservations.
Museum Shop: Open during museum hours.

Munch Museet

P. O. Box 2812 Tøyen, N-0608 Oslo, Norway
(47) (22) 67 37 74

Permanent Collection

The bequest of Edvard Munch (1863-1944), pioneer Scandinavian Expressionist, includes a vast collection of the artist's paintings, graphics, drawings, and sculpture. **Highlights:** Munch, *The Scream* (1893), *Death in the Sickroom*, *Madonna*. **Architecture:** 1963 building by Gunnar Fougner and Einar Myklebust.

Admission: Adults, NOK 50; concessions, NOK 20. Handicapped accessible, including elevator.
Hours: Sept. 15–June 1: daily, 10–6; Jan.–May 31: Tues., Wed., Fri., Sat., 10–4; Thurs., Sun., 10–6. Closed Mon.
Tours: Sun., 1. Call (47) (22) 67 37 74 for information.
Food & Drink: Café Edvard Munch open during museum hours.

Royal Castle in Warsaw

Plac Zamkowy 4, 00277 Warsaw, Poland
(48) (22) 635 08 08; (48) (22) 657 21 50

1998 Exhibitions

Spring
The Best of the Royal Castle Collection
Features 17th–18th-century paintings, furniture, and decorative arts.

Autumn-Winter
European Gardens from Ancient Times
Includes plans, paintings, sculptures, arts and crafts.

Permanent Collection

16th–17th century Court Rooms; historic Parliament Chambers; Royal Apartments of King Stanislaus Augustus, reconstructed and refurbished, with original furnishings and paintings; Castle cellars; Polish coins and medals; outstanding collection of Far Eastern carpets; paintings. **Highlights:** Canaletto, 23 *Views of Warsaw*. **Architecture:** Royal Castle, located on banks of Vistula River since early 15th century. New wings added, 17th–18th centuries, partially destroyed by fire in 1767. Substantially damaged during World War II. Exterior rebuilt, 1971-74; interior renovation, 1988.

Admission: Parliment Chambers, Prince Stanislaus' Apartment: 52 LP. The Royal and State Apartments: 82 LP. Handicapped accessible; ramps, elevators, and wheelchairs available.
Hours: Oct. 1-Apr. 14: Tues.-Sun., 10–4; Apr. 15-Sept. 30: Tues.-Sun., 10–6.
Programs for Children: Offered during school year. Call for details.
Tours: Call (48) (22) 65 72 338 or fax (48) (22) 65 72 170 for reservations.
Food & Drink: Restaurant and Café open Tues.–Sun., 12–12.
Museum Shop: Located in nearby building. Offers books, cards, and maps.

Museo de Arte de Ponce

25 Avenida de las Americas, Ponce, Puerto Rico
(787) 848-0505

1998 Exhibitions

Thru Jan. 11
Rafael Trelles: Secret Landscape

Feb. 7-Apr. 5
Picasso: The Suite Vollard

Apr. 19-June 21
The Role of Paper—Antonio Martorell

July 4-Sept. 6
Third Biennial of Wooden Saints (Santos Contemporáneos)

Sept. 19-Nov. 29
Arnaldo Roche Rabell: Nomad

Dec. 12, 1998-Feb. 7, 1999
Trámite: Recent Works by García Burgos, Graulau and Rodríguez Santos

Frederic, Lord Leighton, *Flaming June*. Photo courtesy Museo de Arte de Ponce.

Permanent Collection

Paintings and sculptures from the important schools of Western art, including works by Rubens, Velázquez, Murillo, Strozzi, Delacroix, and Bougereau; an outstanding collection of Pre-Raphaelites and Leighton's *Flaming June*. Includes 18th-century paintings from Peru and South America, as well as 18th- and 19th-century works by Puerto Rico's Jose Campeche and Francisco Oller. Contemporary artists include Fernando Botero, Claudio Bravo, Myrna Báez, Jesús Rafael Soto, and Antonio Martorell. **Architecture:** Museum founder Don Luis A. Ferré commissioned Edward Durrell Stone to design the museum, which opened in 1965. A "work of art housing works of art," there are 14 galleries and two gardens, one based on Moorish design from Granada, the other contemporary in style.

Admission: Adults, $4; children, $2; students with ID, $1; special group rates; members, free.
Hours: Daily, 10–5. Closed Dec. 25, Jan. 1, Three Kings Day, and Good Friday.
Tours: Daily in English and Spanish; group reservations required.
Food & Drink: Snack bar in Granada Garden.
Museum Shop: Open during museum hours.

Pushkin Museum of Fine Arts

Ul. Volkhonka 12, Moscow, Russia
(7) (95) 203-7412
http://www.global-one.ru/english/culture/pushkin//

1998 Exhibitions

Mar.-May
Master Drawings from the Morgan Library, the State Hermitage Museum, and the Pushkin State Museum of Fine Arts
Features 120 western European drawings from the 15th to 20th century. (T)

Permanent Collection

World-class art, second only to the Hermitage, with 4300 sq. ft. of Ancient Greek and Roman sculpture, including the marble sarcophagus *Drunken Hercules*, a torso of Aphrodite, and more, plus classical masterpieces and one of the best collections in the world of French Barbizon and Modern painting. **Highlights:** Botticelli, *The Annunciation;* San di Pietro, *Beheading of John the Baptist*; six Rembrandts, including *Portrait of an Old Woman*; five Poussins; Picasso, from blue period; Cézanne, *Pierrot and Harlequin*; Van Gogh, *Landscape at Auvers after the Rain* and *Red Vineyards*; Monet, *Rouen Cathedral at Sunset*; Renoir's well-known *Bathing on the Seine* and *Nude on a Couch,* plus ten fantastic Gauguins, and more. **Architecture:** New classicism (1895-1912). Two-storey dark gray stone building with a large colonnade and glass roof by architect Roman Klein.

Hours: Tues.–Sun., 10–7.
Tours: Group tours by reservation only.
Food & Drink: Cafés located nearby.

Tretyakov Gallery

Lavrushinsky Pereulok 12, Moscow, Russia
(7) (95) 231-1362

1998 Exhibitions
Not available at press time.

Permanent Collection

More than 100,000 works of Russian art including ancient Russian art, myriad icons, classical 18th- and 19th-century Russian works, and 20th-century works by Kandinsky and Malevich, with selections on display in brand new expanded and restored exhibition galleries. Original collections donated by Tretyakov brothers in 1895 from their private home next door have grown to museum of twenty buildings. **Architecture:** Unique creative 1900 design by Viktor Vasnetsov in the style of early Art Nouveau, with architecture and decorative styles interwoven.

Hours: Tues.–Sun, 10–7.
Tours: Call (7) (95) 238-2054.

State Hermitage Museum

36 Dvortsovaya Naberezhnaya, St. Petersburg, Russia
(7) (812) 311-3420
http://www.hermitage.ru

1998 Exhibitions

Continuing
Rembrandt's Danae
This masterwork is once again on view after 12 years of restoration.

Thru Mar.
Western European Applied Arts of the 16th through 18th Centuries: For the 100th Anniversary of the Baron Shtiglits Museum
About 100 objects from the Hermitage's permanent collection.

Opens Mar.
On Loan from the National Gallery, Washington, D.C.
Features one of the 21 masterpieces purchased from the Hermitage by Andrew Mellon in the 1930s.

May 28-July
Master Drawings from the Morgan Library, the State Hermitage Museum, and the Pushkin State Museum of Fine Arts
Features 120 western European drawings from the 15th to 20th century. (T)

Permanent Collection

One of the most all-encompassing repositories of art in the world, begun with Tsarist treasures and including, since the Revolution, private collections. More than four hundred exhibition galleries house a veritable treasure trove of antiquities from Egypt, Babylon, Byzantium, Greece, Rome and Asia; Russian pre-historic artifacts; elaborate medals and decoration. Old masters from every period of Western Art and the largest collection (along with the Pushkin Museum) of major French Impressionist, Post-Impressionist and the Barbizon School outside Paris. The lavish Winter Palace adjoins the museum. **Highlights:** Osobaya Kladovya—the Gold Room—with spectacular gold, silver and royal jewels; the Jordan staircase; works by Leonardo, including *Madonna with Flowers*, *Madonna Litta*; Raphael, *Madonna Connestabile*, *Holy Family*; eight Titians; works by El Greco, Velazquez, Zurbaran, Goya; Van Dyck, *Self Portrait*; 40 Rubens and 25 Rembrandts including *Danae* and *The Prodigal Son*; Matisse, *The Dance*; Cézanne, *The Banks of the Marne*; Picassos from blue, pink and cubist periods. British masters are also on view. **Architecture:** Built in several phases, first as a retreat for Catherine the Great, then the Great (Bolshoi) Hermitage, then the New Hermitage, the building is in the quintessentially St. Petersburg style of monumental Imperial Russian architecture with an assimilation of western architectural principals on a scale that is uniquely Russian. Court Architects: Bartolomo Francesco Rastrelli (1764-1775); Mikhail Zemstov, (1839-1852); Shtaakenshneider renovations 1852.

Hours: Tues.–Sun., 10:30–6.
Tours: Daily.

National Galleries of Scotland

National Gallery of Scotland
The Mound, EH2 2EL Edinburgh, Scotland
(131) 556-8921 (information for all three museums)

1998 Exhibitions
Thru Feb. 15
Sir Denis Mahon Collection
17th- and 18th-century Italian paintings from the collection of one of Britain's most distinguished art historians. Includes works by Guercino, Reni, Domenichino, and Carracci.

Jan. 1-31
Turner Watercolours
Annual display of 38 magnificent works by J.M.W. Turner, bequeathed to the museum by Henry Vaughn in 1900.

Permanent Collection
Masterpieces from the Renaissance to Post-Impressionism by Raphael, Titian, El Greco, Velázquez, Rembrandt, Turner, Constable, Cézanne, van Gogh; Scottish paintings include works by Ramsay, Raeburn, Wilkie, and MacTaggart. **Architecture:** 1859 neoclassical building by William Playfair.

Scottish National Portrait Gallery
1 Queen St., Edinburgh, Scotland

1998 Exhibitions
Thru Feb. 22
Faces of Excellence
Photographs of several of the University of Edinburgh's distinguished scholars, continuing the 18th-century university tradition of commissioning portraits of its academic staff.

Feb.-Apr.
Looking Through the Stone: Hugh Miller and the Testimony of Rocks

Examines the life and prose of this geologist and journalist, including photographs, drawings, and geological specimens.

Mar. 12-May 31
The Science of the Face
Examines the face through a variety of scientific angles: biological structure, perception, recognition, and facial language.

Apr.-May
John Kobal Photographic Portrait Award
International entries in fifth annual photographic portrait award.

Stephen Conroy, *Sir Steven Runciman*. Photo courtesy Scottish National Portrait Gallery.

Permanent Collection
Subjects include Mary, Queen of Scots; Bonnie Prince Charlie; Robert
Burns; Sir Walter Scott; Charles Rennie Macintosh; Queen Elizabeth.
Scottish Photography Archive, including work by Hill & Adamson and
contemporary photographers.

Scottish National Gallery of Modern Art
Belford Rd., Edinburgh, Scotland

1998 Exhibitions

Thru Feb.
Correspondences: Scotland/Berlin
Contemporary artists from Berlin and Scotland.

Feb. 14-May 10
William MacTaggart (1903-1981)
Paintings by this artist of the Edinburgh School, known for his Post-
Impressionist landscapes and later expressionist works.

Apr. 25-June 28
Sacred and Profane
Features ten specially commissioned works by Calum Colvin, one of
Scotland's leading contemporary artists who is known for his unique style of
"constructed" photography.

Permanent Collection
Twentieth-century paintings, sculpture, graphics, including works by
Picasso, Matisse, Giacometti, Moore, Hepworth, Lichtenstein, Hockney.
National collection of Scottish art, from the Colourists to contemporary
artists.

Admission: Free. Charge for some loan exhibitions.
Hours: Mon.–Sat., 10–5; Sun., 2–5. During Edinburgh International
Festival: Mon.–Sat., 10–6; Sun., 11–6. Closed Dec. 25–26, Jan. 1.
Tours: Call (131) 556-8921
Food & Drink: Cafés at Modern Art and Portrait Galleries open Mon.–
Sat., 10:30–4:30; Sun., 2–4:30.

Fundació Joan Miró

Parc de Montjuïc, 08038 Barcelona, Spain
(34) (3) 329 19 08
http://www.bcn.fjmiro.es

1998 Exhibitions
Thru Feb. 15
Alexander Calder
Over 100 works, from early wire pieces to his Constellations, mobiles, and
stabiles, demonstrate Calder's essence of movement. Commemorates the
centenary of the birth of Calder and his friendship with Joan Miró.

Feb.-Apr.
Singular Electrics

Permanent Collection
More than 200 paintings, sculptures, works on paper, textiles (1917–1970s) donated by Miró to his native city. Foundation is dedicated to conserving and showing his work, and that of both major and emerging artists.
Highlights: Major works by Miró; "To Joan Miró" (works dedicated to Miró by major artists). **Architecture:** 1975 building by Joseph Lluis Sert, enlargement in 1986 by Jaume Freixa.

Joan Miró, *Tapestry*, 1979. Photo courtesy Fundació Joan Miró.

Admission: 700 pesetas.
Handicapped accessible.
Hours: Tues.–Sat., 11–7; Thurs. 11–9:30; Sun., holidays, 10:30–2:30. Closed Mon. Summer hours: Tues.–Sat., 10–8; Thurs., 10–9:30; Sun., holidays, 10–2:30. Closed Mon.
Programs for Children: Guided tours, call 329 19 08 for reservations.
Tours: General public, Sat.–Sun., 12:30; schools, weekdays; call 329 19 08 for reservations.
Food & Drink: Buffet and restaurant with outdoor café open during museum hours.
Museum Shop: Open during museum hours. Gift catalogue available.

Museu Picasso

Carrer de Montcada, 15-19, 08003, Barcelona, Spain
(34) (3) 319 63 10

1998 Exhibitions

Thru Jan. 25
Picasso, The Making of a Genius: Drawings, 1890-1904
About 250 works trace the development of this great 20th-century avant-garde artist, from his early training in Spain to Cubism and beyond.

Feb. 18-May 31
Egon Schiele: The Leopold Collection
Over 150 works by this Austrian artist (1890-1918), a modernist fin-de-siècle rebel who portrays human nature at its deepest levels.

Oct. 1998-Jan. 1999
Picasso: Engravings, 1900-1940
Surveys the artist's engravings from his early career through 1940.

Permanent Collection

More than 3,500 works from Picasso's formative years, including early paintings, drawings, engravings, ceramics, and graphics, installed in a former private mansion. **Architecture:** Berenguer d'Aguilar, Baró de Castellet, and Meca palaces, 13th century.

Admission: Adults, 600 ptas; seniors, students, unemployed, 300 ptas; children under 12, free; Wed., half-price; first Sun. of the month, free. Handicapped accessible.
Hours: Tues.–Sat., 10–8; Sun., 10–3. Closed Mon., Jan. 1, Good Friday, May 1, June 24, Dec. 25, 26. Ticket office closes half hour before closing.
Tours: For group tour reservations, call (34) 3 319 6310, Mon.–Fri., 10–2.
Food & Drink: Café and Terrassa del Museu open during museum hours.

Fundació Antoni Tàpies

Aragó 255, 08007 Barcelona, Spain
(34) (3) 487 03 15

1998 Exhibitions

Apr. 2-July 5
James Coleman
Installations by this artist who questions the nature of reality, perception, representation, imagination, and identity.

Permanent Collection

Over 300 paintings, drawings, and sculptures representing every aspect of the artist's work; library collections on Tàpies, modern art history, and art of the Orient. **Architecture:** 1885 building by Lluís Domènech i Montaner; 1990 renovation by Roser Amadó and Lluís Domènech Girbau.

Admission: Adults, 500p; students, 250p. Handicapped accessible.
Hours: Tues.–Sun., 11–8. Closed Mon.
Tours: Groups by appointment; call (34) (3) 487 03 15.

Museo Guggenheim Bilbao

Abandoibarra Etorbidea 2, 48001 Bilbao, Spain
(34) (4) 423 27 88
http://www.guggenheim.org

1998 Exhibitions

Ongoing
Selections from the permanent collection of the Guggenheim Foundation survey the spectrum of 20th-century art, from Cubism and Expressionism to Pop Art, Minimalism, and Conceptual art.

Nov. 20, 1998-Feb. 26, 1999
Robert Rauschenberg: A Retrospective
Surveys the prolific career of one of the most acclaimed American artists of the 20th century. Includes nearly 400 works from the late 1940s to the present. Catalogue. (T)

Permanent Collection
American and European art of the 20th century. Focus on works created since mid-century, including Abstract Expressionism, Pop Art, Minimalism, Arte Povera, Conceptual art, and developments of successive generations. Contemporary Basque and Spanish art, including works by Tàpies, Iglesias, Solano, and Torres. **Highlights:** Modern and Contemporary works by de Kooning, Dine, Polke, Kiefer, Still, and Rothko. Special commissions by Serra, Clemente, and Holzer. **Architecture:** Building design by Frank Gehry, 1991; interconnected building blocks organized around a large central atrium; three levels of exhibition space, café, shop, and library; also incorporates a busy traffic bridge, the Puente de la Salve; signature metal roof, called the "Metallic Flower." Museum opened in October 1997.

Hours: Tues.–Wed., 11–8; Thurs.–Sat., 11–9; Sun., 11–3. Closed Mon.

Museo del Prado
Paseo del Prado s/n., 28014 Madrid, Spain
(34) (1) 330 28 00
http://museoprado.mcu.es

1998 Exhibitions
Not available at press time.

Permanent Collection
One of the major museums of the world, with Master paintings from Italian Renaissance, Northern European, Spanish Court Painters collected by Royal family since the 15th century. Works by Brueghel, van Dyck, Goya, El Greco, Giorgioni, Rubens, Titian, Velázquez, Zurbarán. **Highlights:** Fra Angelico, *The Annunciation*; Titian, *Danae*; Bosch, *The Garden of Delights*; Brueghel, *The Triumph of Death*; El Greco, *The Nobleman with his Hand on His Chest*; Velázquez, *The Surrender of Breda, Las Meniñas*; Goya, *Nude Maja, Clothed Maja, Third of May*; frescoes; works by Rubens, Titian, Tintoretto, Veronese. **Architecture:** 1780 Neoclassical building by Juan de Villanueva.

Admission: 400 ptas.
Hours: Tues.–Sat., 9–7; Sun., holidays, 9–2. Closed Mon.
Tours: Call (34) (1) 330 28 25.
Food & Drink: Cafeteria, restaurant open 9–5.

Museo Nacional Centro de Arte Reina Sofía

Santa Isabel 52, 28012 Madrid, Spain
(34) (1) 467 50 62; (34) (1) 467 51 61
http://www.spaintour.com/museomad.htm

1998 Exhibitions

Thru Jan. 12
Fernand Léger
Features 120 paintings spanning Léger's career from his "tubist" paintings of 1911-12 to his later series of construction works in the 1950s. (T)

Mark Tobey
Retrospective of works by this North American artist, including portraits, watercolors, and selections from his "Seattle" and "Broadway" series.

Thru Jan. 18
Josep de Togores
Features magical-realist and surrealist works by this Catalán painter who was active between 1914 and 1931.

Thru Jan. 25
Philip-Lorca di Corcia: Photographs

Thru Feb. 23
Severo Sarduy

Jan. 27-Mar. 16
Cuevas

Feb. 3-Mar. 23
Alcolea
Arroyo

Feb. 5-Apr.
Cristina Iglesias

Mar. 17-June 1
Fotografía Pública de Entreguerras

Mar. 31-June 1
Esteban Vicente

Apr. 7-June 8
R.B. Kitaj

May-Sept.
Kiefer
Diseño Industrial
Correspondencia Miró–Dalmau

June 16-Sept. 14
Robert Frank

June 23-Sept. 21
Garcia Lorca

Sept.-Nov.
Günther Forgg
Fontana

Oct. 10, 1998-Jan. 10, 1999
Arte Brasileño
I. Zuloaga
Papeles Constructivistas

Permanent Collection
Over 10,400 works spanning European and Spanish modern and contemporary art. Works by Spanish artists Gris, Dali, Picasso, Miró, and Gonzalez, and important artists influenced by the Modernist movement, 1900–1940; sculptures, including works by Gargallo, Alfaro, and Serrano; over 4,500 drawings and engravings. **Highlights:** Picasso, *La Naguese*, *Guernica*; Kapöor, *1000 Names*; large collection of important works by Dali and Miró. **Architecture:** Former Madrid General Hospital created by Sabatini during the reign of Carlos III, 1788; 1990 renovation and expansion, Vasqez de Castro and Iñiquez de Onzoño.

Admission: Adults, 500 ptas; students, half-price; children under 18, seniors, members, Sat. 2:30–9, Sun., free. Handicapped accessible.
Hours: Wed.–Mon., 10–9; Sun., 10–2:30. Closed Tues.
Tours: Mon.,Wed., 5; Sun., 11. For information, call (34) 1 467 50 62.
Food & Drink: Café open museum hours; Restaurant open Mon.,Wed.–Sat., 1–4.

Fundación Colección Thyssen-Bornemisza
Paseo del Prado 8, 28014 Madrid, Spain
(34) (1) 420 39 44

1998 Exhibitions
Thru Jan. 11
Joan Miró: Catalan Peasant With Guitar, *1924*
Spotlights this work by Miró from the museum's permanent collection.

Permanent Collection
European art, focusing on paintings from the 13th through 20th centuries; German Expressionism. **Highlights:** Works by Titian, Bellini, Veronese, Carravaggio, Cranach, Gaddi, El Greco, Beckmann, Miró, Grosz, and Cézanne.

Hours: Tues.–Sun., 10–7. Ticket office closes at 6:30.
Tours: Group tour reservations, call (34) (1) 369 01 51.
Food & Drink: Cafeteria-Restaurant.
Museum Shop: Offers jewelry based on museum works, CD-Rom of the collection, and other gift items.
Branch: Monastery of Pedralbes in Barcelona; works are rotated between the two locations.

Moderna Museet

Box 16176, 103 27 Stockholm, Sweden
(46) (8) 666 42 50

NOTE: The new Moderna Museet is under construction, scheduled for completion in 1998. Exhibitions are being held in the old 1887 Tram Depot, Spåvagnshallarna, Birger Jarlsgatan 57.

1998 Exhibitions
Not available at press time.

Permanent Collection
Works by Swedish, international artists; modernist works by Braque, Dalí, Duchamp, Ernst, Giacometti, Kandinsky, Picasso; American art of the 1960s and 1970s. **Highlights:** Brancusi, *Le Nouveau-né*; de Chirico, *Le Cerveau de l'enfant*; Rauschenberg, *Monogram*; Duchamp room. **Architecture:** Museum opened in 1958, housed in a former naval drill hall built by Fredrik Blom in 1852, renovated by Per-Olof Olsson. New museum by architect Rafael Moneo due to open in 1998.

Admission: Adults, 50 SEK; under 16, free.
Hours: Tues.–Thurs., 12–7; Fri.–Sun., 12–5. Closed Mon.
Tours: Call (46) (8) 666 43 56.
Food & Drink: Café and restaurant at Spåvagnshallarna.

Nationalmuseum

Södra Blasieholmshamnen, Box 161 76, 103 24 Stockholm, Sweden
(46) (8) 666 42 50

1998 Exhibitions
Thru Jan. 11
Focus on Cézanne
Paintings and drawings by Paul Cézanne (1839-1906), concentrating on motifs of portraits, landscapes, still lifes, and bathers.

Thru Mar. 15
Design Sigvard Bernadotte
Contributions to design and the applied arts by this Swedish aristocrat.

Feb. 27-May 24
Scandinavia and Germany, 1800-1914
Major historical exhibition concerning the connections between these two regions in history and myth, and the impact of social and political realities on cultural and artistic developments.

May 28-Oct. 11
Orrefors Glassworks Celebrates 100th Anniversary
Sweden's leading glassworks has grown from a modest factory to an influential corporation with the manufacture of art objects and utility wares.

Oct. 9, 1998-Spring 1999
Catherine the Great and Gustav III
Explores the themes of war, peace, science, trade, and the fine arts, as influenced by the cultural and political contact of these two royal cousins.

Permanent Collection
Swedish painting and sculpture; 17th-century Dutch painting; 18th- and 19th-century French paintings; 45,000 drawings and prints from the 15th century to the present; fine collection of decorative arts from medieval furniture and tapestries to contemporary design. **Highlights:** Turn-of-the-century Nordic art by Larsson, Liljfors, Zorn; Impressionist works by Renoir, Manet, Degas; Rembrandt, *The Batavians' Oath of Allegiance*; Rubens, *Bacchanal at Andros*. **Architecture:** 1866 Italian Renaissance building, with decorative sculpture by Swedish artists.

Admission: Adults, 60 SW crowns; seniors, students, 30 SW crowns. Handicapped accessible, including elevators and hearing aids.
Hours: Tues., Thurs., 11–8, Wed., Fri.–Sun., 11–5. Closed Mon.
Programs for Children: Special children's activities.
Tours: Call (46) 8 666 44 28, Tues.–Fri., 1.
Food & Drink: Café and restaurant open during museum hours.
Museum Shop: Open during museum hours.

Kunstmuseum Bern

Holderstrasse 8–12, CH-3000 Bern 7, Switzerland
(41) (31) 311 09 44

1998 Exhibitions

Thru Mar. 1
The Blue Four: Feininger, Jawlensky, Kandinsky, Klee
First exhibition in Europe on Galka Scheyer's activities in the U.S. and on the highly productive artistic relationships between the four artists.

Permanent Collection
Also known as the Klee Museum, with an extensive collection of the artist's work; portraits by Anker; altarpieces by Deutsch; old panels by di Buoninsgna, Angelico; works by Beuys, Byars, Chagall, Dalí, Matisse, Kirchner, Picasso. **Architecture:** 1879 Classical building by Eugen Stettler; 1983 ultra-modern annex by Karl Indermühle and Otto Salvisberg.

Admission: SFr 6; fees for temporary exhibits. Handicapped accessible.
Hours: Tues., 10–9; Wed.–Sun., 10–5. Closed Mon.
Tours: Public tours (free with admission) usually Tues. Individual tours by reservation only; call (41) (31) 311 09 44.
Food & Drink: Cafeteria open museum hours.

Hermitage Foundation
2, Route du Signal, CH-1000, Lausanne 8, Switzerland
(41) (21) 320 50 01

1998 Exhibitions
Jan. 23-May 31
Pointillism, the New Codes of Color
Explores the aesthetics of color in early-20th-century painting, highlighting these works made with tiny spots of color. Includes works by Seurat, Signac, Matisse, and others.

Permanent Collection
Temporary exhibitions focus on 19th- and 20th-century painting. The collection (which is not on permanent display) consists of paintings by foreign and local artists, including works by Bocion, Sisley, Degas, Magritte, Oudot, and Plazzotta; also sculptures, drawings, and prints.

Paul Signac, *Capo di Noli, Near Geneva,* 1898. Private Collection. From *Pointillism: The New Codes of Color.* Photo courtesy Hermitage Foundation.

Architecture: Country villa designed by architect Louis Wenger built for Charles-Auguste Bugnion between 1842 and 1850; restoration in 1976.

Admission: Adults, SFr 13; children under 18, free. Handicapped accessible, including ramps and elevator.
Hours: Tues.–Sun., 10–6; Thurs. until 9.
Programs for Children: Offered throughout the year; call for details.
Tours: Thurs., 6:30; Sun., 3; groups by request.
Food & Drink: Cafeteria open during museum hours. Picnic areas available in the Hermitage park.
Museum Shop: Open during museum hours.

Fondation Pierre Gianadda
Rue du Forum 59, 1920, Martigny, Switzerland
(41) (27) 722 39 78

1998 Exhibitions
Thru Jan. 18
Russian Icons from the Tretyakov Gallery, Moscow

Jan. 24-June 1
Diego Rivera and Frida Kahlo

June 10-Nov. 22
Paul Gauguin

Permanent Collection
Three permanent galleries:
Le Musée Gallo-Romain,
featuring statues, coins,
jewelry, and other artifacts
from a first-century Roman
temple discovered in 1976
(museum is constructed
around the site); **Le Musée
de l'Automobile**, a
collection of vehicles from
1897–1939; and the **Parc de
Sculptures**, featuring works

Fondation Pierre Gianadda. Photo by H. Preisig.

by Miró, Arp, Moore, Brancusi, and others. Adjacent to the museum is an
excavated Roman amphitheater.

Admission: Adults, SFr 12; discounts for children, seniors, and groups.
Hours: Open daily; Feb.–June: 10–6; Jun–Oct.: 9–7; Oct.–Feb.: 10–12,
1:30–6.
Tours: Guided tours in English, German, French. Reservations required;
call (41) (27) 722 39 78.
Food & Drink: Restaurant and picnic area in the sculpture park. Self-
service cafeteria open Mar.–Oct.
Museum Shop: Open during museum hours.

Kunsthaus Zürich

Heimplatz 1, 8024 Zürich, Switzerland
(41) (12) 51 67 55

1998 Exhibitions

Thru Jan. 18
Böcklin—De Chirico—Max Ernst: A Journey Toward the Unknown (T)

Feb. 13-May 10
From Anker to Zünd: The Art of the Young Confederation

June 3-Aug. 30
An Open View Toward the Mediterranean: Young Swiss Artists

Sept. 25, 1998-Jan. 6, 1999
An Encounter with Modernism: Max Beckmann in Paris
Features the work of Beckmann and his contemporaries in early 20th-
century Paris, including Matisse, Picasso, Léger, Braque, and Rouault.

Permanent Collection

Features Old Master sculptures and paintings; works by Swiss artists including Koller, Zünd, Böcklin, Welti, Segantini, Hodler, Augusto Giacometti, Vallotton, Amiet and Giovanni Giacometti; 20th-century works by Matisse, Picasso, Max Ernst and Miró; graphic art; photography. **Architecture:** 1910 building by Karl Moser; expanded in 1925, 1958 and 1976.

Admission: Permanent Collection: adults, SFr 5; students, groups of 20 or more, seniors, SFr 3. Sun., free. Special exhibitions: adults, SFr 8–14; students, seniors, SFr 4–7; groups of 20 or more, SFr 7–12.
Hours: Tues.–Thurs., 10–9; Fri.–Sun., 10–5. Reduced hours on some holidays. Closed Mon., major holidays.
Tours: Groups call (41) (12) 51 67 65.
Food & Drink: Café-bar and restaurant; garden café open in summer.

Musée Barbier-Mueller

10 rue Calvin, 1204 Geneva, Switzerland
(41) (22) 312 02 70

1998 Exhibitions
Thru Sept. 30
Art of New Ireland

Oct. 1-Dec. 31
African Masks

Admission: Adults, SFr 5; seniors and students, SFr 3.
Hours: Daily, 11–5.
Programs for Children: Special programs depending on exhibition.
Tours: Contact (41) (22) 312 02 70 for information.
Museum Shop: Bookshop offers museum publications.

Index of Museums

Index

NOTES: